32

WALKER EVANS

EDITED BY CLÉMENT CHÉROUX

This catalogue is published on the occasion of the exhibition *Walker Evans* held at the Centre Pompidou, Paris, April 26–August 14, 2017, and at the San Francisco Museum of Modern Art, September 30, 2017–February 4, 2018.

Major support for the exhibition and catalogue is provided by the Terra Foundation for American Art

Edited by Philomena Mariani
Translated from the French by Sharon Grevet
Production coordinated by Luke Chase, DelMonico Books•Prestel
Typeset by Tina Henderson

Printed and bound in China

Front cover: see page 149.
Back cover: see page 69.

Published in 2017 by Centre Pompidou and DelMonico Books•Prestel

DelMonico Books, an imprint of Prestel, a member of Verlagsgruppe Random House GmbH

Prestel Verlag
Neumarkter Strasse 28
81673 Munich

Prestel Publishing Ltd.
14-17 Wells Street
London W1T 3PD

Prestel Publishing
900 Broadway, Suite 603
New York, NY 10003

www.prestel.com

WALKER EVANS

EDITED BY CLÉMENT CHÉROUX

 Centre
Pompidou

DelMonico Books•Prestel Munich, London, New York

FOREWORD

"Enfin Paris, chose incroyable!"

It was with these words that, in 1926, the young Walker Evans (1903–1975)—a great admirer of the photographer of Old Paris, Eugène Atget—described his first impression of the French capital where he had just arrived for a nearly year-long linguistic and cultural experience. A few years earlier, at the age of eighteen, he had discovered the poems of Baudelaire at the New York Public Library. And toward the end of his life, in 1971, he again declared that Baudelaire's "spirit" and Flaubert's "method" had influenced him "in every way."

That gives us some idea of just how large a role French culture played in Walker Evans's work. Yet, while he is now idolized by many of his peers, and certain of his images are instantly recognizable to the general public, the photographer has been exhibited all too rarely in France. Of course, in recent decades there have been several small exhibitions of some parts of his oeuvre: his trip to Cuba, his work on assignment for the American government as part of the Farm Security Administration, and his portfolios for *Fortune* magazine. But as surprising as it may seem, the Centre Pompidou exhibition is the first major retrospective of Walker Evans's work—from his early photographs of the late 1920s to the Polaroids of the 1970s—at a French museum. It is about time. Thus the words he wrote in 1926 and quoted here are imbued with an entirely new meaning: "Paris at last—unbelievable!"

The French think of Walker Evans, above all, as the photographer of the Great Depression that followed the 1929 stock market crash. With incomparable perspicuity, he captured the memorable faces of those Alabama sharecropper families, overwhelmed by life yet dignified, and revealed to the world the gaunt face of Allie Mae Burroughs, the dark eyes of her husband Floyd, and the difficult conditions of their hardscrabble lives. His acute attention to the details of everyday life— rural and urban—and to people of modest means greatly contributed to establishing the visibility of twentieth-century American culture. Some of his photographs have become iconic.

The retrospective presented at the Centre Pompidou shows, however, that Walker Evans's work extends well beyond that. It is unquestionably richer and more complex than it seems at first glance. Comprising more than 300 period prints from the most important American collections and about a hundred documents, this broad retrospective centers around the notion, so dear to the photographer, of "vernacular culture." The vernacular defines the forms of popular expression used by ordinary people for utilitarian purposes. It is all the little details of the everyday environment that reveal a specifically American form of culture: the wooden roadside shack, the way a shopkeeper arranges merchandise in his storefront window, the silhouette of the Ford Model T, the corrugated iron, the stamped aluminum, the convoluted typography of Coca-Cola signs.

This ambitious retrospective, which expands and deepens our understanding of Walker Evans's work, could not have been accomplished without generous loans from several major American institutions—in particular, New York's Metropolitan Museum of Art and Museum of Modern Art, and the J. Paul Getty Museum in Los Angeles—which have my sincere thanks, along with all the private collectors who agreed to part with their treasures for a few months, in order that our visitors might admire them.

Serge Lasvignes
President, Centre Pompidou

PREFACE

The work of Walker Evans exerts an effect that never fades. The diversity of the subjects he took on, the singularity and directness of his eye, the audacity of his compositions, so often reworked over the course of his publications, give his work the dimension of a manifesto and make him the standard bearer for recognition of photography as art. Thus, in 1938, he was the first photographer to have a solo exhibition at The Museum of Modern Art in New York.

Rooted in the 1930s, his work spanned profound social transformations in America, to which he remained a committed and unparalleled witness. Evans was undoubtedly to American photography what August Sander was to twentieth-century Germany and what David Goldblatt, who is featured in an upcoming exhibition at the Centre Pompidou, may now be to South Africa.

For Walker Evans's art combines artistic diligence and an ever-present concern for being the privileged eyewitness of his time. As such, he has inspired whole generations of photographers who have identified with his "documentary style." Better than anyone else, he was able to capture aspects of the everyday urban environment that ultimately formed a specifically American culture. Before anyone else, as early as the 1940s, he grasped the importance of working on artistic projects specifically for the pages of magazines, to make them accessible to a large audience.

At the end of the day, however, in Europe we have only a limited knowledge of Evans's work, usually confined to a few images taken in Alabama during the Great Depression, a few faces captured on the New York subway, or a few pages skillfully orchestrated for *Fortune* magazine. The present exhibition and its accompanying catalogue, organized by Clément Chéroux, now Senior Curator of Photography at the San Francisco Museum of Modern Art, and the entire Photography Department team at the Musée National d'Art Moderne, are intended to provide a more comprehensive, in-depth view of Evans's unique body of work. Here Europeans will discover that Evans also tried his hand at painting, and that, like Baudelaire's ragpickers—those "street poets of Paris" who so fascinated the poet—he was an avid collector of graphic ephemera, postcards, and signs.

Moreover, Evans was one of the very first photographers of his time to engage in autoreflexive work on photography. Thus, in many regards, he was a model for the Pop, Conceptual, and even Pictures Generation artists. Evans is undoubtedly one of the photographers of the past century whose work is constantly conjured by other artists. For everyone from Andy Warhol to Dan Graham and Sherrie Levine, over time he became not only America's photographer but America itself, recognized as such by his peers.

Conceived as a retrospective of the entire span of Evans's work, this exhibition is not constructed chronologically, as is most often the case for this artist, but takes a decidedly thematic approach. This highlights the photographer's genuine obsession with certain subjects such as roadside architecture, storefronts, lighted signs, typographic signs, and faces. This original presentation makes it possible to better understand what is undoubtedly at its core: a heartfelt search for the fundamental characteristics of American vernacular culture, in its fullest sense.

"A good art exhibition," Evans once said, offers "visual pleasure and excitement," but it can also be "a lesson in seeing." There is unquestionably in the work of this great photographer a sort of uplifting momentum. It compels us to look at unheralded things and people, and enjoins us to recognize the essence of their everyday lives, in a celebration of the ephemeral and the banal in the midst of modernity. I therefore hope that the present retrospective, the first of such magnitude at a French museum, may perpetuate a little of this uplifting power of Evans's images, and that it may indeed be "a lesson in seeing."

Finally, allow me to point out the Photography Department's essential role in bringing the photographic medium to the forefront of critical consciousness through its exceptional collection and thought-provoking exhibitions such as this one.

Bernard Blistène
Director, Musée National d'Art Moderne

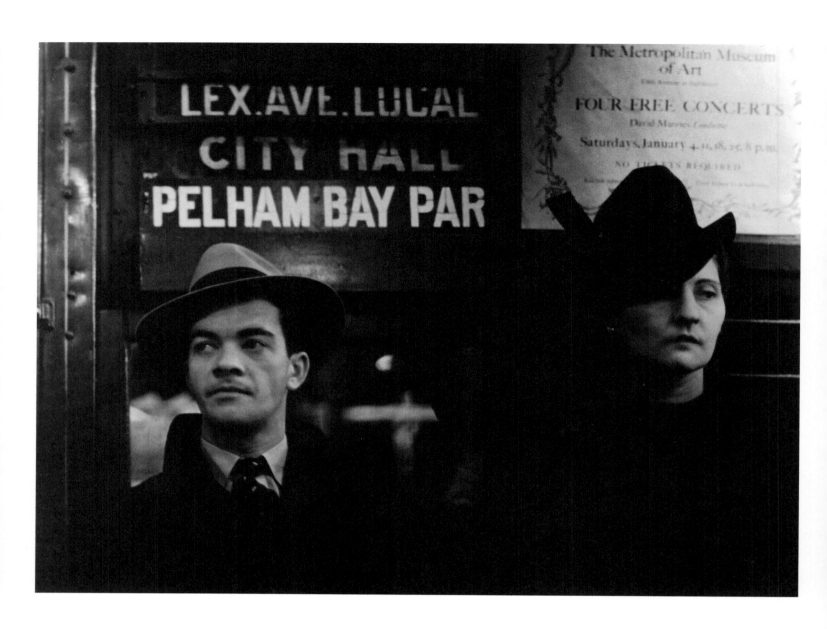

Fig. 1. Walker Evans
Subway Portrait, January 1941
Gelatin silver print, 5⅜ × 7⅛ in. (13.6 × 18.2 cm)
National Gallery of Art, Washington, D.C.
Gift of Kent and Marcia Minichiello, in Honor of
the 50th Anniversary of the National Gallery of Art,
1990.114.7

Fig. 2. Walker Evans
Subway Passengers, New York City,
January 25, 1941
35mm film strip, digital inversion
The Metropolitan Museum of Art, New York,
Walker Evans Archive, 1994, 1994.253.612.3

—CLÉMENT CHÉROUX

THE ART OF THE OXYMORON: THE VERNACULAR STYLE OF WALKER EVANS

A man and a woman sit side by side on the New York subway (fig. 1). He wears a light, wide-brimmed felt hat and a polka dot tie. A sign above his head indicates that he is traveling on the Lexington Avenue line, which connects City Hall to Pelham Bay Park. She wears dark clothes and a somewhat tattered hat. Behind her is a poster for four free concerts at The Metropolitan Museum of Art. Both of them are absorbed in their thoughts. Looking more closely at the picture, several details attract our attention. She seems abnormally taller, or as if seated a little higher than he. A black vertical stripe that merges with the dark wall of the car divides the frame from top to bottom, at three-fifths of the image. A few years ago, Sarah Greenough, curator of the photography collection at the National Gallery of Art in Washington, D.C., which owns this rare Walker Evans print, noted that it is not one but two images.[1] The subjects do not seem to be sitting at the same level because they are not in the same photograph. The black bar that appears on the print is actually the area separating the two successive views on the negative. When printing, Evans did not center his 35mm film strip (fig. 2) in the enlarger window, but instead offset it laterally so that the film holder could frame two consecutive shots. So he printed the right part of one image and the left part of the next one on the same photographic paper.[2] Although they appear to be in the car at the same time, the two passengers had not been photographed at the same time. He belongs to the moment before, while she inhabits the one that follows. A photograph is usually perceived as a coherent whole in space and time. Evans's image breaks out of this logical synchrony. Like a photomontage created in the very material of the film, it offers a diachronic reconstruction of the situation.

This book and the exhibition it accompanies are constructed according to this same diachronic principle. Most retrospectives of Evans's work are chronological: the modernist beginnings, the trip to Cuba, the work for the Farm Security Administration (FSA), the series on the three families of Alabama sharecroppers, and then the portfolios for *Fortune* magazine. With the exception of its introduction devoted to Evans's early years, this project breaks with chronology, mixing times and places from a decidedly more thematic perspective.

This approach has several advantages. It allows us to better understand what might be considered a stretching or a dispersal in Evans's work. The subway portraits, for example, were taken between 1938 and 1941, but the series did not take its final form until 1966, through an exhibition at The Museum of Modern Art (MoMA), New York, and the publication of the book *Many Are Called*.[3] Those who approach the work chronologically generally position this series in either the 1930s or the 1960s—in other words, either as a continuation of the exploration of the human face begun in Alabama or in the context of the more conceptual projects done for *Fortune*. However, as in the example of the photograph described in the introduction, this project combines the two. The thematic analysis solves this dilemma and renders the complexity of the project. It also provides an opportunity to more clearly link photographs separated by time or space and thus bring to light Evans's true preoccupations with certain subjects, like shop windows and typographic signs, which he never stopped compulsively hunting from the beginnings of his career in the 1920s to his death in 1975. Finally, approaching Evans's work through its most recurrent themes makes it possible to better grasp what constitutes its core: the passionate search for the fundamental characteristics of American vernacular culture.

The word *vernacular* is composed of the Latin root *verna*, meaning "slave."[4] Under ancient Roman law, slaves were considered property. Aristotle defined a slave as a "living tool."[5] The vernacular defines an activity linked to servitude or at least to service; it is *utilitarian*. In Roman law, *vernaculus* more specifically described a person who was not a product of the slave trade. He was not purchased or exchanged, but was born at home. By extension, the vernacular includes everything that is made, grown, or raised at home. It corresponds to domestic or homemade production. This is the reason that the vernacular is often associated with things local or regional. Finally, the slave occupied the lowest rung in the social hierarchy. Likewise, on the scale of cultural values, the vernacular has been designated a minor position. It is always located below what has been recognized as most worthy of interest by arbiters of culture. It develops on the periphery of what is considered to be standard, to count, or to carry weight in establishing taste. Decidedly popular, more linked to the culture of the masses than the elites, it is the alternative to fine art. *Vernacular* is one of those intimidating words we do not dare use without quotes. It always seems too broad for what it describes . . . or not precise enough. Its meaning seems to vary depending on who is using it. Here, it is defined from three specific angles: function, place, and spirit. The vernacular is *useful*, *domestic*, and *popular*.

The vernacular occupies a central place in American culture. It is found in literature as early as the nineteenth century, but it was not until the late 1920s that it became the subject of the first theoretical construct in the field of architectural studies. At Harvard University, in the magazine *Hound & Horn*, and during the early days of MoMA, personalities like Lewis Mumford, Alfred Barr, Lincoln Kirstein, Philip Johnson, and Henry-Russell Hitchcock set out to demonstrate that the United States played a role in the development of modernism

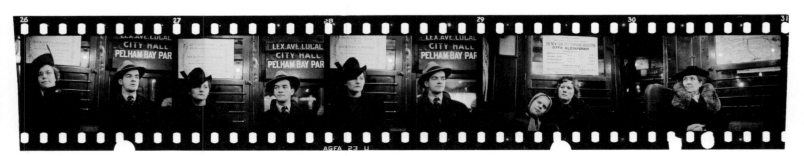

through its regional or functional architecture.[6] In 1934, Hitchcock along with photographer Berenice Abbott organized the exhibition *The Urban Vernacular of the Thirties, Forties, and Fifties: American Cities Before the Civil War*.[7] Not devoid of nationalistic ambitions, the project was intended to Americanize modernism through the lens of the vernacular. However, the term was little used in the 1930s. It was not until the work of American scholar John Atlee Kouwenhoven in the ensuing decade that the word started to migrate from the field of architecture to that of culture. In fact, it was he who would reintroduce the concept into the discussion of American art. Born in 1909, Kouwenhoven began taking an interest in the vernacular in 1939. He published his initial theories on the subject in August 1941 in *The Atlantic Monthly*, and then delved more deeply into them in his doctoral thesis at Columbia University, which culminated in 1948 in the publication of his seminal book *Made in America: The Arts in Modern Civilization*.[8] He returned to these topics frequently throughout his collections of essays *The Beer Can by the Highway* (1961) and *Half a Truth Is Better Than None* (1982).[9]

Kouwenhoven's understanding of the vernacular matches the one defined above: according to him, too, it is *useful*, *domestic*, and *popular*. He analyzes it, however, from a uniquely American point of view, that is, in a decidedly more positive and pragmatic way, one no longer linked to slavery. The main quality of the vernacular is therefore not *servitude*, but rather *serviceability*. Furthermore, from its *utility*, Kouwenhoven derives a particular quality that he describes as a "Truth of Function."[10] To explain this, he cites the example of tools manufactured in the United States, which are less ornamental, simpler, and more efficient than those manufactured in Europe. According to him, there is in the American vernacular a sort of functional beauty. In the scholar's essays, vernacular culture is also *domestic*, but in a much broader sense. By shifting the production process from the home to the factory, the Industrial Revolution brought about an expansion of the concept. The vernacular was no longer solely homemade or handmade, but could also be factory-made. It no longer simply referred to the production of a region, but to that of an entire country. In the industrial era, it was the nation that now acted as the home. While in Europe the vernacular had largely contributed to the formation of regional cultures, in the United States it participated fully in the development of a national identity. To explain this, Kouwenhoven often cites the example of the Ford Model T, which, for the era, represented not only maximum optimization of the industrial production process, but also acquisition of a self-sufficient means of transportation for the masses. It was, he felt, a perfect example of the American industrial vernacular.

According to Kouwenhoven, the vernacular is also defined by contrast with elitist culture. It is inextricably linked to the *popular*— a term he believed was in no way pejorative. Thus in the United States, the vernacular is not *minor*, it is *democratic*. In this regard, Kouwenhoven cites the balloon-frame houses that had sprung up throughout the American territory since the 1830s. Simple, economical, quickly built, using plentifully available materials, and requiring a low-skilled labor force, they represent a first form of industrialization of domestic construction. Intended for the masses,

they also constitute perfectly democratic housing. Over time, they eventually created a typically American architectural style. In Kouwenhoven's estimation, all in all, the American vernacular reflects a cross between the Industrial Revolution and the democratic impulse. The child born of that union was functionality. "It is my premise that roughly two hundred years ago the idea of democracy . . . and the technology of manufactured power quite suddenly collaborated to introduce unprecedented psychological and physical elements into man's environment, elements for which it was necessary to find appropriate and satisfying forms. The innumerable, often anonymous acts of arranging, patterning, and designing that went into the creation of those forms constitute the vernacular as I conceive it."[11] In his estimation, America is the home of the vernacular. There, it feels at home everywhere.

Like the generic category to which it belongs, vernacular photography is also *useful*, *domestic*, and *popular*.[12] Most photographic production is, in fact, *applied* photography. Documentary, scientific, ethnographic, military, and medical images—all of these take advantage of the investigative or recording capacity of the photographic tool, to view it for its functionality, in other words, as a service. Vernacular photography is also *domestic*. The family circle is one of the main sites of its production and circulation. First-communion portraits, wedding photographs, and all amateur production, moreover, constitute the other great vernacular source. Finally, vernacular photography is very widely *popular*. It has no rarity or distinction. Everyone does it, for better and for worse. It is precisely this that long kept it from being considered an art. Due to its profuse and prosaic character, vernacular photography occupies a lesser position in the scheme of images. Kouwenhoven himself became very interested in photography "whose roots are wholly in the vernacular," and he describes it as "the most important visual art."[13] In his exploration of popular cultures, he seems to have gradually realized that photography was both an inexhaustible breeding ground of the vernacular and a model for thinking about it. His last collection, *Half a Truth Is Better Than None*, contains two essays on the topic, one concerning documentary photography and the other the snapshot.[14]

Kouwenhoven's work on the vernacular greatly interested John Szarkowski, curator of photography at MoMA. That "great book" *Made in America*, he says in an interview, "was enormously important to me."[15] It was one of the inspirations for *The Photographer's Eye*, Szarkowski's most important work.[16] Kouwenhoven—curiously, this has never been noted before—was also close to Walker Evans. The academic had been very impressed with his 1938 exhibition at MoMA: "For those who saw it, it was a revelation."[17] It is difficult to accurately date early encounters between the two men, which may have taken place in the 1950s, while Kouwenhoven was preparing a book about New York featuring a photograph by Evans,[18] or, more certainly, in the very early 1960s, when he wrote a letter to support the photographer's application to the Carnegie Corporation requesting funding for his project on American vernacular culture.[19] But it was mainly from 1964 on that they saw one another more regularly. In charge of the archives of one of the largest private U.S. banks, Brown Brothers Harriman & Co., Kouwenhoven commissioned Evans to do a "photographic essay" on the firm. From 1964 to 1967, Evans regularly visited their premises to photograph employees, executive meetings, and the office environment. Some sixty images were appended as an epilogue to the book

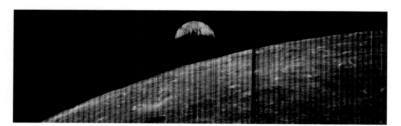

Fig. 3. *Orbiter 1. Earth from the vicinity of the moon*, August 23, 1966
Gelatin silver print, 19½ × 7¼ in. (18.5 × 49.5 cm)
Galerie Daniel Blau, Munich
Walker Evans commented on this photograph in Louis Kronenberger, ed., *Quality: Its Image in the Arts* (New York: Atheneum, 1969), p. 211

Partners in Banking, which Kouwenhoven published in 1968 for the bank's 150th anniversary.[20]

Evans himself took a great interest in vernacular culture. As his father worked in advertising, he developed a special relationship, very early on, with the iconography mass-produced in the trade: graphics, logos, flyers, etc. As a teenager, he began collecting postcards.[21] Later, he avidly collected graphic ephemera—bus tickets, lottery tickets, leaflets, etc.—and enamel roadside advertising signs (pp. 91–93). "I'm interested in what's called vernacular. For example, finished, I mean educated, architecture doesn't interest me, but I love to find American vernacular," he explained in 1971.[22] Evans was also very interested in vernacular photography. In addition to his postcard collection, which he considered a "vernacular art"[23] (pp. 96–97, 190–93), his archives contain many other examples of amateur images—portraits taken in neighborhood studios, photographs from press, police, and military archives (pp. 194–99). In his lists of projects for *Fortune* magazine, he often mentions applied photography: "The Industrial Uses of Photography . . . The Picture Agency Business . . . Pictorial History of Kodachrome . . . An Anthology of Work by Official Company (Ford, etc.) Photographers."[24] And when, in 1969, he wrote the photography section for the Louis Kronenberger book *Quality: Its Image in the Arts*, he naturally included Stieglitz, Strand, and Cartier-Bresson, but he also devoted several chapters to topics such as press images by Erich Salomon and astronomical pictures of Earth from the moon (fig. 3).[25] For him, the photograph of the atomic mushroom cloud over Nagasaki was not only "astounding" but "beautiful" as well.[26] Evans clearly loved vernacular photography.

However, it was with his own photography that Evans best celebrated the vernacular. His very first photographs, taken in the late 1920s, in a style very much influenced by the European New Vision, were already glorifying what is now considered the most spectacular aspect of American architectural modernism—New York skyscrapers. Several decisive encounters in the 1930s moved him toward a more understated and subtle vernacular. Ralph Steiner, who during 1931 trained Evans in the rudiments of the large-format camera, was himself fascinated with the torn posters, backyard life, and poetry of the roadside. James Agee, with whom Evans became friendly shortly afterward, was captivated by vernacular language. In *Let Us Now Praise Famous Men*, the book they produced together in 1941, the writer made abundant use of excerpts from the Gospels, popular song, and idiomatic expressions. It was also through his relationship with Berenice Abbott (p. 84) that Evans developed his interest in the vernacular. After a long stay in Paris, where she was Man Ray's assistant and then a well-known portraitist, Abbott returned to New York in 1929 with thousands of negatives and prints purchased from the executor of Eugène Atget's estate after his death in August 1927. Although while studying in Paris in 1926–27, Evans lived just steps from rue Campagne-Première, where the photographer of Old Paris had his workshop, and even noted the name of that street on the list of places he visited,[27] it is unlikely he saw those images at the time. It was in New York, in late 1929, in Abbott's studio, that he discovered their power.[28] "I was quite electrified and alarmed," he explained later.[29] He kept a few Atget photographs printed by Abbott for a long time (p. 85 top right) and readily acknowledged the influence of the man who did the most admirable visual survey of the Parisian vernacular.

Another important encounter, with Lincoln Kirstein (p. 80), took place during that same period. The conversation seems to have started in 1928. At that time, Evans was working in a Manhattan bookstore, where he devoted a window display to French literature, which had particularly attracted the young Harvard student's attention. The two men met in the early 1930s, at the salon of Muriel Draper. A prolific essayist, member of MoMA's advisory committee, founder of the avant-garde *Hound & Horn* magazine, the Harvard Society for Contemporary Art, and the New York City Ballet, Kirstein was witty, cultured, and enterprising.[30] Evans thought he was "by far the brightest figure in the art world of his generation."[31] Very close to Barr, Johnson, and Hitchcock—all three also graduates of Harvard—Kirstein was another aficionado of vernacular culture. In his magazine, intermingled with the texts of T. S. Eliot, William Carlos Williams, and Ezra Pound, he published articles on vernacular architecture, film, and cartoons.[32] He was also fascinated with photography in all its forms, including vernacular. In early 1931, he suggested Evans accompany him to photograph the Victorian architecture of New England (pp. 81–83).[33] That series of "perfect documents," as Kirstein described them,[34] was exhibited in MoMA's architecture gallery in 1933–34.[35] In the photographer's career, the project with Kirstein marked the start of a long journey to the heart of the American vernacular.

Shortly after the collaboration with Kirstein on Victorian architecture, Evans began to expand his focus to all other manifestations of vernacular culture. He became interested in how the *useful* was transformed into the *visible*. He tracked the most conspicuous signs of market-oriented functionality: how the shopkeeper arranged his display, organized his shop window, painted his signboard. For example, he was fascinated by the Georgia mechanic who, in order to let potential customers know that he sold car parts, hung them on his storefront in a heterogeneous but harmonious arrangement (p. 101). He sought out things that were being used or that had been used, all the way to the scrap heap. The photographer was also enthralled with all the little details of the *domestic* environment that revealed a sort of American-ness: the clapboard facades, the corrugated metal, the stamped aluminum, the silhouette of the Ford Model T, and the pseudo-cursive typeface of Coca-Cola signs. Finally, most of his subjects were decidedly *popular*. The places he roamed were traffic spaces with no particular distinction: the American highway, the main streets of small towns, the city streets, sidewalks, and gutters. The objects that moved him were ordinary, mass-produced, and intended for everyday use. The same applied to the people he photographed. Those who inhabit his photographs were never celebrities, but anonymous, nameless, and devoid of status; they were the ordinary human faces of office workers, laborers, and sharecroppers. In choosing what he placed before his lens, Evans always favored the *useful*, the *domestic*, or the *popular*, and sometimes all three at once. In his archive, rare are the motifs that elude this triad. The vernacular was truly his favorite subject.

In Evans's work, there is also a fairly substantial group of images whose subject is not simply the vernacular, but rather vernacular photography itself (pp. 290–303): the front of a neighborhood studio, the facade of a business selling five-cent driver's license photos, family snapshots tacked to a wall, and a few itinerant or seasonal street photographers. The recurrent nature of these images shows that Evans was as interested in vernacular culture generally as in its more specifically photographic manifestations. For him, vernacular photography was a *model* in both senses of the word: a *subject* he never tired of placing before his lens, but also a *method* from which he liked to draw inspiration. For more than forty years, he never ceased to pattern his *approach* on vernacular photography techniques. To capture the look of the wooden churches of the southeastern United States, he became an architectural photographer (pp. 214–19). To record the image of the main streets of small-town America, he transformed himself into a local worker producing dozens of views for the publication of postcards. To devise his series of tools, metal chairs, and African masks, he became a catalogue photographer, specializing in packshots of objects. To capture the passersby in Bridgeport, Detroit, or Chicago, he worked like the photographers who wait on

street corners, suddenly popping up in front of pedestrians and taking their picture. And to photograph in the New York subway (pp. 244–57), he became, as he himself explained, "an impersonal fixed recording machine,"[36] in other words, a virtual photo booth. The list could easily be lengthened, as Evans adopted the forms or procedures of vernacular photography while at the same time taking an artistic approach.

A few decades ahead of the Conceptual artists of the 1960s, Evans thus made vernacular photography techniques his own. This practice—which, following the "making do" model of Michel de Certeau,[37] could be described as "making like"—is at the heart of his creative strategy and what constitutes his style. In a 1971 interview, in response to Leslie Katz's question about whether documentary photographs could also be works of art, Evans replied: "Documentary? That's a very sophisticated and misleading word. And not really clear. You have to have a sophisticated ear to receive that word. The term should be *documentary style*. An example of a literal document would be a police photograph of a murder scene. You see, a document has use, whereas art is really useless. Therefore art is never a document, though it certainly can adopt that style. I'm sometimes called a 'documentary photographer,' but that supposes quite a subtle knowledge of the distinction I've just made, which is rather new. A man operating under that definition could take a certain sly pleasure in the disguise."[38] This last circumlocution is particularly revealing. After using the personal pronoun "I," and then suddenly taking cover behind the third person singular, Evans acknowledged that his images are not, strictly speaking, documentary photographs, but that he nevertheless liked to make them look that way. On closer inspection, however, the photographic document was not his only model. He also borrowed a good deal from other visual registers such as the snapshot, the postcard, and advertising, whose primary purpose is not, strictly speaking, documentation, but they do have in common their membership in the generic category of the vernacular. Rather than "documentary style," it would be more accurate to describe Evans's approach as "vernacular style."

In that same 1971 interview, Evans also acknowledged the importance that two nineteenth-century French writers had for him: Charles Baudelaire and Gustave Flaubert. He read Baudelaire at the New York Public Library, at eighteen years of age.[39] Later, in Paris, he translated two of Baudelaire's poems into English (pp. 65–67). Evans shared with the poet the intuition that the street was an inexhaustible source of poetic finds. Like Baudelaire, he was interested in the discards of the modern city because they offered a sort of hyperbole of the vernacular: *useful*, *domestic*, and *popular* objects that had reached the final stage of their social development. Describing the photograph of a gutter filled with the remnants of urban life, Evans exclaimed: "It is Baudelairean. I wish Baudelaire was alive to see it."[40] Late in his life, he began collecting the very objects he photographed. After recording a few pieces of paper in a gutter or an enamel sign on the side of the road, he would appropriate and keep them. He saw an obvious relationship between the act of collecting and the act of photographing: "It's almost the same thing," he explained. "I think all artists are collectors of images."[41] "I've noticed that my eye collects," he said in another interview.[42] There is little doubt that Evans identified with the figure so glorified by Baudelaire—the ragpicker, who collects the rejects of industrial society "like a miser guarding a treasure."[43] In his collection, Evans had a postcard depicting two ragpickers sorting through garbage cans in a Paris courtyard (p. 96 top left).

If Baudelaire interested Evans for his choice of

subjects, Flaubert fascinated him more for his *method*. When Katz asked him about his favorite authors, he responded without hesitation, "Flaubert, I suppose, mostly by method."[44] It was probably fairly late that he took an interest in the author. His name does not appear alongside those of Baudelaire, Cocteau, Gide, Huysmans, Laforgue, and others in the notes he took in the 1920s while studying French literature in Paris.[45] The photographer did, however, mention Flaubert in interviews that he gave late in life, after Francis Steegmuller's scholarship contributed to more widespread dissemination of the author's work in the United States. It is difficult to know what works by Flaubert Evans read. Perhaps his novels, probably his correspondence, and certainly the memoirs of his travels in Egypt, as he gave Jerry Thompson a copy of Steegmuller's translation to read in 1973.[46] So it was retrospectively that Evans realized how similar his method was to that of Flaubert. "I wasn't very conscious of it then, but I know now that Flaubert's esthetic is absolutely mine. Flaubert's method I think I incorporated almost unconsciously, but anyway used in two ways: his realism and naturalism both, and his objectivity of treatment; the non-appearance of author, the non-subjectivity. That is literally applicable to the way I want to use a camera and do."[47] What interested Evans in the Frenchman's writing was thus the predominant role that the eclipsing of the author imparted to the subject. Like Flaubert, he was obsessed with impersonality. Flaubert's literary approach was based on transparency of the author. "It is one of my principles that one must not write oneself into one's work," he explained.[48] After all, was not Flaubert's final, posthumously published work a portrait of two copyists, Bouvard and Pécuchet, whose quintessential work consists of transcribing what others write, without style and without pathos?[49]

Evans identified completely with this form of disappearance of the author. He never stopped putting it into practice by using automation as often as possible. To photograph passersby in Detroit, he simply prepared his camera frame and waited for them to walk into it. The same applied to passengers on the New York subway: "I would like to be able to state flatly," he wrote, "that sixty-two people came unconsciously into range before an impersonal fixed recording machine during a certain time period, and that *all* these individuals who came into the film frame were photographed, and photographed without any human selection for the moment of lens exposure."[50] Similarly, when photographing architecture, he generally took the most exactly frontal position, as if he did not want to choose his view angle and preferred to let it be dictated by his subject. This was

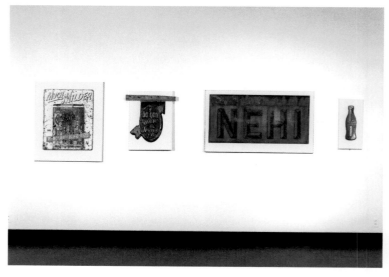

Fig. 4. Jerry L. Thompson
Enameled roadside signs from the collection of Walker Evans exhibited at Yale University Art Gallery in the retrospective *Walker Evans: Forty Years*, 1972
Gelatin silver print, 8 × 10 in. (20.3 × 25.4 cm)
Collection Jerry L. Thompson

another form of automation. Neutral point of view is also reflected in Evans's work by his adoption of the forms and procedures of vernacular photography. By becoming an architectural or catalogue or street photographer for the duration of a project, Evans positioned himself in diametric opposition to the "auteurist" approach exemplified by Alfred Stieglitz. By working this way, Evans too became a sort of copyist. To produce one of his most famous photos, *Penny Picture Display* (p. 291), he positioned himself in front of a photographer's window display, frontally framed a few of the portraits in it, and then simply reproduced them. The picture is a sort of photographic version of *Bouvard and Pécuchet* and, at the same time, a true manifesto of vernacular style. For Evans, reading Baudelaire and Flaubert was a little like looking in a mirror. In the poems of the one, he saw his own predilection for street theater and ordinary people, and in the books of the other, he recognized his own realistic and impersonal way of working. His liking for these two great French literary figures cannot in fact be dissociated from his interest in the vernacular as *subject* and as *method*.

It is undoubtedly not Evans's least original trait that he attempted to define the American vernacular by drawing inspiration from two French writers. And especially because, for American artists of that era, defending the vernacular was supposed to be a strategy for escaping the supremacy of imported European cultural models. This, however, is not Evans's only paradox. His determination to make art by stubbornly photographing minor *subjects* using historically anti-artistic *methods* defies common sense. Therein lies the ambivalence of the vernacular style. He contrasts "style," which reflects the most refined aesthetic vocabulary, with "vernacular," which incorporates everything that is not art. In a permanent situation of great tension, this approach thus attempts to fold elite and popular culture into one another. Evans fully understood the potentialities of this dialectical tension that photography and the vernacular were able to introduce into art. He never stopped tinkering with them. In 1971, for his retrospective exhibition at the Yale University Art Gallery, for example, he decided to push the experience of ambiguity to the limit by exhibiting his photographs in the same space as his collection of advertising signs (fig. 4). In his *New York Times* column, Hilton Kramer noted that Evans had thereby sprung "a beguiling intellectual trap" from which future generations of theoreticians would have to extricate themselves.[51] It is not certain that they have succeeded. In the same period, Evans confided to Louis Kronenberger that he had just discovered the word "oxymoron."[52] "Deafening silence," "gentle violence," or "obscure clarity," this figure of speech juxtaposes two apparently contradictory terms into a potentially poetic phrase. The word fit Evans like a glove. It accurately defined his vernacular style, his concept of photography, and above all, his idea of art.

The author would like to express his profound gratitude to Anne Bertrand, Jeff Rosenheim, Jerry Thompson, John Hill, Judith Keller, and Christian Milovanoff, who helped, guided, and inspired him in his research on Walker Evans.

1. See Sarah Greenough, *Walker Evans: Subways and Streets* (Washington, D.C.: National Gallery of Art, 1991), p. 38.
2. This was not simply a laboratory experiment, as the photographer would publish this image in "Walker Evans: The Unposed Portrait," *Harper's Bazaar* 95 (March 1962), p. 123. It was also shown at the 1966 MoMA exhibition.
3. *Walker Evans' Subway, 1938–1941*, The Museum of Modern Art, New York, October 5–December 11, 1966; Walker Evans, *Many Are Called* (Boston: Houghton Mifflin, 1966).
4. See Alain Rey, ed., *Dictionnaire historique de la langue française* (Paris: Le Robert, 2010), p. 2437; Marguerite Garrido-Hory, "Verna," in *Des formes et des mots chez les Anciens: Mélanges offerts à Danièle Conso*, edited by Claude Brunet (Besançon: Presses Universitaires de Franche-Comté, 2008), pp. 299–308.
5. Aristotle, *Nicomachean Ethics* 8:11.
6. See Mardges Bacon, "Modernism and the Vernacular at the Museum of Modern Art, New York," in *Vernacular Modernism: Heimat, Globalization, and the Built Environment*, edited by Maiken Umbach and Bernd Hüppauf (Stanford: Stanford University Press, 2005), pp. 25–52.
7. See Janine A. Mileaf, *Constructing Modernism: Berenice Abbott and Henry-Russell Hitchcock: A Re-creation of the 1934 Exhibition, The Urban Vernacular of the Thirties, Forties, and Fifties: American Cities before the Civil War* (Middletown, Conn.: Davison Art Center, Wesleyan University, 1993).
8. John A. Kouwenhoven, "Arts in America," *The Atlantic Monthly* 168 (August 1941), pp. 175–80, and *Made in America: The Arts in Modern Civilization* (Garden City, N.Y.: Doubleday, 1948).
9. John A. Kouwenhoven, *The Beer Can by the Highway: Essays on What's American about America* (Garden City, N.Y.: Doubleday, 1961), and *Half a Truth Is Better Than None: Some Unsystematic Conjectures about Art, Disorder, and American Experience* (Chicago: University of Chicago Press, 1982).
10. Kouwenhoven, "Truth of Function," in *Made in America*, p. 16.
11. Kouwenhoven, *Half a Truth Is Better Than None*, p. 80.
12. See Clément Chéroux, *Vernaculaires: Essais d'histoire de la photographie* (Cherbourg: Le Point du Jour, 2013).
13. Kouwenhoven, *Half a Truth Is Better Than None*, p. xii.
14. John A. Kouwenhoven, "Living in a Snapshot World" and "Photographs as Historical Documents," in *Half a Truth Is Better Than None*, pp. 147–204.
15. John Szarkowski, interview with Mark Durden, "Eyes Wide Open," *Art in America* (May 2006), at http://snapshotic.blogspot.fr/2014/02/eyes-wide-open-john-szarkowski.html.
16. John Szarkowski, *The Photographer's Eye* (New York: The Museum of Modern Art, 1966), p. 4. In the acknowledgments on page 4, Szarkowski mentions his debt to Kouwenhoven's book *Made in America*.
17. John A. Kouwenhoven, *Partners in Banking: An Historical Portrait of a Great Private Bank, Brown Brothers Harriman & Co., 1818–1968* (Garden City, N.Y.: Doubleday, 1968), p. 209.
18. John A. Kouwenhoven, *The Columbia Historical Portrait of New York: An Essay in Graphic History in Honor of the Tricentennial of New York City and the Bicentennial of Columbia University* (Garden City, N.Y.: Doubleday, 1953), p. 481.
19. John A. Kouwenhoven, letter to John Gardner, May 25, 1961, The Metropolitan Museum of Art, Walker Evans Archive (MMA/WEA), 1994.250.85(1). I thank Anne Bertrand for providing me with this reference.
20. Kouwenhoven, *Partners in Banking*, pp. 209–28. Correspondence between Evans and Kouwenhoven on this subject is preserved in the MMA/WEA 1994.260.11(9, 10). All photographs and contact sheets for the *Partners in Banking* project, along with some correspondence, are preserved at the New-York Historical Society in New York City.
21. See Jeff L. Rosenheim, *Walker Evans and the Picture Postcard* (Göttingen and New York: Steidl and The Metropolitan Museum of Art, 2009).
22. Walker Evans, in Leslie G. Katz, "Interview with Walker Evans," *Art in America* 59, no. 2 (1971), p. 88.
23. Walker Evans, in Rosenheim, *Walker Evans and the Picture Postcard*, p. 109.
24. John T. Hill and Jerry L. Thompson, *Walker Evans at Work* (New York: Harper & Row, 1982), p. 184.
25. Walker Evans, "Photography," in *Quality: Its Image in the Arts*, edited by Louis Kronenberger (New York: Atheneum, 1969), pp. 169–211.
26. James R. Mellow, *Walker Evans* (New York: Basic Books, 1999), p. 488.
27. Walker Evans, "Disgust in the Boat Train," in *Unclassified: A Walker Evans Anthology: Selections from the Walker Evans Archive, Department of Photographs, The Metropolitan Museum of Art*, edited by Jeff L. Rosenheim (Zurich: Scalo, 2000), p. 68.
28. See Peter Galassi, *Walker Evans & Company* (New York: The Museum of Modern Art, 2000), pp. 15, 47.
29. In a lecture delivered at Harvard University two days before his death and posthumously published in *The New Republic*, November 13, 1976.
30. See Lincoln Kirstein, *Mosaic: Memoirs* (New York: Farrar, Straus & Giroux, 1994); Martin B. Duberman, *The Worlds of Lincoln Kirstein* (Evanston, Ill.: Northwestern University Press, 2008).
31. Walker Evans, interview with Davis Pratt, September 24, 1969, typewritten transcription, p. 12a, MMA/WEA 1994.250.152.
32. See *Hound & Horn: A Harvard Miscellany, 1927–1934* (New York: Kraus Reprint, 1966).
33. See Robert O. Ware, "Walker Evans, the Victorian House Project, 1930–1931," unpublished research paper, University of New Mexico, 1989, viewed at the J. Paul Getty Museum, Los Angeles; Barnaby Haran, "Homeless Houses: Classifying Walker Evans's Photographs of Victorian Architecture," *Oxford Art Journal* 33, no. 2 (2010), pp. 189–210.
34. Lincoln Kirstein, "Walker Evans' Photographs of Victorian Architecture," *Bulletin of the Museum of Modern Art* 1, no. 4 (1933), p. 4.
35. *Walker Evans: Photographs of Nineteenth-Century Houses*, The Museum of Modern Art, New York, November 16–December 8, 1933.
36. Walker Evans, "Unposed Photographic Records of People," *Photographs of Metropolitan Faces*, typescript dated 1942, J. Paul Getty Museum, Los Angeles, 84.XG.963.50.1. The sheet preserved at the Getty (reproduced in this volume on page 257) containing sixteen portraits cropped to the face seems to confirm that relationship to a photo booth.
37. See Michel de Certeau, "'Making Do': Uses and Tactics," in his *The Practice of Everyday Life* (Berkeley: University of California Press, 1984), pp. 29–42.
38. Evans, in Katz, "Interview with Walker Evans," p. 87.
39. Walker Evans, "August 7, 1926," typescript dated August 7, 1926, MMA/WEA 1994.250.2(5).
40. Evans, in Katz, "Interview with Walker Evans," p. 85.
41. Ibid.
42. "Walker Evans, Visiting Artist: A Transcript of His Discussion with the Students of the University of Michigan, 1971," in *Photography: Essays & Images*, edited by Beaumont Newhall (New York: The Museum of Modern Art, 1980), p. 317.
43. Charles Baudelaire, "Les paradis artificiels. Du vin et du hachisch, I. Le vin" (1851), in *Oeuvres complètes*, vol. 1 (Paris: Gallimard, Bibliothèque de La Pléiade, 1961), p. 327.
44. Evans, in Katz, "Interview with Walker Evans," p. 84.
45. Walker Evans, "Homework, French Civilization Class," typescript dated November 12, 1926, MMA/WEA 1994.250.2(9).
46. See *Flaubert in Egypt: A Sensibility on Tour: A Narrative Drawn from Gustave Flaubert's Travel Notes & Letters*, translated and edited by Francis Steegmuller (Boston: Little, Brown, 1972); Jerry L. Thompson, *The Last Years of Walker Evans: A First-Hand Account* (New York: Thames & Hudson, 1997), p. 24.
47. Evans, in Katz, "Interview with Walker Evans," p. 84.
48. Gustave Flaubert, letter to Marie-Sophie Leroyer de Chantepie, March 18, 1857, in *Correspondence*, vol. 2 (Paris: Gallimard, Bibliothèque de la Pléiade, 1980), p. 691. For the impersonality of Flaubert's style, see Victor Brombert, "Réalisme et impassibilité," in *Flaubert par lui-même* (Paris: Éditions du Seuil, 1971), pp. 5–11.
49. Gustave Flaubert, *Bouvard et Pécuchet* (Paris: Société des Belles Lettres, 1945).
50. Evans, "Unposed Photographic Records of People," J. Paul Getty Museum, Los Angeles, 84.XG.963.50.1.
51. Hilton Kramer, "Second Evans Retrospective—Smaller but Powerful," *The New York Times*, December 10, 1971. Jerry Thompson also commented on this remark in *The Last Years of Walker Evans*, p. 20.
52. Walker Evans, letter to Louis Kronenberger, September 17, 1968, Louis Kronenberger Papers, Series 1, Correspondence 1939–1981, Box 1, Folder 47, Manuscripts Division, Department of Rare Books and Special Collections, Princeton University Library. I thank Anne Bertrand for providing me with this reference.

—JERRY L. THOMPSON

A "DEVIOUS GIANT" AND A "GIANT SEQUOIA": WALKER EVANS AND LINCOLN KIRSTEIN

He was lucky in his friends.
James R. Mellow[1]

Walker Evans was slight of stature, standing about 5 feet 8 inches, and always slender: thin, even, in later life. He was extremely high-strung, often on fire with nervous energy. Consequently, he had "stomach trouble"—gastric ulcers requiring surgery. His last abdominal surgery (in late 1972) entailed a long, slow recovery involving strong painkillers. These tended to cloud his mind and put him to sleep. Those who were caring for him devised strategies to revive his interests, or (at a bare minimum) simply keep him awake.

One of these strategies involved conversations to be tape-recorded. During one of these conversations (February or March 1972; the recording machine may not have been actually turned on), he said something about a particular picture he had taken that led me to suspect he had not been alone when that picture—a view of a distressed building in a rundown part of lower Manhattan (fig. 1)—was made. In fact, he had not been alone: a "sailor buddy" of his friend the poet Hart Crane had been with him, acting as bodyguard (recall, Evans was slight of stature) and even leading him to some good subjects he would not otherwise have known about.

This revelation led to a kind of parlor game: I would think of a picture I admired and then ask Evans who *else* had been there when the picture was made. To my surprise—at the time (I was twenty-seven) I assumed that great artists did their greatest work in splendid solitude, as Atget had—to my surprise, most of the pictures I mentioned had depended on (or at least involved) the knowledge or presence of another person. As an artist, Evans began to seem less like "the marble index of a mind for ever / Voyaging through strange seas of Thought, alone" (Wordsworth's description of the statue of Newton at Cambridge), and more like a cunning Odysseus, contriving to find a helpful guide to lead him down to Hades.

I learned that the pictures of Belle Grove plantation (Louisiana, 1935; p. 167) had been taken with his New Orleans girlfriend (later

first wife) Jane Smith Ninas in tow. Having lived in New Orleans for some time, she may even have known the way. On other occasions, she stood in front of Evans as he pretended to take her picture; he was actually using a right-angle viewfinder so as to photograph bystanders who watched. A later view of an interior with a large upholstered chair (Kentucky, 1970) had been made in the house of a friend's cook, whom he had followed home. A facade in Colorado displaying a grid of bold numbers had been pointed out to him by friends he was visiting. And on and on.

It became clear that Evans was a master at picking other people's brains, at turning what they knew and what they could do to his advantage. My own then-recent experiences with him bore that conclusion out: he regularly depended on informants (including his students at Yale) to lead him to the painted signs and other things he was at that time (1971–74) interested in collecting. In some instances, his enthusiastic helpers brought the signs to him—not only particular signs they knew him to be interested in, but also others they had spotted on their own and judged he might like. He accepted all offers, but fawned over and displayed only the "finds" he approved.

By 1930, Evans was a clever, ambitious young man already finding his ways into the small but rich world of art and culture in New York City. He had managed to get his pictures of Brooklyn Bridge in front of Harry and Caresse Crosby, the wealthy, stylish couple who were planning to publish Hart Crane's book-length poem *The Bridge* in 1930. Initially, they planned a deluxe edition to be printed in Paris, using a painting of the bridge by Joseph Stella as an illustration. They decided to use three of Evans's photographs instead: Crosby was a photographer himself, having worked with Henri Cartier-Bresson, and also (like Evans) having published his photographs in fashionable magazines.[2]

Crane strongly approved the decision to use photographs: "I liked that portfolio he [Evans] sent you via Gretchen [Powel, a photographer whose work Black Sun Press had published]. I think that Evans is the most living, vital photographer of any whose work I know. More and more I rejoice that we have decided on his pictures rather than Stella's."[3]

Evans was regularly meeting people who could help him advance—and these were also people he could learn from. He became buddies (of a sort) with Crane, who (in spite of his poverty and reckless habits) had contact with figures prominent in the New York literary scene.[4] The cultural world in New York in 1930 was small enough that people connected to it ran into each other from time to time, again and again: in a nightclub in Harlem, at a sailor's bar in Brooklyn, at a "literary" party in Greenwich Village—or at the stylish weekly salon conducted by Muriel Draper, an American whose colorful life would include a visit to Russia in 1934 as well as involvement in the Spanish Civil War. Draper brought together visiting Europeans with artists of various kinds, including figures prominent in what was known as the Harlem Renaissance. Photographer and filmmaker Ralph Steiner (who gave Evans his first view camera) characterized the gatherings as "chi-chi." Steiner said the talk there was "pretty much over [his] head."[5]

Evans found his way to this salon, probably taken there by Lincoln Kirstein.[6] Evans's presence was definitely noticed, as Kirstein's journal entries record; by November 1930, the two were seeing each other as frequently as several times a week. They went together to bars and nightclubs, but also to museums and films. Kirstein, whose temperament, upbringing, education, and travel had all prepared him to be an enthusiastic aesthete, was a great fan of the cinema—of the Soviet

Fig. 1. Walker Evans
South Street, New York City, 1934
Gelatin silver print, 7³⁄₈ × 5³⁄₄ in. (18.7 × 14.6 cm)
The J. Paul Getty Museum, Los Angeles,
84.XM.956.93

cinema especially, and of the film work of Sergei Eisenstein in particular.

Kirstein's diary entry for November 12, 1930, records not only a meeting with Evans, but also impressions of his new friend: "Manner of suppressed nervousness; colossal strain . . . He said the whole possibility of the medium [of photography] excited him so much that he thought sometimes he was completely crazy. However, his extreme narcissism was extremely appealing to me."[7]

On January 19 of the next year (1931), Kirstein reports walking Evans home from Muriel Draper's at five o'clock in the morning. In later life, Kirstein recalled walking home with Evans from Draper's to 14th Street, date unspecified. They were so involved in talk, Kirstein reported (about 1990), that when they arrived at Evans's address, they kept on walking, turning around to retrace their steps back to Draper's, still deep in conversation.

A word about this conversation: Throughout his life, Evans was elusive, evasive, even secretive about what was going on inside him while he was at work. He was a stimulating, wide-ranging conversationalist in later life, but he never spoke of his own working process except to say it was a private matter. When asked about his sureness in framing and capturing subjects, he often said he felt as if some force were working *through* him, guiding his choices.

Kirstein was a forceful intellectual presence, even in late life. He listened to others, but over ten years of visits with him, I never saw him retreat to a passive stance in the face of an assertive partner in conversation, someone who might press an alternative version of whatever subject had come under discussion.[8] From an early age, he had exposed himself (through reading and firsthand experience) to a wide range of interests. By the time Evans met Kirstein, the latter had toured Europe more than once (including a visit to the Bayreuth Festival), studied at Harvard with fellow students and tutors who would become the first generation of American museum directors, and taken the lead in founding (and funding) both an exhibition society and a "little magazine"—*Hound & Horn*, which began in 1927 as a "Harvard Miscellany" but went on to become a cultural journal of international importance. In managing this little magazine, young Kirstein would ask for (and receive) advice from Ezra Pound and T. S. Eliot. The precocious young man Evans talked with in 1930 would end with a bibliography listing 575 entries, many of them book length, on a bewilderingly wide range of topics. After his death, Arlene Croce wrote of him: "Kirstein leaves no successor. The woods are full of arts patrons and promoters. He was a giant sequoia . . ."[9]

Kirstein's forceful presence supplied one half of the "conversation" during the walk home from Draper's. The other half came from Kirstein's latest enthusiasm, his passive, reticent new friend.

Evans's youthful correspondence with his friend Hanns Skolle

displays Evans during these years as ambitious, witty, and even plucky—at least when writing letters, which is a form of talking to oneself. Talking with Kirstein would have been another matter. Evans would recall later that Kirstein was "an aggressive, quite unrestrained young man. . . . He invaded you; you either had to throw him out or listen to him." Evans described the younger man as "teaching [him] something about what [he] was doing—it was a typical Kirstein switcheroo, all permeated with tremendous spirit, flash, dash and a kind of seeming high jinks that covered a really penetrating intelligence about and articulation of all esthetic matters and their contemporary applications. . . . Professor Kirstein."[10]

In spite of the imbalance of their backgrounds and assertive energy, Evans was not at a total disadvantage. Compared to Kirstein, he had gotten a pretty late start—he was twenty-five before he found his medium—but he had taken to it quickly. He began with impressive visual organization in the manner of the New Vision, making what might be called "abstractions" using the lines and surfaces offered by the modern city. But very soon, gritty, fact-heavy content began to weigh into his pictures.

The pictures he made of Brooklyn Bridge (1928–29) are instructive. These include "angle shots" tilting the bridge to fill the frame and views focusing on the bridge's weblike diagonal stays, a formalist's feast (p. 71 left). But other pictures include such elements as a lumpy sleeping foreground figure, a Manhattan skyline visible through the stays, and loaded barges viewed from above—not as geometric patterns, but as boats full of *stuff*.

By 1930, Evans was drawn to notice the corner of a room in a modest house in Truro, Massachusetts (p. 299). He framed the telling collection of objects he found there so tightly that geometric composition hardly came into play at all. A cactus in a repurposed wooden tub shares the frame with dried flowers in a column-shaped glass vase. The capital of a pilaster adorning a white mantelpiece appears prominently in the picture's lower left corner. The rest of the picture shows pieces of studio portraits of sallow faces and figures (suitably dressed up and composed for their formal portraits) peeking through and around the "bouquet" arrangement. Stuck into the top of the arrangement is a small American flag. The whole rowdy concatenation—dusky immigrants in fancy dress, dried flowers, a cactus, Greek columns, a tub saved from the junkpile, and a small dime-store American flag whose tiny staff reaches just to the picture's top margin—amounts to a tightly packed poem about America. And this "poem" was neither constructed along the lines of, nor composed of materials drawn from, the world of "high culture." The capital of the pilaster and the columnar glass vase sound notes echoing classicism, but the rest of the found still life tells of the common daily life of ordinary people. Both *composition*—the picture is a tightly packed jumble—and *content*—the materials shown—are drawn from the common everyday, from the vernacular.

The facile formalist has by 1930 begun to register the weight of his early (and deep) involvement with the perceptive, complex literary writing—in French as well as in English—he so admired. In this tight interior detail, as in his acknowledged influence Flaubert, artistry hides its hand. No virtuosic "composition"—no dizzying perspective, no striking chiaroscuro, no "tricks" of sophisticated artistic practice—obtrude to claim the viewer's attention. The unremarkable things themselves seem to be doing all the work. A collection of ordinary things seen in what seems to be an ordinary way claims and holds the thoughtful viewer's attention.

MINSTREL SHOWBILL, 1936

Fig. 2. Spread from *American Photographs*, exhibition catalogue (New York: The Museum of Modern Art, 1938), pp. 76–77

This impressive level of accomplishment was what Evans brought to the conversation with

Kirstein. Evans may not have advanced a logical, verbal presentation of what he was coming to be able to put into pictures, but Kirstein recognized in some of the prints a quality not present in Evans's conversation.

In spite of what he admired in the pictures, Kirstein dwelt on the presence of the man he was interested in. He records telling Evans that "he submitted too easily to his terrors" (entry dated "January–February (?)" [1931]). Kirstein proposes projects Evans fails to respond to; he attempts conversational gambits, only to be met by, "I don't know." By April 1931, Kirstein concludes: "Walker Evans I find a considerable disappointment inasmuch as he has to be constantly amused; he seems perennially bored, thin blooded, too easily tired." And then—significantly—"I find it impossible to bully him by rushing him or telling him just what to do" (April 15). And yet: he finds the pictures Evans made of nineteenth-century architecture "far better than I had dared hope" (May 13).

Kirstein had hoped Evans would record a collection of structures (most wooden; many imperiled) built through the energetic efforts of native craftsmen. Kirstein saw in these structures an outpouring of inventive design, and a skill in adapting local materials to realize these inventions. The builders were not trained architects, perhaps not even educated at all beyond elementary basics, but what they built spoke of an energetic native culture.

Kirstein, like other thoughtful American aesthetes, was not interested in American works that attempted to copy the achievements of Europe. He was interested to identify a culture springing from native roots, a culture authentically American. In this (as in other things of interest to Kirstein), Russian/French impresario Sergei Diaghilev had shown the way. During his visit to New York in 1918, he told a group of journalists:

> "Dear Sir, there is plenty of American art, virile, characteristic art. The only difficulty is that America doesn't know it . . . In America it seems to me that what is vulgar, parvenu, affected and insincere is considered beautiful, and what is beautiful—vulgar!"
>
> "For instance?"
>
> "For instance when I am shown an immense mansion which is an ugly imitation of Gothic architecture, and am asked to admire its beauties. For instance when I marvel at Broadway at night time, the life, the power, the endless variety of beauty to be found there, and I am laughed at! They think I am joking. Well, I am not joking. It is time that the American people realized themselves. Broadway is genuine."[11]

Kirstein found vernacular buildings he took to be as "genuine" as Diaghilev had taken Broadway to be, and he wanted these vanishing architectural efforts recorded. Evans, for his part, learned to use a large camera on a stand (rather than the small handheld cameras he had relied on) in order to make pictures that were clear and teeming with fine detail; he made it his study to observe how sunlight strikes facades differently at different times of the day and in different weathers.[12] Evans expanded his way of working in order to make the pictures of vernacular architecture Kirstein so admired—but also in order to extend his own range as an artist: by 1930, he had become aware of the work of Eugène Atget.[13]

Clearly, Kirstein was powerfully attracted to Evans and his talents, but he was also frustrated by what he judged to be Evans's apparent passivity. Though Kirstein seemed to lose the intense level of fascination with Evans he had at first, the two stayed in touch. Kirstein arranged to have pictures by Evans exhibited at New York's new Museum of Modern Art (*Photographs of Nineteenth Century Houses*, which opened November 16, 1933). Five years later, Kirstein wrote an afterword for Evans's book *American Photographs*. This important—even seminal—essay on photography, and on Evans's contribution to the medium (not to mention his contribution to a contemporary understanding of America itself), made clear that Kirstein still held Evans's work in high regard—in *very* high regard: in places, the essay verges on panegyric.

In his contact with Kirstein, Evans was outgunned but not completely overwhelmed. Understanding and conversation belong to one place; achievement as an artist (as Kirstein, the perennial amateur, more able to identify talent than to exercise it, certainly and unequivocally knew) belongs to another—a higher—place.

Most serious students of Evans recognize that the book *American Photographs* was—in some measure, in some not-so-easy-to-describe-precisely way—a collaboration between Evans and Kirstein. Evans admitted in later interviews that Kirstein played some role in arranging the sequence of pictures.

In a conversation with Douglas R. Nickel in 1989, Kirstein recalled that he in fact had helped in this way. But Nickel reports that "[Kirstein] was certainly not eager to take any credit away from Evans or claim authorship retroactively." In Nickel's recollection, Kirstein described the picture part of the book as a "collaboration," one in which each brought "different talents and perspectives" to the process of bringing the book to completion.[14] This recollection parallel's Evans's own, related to interviewer Leslie Katz in 1971: "I remember Lincoln helping me very much compose the thing [*American Photographs*]. I would get stuck over a work, the layout of the book and he was so breezy and fast that he would untie all the knots in an afternoon and say come and do it this way and slap it in and it would be right."[15]

Interestingly, Frances Lindley's account, given in 1975, a few months after Evans's death, was different. Frances Strunsky Collins Lindley was head of the publications department at MoMA when *American Photographs* was produced. She worked closely with Evans and also with the printer, Joe Blumenthal, discussing technical details of the reproductions with both men. In addition, she and Evans were, for a time, lovers, living in separate apartments in the same building on East 92nd Street. Even though this civilized arrangement came to an abrupt end when Evans's other girlfriend (Jane Smith Ninas, the "J.S.N." to whom the book Lindley had worked to produce was dedicated) suddenly turned up on Evans's doorstep (literally) after leaving her New Orleans husband, Lindley and Evans remained close friends until the end of his life.

In a conversation (with me) on September 26, 1975, Lindley remembered

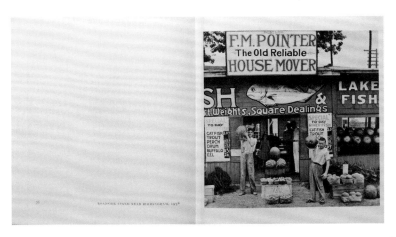

ROADSIDE STAND NEAR BIRMINGHAM, 1936

Fig. 3. Spread from *American Photographs*, exhibition catalogue (New York: The Museum of Modern Art, 1938), pp. 78–79

"absolutely that Walker was responsible for the order and even much of the design of the first edition of *American Photographs*." She describes it as "a collaboration between [*sic*; my error not hers] her, Walker, and Joe Blumenthal, the printer (Spiral Press)."[16]

Lindley's account is at odds with Kirstein's version. I pause over this disagreement not in an attempt to award the vanity of full achievement, of victory to one camp or the other, but because understanding the nature of this manifold "collaboration" is key to understanding something about Evans as an artist.

I know of no record of (and have heard no account of) meetings when Evans, Kirstein, and Lindley were in the same room. I can say with certainty that Evans was secretive, and also that he had a good deal of pride in his own worth and accomplishments. I also saw his vanity on display, the vanity of a man whose favored dress included one of his English tweed jackets worn with a Turnbull & Asser shirt, an ascot, and English shoes (later, Peal and Co.; earlier N. Tuczek, a Bond Street shoemaker whose heirs sold his client list to John Lobb) when going out, or opera pumps with bright red socks when entertaining at home.

Let me also recall that Evans not only liked to be around women; he liked to impress them, as the wardrobe I just described suggests. In front of Lindley, Evans would not likely let show that someone else had contributed to the work over which she, his "girl," was taking so much trouble in a determined effort to make it into the best book she could. As much contact as they had during that time, Evans was completely capable of leaving part of the story out altogether—just as, during the several years I was closely associated with Evans, I never once heard the name of Frances Lindley, or learned with what close friend he shared the long late-night phone calls I heard as a muffled sound coming from his bedroom as I worked in the darkroom on the other side of its wall.

My experience with Evans suggests he was secretive; my experience working with Kirstein suggests an energetic, forceful, wildly expansive ability to make connections. I would discover (while working to arrange pictures I had taken into books he wanted to produce, often with his texts) that editing sessions with Kirstein could become explosive when his formidable associative faculty came into play. As he talked, widely divergent things could suddenly be seen as *connected*, in a certain light—the light of his broad understanding. He was capable of enormous stimulation, fierce enthusiasms over things of immediate interest. During a brainstorming session, Kirstein could strike off a dozen possibilities drawing on scores of connections; one or two, or possibly none, might lead to realized work.

Kirstein's essay in *American Photographs* reveals—to the careful, patient reader—some of these enthusiasms. The essay ends with a wondering speculation about what Evans might do in film. More than one student of *American Photographs* has noted the cinematic quality of the book, which presents each picture across from a blank page; the reader turns the pages to see image after image flash before her in sequence. *Montage* appears in single images, in which multiple objects, each suggesting a different, perhaps contradictory association, share the same frame. *Contrast*, even *reversal* of the significances of some of these things (and combinations of things) appears from image to image, as the pages turn (figs. 2, 3). The techniques of montage and sequential contrast were, of course, on generous display in serious films of the late 1920s.

In 1929, Eisenstein drew a distinction between what film had been at first—a parade of superficial effects—and what it was becoming in the hands of Soviet masters: a sequence of carefully orchestrated *ideas*. Whereas older films aimed to deliver "a quick emotional *discharge*" by means of "purely stylistic mannerism," the newer films will include "*deep reflective processes*, the result of which will find

expression neither immediately nor directly."[17] And Kirstein understood that what was possible in film could be instructive in still photography: "The moving picture camera, in most cases an entirely different development, has taught the still-photographer many dramatic uses," he wrote in a 1934 assessment of photography in America.[18]

What torrent of enthusiasm for the possibilities of the "sequence of ideas" possible in the new Soviet cinema, the cinema of Eisenstein, might have poured out to Evans on that walk home from (and back to) Muriel Draper's in 1930 or 1931? For that matter, what parallel enthusiasms might Evans have heard from his occasional roommates Ben Shahn and Jay Leyda: Leyda had traveled to Russia to work with and study Eisenstein. Might one of these co-conspirators (or Evans's German friend Skolle) have known about Walter Benjamin's "Little History of Photography" (first published in October 1931)? Evans's own "little history" of photography appeared in *Hound & Horn* in 1931. It is hardly likely either had read the other before writing; the essays appeared at almost the same time. But both respond to developments, to *ideas*, that were (as Nickel felicitously puts it) "in the air." Evans managed to surround himself with people who breathed that air. He was lucky in his friends.

"Perhaps the best photographers in their best years come to resemble their unexposed film—passive, unprejudiced, patient, waiting for the revelation that will open the shutter," wrote John Szarkowski apropos of Evans in 1971.[19] This sentence describes the Evans Kirstein met in 1930—the artist who moved through the America of his time with hyper-awareness, an alert (if quixotic) openness to *telling significance* likely to appear anywhere, at any time: at a demolition site, in a rundown neighborhood or in an abandoned house, in a roadside shack, on the faces of anonymous strangers involved in the routine business of their days. Evans saw and recorded these random sightings: the shutter opened in front of a good find, in front of what he called "some sort of perfection."[20] The variety of these finds, and the fresh, appropriate picture-approach he brought to bear on each, resisted classification and categories. Each successful picture was an insight; he came to see that these insights came to life most effectively when presented in sequence—where, as in film, a poetry of contrasts could come into play.

I know of no evidence, in the written records of his early years, in his late interviews, or from the many hours I spent in observing and in conversation with him when he was an older man—I know of no evidence to suggest that Evans constructed or followed any "system" for analyzing the subject matter he approached, or the pictures he made of it. When pressed on this question, he turned again and again to the word "instinctive."

Instinctively, he picked through what his times, his culture, and his friends offered; instinctively, he chose to keep what he could use, making it his own. In this he was like the Modern, the twentieth-century person given full voice (for the first time, in a widely read influential work) by Eliot in *The Wasteland*:

These fragments I have shored against my ruins.

The careful reader will note that the line reads *ruins*, not *ruin*. *Shored against my ruin* would mean: gather close to me to stave off, to try to *prevent* my ruin. *Shored against my ruins* means: fragments piled up alongside the other fragments *I have already collected*. The speaker is in a condition of ruin *already*, reduced to collecting fragments, pieces of things. As written, the line describes a bleaker, darker condition, a vision entirely appropriate to the young Eliot, who (as Kirstein wrote of the young Evans) worked as a diagnostician, rather than as a healer.

For Evans, these *pieces of things* included the shattered fragments of "classical" traditions he found in disarray, but also the *vernacular*:

the common but whimsical, even idiosyncratic productions of native carpenters, craftsmen, and sign painters, unschooled except by what their energetic imaginations could recognize as useful. Evans himself can be understood as one of these, and *American Photographs* as "a sort of dictionary/bible of the American vernacular" (to use Clément Chéroux's accurate and succinct image).

The New York Times art critic Hilton Kramer used the term "devious giant" as the title of the front-page article published on the occasion of Evans's death. "Like many great artists," Kramer wrote," he was a difficult man, often indeed a devious man, and never more devious than at those moments—and they were not infrequent—when he allowed his work to pass into the world and be praised as something he knew it was not."[21] Evans himself had remarked, "Very often I'm doing one thing when I'm thought to be doing another."[22] Why did he never set the record straight and give the right answer?

Perhaps because he knew there was no single right answer he could give. Evans said, famously, that his pictures were "reflective rather than tendentious."[23] What is tendentious *tends* toward something: toward a point of view, a recommendation, a settled conclusion. What is reflective prefers to consider multiple sides of a thing, rather than settling on one aspect taken as "definitive."

Kramer ends his first paragraph by quoting Rilke: "Fame is but the sum of misunderstandings that accumulate around a well-known name." Kramer implies that this state of affairs is sad, a loss only, a thing clearly bad. But Evans may have understood that misunderstandings—what are they but a type of *multiple* understandings?—are not only inevitable, but also a large part— perhaps, finally, the largest part—of "understanding" a work of art destined to last beyond the time of its maker.

1. James R. Mellow, *Walker Evans* (New York: Basic Books, 1999), p. 377.

2. Some of Crosby's photographs would appear (after his suicide in 1929) in *Hound & Horn*.

3. Hart Crane, letter to Caresse Crosby, January 2, 1930, in *Hart Crane: Complete Poetry and Selected Letters*, edited by Langdon Hammer (New York: Library of America, 2006), p. 635.

4. A lively description of Crane and his mileu can be found in a memoir written by Lincoln Kirstein: "Carlsen, Crane," first published in *Raritan* (Winter 1982), reprinted in *By With To and From: A Lincoln Kirstein Reader*, edited by Nicholas Jenkins (New York: Farrar, Straus & Giroux, 1991), pp. 38–71.

5. Ralph Steiner, interviewed by Donald Dietz and David Herwaldt, 1976 or 1977, from an annotated photocopy of a typed transcript given to the author by Frances Lindley in 1982.

6. In later life, neither Evans nor Kirstein was able to give an unequivocal answer to a question about how and where they met. Evans surmised (in an oral history taken by Paul Cummings in 1971) they might have met when Evans worked in a bookstore Kirstein visited, but his account is laced with qualifications and uncertainties. They ran into each other "somewhere" (Evans's words in 1971); they both went to Muriel Draper's.

7. Quotations from Kirstein's diaries are taken from five pages of extracts, typed out by Kirstein, probably in the 1960s, to judge from the erasable typing paper used. Kirstein gave a carbon copy of these extracts to the author in 1984. The original diaries are among Kirstein's papers, which occupy 22 linear feet of shelf space in the Dance Collection of the New York Public Library.

8. The only exceptions would be discussions of some technical question with an experienced professional; then Kirstein might defer to an expertise he respected.

9. Arlene Croce, "Century's Son," *The New Yorker*, January 22, 1996, p. 54.

10. *Walker Evans: Incognito* (New York: Eakins Press Foundation, 1995), pp. 9–10. This book's text is taken from Leslie Katz's interview with Evans, first published in *Art in America* in 1971 and reedited by Katz for this book.

11. Richard Buckle, *Diaghilev* (New York: Atheneum, 1979), p. 300.

12. A process described by Kirstein in a journal entry dated April 12, 1931.

13. Evans had in his studio pages from the rotogravure section of a New York newspaper (dated 1930) reproducing some of Atget's pictures; he had also, by that year, met Berenice Abbott, who had acquired much of Atget's surviving work after his death in 1927 and brought it back to New York, where some of it had been exhibited and published by late 1930.

14. Quotations are from Nickel's recollections of his visit to Kirstein, generously communicated to the author in writing, January 5, 2016.

15. From the full, unedited transcript of the taped session; cited in Mellow, *Walker Evans*, p. 370.

16. Manuscript notes taken by the author, September 26, 1975, p. 2 of 2.

17. Sergei Eisenstein, "The New Language of Cinema" (translated by Winifred Ray), first published in English in 1929 in *Close-Up*; reprinted in *Film Essays and a Lecture by Sergei Eisenstein*, edited by Jay Leyda (New York: Praeger, 1970), pp. 32–34.

18. Lincoln Kirstein, "Photography in the United States," in *Art in America in Modern Times*, edited by Holger Cahill and Alfred E. Barr Jr. (New York: Reynal & Hitchcock, 1934), p. 87.

19. John Szarkowski, *Walker Evans* (New York: The Museum of Modern Art, 1971), p. 14.

20. From the transcript of a 1947 interview conducted by *Time* magazine; cited in Mellow, *Walker Evans*, p. 512.

21. Hilton Kramer, "Walker Evans: A Devious Giant," *The New York Times*, April 20, 1975, p. 1.

22. *Walker Evans Incognito*, p. 18.

23. Draft for an introduction to the second edition (1962) of *American Photographs*, published in John T. Hill and Jerry L. Thompson, *Walker Evans at Work* (New York: Harper & Row, 1982), p. 151.

—JEFF L. ROSENHEIM

FOLK DOCUMENTS

Walker Evans began to collect postcards during his childhood and kept at it for more than sixty years (figs. 1, 2). He collected postcards when they were new and he was young, and when he was old and they had become antiquated. He collected postcards in the mid- to late 1920s, before he had taken up the camera and was struggling to emerge as a writer in New York City; he collected postcards in 1935–37 during the height of his career, when he photographed across the American South for the Resettlement (later Farm Security) Administration; he collected postcards from 1945 to 1964 during the two decades he was an editor at *Fortune* magazine; and, finally, he collected them in the last years of his life, when he was often too infirm to hold a camera to his eye.

Evans assembled and carefully maintained other collections as well—printed ephemera (pp. 94 right, 95), driftwood, tin-can pull-tabs (p. 94 left), and metal and wood signs (pp. 90–93) that he first photographed and then physically removed from their moorings along the roadside—but it was his vast collection of postcards that was most meaningful to Evans the artist. He saw them as a form of indigenous American realism that directly influenced his artistic development.

This essay explores the collection of over 9,000 picture postcards amassed by Walker Evans and preserved in the Walker Evans Archive at The Metropolitan Museum of Art, New York. The museum acquired the archive in 1994 as a gift from the artist's beneficiaries.[1]

A Brief History of Postcards

Penny picture postcards came of age in America in the 1900s and 1910s when Walker Evans was in grade school, and they entered his aesthetic consciousness before any other cultural artifact of the period. Inexpensive, ubiquitous, and unprepossessing, the postcard seemed to be everywhere in the early decades of the new century, even in the hands of a young connoisseur of the American scene who had yet to pick up his first camera. Early in the 1930s, Evans began to methodically classify and organize his collection into subject categories such as "Factories," "Street Scenes," "Fancy Architecture," "Summer Hotels," "Madness," and "Railroad Stations."[2] He also became entranced by the cursory messages written on the cards, which he regarded as a kind of found poetry— allusive, egalitarian, and vernacular (p. 192 top left).

Fig. 1. *Post Office, Mount Vernon, New York*, 1907 or before, collection of Walker Evans
Postcard, photomechanical print, 3⁹⁄₁₆ × 5½ in. (9 × 14 cm)
The Metropolitan Museum of Art, New York
Walker Evans Archive, 1994, 1994.264.69.21

Fig. 2. *Tennessee Coal, Iron & Railroad Company's Steel Mills, Ensley, Alabama*, 1910, collection of Walker Evans
Postcard, photomechanical print, 3⁹⁄₁₆ × 5½ in. (9 × 14 cm)
The Metropolitan Museum of Art, New York
Walker Evans Archive, 1994, 1994.264.10.2

The pivotal year for the postcard in the United States was 1907, when the Postal Service amended its regulations and finally permitted the mailing of postcards with divided backs (message on the left, address on the right). This freed up one entire side for the picture—of anything from a hotel in Saratoga Springs, New York (p. 191 top left) to a Civil War monument in Dayton, Ohio (p. 193 top) or an automobile tunnel in Detroit, Michigan.[3] By 1914, the international craze for picture postcards had become a boon to local photographers, who saw their black-and-white photographs of the country's main streets, public buildings, and new factories transformed into millions of handsomely colored photolithographic cards. The number of postcards mailed in the early years of the century is staggering. In 1903, the U.S. post office handled 700 million.[4]

Born in 1903, Evans matured in the peak years of the classic postcard era and was deeply influenced by what he called "those honest, direct little pictures that once flooded the mails."[5] In *Fortune* magazine, he wrote: "Among collectors of Americana, much is made of the nation's folk art. The picture postcard is folk document."[6] Sold in virtually every five-and-dime store, newsstand, and hotel from Brooklyn to Bakersfield, postcards satisfied the country's need for human connection in the age of the railroad and the Model T, when, for the first time, many Americans regularly found themselves traveling far from home. By age twelve or so, Evans had begun to collect: "Yes, I was a postcard collector at an early age. Every time my family would take me around for what they thought was my education, to show me the country in a touring car, to go to Illinois, to Massachusetts, I would rush into Woolworth's and buy all the postcards."[7]

What appealed to the nascent photographer were the cards' vernacular subjects, the simple, unvarnished, "artless" quality of the pictures and the generic, uninflected, mostly frontal style that he would later borrow for his own work with the camera. Both the picture postcard and Evans's photographs seem equally authorless, quiet documents that record the scene with an economy of means and with simple respect. In 1971, Evans commented about the establishment of what he called the documentary style in American photography:

> It's a very important matter. I use the word "style" particularly because in talking about it many people say "documentary photograph." Well, literally a documentary photograph is a police report of a dead body or an automobile accident or something like that. But the style of detachment and record is another matter. That applied to the world around us is what I do with the camera, what I want to see done with the camera.[8]

The Postcard Collection

Walker Evans collected virtually every type of postcard known to have been published: standard scenic cards, souvenir beach scenes, historical cards, and catastrophe cards (e.g., the 1906 San Francisco earthquake). He collected comic cards and exaggeration cards, romantic cards, French erotic cards, postcards on which the windows of buildings light up, and postcards sprinkled with glitter. About the only postcards not found in Evans's collection are leather cards and cards made from such materials as velvet, copper, wood, and hair.

Even a cursory examination of the collection confirms that Evans much preferred postcards printed from black-and-white photographs executed in the early part of the century (that were colored during the printing process) to cards made after World War II from original full-color photographs. He commented on this matter in 1973 at The Museum of Modern Art (MoMA), New York: "How much of the value of the cards has to do with hand-coloring?" he was asked. "Oh, a great deal," he replied. "The postcards of this period were pre-color photography pictures. They were done by important German lithographers and color workers and it was relatively inexpensive to do it that way and their charm is largely due to that, greatly."[9]

Nearly all of Evans's closest friends and family, his neighbors and lovers, fellow artists and art students, museum curators and private collectors knew that he was an inveterate collector. In their own way they helped Evans build and refine his collection, dutifully delivering to him prime examples they had received from others or sending along important discoveries from their own travels (pp. 96 bottom left, 97 bottom, 191 bottom right). The Walker Evans Archive also includes postcards mailed by Evans to friends, family, and colleagues that he later retrieved for his own archive, suggesting that he could not bear to part with his roadside discoveries.[10]

The Walker Evans Archive includes not only postcards distributed by the world's largest manufacturers and those with the highest quality lithographic printing (made primarily in Germany), but also cards produced by local printers, whose only postcards were perhaps of their own shopfronts. Evans collected and carefully filed and classified postcards of state capitols and courthouses, bridges and mills, amusement parks and war monuments.

But his favorite type of postcard, and by far the largest quantity of cards in his collection, were those he classified simply as "Street Scenes"—the straightforward view down the middle of Front Street in Morgan City, Louisiana, serves as a typical example (p. 190 bottom). The natural patterns of America's main streets held special meaning for Evans, who studied the false fronts of the buildings and what was before them, the rhythm of telephone poles, and the way cars were parked diagonally to the curb. Each detail was important because the street was a veritable catalogue of the American experience. Evans commented on this predilection in a 1971 conversation with students at the University of Michigan:

> I think that artists are collectors figuratively. I've noticed that my eye collects. The rare collector does. The man who's interested in nineteenth-century French first editions, he gets his mind on that, and instinctively goes around. My eye is interested in streets that have just rows of wooden houses in them. I find them and do them. I collect them.[11]

The 1929 postcard *Front Street, Looking North, Morgan City, Louisiana*, however, raises an important question. The card depicts a small town on the Atchafalaya River, ninety miles from New Orleans. In vantage point and composition, the unmailed card closely parallels three of Evans's own photographs from the spring of 1935 (p. 218). Which came first, the postcard or the photograph? Did Evans stop at a local diner for a cup of coffee, see the postcard, and then wander the streets seeking out its location? Or did he make his photographs first and later discover that he had exactly duplicated the postcard view? The former scenario seems more likely. The postcard's generally frontal viewpoint and conceptual matter-of-factness had probably intrigued Evans for years and were significant in defining his objectives. Essentially, picture postcards offered precisely the anonymous, anti-aesthetic, documentary quality that he sought to achieve in his own work.

There are countless instances of locations and subjects photographed by Evans that also appear in postcards in his collection: hotels in Saratoga Springs, New York; houses in Kennebunk, Maine; the Hermitage Plantation near Savannah, Georgia; and a Folk Victorian cottage in Ossining, New York. The Walker Evans Archive includes some 30,000 black-and-white negatives and 10,000 color negatives and transparencies. Yet of his more than 9,000 postcards, there appears to be only one example, the aforementioned *Front Street, Looking North, Morgan City, Louisiana*, where Evans made an exact replica of a postcard he had collected. It is clear, after a thorough

Fig. 3. Walker Evans
Mississippi Town, Negro Quarter, 1936
Gelatin silver print, 3⁷⁄₁₆ × 5⅜ in. (8.7 × 13.7 cm)
The Metropolitan Museum of Art, New York
Purchase, The Horace W. Goldsmith Foundation Gift, through Joyce and Robert Menschel, and Randi and Bob Fisher Gift, 1996, 1996.167.2

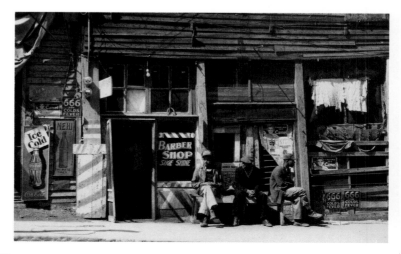

analysis of his archive, that copying the content and composition of existing picture postcards was not Evans's intent. What he sought instead was to duplicate their spirit.

Postcard-Format Photographs
In 1936, Evans began to work on an imaginative new project. In an effort to reclaim a portion of his work from the control of the Resettlement Administration, his primary employer from 1935 to 1937, Evans printed approximately two dozen photographs on standard 3 x 5 inch postcard-format photographic paper with preprinted postcard backs (fig. 3).[12]

The idea was not to make postcards to send through the mail (none have ever appeared with postmarks or messages), but to produce an exclusive set of images that would not have public currency, that could not be distributed by the federal government as official documentary imagery, and that would serve no purpose but Evans's own.[13]

Evans kept virtually all of these small prints in his own collection until the late 1960s.[14] Only one postcard-format photograph, *House in New Orleans* (1935), is known to have been exhibited and collected by a public institution in Evans's lifetime. It was the first photograph on view in *American Photographs*, Evans's groundbreaking 1938 retrospective at MoMA.[15] For an artist as careful with the camera as Evans, making the right "edits" from the Resettlement Administration negatives was an interesting graphic problem. The minute field of the postcard offered little room for mistakes, and the process of distillation required careful contemplation. Could one eliminate three-quarters of a successfully composed image and still preserve its essence? The answer is a resounding yes.

Carefully isolating details from 8 x 10 inch negatives, Evans generated an extremely interesting suite of images, his first culling of the work he had produced for the New Deal. Like a poet refining an idea word by word, Evans had often clarified and intensified his pictures by trimming the prints to present the leanest possible image; with the postcard-format photographs, he took that impulse to another level. Evans was a master of the edge and one of photography's greatest precisionists. Late in life he remarked, "Stieglitz wouldn't cut a quarter-inch of a frame. I would cut any inches off my frames in order to get a better picture."[16] The postcard-format prints are inspired examples of this philosophy, framing as they do virtually new and often "better" pictures from the photographs that already attested to Evans's meticulous eye.

"Main Street Looking North from Courthouse Square"
In 1937, Evans lost his position as an "information specialist" with the U.S. government. The following years were difficult ones for Evans, and he survived by stringing together a series of freelance jobs, including assignments from book publishers and *Fortune* magazine.[17] He also worked over a period of five years with the writer James Agee on *Let Us Now Praise Famous Men*, their collaborative study of tenant farmers in Alabama that was eventually published in 1941. He did not find regular employment until 1943, when he accepted a position writing book, art, and film reviews at *Time* magazine. Then, at the end of World War II, in September 1945, Evans was hired by *Fortune* as their first full-time staff photographer; three years later, he earned the status he had strategically sought from the outset, that of special photographic editor. It was an unusual position, independent of the magazine's art director, and without any real supervision or monthly deadlines. Evans retained this unique autonomy at *Fortune* for the next sixteen years.

Long before he was promoted to editor, Evans began sending memos of his proposed portfolio ideas to his magazine colleagues. Papers in the Walker Evans Archive confirm that he considered the subject of picture postcards among the most important. An undated two-page manuscript of twelve portfolio ideas puts things into context: "undesigned forms // ~~postcards~~ // American postcards of the 1900s // found objects // automobile design // vanishing interiors // southern plantations // monumental sculpture of U.S. // "Biochemistry of the Eye" // machines // Palomar // U.S. style // shopfronts?"[18]

In May 1948, *Fortune* published a deluxe, five-page, full-color portfolio featuring postcards from Evans's personal collection: "'Main Street Looking North from Courthouse Square': A Portfolio of American Picture Postcards from the Trolley-Car Period" (pp. 220–21). An unsigned editorial comment about the article published in the magazine places the portfolio in the context of Evans's own work with the camera:

> The postcards are only another aspect of Evans's persistent documentation of his native scene. Most of them are from his own collection, which he has been gathering for years, stalking them informally in their wild state, in small-town junkshops about the country, or swapping with friends who share his taste. His selections are manifestly neither a gag nor a fad nor an amusing hobby; they perform exactly the same function as his photographs— they are eloquently resounding statements about the world that is open to the inspection of the devoted eye.[19]

Evans worked for six months on every aspect of the "Main Street" project. He researched the history of postcards, wrote the essay, edited it, selected the type fonts, and designed the page layout. He also determined precisely how the reproductions and the blocks of type would fit together and demanded that the cards be reproduced one-to-one (the same size as the original), with just the right amount of light gray-blue shadow on the right and bottom edges. This last detail ensured that the postcards would retain their objectness when printed on the page.

More than a decade after the "Main Street" article, Evans wrote, designed, and oversaw the publication in 1962 of two more magazine portfolios on the picture postcard, one for *Fortune* and one for *Architectural Forum*. "When 'Downtown' Was a Beautiful Mess" included cards mainly from 1907 or earlier and was published by *Fortune* in January 1962. Evans dramatically altered his page design, enlarging the cards from their original size to span up to two full pages (13 x 20 inches). This in effect transformed the postcard from an object to an image—a photograph. It also allowed the reader to focus on the handwritten messages. The published article expands upon Evans's earlier ideas about the postcard and offers a rather stern, if humorous, warning to the magazine's readers:

> The very essence of quotidian U.S. city life got itself recorded, quite inadvertently, on the picture postcards of fifty years ago . . . Studying them, it is better to renounce sentimentality and nostalgia, that blurred vision which destroys the actuality of the past. Good old times is a cliché for the infirm mind.[20]

"'Come on Down,'" Evans's third and final article on the picture postcard, appeared in the July 1962 issue of *Architectural Forum*, a Time Inc. publication focused on architecture, design, and the building industry. Technically it is the weakest of the three essays. The enlarged images are in black-and-white, not color, and, grainy and dull, they do

not come close to Evans's standards for photographic reproduction. Nonetheless, the seven cards featured in the portfolio are accompanied by some of his best and most droll writing on the subject. On *Earl's Court Water Tower, Narragansett Pier, Rhode Island*, Evans comments: "The battlemented, shingled water tower, opposite, might have been the result of a visit to Rhode Island by William Beckford, Horace Walpole, Ludwig of Bavaria, or all three."[21]

"Lyric Documentary"

The two articles on the picture postcard in 1962 generated an unexpected response. The art department at Yale University invited Evans to present a public lecture on a subject of his own choosing. With little hesitation, he elected to speak about his postcard collection, not his work as a photographer. Evans's talk at Yale on March 11, 1964, would be his very first academic presentation, and the occasion must have resurrected long-repressed anxieties of the mediocre student who had dropped out of college in 1923 after two semesters at Williams College, in Williamstown, Massachusetts. The Walker Evans Archive preserves the lecture notes, outlines, and drafts of what would be an important test of Evans's ability to impress the esteemed university that had denied him a place in the freshman class forty-two years earlier.[22] It would also prove to be an occasion that changed the course of the last decade of his life.

Evans settled on his title, "Lyric Documentary," quite early in the process of developing his presentation. On February 2, 1964, he wrote to the chair of the lecture committee at Yale to confirm the date of his talk: "I should like to entitle my subject 'Lyric Documentary.' The lecture would concern an aspect of early Twentieth Century popular photography. Many of my illustrations would be on postcards."[23] With the general concept in place, Evans set out to define a strategy that he hoped would convince the academic audience to look upon the lowly picture postcard as a visual form worthy of serious attention. One sheet of draft notes includes: "I shall ask you to perform a psychological adjustment and an aesthetic reordering in yr minds. My material is madly unfashionable." Another: "It is a pleasure and a relief to speak to people who are visually knowledgable. My subject requires it; it is something I have lived with and which I cannot usually get across even to friends."[24] Evans would include neither comment in his final lecture documents.

The more Evans worked on his presentation, the more obsessed he became that his audience might misinterpret his intentions and assume that by showing old postcards he was championing a nostalgic view of the past. In notes that once again he did not use, he addressed this concern:

> I shall ask you to detach your minds from nostalgia ~~and of course sentimentality~~, just as you have easily done for example in studying such artists as Toulouse Lautrec and [Constantine] Guys, even when you may love Paris nostalgically. . . . I cannot risk seeming to come to New Haven in the idiotic role of a sentimentalist; I would not of course dream of placing you in the role of listeners to grandfather's moist reminiscences of some such flummery as *the good old days*. My examples are deliberately not major ones but at least one of my subjects is *style*, which in our circles is serious.

Evans next selected a group of artists in the fields of literature and the visual arts whose style and subject matter he believed expressed the proper balance of the lyric and the documentary. One early list includes John Grierson, Charlie Chaplin ("early, flat photography"),

Eric von Stroheim ("*Greed*"), James Agee, Alfred Stieglitz ("tried and when he tried it eluded"), Paul Strand ("more often had it"), Eugène Atget ("almost every time"), August Sander, Mathew Brady, Helen Levitt, William Henry Jackson, Ben Shahn, and "HOPPER." And, in literature, Sinclair Lewis, James Joyce ("place essays"), T. S. Eliot, Vladimir Nabokov ("all over"), Anton Chekhov ("often"), Ernest Hemingway ("got to trying & lost"), and Frank O'Hara ("sometimes has it").[25] Only a few made the final edit and were included in the lecture. What his notes clearly reveal, however, is the care with which Evans weighed each artist on his specially calibrated scale.

Evans organized his ideas for the lecture on two sets of small white index cards approximately the size of postcards on which he scrawled his loosely formed argument. Strung together like the preparatory remarks of an anxious student, the sentences provide the physical framework for the finished talk. In their simplified form, rather than in their more embellished presentation in the lecture, the notes are highly revealing of Evans's thought process.

> 2. // I owe you some discussion // of my title Lyric Documentary // Came to me out of dissatisfaction // with "documentary"—my personal style. // Vague inexact subjective // Even grammatically weak. 3. // When I added "lyric" I had // the quality I was after. 4. (I am speaking of photography // both still and cinema // The fields I think the word // documentary *as style was made for*.)[26]

In his presentation, Evans quoted from Nabokov's *The Gift* and also from his own essay "When 'Downtown' Was a Beautiful Mess." But when it came time to show his beloved postcards, the actual subject of his lecture, Evans spoke without notes, extemporaneously. At the very end of the talk, he offered the audience a small surprise. The last two slides were reproductions of his own photographs. The penultimate work was one of his postcard-format photographs made from a Resettlement Administration negative showing a row of Virginia houses from 1936.[27] The final slide was a view of a luggage cart seen against a field of grass (fig. 4). In the printing of the photograph, *Baggage Wagons, Galena, Illinois* (1963), Evans cropped his 2-inch-square negative into a rectangle. Height to width, the photograph has nearly the same proportions as a postcard.[28]

Evans ended the lecture with a soliloquy on the significance of vernacular subjects and the elusive qualities he had discovered in picture postcards, and in his photographs.

> This is also a very recent picture of mine . . . absolutely unretouched . . . It's an old railroad carriage as you see, standing, still used . . . in Galena, Illinois, at the railroad station. But it just so happens that the grass behind it, and the quality of that faded wood, and the utilitarianism of it . . . *in that lighting*—that's late day lighting—it gives me a quality of . . . As I say, I didn't know what this was going to be like when I did it and I wasn't after such a mood as I think this picture does now produce . . . Here is something of my own that has the quality that I wasn't going after.[29]

"Lyric Documentary" proved to be a critical success, at least among the young faculty at the university. Alvin Eisenman, a professor of graphic design at Yale, recalled that "[Evans] found things

Fig. 4. Walker Evans
Baggage Wagons, Galena, Illinois
Industrial Architectural Views, for an Unpublished Series, Fortune *Magazine*, 1963
Negative, digital inversion, 2¼ × 2¼ in. (5.8 × 5.8 cm)
The Metropolitan Museum of Art, New York
Walker Evans Archive, 1994, 1994.252.33.1–.227

in his postcards that dazzled me, information that's very difficult and even impossible to put into words."[30] Eisenman and Jack Tworkov, chair of the Yale art department, among many others, believed that Evans would make an excellent professor, and only weeks later Yale University invited him to be a "visiting critic" beginning in fall 1964. When Evans was made professor of graphic design in 1965, he submitted his resignation to *Fortune* magazine and would teach photography at Yale until 1973, when by the school's rules he had to retire at age seventy.

———

On November 7, 1973, Evans gathered his postcards, slides, and notes and headed to New York City to give a reprise performance of his postcard lecture at MoMA. John Szarkowski, director of the museum's Department of Photography, introduced Evans and primed the audience for a talk "about work that was done long before his [Evans's] own pictures and to which he may not only have some sense of affection, but obligation."[31] In his brief introduction, Evans mentioned that he had been disappointed by the reception of his talk at Yale, presented, he said, to "a bunch of Yahoos, in imitation work clothes . . . They thought I was there to entertain them and lo and behold I showed some photographs and had them rolling in the aisles with laughter. I was utterly defeated. I took these things [the postcards] seriously and I still do."[32]

Whether or not Evans considered his lecture at MoMA a greater success than his presentation at Yale will remain unknown. What is certain is that many of the artist's students, colleagues, and friends in the audience found the presentation extraordinary. Leslie Katz, publisher of Evans's *Message from the Interior* (1966), received from the museum a copy of the audio recording and began to work on a transcript suitable for publication. By the time it was completed, however, Evans was ill. In early December 1974, he had checked himself into Yale–New Haven Hospital for a complete evaluation. While there, he broke his collarbone and contracted pneumonia. Perhaps to cheer up his friend, Katz sent him a transcript of the MoMA talk and

proposed that they work together on a new book dedicated to Evans's postcard collection. Sadly, it was not meant to be.

Evans received the MoMA transcript at Gaylord Hospital in Wallingford, Connecticut, where he was still convalescing. Discharged on February 7, 1975, he returned to his apartment in New Haven and slowly began to regain his health. By April, he was just strong enough to keep an engagement to lecture at Radcliffe College in Boston. After speaking to students on April 8, Evans returned by train to New Haven, where, on the night of April 9, he suffered a massive stroke. He died the following day, April 10, 1975. Fate would nonetheless smile on Evans. His now world-famous collection of postcards and all his surviving photographs, negatives, papers, and correspondence, his library, and his collection of roadside signs are all maintained as one of the treasures in the Department of Photographs at The Metropolitan Museum of Art.

1. This text is drawn from a book-length treatment of the subject; see Jeff L. Rosenheim, *Walker Evans and the Picture Postcard* (Göttingen and New York: Steidl and The Metropolitan Museum of Art, 2009). Unless otherwise noted, each of the postcards illustrated is a photomechanical reproduction with overall dimensions of approximately 3 x 5 in. (8.9 x 14 cm).

2. Evans generally filed his postcards by subject, not locale, the two main exceptions being "London" and "Europe." During the twenty years between Evans's death in 1975 and the acquisition of his archive by the Metropolitan Museum in 1994, his papers were studied by many individuals and at times rearranged. In several instances, his original index-card category dividers came to the museum separated from the postcards themselves. What upset the original order most, however, was the work of a graduate student in the late 1970s who, with the approval of the Evans estate (and presumably in good faith), refiled postcards in categories where they had not been placed originally and, furthermore, created categories that Evans had not envisioned. The Metropolitan's Walker Evans Archive (MMA/WEA) maintains the postcards in the order in which they arrived at the museum: that is, in Evans's own categories, as well as in categories imagined for the collection by one scholar after the artist's death.

3. Prior to this date, postal clerks had maintained that addresses would be indecipherable written only on one half of a side. With one decree, the essential problem for the typical card sender was a thing of the past: no longer would the devoted writer have to compose and inscribe minute and often illegible notes on the picture side of a postcard.

4. The actual numbers, as reported by the *Journal of the Society of Arts*, were: Germany 1.61 million cards, United States 700 million, Great Britain 613 million, and Japan 487.5 million.

5. Walker Evans, "When 'Downtown' Was a Beautiful Mess," *Fortune* 65, no. 1 (January 1962), p. 101.

6. Ibid.

7. Evans's lecture on postcards, presented November 7, 1973, at The Museum of Modern Art, New York; transcript: MMA/WEA 1994.250.152.7, p. 15.

8. Paul Cummings, "Oral History Interview with Walker Evans, October 13–December 23, 1971," Smithsonian Institution, Archives of American Art, at www.aaa.si.edu/collections/interviews/oral-history-interviewwalker-evans-11721.

9. MMA/WEA 1994.250.152.7, p. 16.

10. Throughout his life, Evans was a dedicated and frequent correspondent, and he often noted in his appointment books to whom he had written on a specific day. On February 5, 1935, for example, after a day's work making photographs on the streets of Savannah, he noted that he had sent postcards to "Morrie, Cheever, Ben, J.C.E., B., Irving," a roundup of his most intimate friends at the time. The list includes two erstwhile girlfriends, Morrie Werner and Beatrice Jacoby; the writer John Cheever (who was working in Evans's apartment); Evans's roommate, Ben Shahn; the filmmaker Irving Jacoby, who was Beatrice's brother; and Evans's mother, Jessie Crane Evans. See MMA/WEA 1994.250.97.

11. "Walker Evans, Visiting Artist: A Transcript of His Discussion with the Students of the University of Michigan, 1971," in *Photography: Essays & Images*, edited by Beaumont Newhall (New York: The Museum of Modern Art, 1980), p. 317.

12. Per his contract with New Deal agencies, Evans had to submit all his negatives to the federal government for public use. Previously Evans had only used postcard-format photographic paper for contact printing his smaller, roll-film negatives.

13. Like his contemporaries André Kertész and Man Ray, Evans may have selected postcard-format paper partly because it was high in quality and inexpensive. But as an enthusiastic postcard collector, he also would have appreciated the postcard's direct link to popular culture and its role as a democratic means of visual communication.

14. Postcard-format photographs by Evans can be found today in many public collections, including the J. Paul Getty Museum, Los Angeles; the National Gallery of Art, Ottawa; the Chrysler Museum of Art, Norfolk; The Museum of Modern Art, New York; and The Metropolitan Museum of Art.

15. The Museum of Modern Art acquired *House in New Orleans* in 1938. It does not appear in the exhibition catalogue *American Photographs*, which features a slightly different selection of images. The Library of Congress dates the 8 x 10 negative January 1936.

16. Leslie G. Katz, "Interview with Walker Evans," *Art in America* 59, no. 2 (1971), p. 85; transcript, MMA/WEA 1994.250.152.7, p. 25.

17. Evans was busy, just not regularly employed. He worked for a year on his retrospective exhibition *American Photographs*, which opened at The Museum of Modern Art, New York, in September 1938. He also began in 1938 and completed in 1941 a series of photographs of passengers in the New York City subway. This extraordinary body of work would not be published in book form until 1966. See Walker Evans, *Many Are Called*, with an essay by James Agee (Boston: Houghton Mifflin, 1966; 2d ed., New Haven and New York: Yale University Press and The Metropolitan Museum of Art, 2004).

18. See MMA/WEA 1994.250.6.6. "Biochemistry of the Eye" is a reference to the 1934 Johns Hopkins volume of the same title by Arlington C. Krause. Evans took great interest in the visual representations found in many medical textbooks on the eye. The Palomar Observatory in California, the largest in North America, was in the news when Evans made his list. It was completed in 1948.

19. "Fortune's Wheel," an unsigned editorial comment in *Fortune* 37, no. 5 (May 1948), p. 32.

20. Evans, "When 'Downtown' Was a Beautiful Mess," p. 101.

21. Walker Evans, "Come on Down," *Architectural Forum* 117 (July 1962), p. 98.

22. Evans even briefly considered, then rejected, confronting the matter in his introductory remarks: "I am perhaps the only man you have seen lecturing here who failed to get into Yale, and wanted to—it was the class of 1926 at a time when, in the light of your present standards, almost anyone from a good school could matriculate." MMA/WEA 1994.250.6.6. Evans clearly passed the test.

23. MMA/WEA 1994.250.6.8.

24. MMA/WEA 1994.250.6.6.

25. Ibid.

26. MMA/WEA 1994.250.6.10.

27. See Rosenheim, *Walker Evans and the Picture Postcard*, p. 32, fig. 27. Evans included another cropping of this image in *American Photographs* (1938).

28. For the other 226 2 x 2 inch negatives made on this trip, see MMA/WEA 1994.252.33.1–.227.

29. See the original audiotape of the "Lyric Documentary" lecture, MMA/WEA 1994.250.151.

30. Mia Fineman interview with Alvin Eisenman, June 8, 1999, quoted in Mia Fineman, "'The Eye Is an Inveterate Collector': The Late Work," in Maria Morris Hambourg et al., *Walker Evans* (New York: The Metropolitan Museum of Art, 2000), p. 131.

31. MMA/WEA 1994.250.152.7, cover page.

32. Ibid., p. 2.

—JULIE JONES

PORTRAYING OBSOLESCENCE: WALKER EVANS, RAGPICKER OF AN AMERICA IN DECLINE

*I loved idiotic pictures, over-door decor, stage sets, acrobats'
backdrops, shop signs, popular illustrations, antiquated literature,
church Latin, poorly written erotica, novels of our grandmothers'
day, fairy tales, little children's books, old operas, silly refrains,
simple rhythms.*
Arthur Rimbaud, *A Season in Hell* (1873)

During the Great Depression in the United States, waste lay
everywhere and triggered everyone's imagination. The rise of the
automotive, chemical, and electronics industries had already
transformed America several decades earlier and led to overproduction
of manufactured products and unprecedented dumping of trash. In
addition to this industrial waste in urban and rural areas, there were
numerous architectural destruction, construction, and restoration
projects. The hardest-hit areas, populated by those whom progress
had left behind, multiplied. At the same time, a culture of cleanliness
arose, and waste management solutions were initiated, such as
the construction of storage and treatment sites, and camouflage
measures. The creation of parks on those sites was one of the
most successful ways of domesticating waste. The word "junk"
best describes all the forms of such refuse of modernity, howsoever
diverse. Garbage, waste, trash . . . junk evokes all these poor objects,
people, words, and ideas, of no apparent value or real utility, that
are—or should be—discarded.

The ubiquity of junk in the first half of the twentieth century made
itself felt in its artistic, literary, and cinematographic productions that
expressed anxiety about industrialization. In his study of the concept
of realism in American culture from 1880 to 1940, historian Miles Orvell
explained this trend by the fact that junk was "the antiword of the
technological civilization, the stuff that is useless, discarded, utterly
lacking in appeal, the unadvertised object." It was, in fact, "a symptom
of disorder, of things gone wrong, of waste, a negative in the balance
sheet of civilization." But it was also "raw material" for the artist;
it was "the object found and rescued, reclaimed, reworked,
reintegrated, the thing with a history, the mass-produced object
become individualized, the object to be collected."[1]

The dual nature of junk found one of its most perfect expressions
in the work of Walker Evans. From 1930 on, the photographer never
stopped stalking it in all its incarnations: industrial detritus, torn
posters, architectural debris, rusted out cars, dilapidated wooden
houses, despondent
people. This attraction for
castoffs, for decline and
obsolescence, reveals an
ambiguous position with
regard to modernity.
Obsessively making

America's degradation visible can be viewed as the obvious expression
of an anguish born of a contemporary downward spiral. But do not
these choices also reveal a fascination for the mechanisms, objects,
and excesses of capitalist society?

A Depressive Modernity?
In her book *Down in the Dumps*, historian Jani Scandura introduces
the concept of depressive modernity as an essential component of
American culture in the 1930s, by collecting and analyzing anonymous
photographs, press clippings, and pulp novels dealing with the topic
of trash and junk collected in Reno, Hollywood, and Harlem. Indeed,
the crash of 1929 shifted the early progressive modernity, as it was
constructed in the Age of Enlightenment around the values of
"capitalism, democracy, individualism, secularism, utopianism,"
toward a late modernity "that does not follow the forward thrust of
mania, speed, and progress" but emerged as a "depressive modernity"
at a "standstill"—"like an idling car, like a video on still, it moves
neither forward nor backward, but shimmers in place"[2] (p. 179). This
dark modernism had many defenders among the photographers of
the period. Some, adepts of technical and scenic experiments, aimed
to re-create the feelings of despair, dislocation, and disorientation
induced by a materialistic and mechanized society. Others, advocates
of a more "objective" photography, conveyed those same emotions by
taking a documentary approach.

Each approach was in its own way a form of opposition. For all
the proponents, the representation of those left behind by progress
(whether humans, architecture, or objects) occupied a central place.
It allowed them to denounce the established "categories of order
and classification . . . becoming in the process threatening or even
subversive."[3] The importance of junk in Walker Evans's production
bears witness to a shared critical stance. In 1971, he analyzed his
pessimistic rebellion of the 1930s in the following terms:

> I was really anti-American at the time. America was big
> business and I wanted to escape. It nauseated me.
> My photography was a semi-conscious reaction against
> right-thinking and optimism; it was an attack on the
> establishment. I could just hear my father saying, "Why

Fig. 1. Walker Evans
*Demolition Site with Cranes and Lunch Sign in
Foreground, New York City*, 1930s
Negative, digital inversion, 8 × 10 in. (20.3 × 25.4 cm)
The Metropolitan Museum of Art, New York,
Walker Evans Archive, 1994, 1994.258.476

do you want to look at those scenes, they're depressing. Why don't you look at the nice things in life?"[4]

Like other artists and intellectuals disgusted by "the perverse health of America,"[5] its materialism and standardization, Evans went into self-imposed exile in Europe in the mid-1920s. In Paris, he studied and translated the Symbolist writers, who had, before him, sought to flee to new horizons. Remy de Gourmont, Baudelaire, Rimbaud, Cendrars, and Huysmans had all taken this same defiant position regarding modernity, in writing that was often "extravagant and morbid."[6] The lexical fields of loss and collapse abound in Evans's correspondence and notebooks from the 1920s onward. In one of his first articles, published in 1930 in *Alhambra*, he predicted the advent of a society racing to ruin: "The world is going to manufacture, buy, and sell goods violently, madly, and exclusively for some time to come."[7] In late 1931, he told his friend Skolle: "The world . . . is about to collapse."[8] Back in New York in early 1932 after a four-month stay in the Pacific, he confessed he was particularly shocked by the city's "spectacle of disintegration such as has never been equalled."[9] His manifesto, the book *American Photographs*, expressed the quintessence of that very dark vision. In it, Lincoln Kirstein presented the photographs as "the records of the age before an imminent collapse. His pictures exist to testify to the symptoms of waste and selfishness that caused the ruin and to salvage whatever was splendid for the future reference of the survivors."[10] This pessimistic dimension did not escape certain commentators who were saddened by this "parade of dreary, drab and depressing scenes."[11]

Evans's interest in American decadence was evident some ten years before that publication. Although his first images reveal the appeal of modernist architecture and urban perspectives, in 1929 he began pointing his camera toward litter, ordinary people, and vernacular architecture. This turning point was stimulated by several encounters: from his momentous discovery in that same period, through the intermediary of Berenice Abbott, of Eugène Atget's photographs of Old Paris, its nooks and crannies and its inhabitants, to his friendship with James Agee a few years later, with whom he shared a sensitivity to those abandoned by modernity. His admiration for Paul Strand and his friendship with Ralph Steiner—both of whom were attuned to the traces of an America in distress—also affected his work. In May 1930, Steiner lent his view camera to the young photographer, with which he took some of his most famous images, declarations of his new interest in the dark side of progress.[12] In the spring of the following year, Kirstein persuaded him to photograph Victorian houses, most of which were doomed to disappear—buildings that, according to historian Barnaby Haran, "in their own creeping decline exposed the diminished power of American progress."[13] In addition to these "delicate relics,"[14] in the ensuing years Evans continued to seek the vestiges of an America in decline in its vernacular architecture: abandoned mansions of the Old South, wooden shacks along the roadside, the destruction and rehabilitation of old New York neighborhoods (fig. 1). These buildings were not the only debris amassed by Evans: litter on the ground, junkyard cars, men and women left behind by progress, graphic remnants of posters, popular magazines, and newspapers—all added up to form a collection of "discards." The scrapbook that Evans kept in the summer of 1938 (pp. 196–99), while he was working on the publication of *American Photographs*, also revealed an obsession with collecting images of disasters, traces of the other side of progress, worthless, forgotten images revived by the photographer's intercession.

The junk "collected" by Evans's camera enjoyed a second life. It continued to exist beyond its original connection with the consumerism that produced it. This practice of recycling objects is reminiscent of Baudelaire's ragpicker so admired by Evans.

> Here is a man whose job it is to pick up the day's trash in the capital. Everything the big city has rejected, everything it has lost, everything it has discarded, everything it has broken, he catalogues and collects. He searches the archives of decadence, the jumble of refuse. He picks it over, makes a clever choice; like a miser with his treasure, he picks up garbage that, once rehashed by the goddess of Industry, will become useful or enjoyable objects.[15]

The ragpicker and the poet, conflated by Baudelaire, were concerned with waste and, as Walter Benjamin noted, "go about their solitary business while other citizens are sleeping; they even move in the same way."[16] Junk attracted the ragpicker and the poet, just as it fascinated Evans with its sovereignty. Autonomous, it exists for itself, beyond the utilitarian world and established value systems. Its nature satisfied the photographer's antibourgeois stance, as it did his apoliticism and his independence of any ideology. However, as Gillian Pye remarks, this apparent independence "is tempered by an awareness that trash may also serve to reveal the opposite aspect of material things: that their existence is entirely dependent on us, that they are, in a sense, 'without power of resistance to man.'"[17] This duality is clear in Evans's work. His photographs show how junk is anything but a "stable category," always seeming "ready for disappearance and yet ripe for reinvestment, reinterpretation or revaluing."[18]

Dynamic Waste

Preindustrial objects, decadent architecture, or mass-produced products fallen into desuetude—all reveal the photographer's fascination with the popular artifact, whether preindustrial or contemporary. He often photographed rubbish that was already "recycled" or in the process of reappropriation, displayed in antique and resale shops (fig. 2), or collected, already "put away" in trashcans or other

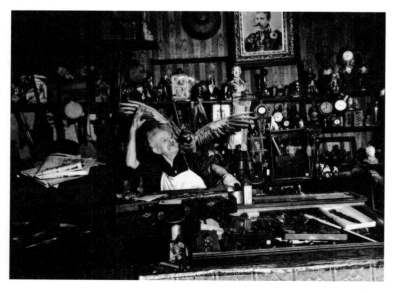

Fig. 2. Walker Evans
Junk Shop Owner with Parrot on Shoulder,
Williamsburg, Brooklyn, January 31, 1939
Negative, digital inversion, 4 × 5 in. (10.16 × 12.7 cm)
The Metropolitan Museum of Art, New York,
Walker Evans Archive, 1994, 1994.254.664

containers (pp. 180, 182–83). Evans perceived his photography as a collection: "It's compulsive and you can hardly stop."[19] This rapacious appetite for image and object was evident from the 1930s and continued throughout his career. In the early 1970s, Evans himself acknowledged this obsessive relationship to objects, and in particular to those doomed to oblivion: "I'm an incurable and inveterate collector. Right now I'm collecting trash, literally. I've gotten interested in the forms of trash, and I have bins of it, and also discarded ephemera, particularly in printing."[20]

The care with which Evans put together these collections shows the complexity of the photographer's preoccupation with junk. His images serve not merely as the expression of his criticism of materialism and standardization, but perhaps especially as his confession of an abiding attraction. The very act of collecting such objects gives them a new value that contradicts their obsolescence. In this, was Evans not ultimately mimicking the principle of capitalism? Theodor Adorno had pointed out a similar ambiguity in the figure of Benjamin's ragpicker/collector but omitted to indicate the economic function of a practice tending to reintegrate waste into the capitalist system. As Douglas Smith analyzed it, "In these terms, ragpicking is the ultimate form of capitalism, wringing the last drops of exchange value from material that seems already exhausted. For Adorno, to adopt ragpicking as a methodological model is not to resist capitalism but to surrender to it."[21]

This ambivalence was at the core of American society in the 1930s. The article "Vanishing Backyards," published in *Fortune* in May 1930, is paradigmatic in more ways than one. Illustrated with paintings by Charles Burchfield and photographs by Ralph Steiner, who was already close to the young Evans at the time, it afforded an analysis of the forms of American junk. It appeared side by side in that issue with other articles related to the country's wealth, for example, on the Vanderbilt family and the International Paper Company. In it, junk was described as "a multivalent sign—a sign of disorder, but also of vitality."[22] The overproduction of waste was proclaimed to be evidence of America's wealth and good fortune. "It is smelly, but it is also exuberant and vigorous to strew the country with things worn out and left over. Every garbage dump, every row of ramshackle houses lining the railroad track, is evidence of our boundless wealth. This is space we do not need. We have so much."[23] The writer reminded the reader of the economic value of waste. The creation of "exquisite Garbage Parks" would provide an unprecedented source of income. "Thus will even garbage, according to the propitious laws of nature and capitalism, be changed into money."[24] While controlling such losses was a priority, their presence in the American landscape seemed definitively desirable. Suggesting economic prosperity, they stood out as one of the cornerstones of legitimation of the very idea of progress supported by capitalism.[25] "Garbage," as the writer of the *Fortune* article remarked, was actually "a relative term."[26] The lucrative potential of its recycling was also widely exploited during the Depression. Its reappropriation was, for many, a means of subsistence. In an article about auto junkyards, which appeared a few decades later in *Fortune*, Evans in turn pointed out the economic value of garbage. "The sale of used parts can be fairly profitable when executed with energy and savoir"[27] (p. 178). The photographer's ambivalence was reflected in most of his images. His desolate subjects are depicted "with a strong affection tinged with irony."[28] They are as effective as symptoms of "modernity at a standstill" as they are as indicators of momentum.

The vitality of junk in Evans's work is largely due its aesthetic appeal. In this same article, he admits to the irresistible attraction of these fields of junkyard cars in the following terms: "obscene perversities" resting "in the middle of idyllic rural spots," they are "agonized travesties of what was once grandeur . . ."; and "they gasp on their sides," evoking "some timeless carnage."

> Pictorially speaking, the result is chaos abstracted, and this has considerable curious interest in itself. There is a secret imp in almost every civilized man that bids him delight in the surprises and the mockery in the forms of destruction. At times, nothing could be gayer than the complete collapse of our fanciest contrivances. Scenes like these are rich in tragicomic suggestions of the fall of man from his high ride.[29]

While Evans never again expressed his attraction to the decadent forms of destruction and to "the grotesque charm of obsolescence"[30] quite as well as he did here, the darkness of the Depression years was particularly conducive to his quest for junk. In 1934, he told Ernestine Evans of his desire to go and photograph Pittsburgh, Toledo, and "some dirty cracks" in Detroit, as that city was "full of chances." At the time, he had the idea of producing a book of photographs on "American urban taste," namely, "the hateful stuff," "fake culture," "bad education," and "religion in decay."[31] The photographer's attraction to the abandoned industrial city was confirmed the following year in a work plan he sent to Roy Stryker. In it, Evans stated he wanted to spend a week in Pittsburgh and its outskirts, where he intended to make "graphic records of a complete, complex, pictorially rich modern industrial center."[32]

Evans's use of the word *pictorial* here refers, as Jean-François Chevrier notes, "to a visual culture that includes painting but also the iconographic and picturesque."[33] In his study on the photographic images of decay and the pictorial tradition, historian Wolfgang Kemp reminds us that, already in the eighteenth century, the word *picturesque* referred to decrepitude, ruin, and destruction.[34] In a letter written in 1821, the painter John Constable provided a list of picturesque subjects including "old rotten planks . . . and brickwork." Another eighteenth-century author included in that category "decayed cart horses and . . . backyard nooks filled with junk, crude thatched cottages, and ramshackle cabins."[35] From a strictly iconographic point of view, if Evans's ruins appear to be linked to the pictorial picturesque, the record he presents of them stands out from the romanticism generally associated with such images. To be sure, his photographs evoke absence, oblivion, and loss, and sometimes verge on abstraction (p. 170 left), but they never express nostalgia or melancholy. What is more, his perception of reality is in all respects contrary to the pristine picturesque, which is necessarily constructed beyond consideration of "all associations with utility and morality," and any representation of "historical and political issues . . . for the sake of aesthetic effect."[36] Evans challenged the good taste, artistic education, and social superiority associated with the figure of the painter. He loved waste for what it personified, i.e., contemporaneousness. Its image allowed him to get as close as possible to the represented reality that he never stopped constructing. With the remote beauty of a Baudelairean dandy, the photographer portrayed trash as "a surgeon has to be detached from human pain"[37] through a staunchly democratic vision.

This apparent coldness emerges as a guarantee of ethics. The abandoned object, the ruined architecture, and the distraught human being are captured without hierarchy, with the same detachment and the same "clinical eye."[38] In 1935, Evans traveled to West Virginia and Pennsylvania, regions particularly hard hit by the Depression.[39] He brought back from there some of his harshest portraits (fig. 3). In his diary, the photographer wrote that he had concentrated on "the most gruesome specimens" and "a homecoming of . . . very degenerate

natives, mush faced, apathetic, the pall of ignorance on all sides."[40] The construction, framing, and timing of these portraits reveal a sensitivity to their delicate balance, very similar to the way Evans approached precarious architecture. Bodies, like buildings, were shown with no blandishment. The emphasis was on their "gravity." They fell, literally pulled to the ground. This heaviness of bodies-cum-waste objects is also obvious in his photographs of urban sleepers, their heads burrowed and inanimate bodies curled up in corners (pp. 142 bottom, 143), like the piles of garbage that the photographer hunted in the recesses of the city (p. 181). It is also visible in his images using the flattening effect of the full top view: looking downward flattens and reinforces the "depression effect"[41] (p. 186). This visual and physical interplay of collapse also gave structure to *American Photographs*. The first part of the book ends with a rhythmic sequence producing an effect of separation from the verticality and frontality of the preceding images: a victim fleeing from a flood in Arkansas, despondent and bedridden (p. 159), vagrants asleep in the street, or an uprooted tree lying on the ground, partially obstructing the view of a decadently glamorous old Louisiana mansion (p. 166 top). The second part of the book, presenting frontal views of buildings, begins and ends with close-ups of architectural debris. The compression effect of the materials was reinforced by a close-up top view (pp. 168–69). Relics of an ancient-style American architecture, "fake archaeological vestiges, derived from a culture with no memory,"[42] such refuse also revealed the photographer's derision of a new world captivated by superficiality and eager for an authenticity yet to be developed.

"In order that any form of modernity may be worthy of becoming antiquity"[43]

Miles Orvell notes a major transformation within the arts and material culture of the United States from the late nineteenth to the early twentieth century, through "a shift from a culture in which the arts of imitation and illusion were valorized to a culture in which the notion of authenticity became of primary value."[44] That shift followed a general trend in this young country that was seeking to showcase and even to develop its roots and its own national character. The concepts of realism, tradition, and history were therefore valued by the defenders of the capitalist system as well as by its most ardent opponents. While in this context, preindustrial architecture and artifact were naturally reassessed, it was above all their abandonment that guaranteed their importance in the process of constructing an "authentic" historical past. Purportedly part of a defined space and time, vested with a specific biography, junk in fact instantly connected with real life.[45]

The article "Vanishing Backyards" once again perfectly illustrates this phenomenon. Faced with the advent of a new and modern "taste," Steiner's photographs (advertising posters, trash, facade of a Victorian house, or rocking chair on a porch) all, according to the author of the text, depict "things that are passing." The desuetude of the preindustrial object, amply sustained by its association with "garbage," here ensures the legitimation of a progressive ideology. In support of these illustrations, "the new America, its skyscrapers, its airplanes, its dynamos" was therefore contrasted with "the America which remains unregenerate, its back porches and backyards, its ugliness and its waste."[46] As Orvell analyzes it, the article clearly demonstrates a tension between the defense of "an ideology of progress that pushes the past from our view as fast as possible," and "a contrary, deep attachment to things as they were, to old things, to junk."[47]

The historicizing value of preindustrial junk appealed to a number of avant-garde writers in their quest to write "truth": John Dos Passos,

William Carlos Williams, John Steinbeck, and James Agee each linked the advent of capitalism with the disappearance of a local, domestic culture and discovered "in some worn-out objects the gist of authenticity for which he was looking."[48] Developing a system for exploring, objectifying, and exhibiting "remnants of a supposedly more organic"[49] precapitalist culture, they participated in a generalized ethnographic momentum that characterized the United States early in the twentieth century. As cultural figures, in James Miller's analysis, they aimed to restore "the idea(l)s of 'locality' and 'community,'" which they posited as "redemptive counterpoints to the standardization and anonymity of modern commercial life." However, as Miller points out, their emphasis on "the vestiges (both material and human) of America's putatively 'vanishing' past" drew upon "complex (and largely unresolved) feelings regarding both the nature and function of 'history' in an age of mass industrialization and commercialization."[50]

This ambivalence was also an impetus for Evans's work. His systematic excavation of the dump participated in and opposed, in equal measure, the construction of the capitalist past. His involvement is visible in several illustrated articles he devoted to architecture and deteriorated objects, published in *Fortune* and other broad-circulation magazines such as *Vogue* and *Harper's Bazaar*, beginning in the early 1940s. The article "The Circus at Home" (1942) penned by Alice Morris and illustrated with three images by Walker Evans (pp. 286–87) perfectly illustrates how companies profited from the obsolescence of objects of the past. The article featured the Ringling Brothers Circus. Located in Sarasota, Florida, it was a source of vitality for the city. In addition to its shows, the public also had the opportunity to visit its historic wagons dating back to the institution's golden age (1870–1914). Now immobile, they fascinated Evans. The reminder, in both text and image, of the beauty of these wagons in their glory days served to promote the modernity of that circus, still suffering the effects of the Depression at that time:

> . . . the magnificent circus wagons of the past—heavily carved, adorned with caryatids and weathered paint—too old now, or too cumbersome, for the new, crack, streamlined, air-conditioned Greatest Show on Earth.[51]

The obsolescence of these vehicles, emphasized here by both text and image, were building blocks of the institution's prestige, myth, and history.

If the showcasing of preindustrial junk contributed to the construction of capitalist history, this could also be established by exploiting the obsolescence of the manufactured object and its shift "into the larger category of vernacular culture."[52] This process was a recurrent theme in Depression-era writing, exemplified by the Joad family in Steinbeck's *The Grapes of Wrath* (1939):

> For the Joads, the most resonant mementos of their putative roots (e.g., to the land, community, tradition) are not the homespun craft things or handmade talismans of a preindustrial economy, but rather the few, outworn commercial objects (the dime-store trinkets, the toys from the catalogue, the tourist knick-knack, and such) they have managed to purchase from the national marketplace.[53]

In *Let Us Now Praise Famous Men* (1941), James Agee described multiple family homes, on several occasions similarly

Fig. 3. Walker Evans
Street Scene, Kingwood, West Virginia, 1935
Gelatin silver print, 6½ × 8½ in. (16.5 × 21.6 cm)
The Bluff Collection

lingering over the adoption of manufactured objects in their interiors. Evans's photographs accompanying that text also give visibility to this domestication of the industrial vernacular: printed calendars, advertisements, and other documents from periodicals adorn a modest chimney; in the interior of a shop, a poster touting the merits of Coca-Cola mingles with bare necessities; in a cemetery, a rudimentary grave is decorated with worn containers. The shape of one of them is reminiscent of a bottle of the famous American soda. Its impoverished appearance mocks its original gleaming character. More than suggesting the end of a journey, its funereal location vests this object with "real" experiential value (p. 156 bottom). Text and photographs jointly contributed to the destandardization of the mass-produced object, to its artifactualization, "by reinscribing it with the traces of local, vernacular use, and a specific lived history."[54]

Other images by Evans include worn, discarded manufactured objects, alone or in context, in interiors or in public spaces. Individualized, historicized on the same footing as preindustrial objects, they are given an "aura" they did not originally possess due to their standardized character. This can be seen in his photographs of advertising posters on the walls and fences of homes. Their fading colors and decomposing paper create a visual effect of absorption of the image by its support, such that the commercial object becomes an integral component of the domestic space (pp. 106, 125, 170 right). In *Show Bill, Demopolis, Alabama* (1936; p. 116), Evans used another process to historicize the contemporary. Two posters are shown together; one, nearly intact, announces the release of a recent film to the general public, the other, deteriorated, advertises a "Minstrel Show," a form of entertainment popular in the early nineteenth century but now in decline. The juxtaposition of the two posters not only suggests the abandonment of a certain type of popular show and the emergence of another, but also constitutes a more "encompassing" reflection on the passage of time. The photograph was taken the year following the release of the film *The Roaring West*, which already bears the mark of its own obsolescence. In fact, it would experience the same fateful oblivion as the Mighty Minstrels of J. C. Lincoln.

In its most heterogeneous forms, the American junk photographed by Evans reveals the "unquenchable appetite for the prestige of the past in a new land."[55] These "depressive" images are the dark portrait of a modern America, or, to borrow the words of a critic of *American Photographs*, "a certain hideous miscellaneousness of American life."[56]

The apparent baseness of junk also satisfied Evans's total devotion to realism. It allowed him to "degrade himself," like Rimbaud—that other great lover of junk, who worked that way in order to become a "poet" and "make [himself] a Seer."[57]

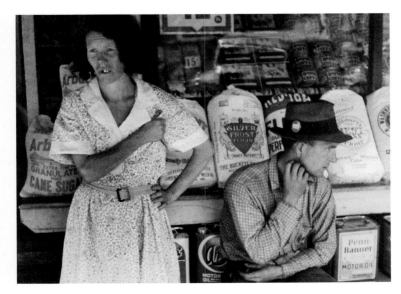

1. Miles Orvell, *The Real Thing: Imitation and Authenticity in American Culture, 1880–1940* (Chapel Hill: University of North Carolina Press, 1989), p. 287.
2. Jani Scandura, *Down in the Dumps: Place, Modernity, American Depression* (Durham, N.C.: Duke University Press, 2008), pp. 5, 4, 11.
3. Gillian Pye, ed., *Trash Culture: Objects and Obsolescence in Cultural Perspective* (Oxford: Peter Lang, 2010), p. 6.
4. Walker Evans, in Leslie G. Katz, "Interview with Walker Evans," *Art in America* 59, no. 2 (1971), pp. 84–85.
5. Walker Evans, essay dated August 7, 1926, cited in *Unclassified: A Walker Evans Anthology: Selections from the Walker Evans Archive, Department of Photographs, The Metropolitan Museum of Art*, edited by Jeff L. Rosenheim (Zurich: Scalo, 2000), p. 42.
6. Hanns Skolle, letter to Walker Evans, July 1929, cited in Maria Morris Hambourg et al., *Walker Evans* (New York: The Metropolitan Museum of Art, 2000), p. 29.
7. "Dancing Catalans. Reviewed by Walker Evans," *Alhambra* (January 1930), p. 44, cited in *Unclassified*, p. 78.
8. Walker Evans, letter to Hanns Skolle, October 2, 1931, cited in Hambourg et al., *Walker Evans*, p. 39.
9. Walker Evans, letter to Hanns Skolle, May 19, 1932, cited in *Unclassified*, p. 162.
10. Lincoln Kirstein, in *Walker Evans: American Photographs* (New York: The Museum of Modern Art, 1938), p. 196.
11. *The Washington Post*, October 7, 1938, cited in John Tagg, "Melancholy Realism: Walker Evans's Resistance to Meaning," *Narrative* 11, no. 1 (January 2003), p. 44.
12. Hambourg et al., *Walker Evans*, p. 37.
13. Barnaby Haran, "Homeless Houses: Classifying Walker Evans's Photographs of Victorian Architecture," *Oxford Art Journal* 33, no. 2 (2010), p. 205.
14. Ibid.
15. Charles Baudelaire, "Les paradis artificiels. Du vin et du hachisch, I. Le vin" (1851), in *Oeuvres complètes*, vol. 1 (Paris: Gallimard, Bibliothèque de La Pléiade, 1961), p. 381.
16. Walter Benjamin, "The Paris of the Second Empire in Baudelaire" (1938), in *Selected Writrings*, vol. 4, translated by Edmund Jephcott et al. (Cambridge, Mass.: Harvard University Press, 2003), p. 116.
17. Pye, *Trash Culture*, p. 6. The author cites Karl Marx, *Capital*, vol. 1 (London, Lawrence & Wishart, 1996).
18. Ibid.
19. Evans, in Katz, "Interview with Walker Evans," p. 85.
20. "Walker Evans, Visiting Artist: A Transcript of His Discussion with the Students of the University of Michigan, 1971," in *Photography: Essays & Images*, edited by Beaumont Newhall (New York: The Museum of Modern Art, 1980), p. 317.
21. Douglas Smith, "Scrapbooks: Recycling the *Lumpen* in Benjamin and Bataille," in Pye, ed., *Trash Culture*, p. 119.
22. Orvell, *The Real Thing*, p. 287.
23. Anonymous, "Vanishing Backyards," *Fortune* 1, no. 4 (May 1930), cited in ibid., p. 288.
24. Orvell, *The Real Thing*, p. 288.
25. Scandura, *Down in the Dumps*, p. 18.
26. Anonymous, "Vanishing Backyards," cited in ibid., p. 20.
27. Walker Evans, "The Auto Junkyard," *Fortune* 65, no. 4 (April 1962), p. 136.
28. Orvell, *The Real Thing*, p. 290.
29. Evans, "The Auto Junkyard," pp. 132–33.
30. Wolfgang Kemp, "Images of Decay: Photography in the Picturesque Tradition" (1978), *October*, no. 54 (Fall 1990), p. 120.
31. Walker Evans, unfinished letter to Ernestine Evans, February 1934, in John T. Hill and Jerry L. Thompson, *Walker Evans at Work* (New York: Harper & Row, 1982), p. 98.
32. "Outline Memorandum for Mr. Stryker," cited in ibid., p. 113.
33. Jean-François Chevrier, "Walker Evans: *American Photographs* et la question du sujet" (2001), in his *Walker Evans dans le temps et dans l'histoire* (Paris: L'Arachnéen, 2010), p. 46.
34. On this subject, see Kemp, "Images of Decay."
35. Ibid., p. 105.
36. Ibid., p. 107. Here Kemp expounds on John Ruskin's social critique of the Picturesque, as expressed in his *Modern Painters* (London, J. M. Dent, 1906), pp. 9–10.
37. Walker Evans, interview with Jonathan Goell, August 4, 1971, cited in Hambourg et al., *Walker Evans*, p. 23.
38. See Kirstein in *Walker Evans: American Photographs*, p. 194: "The view is clinical. Evans is a visual doctor . . ."
39. Hambourg et al., *Walker Evans*, pp. 69–71.
40. Walker Evans, diary entry, July 4, 1935, cited in ibid., p. 71.
41. The etymological roots of the term *depression* refer to a "debasement" or a physical "recessing," suggesting the action of "depressing" and "lowering." See Scandura, *Down in the Dumps*, p. 4.
42. Chevrier, "Walker Evans: *American Photographs* et la question du sujet," p. 37.
43. Charles Baudelaire, "Le peintre de la vie moderne. IV. La Modernité," in *Oeuvres complètes*, vol. 2 (Paris: Gallimard, Bibliothèque de La Pléiade, 1961), p. 695.
44. Orvell, *The Real Thing*, p. xv.
45. Pye, *Trash Culture*, pp. 4, 7.
46. Anonymous, "Vanishing Backyards," cited in Orvell, *The Real Thing*, p. 288.
47. Ibid.
48. Ibid., p. 295.
49. James S. Miller, "Inventing the 'Found' Object: Artifactuality, Folk History, and the Rise of Capitalist Ethnography in 1930s America," *Journal of American Folklore* 117 (Fall 2004), p. 382.
50. Ibid., pp. 382, 373, 376.
51. Alice S. Morris, "The Circus at Home," *Harper's Bazaar* 73 (April 1942), p. 65.
52. Scandura, *Down in the Dumps*, p. 19.
53. Miller, "Inventing the 'Found' Object," pp. 382–83.
54. Ibid., p. 386. See James Agee and Walker Evans, *Let Us Now Praise Famous Men* (Boston: Houghton Mifflin, 1941). The industrial vernacular as a specifically American feature was studied by John A. Kouwenhoven in *Made in America: The Arts in Modern Civilization* (Garden City, N.Y.: Doubleday, 1948). He was an acquaintance of Walker Evans in the 1960s.
55. Kirstein, in *Walker Evans: American Photographs*, p. 192.
56. David Wolff, *The New Masses*, October 4, 1938, cited in James R. Mellow, *Walker Evans* (New York: Basic Books, 1999), p. 379.
57. Arthur Rimbaud, letter to Georges Izambard, May 13, 1871, *La Revue Européenne* (October 1928), reprinted in *Oeuvres complètes* (Paris: Gallimard, Bibliothèque de la Pléiade, 2009), p. 340.

—DAVID CAMPANY

"WORKING FOR MAGAZINES" AND "WORKS" FOR MAGAZINES: WALKER EVANS, THE POPULAR PRESS, AND CONCEPTUAL ART

The career of Walker Evans spanned the period in which the photographically illustrated magazine was both the dominant cultural force in North America and Europe, and an important platform for dissenting voices and avant-gardes. When Evans took up photography in 1928, mass visual culture had been expanding intensively for a decade. The number of magazine titles had grown exponentially, and their circulation was rocketing. By 1965, when Evans stepped back to take a teaching post at Yale, magazine culture was in the long process of being pushed aside by television.[1]

Between those dates, Evans produced work for mainstream magazines that is notable for its independence, intelligence, and wit. He understood their pages as sites of resistance and ideological contest, a space to be struggled over. As American culture hurtled into consumerism, distraction, celebrity, and amnesia, Evans fashioned a slow and measured counter-commentary from within its largest media empire, Time Inc. This often neglected aspect of Evans's oeuvre is a remarkable and uncommon achievement. Moreover, as we shall see, his magazine work prefigures the interests of many artists who have emerged since the mid-1960s, looking to move beyond the gallery, to infiltrate or subvert the popular press.

To work from within one needs access, and the young Evans had very little. His debut in print came in August 1929, in *Alhambra*, a short-lived New York journal of Anglo-Spanish culture.[2] "New York in the Making" was the title given to his photograph of skyscraper construction on Manhattan's East 42nd Street. It was placed on the page opposite a photo by Lopez Segura of a cobbled Spanish alleyway. Thrusting metropolis and rustic village. Such image pairings were commonplace in European magazines and were spreading to the U.S.[3] But it was not Evans's idea. He supplied the image, while the editorial juxtaposition directed its reading.

On the magazine page, meaning is not confined within the borders of the image. It is a matter of complex relations between images and texts. With little influence over this aspect, Evans soon recognized he was giving away too much. For a photographer, the page presentation of images is always easier to control in books than in magazines. In general, the larger the audience, the less control a photographer has over his/her work. This is why such a great number of twentieth-century photographers who found themselves compromised by magazine work sought to publish books. It was a way of asserting expression and authorship. Evans did this too, notably with *American Photographs* (1938), *Many are Called* (1966), and *Message from the Interior* (1966), and with his equally groundbreaking image sequences for books made in collaboration with writers (*The Crime of Cuba* with Carleton Beals in 1933; *Let Us Now Praise Famous Men* with James Agee in 1941; and *The Mangrove Coast* with Karl A. Bickel in 1942). But he retained a commitment to the possibilities of magazines.

In the coming year or so, Evans had to sell photographs to a variety of publications, and he took occasional commissions, but it became a matter of principle to try to orchestrate his work on the page. This itself ran against the grain of magazine culture, which was, and still is, premised on a division of labor that separates image makers from editors, writers, and art directors. The content of magazines is construed by committee and produced through a chain of discrete skill sets. This arrangement was embodied in the rise during the 1920s of photography agencies, commercial "middle men" who would sell photographers' work to magazines and newspapers, hopefully several times over to maximize the profit from a single shoot. The photographer would often be entirely removed from the editorial decision making. Evans never joined an agency, and beyond his work for the Farm Security Administration in the mid-1930s, he had very few photographs syndicated.[4]

So what was the alternative? Evans had slightly more success in the early 1930s publishing groups of pictures in the pages of *Hound & Horn*, a little arts and culture magazine founded and edited by his close friend and champion Lincoln Kirstein. These were essentially mini-portfolios of New York street scenes and portraits of working tradesmen. However, there were significant signs of Evans's thinking in a short text he wrote for *Hound & Horn* in 1931. "The Reappearance of Photography" was an opportunity to review a clutch of new photographic books, mainly from Europe, but Evans turned it into a statement of intent.[5] He was struck by the lyric documentary vision he found in the first book of the late Eugène Atget's photographs (*Atget, photographe de Paris*, 1930), and also by the inherent openness and ambiguity of those images: "It is possible to read into [Atget's] photographs so many things he may never have formulated to himself. In some of his work he even places himself in a position to be pounced upon by the most orthodox of surréalistes." Evans was probably referring to the use of four Atget photographs in the Parisian journal *La Révolution Surréaliste*, one of which was reproduced on the cover of issue 7, 1926 (which he saw either in Paris that year or back in New York, where he was an avid reader of avant-garde journals). Atget's own title for his image was simply "L'Éclipse, avril 1912," but here it was replaced by the provocative "Les Dernières Conversions" (The Last Conversions). A photo of a group gazing at the heavens becomes an antireligious jibe.[6]

Evans praised *Antlitz der Zeit* (Face of the Time, 1929), August Sander's sequenced book of sixty portraits drawn from his huge survey of the German people, noting these "type studies" were "one of the futures of photography foretold by Atget . . . a photographic editing of society, a clinical process."[7] He also highlighted *Photo-Eye* (1929), an influential survey book put together to coincide with *Film und Foto*, the huge touring showcase that debuted in Stuttgart. Its mix of artistic, scientific, and news photographs was "nervous and important." It included a shocking anonymous press photo of a corpse in a street. It confirmed Evans's own understanding of the power of disruption, and his suspicion of the idea that photography's highest calling was Art, with a capital A:

> The latter half of the nineteenth century offers that fantastic figure, the art photographer, really an unsuccessful painter with a bag of mysterious tricks. He is by no means a dead tradition even now, still gathered into clubs to exhibit pictures of misty October lanes, snow scenes, *reflets dans l'eau*, young girls with crystal balls. In these groups arises the loud and very suspicious protest about photography being an art. So there is in one of the anthologies under review a photo of a corpse in a pool of blood *because you like nice things*.

Unpalatable, uncompromising, and quasi-automatic, the raw document disturbs the comfortable aspirations of the photo salon and gallery. Evans strove to resist artistic pretension in his own photography and soon began to incorporate archival documents in his work for the page. For example, into the sequence of Havana street shots produced for the writer Carleton Beals's exposé *The Crime of Cuba* (1933), Evans placed news agency photos of murdered revolutionaries and political prisoners, acquired from a local newspaper office (fig. 1).

In 1934, Evans was commissioned by *Fortune* to photograph an American Communist Party summer camp. He shot surreptitiously, with a right-angle viewer on his 35mm camera. The more overtly left-leaning Dwight Macdonald supplied the text. It was an engaging if perfunctory piece, the photos reduced to mere illustrations. Designed to be the definitive magazine of American business and industry, the graphically lavish *Fortune* had launched in the wake of the 1929 economic crash, and its editorial agenda was often open to dissenting voices. *Fortune* was the jewel in the crown of Time Inc., the publishing empire of Henry Luce, who owned *Time* and went on to launch *Life* in 1936 to instant commercial success.

From the start, Evans and his friend the writer James Agee disliked *Life*'s presumption that a popular magazine must be crudely populist. Voyeurism, sentimentalism, and spectacle ought to be avoided, as should any fixed presumptions about how the world can be described by images and words. But *Life* was busy honing the photo-essay format into formulaic conventions for easy consumption. So Evans and Agee submitted a proposal for a subsection of *Life* to be devolved to them. As editorial advisors, they would provide a space for experimental writing and a visual approach devoid of what Agee later called "all 'art' and 'dramatic' photography and of the plethoric and flabby ends of Leica photography."[8] They asked for an office and $75 a week each, promising to take care of everything. *Life* actually considered the idea for a while but eventually declined. Nevertheless, the desire to carve out an independent space within mainstream culture remained. A sizeable audience was too significant to be ignored. Both men sensed there might be other approaches.

By the summer of 1935, Evans was working full-time for the Farm Security Administration (FSA). He was making some of his most accomplished and best known images, but it was government agency work, and Evans had little say as to how it might be used. A year into

the job, he took a leave of absence to join Agee on a *Fortune* commission to document the lives of tenant farmers and sharecroppers struggling in the American South. Would this be their breakthrough?

Evans photographed intensively, while Agee wrote thousands of words that veered episodically into inner monologue, confession, speculation, and deep contemplation of what it is to observe and report on others. *Fortune* refused to publish. It eventually surfaced in 1941 as the book *Let Us Now Praise Famous Men*. Radically, Evans's sequence of thirty-one images stood apart from Agee's text, untitled and uncaptioned, leaving readers to make their own connections (pp. 144–57). It sold just 199 copies in its first two years and was remaindered at nineteen cents a copy. It was only in the 1960s and 1970s, when the subject matter was no longer urgent, that the book was hailed as the pinnacle of a genre it had all but invented: high modernist experimental documentary.

The breakthrough finally arrived in 1945, when Evans became the only salaried photographer at *Fortune*. He soon began to test the magazine's boundaries of acceptability. A special issue on housing was being prepared in early 1946; *Fortune* would describe the economics of building, new construction methods, and interior design. Evans collaborated with another writer friend, Wilder Hobson, to produce "Homes of Americans" (*Fortune*, April 1946). Its ten pages comprised an introductory text, thirty-three black-and-white photographs, and captions at the end. None of the photos were shot specifically for the feature, and only seven were by Evans himself, the others coming from prints he owned by fellow photographers. At first glance, it looks to be a survey of the nation's domestic architecture, but the text points the reader to the slippery status of visual documents:

> Photography, that great distorter of things as they are, has, here as elsewhere, played its peculiarly disreputable, charming tricks . . . But like the deliberate inflections of men's voices, they are tricks now and then lifted to an art. Take your time with this array. You may be in a hurry to turn to page 157 [the back of the piece] for the names of what you are seeing. On the other hand, it may pay you to incline with Herman Melville to "let the ambiguous procession of events reveal their own ambiguousness."[9]

The tone continued in the caption for the first two images:

> These are a Shaker doorway in New Lebanon, New York, built in 1819, and Mrs. Cornelius Vanderbilt's New York drawing room as of 1883. That Shaker reticence should meet cupids, ormolu, and brocade in the same nation, while no great surprise, is certainly a telling matter for pictorial juxtaposition. There could scarcely be a more vivid parable concerning the extreme diversity of American manners and character.[10]

Neither could there be a more vivid account of the vagaries of the photographic document. The modern-looking interior was actually 133 years old, predating the Baroque-looking drawing room by 64 years. Further on, a field of Airstream caravans is revealed to be a temporary home for defense workers returning from the war. A photo of a Long Island housing development of the 1930s is captioned "A Life-time Opportunity. Steam Heat, with Gas, Electricity and Water. On Easy

28. GONZALEZ RUBIERA
Anonymous Photograph

Fig. 1. Unidentified Photographer
Gonzalez Rubiera
Press photograph selected by Walker Evans for
a sequence of images included in Carleton Beals's
The Crime of Cuba (Philadelphia and London:
J. B. Lippincott, 1933)

Terms . . .," mocking the real estate rhetoric to be found elsewhere in the magazine. A sleek modernist home by Walter Gropius and Marcel Breuer is squeezed into a grid of nineteenth-century vernacular wood-frame houses. Other captions insist the beauty of built form is rooted in tradition and anonymous craft, not in the ideas of the new star architects.

Conventionally, captions serve to anchor the naturally open meaning of all photographs, to tame them and make them functional. "Homes of Americans" does the opposite. It slows down and complicates, rather than hastening the reader to the tempo necessary to consume a photo-essay as quick information. The reader is left doubting the capacity of photographs and words to describe the world. Clearly, none of the effect of "Homes of Americans" survives if the images are removed and re-presented. The highly reflexive gesture is entirely specific to these pages.

"Labor Anonymous" (Fortune, November 1946) plays similar games with expectations. On a sidewalk in Detroit, Evans faced a featureless wall to catch people mid-stride. Eleven of his square Rolleiflex images were selected and cropped for a deceptively simple double spread (pp. 242–43). It appears to be a serial typology of laborers, perhaps taken surreptitiously as they leave their place of work. That is how these portraits have been posthumously recycled in exhibitions and monographs. However, the page has several details that undermine this assumption. In the opening image, a man in overalls seems to look directly at the lens, but the brim of his hat overshadows his eyes, giving the impression that he notes the presence of the camera while keeping something of himself hidden. This stalls the fantasy of invisibility, of observing and classifying unsuspecting specimens. Placed top left, this image helps to suggest that the subsequent portraits should not be taken at face value. The final photo shows a man and a woman together in the same frame, scrambling the distinction between labor relations and sexual relations. Are they a couple or just next to each other on the street?

Furthermore, the short but crucial text of "Labor Anonymous" makes no reference to the end of a working shift, and not all of the people wear clothes associated with labor. The subtitle "On a Saturday Afternoon in Downtown Detroit" suggests this may not be a day of work at all, even if this is one of America's foremost industrial cities. They may be laborers, but they are not laboring here. Then the reader is told there is no classifiable physiognomy on show, that people on the street cannot be judged by appearance: "His features tend now toward the peasant and now toward the patrician. His hat is sometimes a hat, and sometimes he has molded it into a sort of defiant signature." In other words, photographs offer no sure measure of the world. The text concludes: "When editorialists lump them as 'labor,' these laborers can no doubt laugh that one off." Published in an issue of Fortune on the theme of work, "Labor Anonymous" is a bold criticism of the magazine's editorial attitude.[11]

Slowly Evans found a niche for himself, but it was always going to be precarious if he wanted to be at so at odds with his employer (and his audience). But in 1948, he was given the title Special Photographic Editor. He would advise on Fortune's visual direction in exchange for the chance to set his own assignments, shoot, write, and design his own pages. Such independence was unheard of in magazine culture.

Setting himself a contemplative schedule far removed from the hectic pace of the magazine offices, Evans began to explore his lifelong themes. Where Fortune championed the new, he looked to the outmoded or enduring. Where Fortune celebrated the world of work, he considered unemployment or idle pleasures such as wandering. Where Fortune heralded steel-and-glass construction, he cherished endangered vernacular buildings that improved with age and patina. When Fortune announced the new modular office, he drew readers'

attention to long-standing small businesses with vintage furniture. When Fortune celebrated slick department stores, Evans looked to the informal sidewalk displays of small shops.

Evans had always wanted to write, even before he became a photographer. After a wartime stint as an art and book reviewer for Time, he could now explore the interactions of word and image. He cultivated a style of writing that was rich in rhetorical flourish, vernacular expressions, literary quotations, obscure historical references, pithy facts, and adjectives of baroque splendor. There were also moments of high polemic. Although no longer than a few hundred words, he crafted these texts tirelessly. He also kept a close eye on the typesetting, with a poet's sensitivity to the placement of line breaks. In a later interview, he recalled: "The writing wasn't easy for me to master. But I was determined to be my own editor, so I worked hard on it. Any test met is part of one's development."[12] He continued to use captions to complicate rather than explain. "Imperial Washington" (Fortune, February 1952) resembles a simple tourist's survey of the capital's stately architecture—but Evans wants to note the showbiz of it all: "The last, large burst of classicism struck Washington as a direct result of the Chicago World's Fair of 1893. So successful was that midwestern creation in plaster that its chief architects and planners moved on to the capital almost to a man and forever froze the face of the city into its Roman-Renaissance expression."[13]

"Beauties of the Common Tool" (Fortune, July 1955) was another homage to anonymous workers. A pair of $1 pliers, a crate opener, tin snips, a trowel, and an adjustable wrench are photographed with immaculate plainness and reproduced larger than lifesize (pp. 264–65). Bold and simple, they are monuments to common design and manual labor. The young Robert Frank helped to source the tools and photograph them. Working in a makeshift set-up in Evans's home studio, Frank was amazed at the perfect results, recalling: "I learned what it was to make a simple photograph."[14] The accompanying words were criticism of contemporary design culture, and Evans's first draft had been even more trenchant: "[I]t is the phoniness of much irrelevant, incompetent and immaterial 'design' that forces the weary eye to turn, of all places, to the tool counter for, of all things, candor and purity." A memo from Evans's seniors urged restraint: "Can you not convey your (our) reverence for these objects of beauty without such explicit censure of our fellow-men?"[15]

Evans's magazine photography was increasingly direct and simple, while his words grew poetic, arch, and charged. To do it the other way around, with plain text introducing flamboyant images, would risk pretension, like a gallery of grandstanding pictures. That was the last thing Evans wanted. He was making his own form of counter-journalism. In his twenty years at Fortune, he produced over forty of these carefully crafted pieces, and seven for Architectural Forum, another Time Inc. magazine. "Color Accidents" (Architectural Forum, January 1958) presented square compositions picked out from the weathered walls of a New York street (pp. 174–75). The writing compares but distances them from abstract painting, which was then at its popular height:

The pocks and scrawls of abandoned walls
recall the style of certain contemporary paintings,
with, of course, the fathomless difference
that the former are accidents
untouched by the hand of consciousness.
Paul Klee would have jumped out of his shoes
had he come across the green door below.
The courage, purity and gaiety of these scarlet shots
in violent green space would be applauded
by all the Klee audience.[16]

The photographs are consummate formal exercises, but the words emphasize that what's important are the walls themselves. The images are artful documents of things Evans wants his readers to notice out in the world. They are elegant reports fashioned for the page. Had these pictures been exhibited on the wall, they would have looked forced and prepossessing.

In 1950, Irving Penn noted that "for the modern photographer the end product of his efforts is the printed page, not the photographic print," but by 1964 he was less convinced: "The printed page seems to have come to something of a dead end for all of us."[17] Brassaï, who had left Paris for America and photographed for *Harper's Bazaar*, felt much the same: "[A]fter 1965 it changed and I didn't do any more because they don't have the same conception of things."[18] Indeed, this sentiment was widespread among photographers.[19] The illustrated press was finally facing up to its displacement. It was no longer the dominant center of mass culture. Television was. In general, this meant magazines would be more nervous, take fewer risks, reach smaller audiences, and become less profitable.

Evans retired from *Fortune* on May 1, 1965. Some kind of posterity was in the offing, but it would be on terms set by the museum and the expanding art market for photographs, not the illustrated press. The magazine work would have to be put aside in favor of exemplary single pictures of the kind Evans had perfected in the mid-1930s.[20] In the early 1970s, he gave a number of interviews, and occasionally his magazine work was discussed. He clearly felt he had achieved something significant: "I had to fight for it. But in a way I accepted that as a challenge. I had to use my wits there. And I think I did all right. I think I won in the long run. I was very pleased with that because that's a hard place to win from. [Time Inc.] is a deadly place really, and ghastly. . . . But it's such a large thing for very bright people and you can find places in there that are habitable."[21]

Meanwhile, for a younger generation, the eclipse of the illustrated press seemed to open up a new critical distance toward it. Artists associated with Pop, Situationism, Minimalism, Land Art, and Conceptualism all moved to expand their field of activity from the gallery into the world at large. Several of them looked to the popular magazines. Could an artist make "works" for magazines without actually having to be employed by them? Could an artwork be made in the style of magazine journalism? Many different tactical subversions were tried out, particularly in North America. Robert Smithson parodied conventional photojournalism with pieces such as "The Monuments of Passaic." Published in *Artforum* magazine in December 1967, it was a delirious description of his wandering through a postindustrial wasteland, accompanied by deliberately amateurish photo documentation.[22] In 1971, Robert Heinecken screen-printed reportage images directly onto the pages of *Time* and *Harper's Bazaar*, including one of a Viet Cong soldier smiling while holding two severed heads. The magazines would then be returned to the newsstand for resale to an unsuspecting readership.

The most celebrated and frequently cited of these interventions is Dan Graham's "Homes for America" (1966–72; fig. 2). It provides a startling and somewhat comic coda to Walker Evans's magazine work. Graham was interested in postwar suburban tract housing, the rows of cheaply produced homes that were spreading across America. He took to photographing them on slide film with an Instamatic camera, making images as deliberately perfunctory as his subject matter. First he presented them as a slideshow in his gallery, then he wrote a deadpan text explaining how house building was a crude, cultureless business interested only in money. He hoped to publish it, he later said, in "a magazine like *Esquire*" but settled for *Arts Magazine* (December 1966–January 1967).[23] The editors omitted Graham's images, however, and replaced them with one by . . . Walker Evans (*Wooden Houses, Boston*, 1930). In the mid-1960s, this was one of Evans's most familiar images, having been used on the cover of the 1962 reissue of his book *American Photographs*. It was also one of the publisher's publicity images for the reissue. *Arts Magazine* had reviewed the book and was now recycling the image they had kept on file.[24] The editors also added a subtitle to Graham's piece, "Early 20th-Century Possessable Houses to the Quasi-Discrete Cell of '66," since modular housing was actually nothing new. At this point, Graham had not encountered Evans's work, and was quite unaware he had produced "Homes of Americans" two decades earlier, and for a non-art magazine.[25]

In 1971, Graham made a limited-edition black-and-white lithographic print of "Homes for America," copying some of the graphics from the *Arts Magazine* layout, dropping Evans's image, and adding some of his own, as originally intended. This has been exhibited and published widely in the art press. Indeed several books of Dan Graham's work imply that this is the version he first published.[26] "Homes for America" failed as an intervention only to be retrieved as a gallery piece that parodies and critiques mainstream journalism from the *outside*, not the inside.

Through many exhibitions and discussions, Graham's "Homes for America" has become a touchstone for art's fraught engagement with the mass media. By contrast, almost nothing has been written about Evans's "Homes of Americans" since its publication in 1946. His magazine work in general has only come to be taken seriously in recent years.[27]

When Evans died in 1975, the struggle was on to establish a pedigree and canon for photography that was acceptable to the art world. Commercial work and printed pages were almost invariably pushed aside in favor of the rare or vintage print. But if we take photography seriously as a profound cultural force (rather than taking the art world seriously), we can see that what is most radical about the medium is that important work can and has been made in every context, be it galleries, magazines, books, or even record covers. But what should we make of the fact that magazines in particular are so ephemeral? Whatever cultural force they have is confined to the short

span of their shelf life. Perhaps no more than a week, or month. What does it mean to return to the specificity of magazine work, to exhibit it, to reproduce it here? Is this a travesty of its original intention? Can we ever grasp the manner in which it was originally understood? The critic Denis Hollier has addressed this point: "The significance of the reprint is not the same for a book as it is for a periodical. A novel is republished because it has had some success or because the time has come to rediscover it. *Habent sua fata libelli*. With a journal, the transposition from the aorist to the imperfect alters the textual status of the object, its punctuality. Like an event condemned to linger on."[28]

It is difficult to tell if Evans himself thought this way, but given the manner in which he worked, it should not surprise us if he did. His eyes were not on the future but on *that* audience, for *that* photo-essay, in *that* magazine, *that* month. Evans let his magazine work disappear. Should we? I would suggest there is still something to be gained from looking again, not least to glimpse the tenacity with which Evans fought for an intelligent popular culture.

Fig. 2. Dan Graham
"Homes for America: Early 20th-Century Possessable Houses to the Quasi-Discrete Cell of '66," *Arts Magazine* 42, no. 3 (December 1966–January 1967), pp. 21–22

1. The ideas that inform this text were first formulated in "Une intervention récalcitrante: Les pages de Walker Evans," *Études Photographiques*, no. 27 (2011), pp. 86–110. I thank Clément Chéroux for the invitation to write that piece. The research was subsequently expanded in my book *Walker Evans: The Magazine Work* (Göttingen: Steidl, 2014).

2. Walker Evans, "New York in the Making," *Alhambra* 1, no. 3 (August 1929).

3. See, for example, the German magazine *Der Querschnitt* (1921–36) and the Belgian *Variétés* (1928–30).

4. This certainly confined Evans's professional profile to the United States during his working life. By comparison, his friend and contemporary Henri Cartier-Bresson, who co-founded the Magnum photo agency in 1947, was published in popular magazines almost as many times globally in 1953 alone as Evans was in his entire career.

5. Walker Evans, "The Reappearance of Photography," *Hound & Horn* 5, no. 1 (October–December 1931), pp. 125–28. The books Evans reviewed were: *Atget, photographe de Paris* (New York: E. Weyhe, 1930); Carl Sandburg, *Steichen the Photographer* (New York: Harcourt, Brace, 1929); Albert Renger-Patzsch, *Die Welt ist schön* (Munich: Kurt Wolff, 1928); Franz Roh and Jan Tschichold, eds., *Photo-Eye* (Stuttgart: Akademischer Verlag F. Wedekind & Co., 1929); *Photographie 1930* (Paris: s.n., 1929); and August Sander, *Antlitz der Zeit* (Munich: Transmare Verlag, 1929).

6. For a discussion of the various uses made of Atget's work by avant-garde magazines in the late 1920s, see David Campany, "Eugène Atget's Intelligent Documents," in *Atget, photographe de Paris* (New York: Errata Editions, 2008).

7. As August Sander himself later declared: "A successful photo is only a preliminary step toward the intelligent use of photography . . . Photography is like a mosaic that becomes a synthesis only when it is presented en masse." Cited in Gunther Sander, ed., *August Sander: Citizens of the Twentieth Century* (Cambridge, Mass.: MIT Press,1986), p. 36.

8. For a detailed account of this episode, see Hugh Davis, *The Making of James Agee* (Knoxville: University of Tennessee Press, 2008), pp. 94–96.

9. "Homes of Americans: A Selection of Native Designs in Many Manners and Periods," *Fortune* 33 (April 1946), p. 148.

10. Ibid., p. 157.

11. "Labor Anonymous," *Fortune* 34, no. 5 (November 1946), p. 153. See Thomas Zander, ed., *Walker Evans: Labor Anonymous* (Cologne: Koenig Books, 2016).

12. Walker Evans, cited in Dennis Landt, "Raising the Photograph to a True Art," *Christian Science Monitor*, March 12, 1971.

13. Walker Evans, "Imperial Washington," *Fortune* 45 (February 1952), p. 98.

14. Robert Frank, in "A Dialogue between Walker Evans, Robert Frank, and Various Students and Faculty," *Still* (Yale University School of Art and Architecture), no. 3 (1973), p. 2. Evans soon ensured that Frank, his protégé, received commissions to shoot his own projects for *Fortune*. The two also traveled together when Evans shot his photo-essay about cotton mill buildings ("These Dark Satanic Mills," *Fortune* 53 [April 1956]).

15. "Beauties of the Common Tool," The Metropolitan Museum of Art, Walker Evans Archive.

16. Walker Evans, "Color Accidents," *Architectural Forum* 108, no. 1 (January 1958), p. 112.

17. Penn's first remark appears in Sarah Charlesworth and Barbara Kruger's often-reprinted anthology of quotations "Glossolalia," first published in *Bomb*, no. 5 (Spring 1983), pp. 60–61. The second was made in the Richard Avedon and Irving Penn workshop organized by Alexey Brodovitch at the Design Laboratory (notes for this workshop are in the library of The Museum of Modern Art, New York). In reality, Penn continued to work for *Vogue* for decades to come.

18. See "Brassaï with Tony Ray-Jones," *Creative Camera* (April 1970), reprinted in *Creative Camera: 30 Years of Writing*, edited by David Brittain (Manchester: Manchester University Press, 1999), p. 41.

19. For example, in England, Bill Brandt had worked for magazines since the 1930s, while producing his own books. After the war, he took portrait commissions from *Harper's Bazaar*, but in the 1960s he began to reprint his earlier documentary photos as much more expressionistic works of art, sacrificing realist detail for modish form.

20. Evans's posthumous reputation was sealed by the 1971 retrospective at The Museum of Modern Art, New York. The curator, John Szarkowski, presented 200 images, nearly half of which were from 1935–36. Szarkowski dismissed Evans the writer and editor, describing his years at *Fortune* as a long autumn of comfortable compromise following a creative "hot streak" born of youthful exploration. See Szarkowski's essay in *Walker Evans* (New York: The Museum of Modern Art, 1971).

21. Paul Cummings, "Oral History Interview with Walker Evans, October 13–December 23, 1971," Smithsonian Institution, Archives of American Art, at www.aaa.si.edu/collections/interviews/oral-history-interviewwalker-evans-11721.

22. Smithson also managed to publish a short prose piece, "The Crystal Land," in *Harper's Bazaar* (May 1966).

23. See Dan Graham, *Rock My Religion*, edited by Brian Wallis (Cambridge, Mass.: MIT Press 1993).

24. Josephine Herbst, review of *The Daybooks of Edward Weston* and Walker Evans: *American Photographs*, *Arts Magazine* 27, no. 2 (November 1962), pp. 61–62.

25. See David Campany, "Conceptual Art History or, A Home for Homes for America," in *Rewriting Conceptual Art*, edited by Jon Bird and Michael Newman (London: Reaktion Books, 1999), pp. 123–39.

26. See, for example, Bennett Simpson and Chrissie Iles, eds., *Dan Graham: Beyond* (Cambridge, Mass.: MIT Press, 2009), p. 130.

27. In 1977, two years after Evans's death, Lesley K. Baier organized an exhibition of the images he had made for *Fortune*. Preferring to isolate the photographs and frame them as art, neither the show nor the accompanying book addressed Evans's attention to the page itself or the importance of his writing and editing. See Lesley K. Baier, *Walker Evans at* Fortune, *1945–1965* (Wellesley, Mass.: Wellesley College Museum, 1977). The exhibition at Wellesley College Museum ran November 16, 1977–January 23, 1978.

28. Denis Hollier, "The Use-Value of the Impossible," *October*, no. 60 (1992), p. 23.

—ANNE BERTRAND

"I'M A WRITER TOO."
THE TEXTS OF WALKER EVANS

Before becoming the photographer we know, Walker Evans wanted to be a writer. With that goal, at the age of twenty-two he went from New York to Paris in April 1926 . . . and one year later, without having achieved his goal, he returned to the United States. Shortly afterward, in 1928–29, back in New York, he decided on photography and soon dedicated himself to it fully, garnering deserved success and assembling a corpus of work influential for the photography of his era and for contemporary art. Even so, with the exception of one decade from the early 1930s to the early 1940s, when he focused solely on photography to the exclusion of any other activity, never in his life did Evans stop writing.

In the Walker Evans Archive at The Metropolitan Museum of Art in New York, there can be found rare attempts at fiction; no poetry, other than in the form of lists, which he liked; and translations—all dating back to his early years. The vast majority of his writings, consisting of critiques and essays, were subsequently published in the press, providing part of his livelihood from 1943 onward, and later combined with images, some his own photographs, some not. Late in his life, these writings were joined by interviews given to newspapers and magazines, including one with Leslie Katz, published in *Art in America* in 1971, a major statement of his ideas and one that is constantly quoted.

A few of his other writings have been published in books, such as the very beautiful portrait the photographer dedicated to his friend, the writer James Agee, as a preface to the second edition of their book *Let Us Now Praise Famous Men* in 1960.[1] But Evans did not write his photography books. Disinclined to theorize about photography, particularly his own, he did not resolve to do so until quite late in life, and then only sparingly. On the other hand, over the years, he often wrote short, highly crafted pieces. They give the impression that he taught himself to write by writing assiduously on various subjects: photography, of course, but also film, painting, sculpture, and architecture. He then was able to choose his own topics. By writing for a living, Evans also learned to write; his early love for the craft never left him.

Writing (Paris)
Evans received an education standard for his well-off social background (his father was an advertising executive) at private schools in Mercersburg, Pennsylvania, in 1921, then at Phillips Academy in Andover, Massachusetts, in 1921–22, and finally at Williams College in Williamstown, Massachusetts, the following year. He did not excel but became

"intensely literary"[2] and took advantage of the resources afforded by a new library, receiving the latest magazines, where he discovered the work of T. S. Eliot, D. H. Lawrence, and Virginia Woolf. He then applied to Yale University but was not accepted. After working at a French bookstore in New York and then at the New York Public Library, he convinced his father to finance a year in Paris. Because it was the place to be: the place where modernism lived and breathed. The place where, spurred by constant emulation, the young man could fulfill his dearest wish: to become a writer.

Evans arrived in Paris on April 17, 1926, possibly in the company of his mother and elder sister, Jane, . . . who, to his great relief, eventually returned home. As documented in an itinerary that he saved, in July 1926 he went to the south of France before returning to Paris in August; in October he went to Normandy and Brittany; in January 1927 he was back on the French Riviera, in Marseille, Aix-en-Provence, Villefranche-sur-Mer, and Juan-les-Pins (p. 63). Finally, he visited Italy in April (p. 64), before leaving for New York, arriving on May 16. Thus touring accounted for a large share of his time abroad. But while he was in Paris, Evans lived in the Latin Quarter, at the Hôtel de Fleurus near the Luxembourg in June 1926, and in October of that same year, with Madame Thuillier at 7 rue Monge; but mainly, from August 1, 1926, in a pension at 5 rue de la Santé (pp. 60–62). From there, he took rue Saint-Jacques to go to the Sorbonne. He would later recall hearing Pierre Janet lecture on "Inner Thought and Its Disorders" in 1926–27 at the Collège de France. Evans was more assiduous in attending the French courses for young foreigners at the Collège de la Guilde, 6 rue de la Sorbonne, for which he wrote compositions, some of which he saved, showing his teacher's encouraging comments: "Vous pouvez très bien écrire" ("You can write very well").[3]

These compositions sometimes took a personal turn, as Evans mentioned his taste for reading the likes of Théophile Gautier (*Mademoiselle de Maupin*), Joris-Karl Huysmans (*Against Nature*), Auguste de Villiers de l'Isle-Adam, Jules Barbey d'Aurevilly, and Jules Laforgue. At the same time, Evans did some translations: in August 1926, he translated Baudelaire—"The Double Room" (pp. 65–67) and "À une heure du matin," which he titled "One A.M." Evans said he had

discovered Baudelaire's "The Jewels" at the New York Public Library when he was eighteen.[4] It was also in New York, in 1924–25, that he translated an excerpt from *Promenades littéraires* by Remy de Gourmont, which he titled "The French Book in America." But Evans was also interested in Lautréamont as well as in his own contemporaries, from whose novels he translated excerpts: *Moravagine* by Blaise Cendrars and *Le Diable au corps* by Raymond Radiguet in January 1927, and then *Si le grain ne meurt*, the autobiography of André Gide, from April through August of that same year. After his return to New York, he took on the work of Jean Cocteau ("Scandales," which was published in French in T. S. Eliot's magazine *The Criterion* in January 1926 and translated by

Evans in January–February 1928) and a passage by Valery Larbaud (*Ce vice impuni, la lecture*) in June–July 1928. This francophilia was a way of distancing himself from the United States and its materialism. During his time in Paris, Evans was, as he would later tell Paul Cummings, "intensely a Frenchman," determined not to speak English and even "dressed like a Frenchman." Feeling "anti-American," he "disdained the moneyed, leisured, frivolous, superficial American" in Paris—like F. Scott Fitzgerald—and viewed himself as "very poor and obscure and quite unhappy and lonely" (fig. 1). The young man frequented the Shakespeare and Company bookstore at 12 rue de l'Odéon . . . but when Sylvia Beach offered to introduce him to Joyce, his "god," he fled.[5]

The letters Evans exchanged with his friend, German-born painter Hanns Skolle, who was his roommate in New York, reveal their enthusiasm (for *Ulysses*), as well as Skolle's support for Evans's literary endeavors, which he urged him not to destroy. Evans's efforts show a certain bent for writing and a certain freshness, but not an extraordinary talent. However, it seems it was then that Evans, who sensed or perhaps already knew what it really meant to write, realized that he would not become the great author he dreamed of being.

After returning to New York, Evans did not entirely abandon his literary ambitions, writing the excellent "Brooms" (February 1928–February 1929), full of contained rage: "Soon after I left the house, before I even turned the corner, I saw a worn-out broom lying in the gutter. It is nothing, I said; it will pass. But I saw another, and yet another. All had this horrible, suggestive triangular shape. It was too much. Today, this dateless day, I walked into Macy's and bought a vacuum cleaner. / Now I shall suck the dust out of chaos."[6] *The New World Monthly*, the magazine to which he submitted the piece in March 1930, did not publish it.

In August 1929, however, he saw his work in print for the first time. The magazine of Hispanic culture, *Alhambra*, published his translation of a passage from *Moravagine* by Cendrars, and in the same issue, his photograph *New York in the Making*. For a time, Evans imagined himself a translator and tried to find a publisher for his English translation of Cendrars's novel. But he was already a photographer. The following year, Black Sun Press in Paris and Horace Liveright in New York published *The Bridge*, a poem by his friend Hart Crane, illustrated with Evans's views of Brooklyn Bridge (p. 71 left). Evans had made up his mind.

Photography won out and he threw himself into it fervently. The recognition he quickly received, first from his immediate circle of friends and acquaintances, and then from professionals during exhibitions, confirmed his decision. However, in the meanwhile, he published two critiques: in 1930, a modest review of a book on the Sardana (a traditional Catalan dance), again in *Alhambra*; and the following year, an impressive essay—a virtual manifesto—"The Reappearance of Photography," in Lincoln Kirstein's (p. 80) *Hound & Horn* magazine. In it, the young photographer rejects the misguided habits of artistic photography, which nearly lost its way, in order to better pay tribute to the pioneering work of Eugène Atget (pp. 85 top, 86) and its objective continuation by August Sander. "Apparently [Atget] was oblivious to everything but the necessity of photographing Paris and its environs . . . His general note is lyrical understanding of the street, trained observation of it, special feeling for patina, eye for revealing detail, over all of which is thrown a poetry which is not 'the poetry of the street' or 'the poetry of Paris,' but the projection of Atget's person. . . . *Antlitz der Zeit* [by Sander] is . . . a case of the camera looking in the right direction among people. This is one of the futures of photography foretold by Atget. It is a photographic editing of society, a clinical process; even enough of a cultural necessity to make one wonder why other so-called advanced countries of the world have not also been examined and recorded."[7] This first significant essay, striking in the depth of its insight, would not be followed by another for a very long time.

The decade of the 1930s was thus devoted exclusively to photography . . . While Evans was in Cuba in 1933. While he was working for the Resettlement Administration, which became the Farm Security Administration (FSA), from 1935 to 1937. While he was photographing 477 African sculptures exhibited at The Museum of Modern Art (MoMA) in New York, in the spring of 1935. While, in the summer of 1936, he was producing the images that would form the opening portfolio of *Let Us Now Praise Famous Men*, with text by Agee, published by Houghton Mifflin in Boston in 1941. While he was preparing *American Photographs*—the first solo exhibition MoMA ever devoted to a photographer—and the eponymous book, in 1938. Or while he was embarking upon a major new project, photographing passengers on the New York subway from 1938 to 1941. His life was indistinguishable from his photography. Also, it seems likely that seeing Agee write his great work, *Let Us Now Praise Famous Men*, could not help but lastingly inhibit Evans, who was able to recognize the "genius" of his best friend.

In 1941, the photographer married Jane Smith Ninas (p. 258). Wartime rationing of film stock and gasoline prevented him from working regularly. In the spring of 1943, he joined the staff of *Time* magazine, where he followed Agee as a film critic, before being assigned to the art column. Ever the independent and borderline rebel, Evans, who had managed to turn government commissions to his advantage, now had to produce a weekly column and bow to the authority of bosses who edited his copy, sometimes extensively. Until the fall of 1945, he submitted to that discipline, writing about graphic design, modern art, illustration, the history of art, and the architecture of his time. Regardless of the constraints and his reservations about the quality of the published articles, he transitioned from journalism to criticism, acquiring the craft and the authority that would soon allow him to call himself a writer. On December 15, 1947, during his exhibition at the Art Institute of Chicago, *Time* magazine published an article about Evans entitled "Puritan Explorer." In the interview conducted on that occasion, he made this statement, which was not included in the final piece: "At Fortune, they realize I'm a writer too."[8]

Literary Variations on a Vernacular Theme
In September 1945, Evans went from anonymous critic at *Time*, where his articles had no byline, to Staff Photographer, the first full-time photographer ever hired by *Fortune* (another magazine in the publishing group founded by Henry Luce), where he would remain until 1965. Three years later, he was officially given the status of Special Photographic Editor, no longer reporting to the art director. But as early as May 1948, *Fortune* introduced him as "a writer of delicacy and evocative power." Evans wrote and signed the text for his portfolio "'Main Street Looking North from Courthouse Square'" (pp. 220–21), devoted to the turn-of-the-century picture postcards (1890–1910) that he had collected since childhood (pp. 96–97, 190–93). Evans revisited the subject in a second portfolio for *Fortune*, "When 'Downtown' Was a Beautiful Mess," in January 1962; in another piece for the magazine *Architectural Forum*, "Come on Down," in July of that same year; in a lecture entitled "Lyric Documentary" delivered at Yale University on March 11, 1964; and finally, in a variant of that lecture given at MoMA on November 7, 1973. Postcards constituted one of Evans's favorite subjects: in addition to their charm, he saw in each of them a "minor historical document" (1948) or a "folk document" (January 1962). In 1964, while they embodied his idea of "Lyric Documentary," he described them as "colloquial, vernacular art."

In his writings, Evans rarely used the term "vernacular," whose first appearance slightly preceded his encounter with the scholar John Kouwenhoven, "inventor" of the concept, which he developed in several books beginning with *Made in America: The Arts in Modern Civilization* in 1948. In April 1960, Evans applied for a Ford Foundation fellowship that would allow him to produce a book of photographs and texts entitled "Ex-Pioneers." After defining his approach as "the strictest realism," he stated that he was photographing "vernacular architecture; individual physiognomy; if possible, regional physiognomy; natural interior design in homes (that is, non-professional and non-conscious design); and a host of details concerning clothing, transportation, habits, work, etc."[9] In May 1961, Kouwenhoven recommended Evans to the Carnegie Foundation for a similar award, which he received. According to Kouwenhoven, his project might be called "Walker Evans' America," and the photographer "spoke, for example, of doing a series of 'American Interiors' and one of 'Working Types' . . . Another series will be photographs of what he calls 'Unsophisticated Design' (what I would call vernacular) including 'folk gardening,' improvised architecture, and so on."[10] But the clearest use of the term by Evans occurred in his interview with Katz in 1971: "I'm interested in what's called vernacular."[11] Three years later, he was more explicit: "It's more creative . . . to discover someone naturally creative who is doing something interesting—like children's poetry or children's drawing—than to photograph the works of educated talents like Mies van der Rohe or Louis Kahn. . . . 'vernacular' may be a pretentious word but it conveys what I mean. . . . There is a deep beauty in things as they are."[12]

As the present exhibition demonstrates, the term perfectly encapsulates Evans's photography, his subjects as well as his method, and *American Photographs* (1938) can be viewed, as Clément Chéroux does, as "the Bible of the vernacular" in images.[13] The photographer did not write the text of a book on the vernacular. But it is possible to find in the abundant and varied corpus of writings published under his byline a set of essays dedicated to that notion. The *Fortune* portfolios, for which he produced not only the images but, for some, also the

texts, from 1948 to 1965, can be viewed and read as the scattered articles of a very singular encyclopedia of the vernacular, ranging across "Vintage Office Furniture" (fig. 2), "Beauties of the Common Tool" (pp. 264–65), spontaneous display ("The Pitch Direct"; pp. 114–15), "The Auto Junkyard" (p. 178); or those series of texts about the picture postcard of the 1900s, or about the world of trains—"Along the Right-of-Way" (pp. 228–29), "Before They Disappear" (pp. 134–35), and "The Last of Railroad Steam"—or about the architecture of old factories and warehouses, as well as a rare "American Masonry."[14]

The treatment of these subjects varies. The financial magazine *Fortune* traditionally published long and thorough investigations, examples of serious journalism based on extensive research. Some of Evans's articles employed that approach, using information supplied by zealous researchers. But he transformed it into something entirely different, creating his own style for his portfolios and becoming, in this framework, "the champion of the short form."[15] His texts might fill a page, sometimes extended by substantial captions; but often there are only a few lines, just two or three paragraphs. Not an exhaustive study, but rather a deliberately evocative, original, informed but partial insight. "Along the paths of railroads, the country is in semi-undress. You can see some of the anatomy of its living: a back yard with its citizen poking into a rumble seat for a trusted toolbox; an intent group of boys locked in a sandlot ball game; a fading factory wall; a lone child with a cart. Out on the plains, the classic barns and the battalions of cabbages . . ." It finishes with "the *TING TING TING TING TING TING* of the warning bell—that heart-rending tinny descrescendo which is an early lesson in relativity of the senses."[16]

Evans is concise, allusive, spiritual. At best, his texts verge on the little prose poem; others compare to the vignette, or the opinion piece. Here he philosophically observes: "Among low-priced, factory-produced goods, none is so appealing to the senses as the ordinary hand tool. . . . In fact, almost all the basic small tools stand, aesthetically speaking, for elegance, candor, and purity."[17] Yet, far from theorizing about the vernacular (others do that), he identifies it, sings it.

In 1977, Lesley Baier organized *Walker Evans at* Fortune, *1945–1965*, at Wellesley College Museum, an early revelation of the value of the photographer's work for the press, usually regarded as much inferior to his canonical work. In 2010, Robert Vanderlan showed, in *Intellectuals Incorporated*, the extent to which Evans "altered the visual context of *Fortune* in dramatic ways. Always convinced that text and picture should exert equal demands on the viewer's attention, his portfolios presented a compelling counter-narrative to *Fortune*'s celebration of industry."[18] This analysis is amply confirmed in David Campany's copiously illustrated 2014 book, *Walker Evans: The Magazine Work*, which brilliantly delineates the quality of the photographer-writer's expression, the editorial control he exercised, and the impact of his interventions, which were bold, to say the least, in such a setting. For what Evans insistently pointed up and exalted in the magazine of capitalistic success ran counter to its ideology of progress tied to profit. These objects, which no one other than he would have considered, belong to the vernacular, and its spotlighting in *Fortune*'s pages is all the more striking because it is mixed on several occasions with a theme that recurs in Evans's photography—decay—as expressed through the urban blight of "The Wreckers" in May 1951 and the rusting cars of "The Auto Junkyard" in April 1962 (p. 178).

Evans praised the vernacular through his

Fig. 2. Walker Evans
Office Interior, for the Series "Vintage Office Furniture,"
Fortune, *August 1953*, 1953
Negative, digital inversion,
2¼ × 2¼ in. (5.08 × 5.08 cm)
The Metropolitan Museum of Art,
New York
Walker Evans Archive, 1994, 1994.252.16.1–.76

images, but he would not use vernacular language in his texts, unlike Agee, who, when applying for a Guggenheim Foundation fellowship in 1937, foresaw the "Development of new forms of writing via the caption; letters; pieces of overheard conversation."[19] In *Let Us Now Praise Famous Men*, the writer varies his linguistic register, cites textbooks, the Bible, and newspaper articles, and actually uses vernacular language in the most direct way possible, as a document. When Evans writes on vernacular subjects, he always does so in an elaborate, sophisticated fashion—in the style he created.

He spent time searching for the right word, crafted careful phrasing, and could not help but use a rare or precious term. He used rhetoric, enumeration, favored effect. He was attentive to the rhythm of a sentence, the music of the whole. In 1969, speaking of photography as "the most literary of the graphic arts," he described the qualities it must have: "eloquence, wit, grace, and economy; style, of course; structure and coherence; paradox and play and oxymoron."[20] This is perhaps the only place where he defines, indirectly, the characteristics of his writing.

Even before *Fortune*, Evans had written about the vernacular, in the September 4, 1944, issue of *Time*, for example, devoting a surprising article to an auction of furniture from one of the great hotels of yesteryear in Saratoga Springs, New York, a hotel he had photographed back in the early 1930s. And parallel to his portfolios for *Fortune*, he devised other, similar ones for *Architectural Forum*—on "Color Accidents," compositions from sections of weathered walls, in January 1958 (pp. 174–75), and on rustic but radiant "Primitive Churches" in December 1961 (p. 211 top left)—and, for *Mademoiselle* in May 1963, on the promise of "Collectors' Items" found at the flea market. Finally, when he published that powerful candid portrait gallery of subway passengers photographed between 1938 and 1941, it was with a wonderful short text entitled "The Unposed Portrait," which did not appear in the 1966 book *Many Are Called*, but rather in *Harper's Bazaar* in March 1962 (pp. 254–55). Thus the press welcomed Evans's vision—images and texts—of the vernacular.

In 1965, the photographer-writer retired from Time Inc. to teach at Yale. This new position went hand-in-hand with a new, oral mode of expression, and his teaching took the form of more or less informal conversations with his own students and then with those at other institutions where he was invited to speak. The following year, Evans published two photography books, but did not write their texts: *Many Are Called* was written by Agee and *Message from the Interior* by John Szarkowski. But in 1969, he wrote the "Photography" chapter for the anthology *Quality: Its Image in the Arts*, in which he states his credo and then profiles photographers from his personal pantheon, with a text on each facing one of his (or her) works. From then on, Evans's writings and remarks mainly dealt with photography.

Regarding the vernacular Evans described with such perseverance in images and texts in *Fortune*, it seems likely that this stubborn subversion of the capitalist magazine was scarcely perceived by his contemporaries: such a reading would take time. From then on, it was through photography, exhibited, published, or not, that he would follow through on his passionate exploration of the vernacular—his element?

Style (Flaubert)

The importance of the written word in Evans's photographs is immediately striking, such as in 1930 when he took a picture of signs whose lighted messages combined in the Broadway night (p. 79) or, ironically, the careful transportation of the word DAMAGED (p. 130 bottom). He often noted the fertile, stimulating nature of these found texts (pp. 109, 132 top, 172 bottom, 291). And yet, his photography

cannot be called narrative. In 1961, his editor at Houghton Mifflin astutely observed: "you regard [the camera] as a typewriter, one thing with which an extended, connected statement can be made."[21]

But when Evans wrote, in *Fortune* for example, he only rarely discussed the images accompanying his articles—with the notable exception of the postcards, but then those were not his own pictures; or else he commented on the work of other photographers such as Robert Frank, in November 1955, in "The Congressional." When the portfolios combined his texts and his photographs, Evans juxtaposed them, evoking with the text the treated subject, but not the way it is treated by the image. This reluctance was in keeping with the opinion he expressed twice, in 1957 and 1963: "For the thousandth time, it must be said that pictures speak for themselves, wordlessly, visually—or they fail."[22] He digressed, of course, defending the photography of his peers: Cartier-Bresson in *The New York Times Book Review* in 1952, and later the pictures of those he selected and presented with brio in *Quality* in 1969, and then those by his juniors, Lee Friedlander and William Christenberry, until 1973. But he preferred not to write about his own photographs.

For his goal in writing was only secondarily to serve photography. His writing about photography could, on occasion, be penetrating and persuasive, . . . but that was not his reason for writing. Evans renounced literature early on to become a great photographer. Nevertheless, he did not write throughout his life just because he had to, but because he deeply loved writing and taking on the constant challenge of doing his best to express himself with words. He first abandoned fiction, then, because of external circumstances, turned to the critical essay—without having a role model for this genre.

The number of successive versions of the same text that he saved, the time he expended on a few lines, the research he did and the counsel he sought, the high standards he set for the overall text and picture layout, but also, after a while, the concern the photographer showed for recognition as a writer, his very sharp reactions to criticism . . . all tally to show just how much writing meant to him.

Furthermore, Evans was continually evolving. The executor of his estate, John Hill, points out that he spent his life "reshaping . . . his persona."[23] As a young man, he vigorously rejected the notion that a photographer could be an "artist," since the person who embodied this role at the time was Stieglitz, against whom Evans rebelled. Late in his life, the photographer cared deeply about this word "artist," which then meant something else to him entirely—for, in the meantime, photography had become, in part thanks to him, an art, which he represented uncompromisingly, as opposed to photojournalism, or even . . . pure documentary. Photography must constitute, he said, "lyric documentary" (1964). In 1971, he expressed it differently and coined the term "documentary style."

In 1969, Evans wrote in *Quality*, "If photography tends to the literary, conversely certain writers are noticeably photographic from time to time—for instance James, and Joyce, and particularly Nabokov."[24] But literary references, howsoever well-founded, also allowed the photographer to better distance himself from those elders, such as Mathew Brady and Atget, to whom he wished to owe nothing—only to join them.

In the last ten years of his life, Evans expressed himself verbally in a more flexible, more personal way. He discovered the pleasure of conversing with an attentive audience. And he was surrounded by professionals who valued his art, such as John Szarkowski, curator of photography at MoMA, and Leslie Katz, founder of Eakins Press in New York, with whom he published *Message from the Interior* in 1966. Five years later, the photographer gave his publisher an exceptional interview, on which they worked closely together. It contains the term "documentary style" describing his photography. But Katz also got his

answers on specific points. To the questions, "Who were your favorite authors? Did they influence your photography?," Evans responded, "Flaubert, I suppose, mostly by method. And Baudelaire in spirit. Yes, they certainly did influence me, in every way." Katz continued, "Well, your photographs are known for showing an indigenous American esthetic that doesn't even know it is an esthetic—an archetypal classicism of the ordinary. It's almost as if Flaubert had a camera." Evans replied,

> I wasn't very conscious of it then, but I know now that Flaubert's esthetic is absolutely mine. Flaubert's method I think I incorporated almost unconsciously, but anyway used in two ways: his realism and naturalism both, and his objectivity of treatment; the non-appearance of author, the non-subjectivity. That is literally applicable to the way I want to use a camera and do. But spiritually, however, it is Baudelaire who is *the* influence on me. Even though I haven't really studied Baudelaire very much I consider him the father of modern literature, the whole modern movement, such as it is. Baudelaire influenced me and everybody else too.[25]

Evans's tribute to Baudelaire, who had remained with him since his youth, thus unambiguously establishes his influence. The same does not apply to Flaubert. The homage Evans pays him regarding his essential influence on his photography is unalloyed. But it seems he had never mentioned Flaubert before this interview. This obviously does not mean that Evans had not read Flaubert, even though there is no trace of such reading, which probably occurred in Paris. Indeed, there is this note in the archives at the Metropolitan Museum: "Sad & angry / that there was no photograph like work of Henry James or Eliot / or Joyce or even Flaubert / or whomever / Do something about it."[26] But we don't know when he wrote it.

Two salient facts remain, however. Leslie Katz had chosen as the motto of his young publishing house an observation made by Flaubert: "The moral is not only a part of the esthetic; it is its condition foundationally" (letter to Caroline Commanville, dated March 8, 1880). It is therefore possible that this benchmark for Evans's photography appeared in his remarks owing to exchanges with the editor, refreshing the memory the photographer undoubtedly had of *Madame Bovary*, and possibly also of "Un cœur simple" ("A Simple Heart"), whose title was added by hand to the typewritten transcript of their 1971 interview.[27] In addition, John Szarkowski, in his introduction to the 1971 MoMA exhibition catalogue, drew a link between the photographer and the writer: "It is possible that Evans had read and remembered this advice from Flaubert: 'An artist must be in his work like God in Creation, invisible and all-powerful; he should be everywhere felt, but nowhere seen. Furthermore, Art must rise above personal emotions and nervous susceptibilities. It is time to endow it with pitiless method, with the exactness of the physical sciences.'"[28]

Szarkowski remained cautious in his supposition. For the photographer was no scholar. Jerry Thompson notes: "I don't think Evans ever cited a specific passage in Flaubert, and I'm sure he never read much (if any) critical writing on Flaubert. He had a low opinion of criticism in general . . . For Evans, writing fiction was art, and writing criticism was not."[29] An inveterate reader, by absorbing the art of Flaubert the photographer was able to make the most of it for his photography.

As for Evans's writings, it is not the transparency achieved by Flaubert that

they evoke. But, for better or worse, the image of Evans spending days on a page is irresistibly juxtaposed with that of Flaubert spending months on a chapter and years on a book. Days on a page: nothing admirable, undoubtedly, in that. But in this obsession with style, there is the sign of a profound taste for writing, to which the photographer-writer constantly returns, and which absorbs him completely.

For while, late in life, Evans readily mentioned his joy in reading, his admiration for Proust, Joyce, James, Nabokov, for the "gray prose"[30] of E. M. Forster, and while we know that he read Céline, writing, perhaps even more than literature, was his second passion, his *violon d'Ingres* . . . and his secret garden, so little did he speak about this subject (about which no one asked him). Perhaps it was one of those intimate things that this complex man never wanted to talk about.

On March 17, 1970, in a letter to his second wife Isabelle, Evans mentioned plans for "my book of writings."[31] Is it any wonder that this book never came to fruition? One can only dream of what it might have told us, revealing another side of the artist, alongside his photography books.

———

The last passion of Evans the photographer was the Polaroid, with which he took about 2,400 pictures between 1973 and 1974: many of young faces (pp. 260–61), but also portraits of objects, signs (p. 133), trash (pp. 186, 303)—vernacular items. There emerges an unprecedented series intimately related to the written word. Evans photographed letters, words, word fragments. As if he fundamentally wanted to remake language, through image.

His intense pleasure in this creation and his extreme freedom are conspicuous. For example, "ONLY" (fig. 3), written on the asphalt, becomes a one-word poem as much as a photograph. Flaubert again:

> What seems beautiful to me, what I should like to write, is a book about nothing, a book dependent on nothing

Fig. 3. Walker Evans
Street Lettering, December 15, 1973
Polaroid color print, (7.9 × 7.9 cm)
The Metropolitan Museum of Art, New York
Purchase, Samuel J. Wagstaff Jr. Bequest and Lila
Acheson Wallace Gift, 1994, 1994.245.6

external, which would be held together by the internal strength of its style, just as the earth, suspended in the void, depends on nothing external for its support; a book which would have almost no subject, or at least in which the subject would be almost invisible, if such a thing is possible. The finest works are those that contain the least matter; the closer expression comes to thought, the closer language comes to coinciding and merging with it, the finer the result.[32]

There is no evidence that Evans read this passage. And yet, "ONLY" combines "eloquence, wit, grace, and economy; style, of course; structure and coherence; paradox and play and oxymoron." Text and image, the vernacular and the literary. It's all there.

1. See Anne Bertrand, "Evans's Portrait in Words: A Descriptive History of 'James Agee in 1936,'" in *Let Us Now Praise Famous Men at 75: Anniversary Essays*, edited by Michael A. Lofaro (Knoxville: University of Tennessee Press, 2017), pp. 61–93.
2. Walker Evans, in Paul Cummings, "Oral History Interview with Walker Evans, October 13–December 23, 1971," Smithsonian Institution, Archives of American Art, at www.aaa.si.edu/collections/interviews/oral-history-interviewwalker-evans-11721.
3. See Walker Evans, annotated typescript ("Le soir, je me sentais isolé . . ."), 4 pages, August 7, 1926, corrected by Prof. Broche in red pencil, inscribed by author in pencil, p. 4, The Metropolitan Museum of Art, Walker Evans Archive (MMA/WEA), 1994.250.2.5.
4. Ibid., p. 2.
5. Evans, in Cummings, "Oral History Interview with Walker Evans."
6. Walker Evans, "Brooms," typescript, 4 pages, February 1929, p. 4, MMA/WEA 1994.250.3.45.
7. Walker Evans, "The Reappearance of Photography," *Hound & Horn* 5, no. 1 (October–December 1931), pp. 126, 128.
8. Walker Evans, interview by Alexander Eliot and Manon Gaulin for *Time*, annotated typescript, "Bio File," 1 page, November 21, 1947 (copy), Yale Collection of American Literature, Beinecke Rare Book and Manuscript Library, James R. Mellow Papers (Beinecke/JMP).
9. Walker Evans, typescript draft of application to the Ford Foundation, 5 pages, annotated in pencil, April 28, 1960, p. 2, MMA/WEA 1994.250.85.2.
10. John Kouwenhoven, carbon typescript letter to John Gardner of the Carnegie Corporation, 2 pages, May 25, 1961, p. 1, MMA/WEA 1994.250.85.1.
11. Walker Evans, in Leslie G. Katz, "Interview with Walker Evans," *Art in America* 59, no. 2 (1971), p. 88.
12. Walker Evans, in James R. Mellow, "Walker Evans Captures the Unvarnished Truth," *The New York Times*, December 1, 1974, p. 38.

13. Clément Chéroux, conversation with the author, January 15, 2016.
14. Walker Evans, "American Masonry," *Fortune* 71, no. 4 (April 1965), pp. 150–53.
15. Olivier Lugon, conversation with the author, December 9, 2012.
16. Walker Evans, "Along the Right-of-Way," *Fortune* 42, no. 3 (September 1950), p. 106.
17. Walker Evans, "Beauties of the Common Tool," *Fortune* 52, no. 1 (July 1955), p. 103.
18. Robert Vanderlan, *Intellectuals Incorporated: Politics, Art, and Ideas Inside Henry Luce's Media Empire* (Philadelphia: University of Pennsylvania Press, 2010), p. 290. See also Lesley K. Baier, *Walker Evans at Fortune, 1945–1965* (Wellesley, Mass.: Wellesley College Museum, 1977), and David Campany, *Walker Evans: The Magazine Work* (Göttingen: Steidl, 2014).
19. James Agee, typescript application for a Guggenheim fellowship, 16 pages, 1937, p. 6 (copy), Beinecke/JMP.
20. Walker Evans, "Photography," in *Quality: Its Image in the Arts*, edited by Louis Kronenberger (New York: Atheneum, 1969), p. 170.
21. Lovell Thompson, typewritten letter to Walker Evans, 2 pages, March 7–8, 1961, p. 2, MMA/WEA 1994.250.79.4.
22. Walker Evans, "Robert Frank," *US Camera Annual 1958* (1957), p. 90. A similar statement, concerning Lee Friedlander, is found in Walker Evans, "The Little Screens," *Harper's Bazaar* 96 (February 1963), p. 127.
23. John T. Hill, email to the author, June 24, 2016.
24. Evans, "Photography," in *Quality*, p. 170.
25. Walker Evans, in Katz, "Interview with Walker Evans," p. 84.
26. Walker Evans, handwritten note on index card, n.d., MMA/WEA 1994.250.10.1.
27. Leslie G. Katz, "Interview with Walker Evans," annotated typewritten transcription, 70 pages, n.d., p. 6, MMA/WEA 1994.250.152.4. Evans's library was unfortunately dispersed at his death without being inventoried. But a photograph taken at his home in Old Lyme, Connecticut, shows that,

in addition to a copy of *Madame Bovary*, the photographer had the five French volumes of Flaubert's *Correspondance* (Paris: Éditions Louis Conard, 1910), as well as the Francis Steegmuller edition of *The Selected Letters of Gustave Flaubert* (New York: Farrar, Straus & Giroux, 1953). We thank John Hill for sharing this document with us.
28. John Szarkowski, "Introduction," in *Walker Evans* (New York: The Museum of Modern Art, 1971), p. 11. Szarkowski quotes from a letter from Flaubert to Marie-Sophie Leroyer de Chantepie, dated March 18, 1857, translated by Steegmuller in *The Selected Letters of Gustave Flaubert*, p. 195.
29. Jerry L. Thompson, "A Glance, a Look, a Stare," *The St. Johns Review* 48, no. 3 (2005), p. 25.
30. Walker Evans, "'The Thing Itself Is Such a Secret and So Unapproachable,'" *Yale Alumni Magazine* 37, no. 5 (1974), p. 16.
31. Walker Evans, letter to Isabelle Evans, 1 page, March 17, 1970 (typewritten copy), Beinecke/JMP.
32. Gustave Flaubert, letter to Louise Colet, January 16, 1852, in *The Letters of Gustave Flaubert 1830–1857*, edited by Francis Steegmuller (Cambridge, Mass.: Harvard University Press, 1980), p. 154.

—DIDIER OTTINGER

WALKER EVANS, AMERICAN *AND* MODERN PHOTOGRAPHER

To Q.B.

When chronicling the 1944 *Art in Progress* exhibition held at The Museum of Modern Art (MoMA) in New York, critic Clement Greenberg recognized Walker Evans as "our greatest living photographer after Stieglitz."[1] In the context of 1940s America, this "our" has a double meaning: Evans was recognized as both an authentic "American" artist but also as one whose work conformed to the values of a formalistic modernism of which Greenberg had been the fiercest champion since the late 1930s. To achieve such recognition, Evans had to be not only an "American" artist, but also the most "modern" one—a dual requirement that visual artists would take a few more years to reconcile.

From the end of the 1930s, Evans's work carried with it the concomitant and contradictory aspirations of a time of aesthetic and ideological conflicts that witnessed the emergence of an awareness of cultural identity and an institutionalization of modern art—a tension that was resolved, temporarily, by the simultaneous creation of a museum of American art and The Museum of Modern Art in New York.

1. "American-Style" Photography

Evans took his first artistic steps in the early 1930s, in an America preoccupied by the question of its cultural identity. The old, nagging question experienced its most enlightened expression in "The American Scholar," published by Ralph Waldo Emerson in 1837, which some (including Oliver Wendell Holmes Sr.) saw as America's "intellectual declaration of independence." In the field of the visual arts, it was not until 1908 and the exhibition at New York's Macbeth Gallery of the "Eight" led by Robert Henri that the existence of a national art was asserted: "The work of American artists has never received the full share of appreciation that it deserves, and the time has come when an effort should be made to gain for it the favor of those who have hitherto purchased foreign pictures exclusively."[2] Though the Armory Show, a few years later (in 1913), proved European avant-garde art highly influential in directing the course of modern art, the movement to recognize "American art" had been launched.

An initial response to the question of how to define "American art" was given by the inauguration of the American Wing at the Metropolitan Museum in New York in the early 1920s. There, visitors saw sixteen "Period Rooms" tracing the evolution of interior design from the colonial period through the early days of the republic. In tune with this rediscovery, Harvard and Yale created American Studies chairs. "American-ness" began to have a growing presence in the works of modern artists. In her American Folk Art Gallery, Edith Halpert hung Charles Sheeler's paintings alongside objects made by American pioneers: "Mr. Sheeler's paintings and drawings show a distinct connection with the work of the Colonial and early American painters . . ."[3] Not to be outdone, in 1932, under the direction of Edgar Holger Cahill, MoMA held the blockbuster exhibition *American Folk Art: The Art of the Common Man in America, 1750–1900*.

In his day, Emerson had contrasted the "courtly muses of Europe" with American ordinariness: "I ask not for the great, the remote, the romantic . . . I embrace the common, I explore and sit at the feet of the familiar, the low."[4] Evans's first aesthetic stance concurred with this ordinariness, which was emerging as a distinctive criterion of the American spirit: "I'm interested in what's called vernacular."[5] Bearing the consequences of this choice, the notion of "art" became the target of Evans's first skirmishes, which, in the form of a generational conflict, confirmed a more fundamental split. Alfred Stieglitz, whose photography and work as a gallery owner and publisher had sanctified him as one of the most influential figures in modern American culture, was the barely veiled target of these first clashes over aesthetics. Evans's recurring attacks on "romanticism" were directly aimed at the work of Stieglitz (whose self-proclaimed icons were Vassily Kandinsky and Henri Bergson), which he described as phony, emphatically stating a preference for his collection of postcards.[6]

In light of the implications of the art of his time, Evans's rejection of the model embodied by Stieglitz was intended as a split from a certain European model—Evans would show himself to be more in tune with the work of Georgia O'Keeffe, who, like him, would turn toward a search for what historian Wanda Corn calls "the great American thing."[7] His search for an *artless* (Emerson's term) expression was associated, by his early critics, with a "puritanism" whose artistic virtues were revitalized in the 1930s. The earliest and most avid defender of Evans's work, Lincoln Kirstein (p. 80), analyzed the economy of means and the commitment to subjective neutrality that characterized for him the photographer's aesthetic: "The most characteristic single feature of Evans's work is its purity, or even its puritanism." Summing up his analysis, Kirstein likened Evans's work to the expression of a "purely protestant attitude."[8]

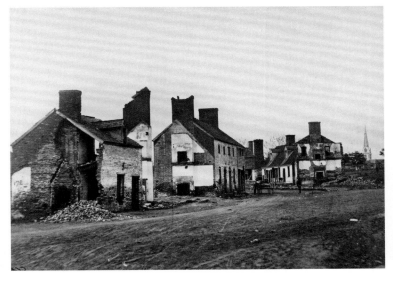

Fig. 1. Mathew Brady
Street in Fredericksburg, Virginia, Showing Houses Destroyed by Bombardment in December, 1862, 1862
Albumen print
Library of Congress, Prints and Photographs Division, Washington, D.C., LOT 4167-D, no. 3

Remote from the context of the 1930s and their aura of nationalism, Evans's "puritanism" would once again in 1971 seem self-evident to MoMA's curator of photography, John Szarkowski: "Evans' work seemed at first almost the antithesis of art. It was puritanically economical, precisely measured, frontal, unemotional, dryly textured, insistently factual, qualities that seemed more appropriate to a book-keeper's ledger than to art."[9]

During the 1930s, when Kirstein saw the United States vacillating between a quest for identity and an aspiration to the leadership of international modernism, he was the one who helped to entrench Evans's art into American culture. Kirstein's father, a businessman with a fascination for history, named his only son Lincoln in honor of the President of the United States during the Civil War. Kirstein was committed to making that cultural and onomastic legacy flourish.

When Kirstein was a student at Harvard, his classmates included Alfred Barr, Henry-Russell Hitchcock, Arthur Everett Austin Jr. (known as "Chick"), and Philip Johnson—all of whom were involved, at one time or another, in the history of MoMA. Catalyst of the Harvard Society for Contemporary Art, which paved the way for the founding of MoMA in 1929, Kirstein would be invited to sit on the first board of the new museum in the spring of 1930. As editor of the literary review *Hound & Horn*, that fall he published three photos by Evans, whom he had just met in the New York bookstore where the photographer was working. While their common love of French literature brought the two men together, Kirstein became determined to steer Evans's taste toward American literature, in particular, the work of Walt Whitman. Like Paul Strand and Charles Sheeler—who had placed their film *Manhatta* (1921) under the mantle of the poet—reading Whitman revealed to Evans the poetic, aesthetic potential of the American vernacular, its architecture, its popular language, and the images of its mass communication. The approach that Whitman took in his poetry—"a perfectly transparent plate-glassy style, artless, with no ornaments"[10]—would soon become the one adopted by Evans. It is not out of the question that Evans found in the American poet an equivalent of Baudelaire and his taste for the "trivial."

Just as he encouraged Evans to transition from French authors to American poets and writers, from André Gide and Blaise Cendrars to Whitman, Kirstein would help to lead him from Eugène Atget to Mathew Brady, from the Paris street photographer to the photographer of the battlefields of the Civil War, and from European "Romanticism" to American "Puritanism." Evans discovered the work of Atget in 1930 at the home of Berenice Abbott, who had returned from her recent stay in Paris with her trunks full of the photographer's glass negatives (pp. 85 top right and left, 86), and an exhibition of Atget's works took place in November 1930 at the Weyhe Bookstore and Gallery on Lexington Avenue. The following year, Evans reported on this discovery in an article he wrote for *Hound & Horn*: "His [Atget's] general note is lyrical understanding of the street, trained observation of it . . ."[11] Evans's adoption of Atget's aesthetic (his "lyricism") was responsible for his photographs being compared for a time to those of the Parisian photographer. In a review of *Photographs by Three Americans* held at the John Becker Gallery in 1931, M. F. Agha observed: "Atget's vision of life was full of horse buggies, headless dressmakers' dummies and corset shop windows; whereas Evans understands life in terms of steel girders, luminous signs, and Coney Island bathers."[12] Drawing the same parallel, on the occasion of his joint exhibition with George Platt Lynes at

the Julien Levy Gallery in 1932, a critic described Evans as "a sort of New York Atget."[13]

Like Jackson Pollock, who distanced himself from European models by substituting the mythology of the Plains Indians for the Greco-Latin references of the Surrealists, Evans discovered Brady (fig. 1), who would soon supplant Atget in his personal pantheon. Belinda Rathbone wrote in her biography of Evans: "It is likely that [Kirstein] pointed Evans in the direction of Mathew Brady's photographs of the Civil War and expounded on their immediacy, the sophistication of their restraint and subtle order, and the palpable detail rendered by Brady's big plate camera."[14] Evans's interest in Brady's work led him to the Signal Corps records at the War Department in Washington, D.C., where he made a list of a hundred images, which he photographed for himself but also for potential exhibition: "I could give the Museum a set of say a hundred prints for your permanent collection, and, I'd hope for a small Brady exhibition, sometime."[15] Evans's "expertise" on Brady was so well known that Beaumont Newhall, who was preparing an exhibition on the history of photography for MoMA (*Photography 1839–1937*), asked Evans to select the photographer's works: "You know much more about his work than I do and if it is not asking too much of you, I should like to have you make a tentative selection of his work."[16]

Kirstein played a decisive role in formulating the aesthetic with which Evans identified in the early 1930s. By encouraging him to produce the images for a book on the Victorian architecture of New England,[17] Kirstein "Americanized" Evans's style and iconography. The mansions Evans photographed (the same ones that painter Edward Hopper used for inspiration when painting a series of watercolors exhibited at MoMA at exactly the same time as Evans's photographs)[18] document his conversion from subjects reflecting nostalgia for his time in Paris to a decidedly "American" pictorial iconography and style (fig. 2).

The houses themselves have cultural overtones. They are associated with pre–Civil War styles of architecture. These buildings represented for many—including Kirstein—a "golden age" of American civilization. While no Northerner questioned the ethical and political values for which the Union fought, many would, after the fact, realize that the civilizational transformation implied by a Northern victory would establish a definitively urban, industrial model.

The perfect stylistic neutrality that Evans sought in representing American architecture (pp. 81–83) led Kirstein to emphasize that

Fig. 2. Walker Evans
Folk Victorian House with Jigsaw Ornament Gables and Porch, Nyack, New York, 1930–31
Gelatin silver glass plate negative, digital inversion, 6½ × 8½ in. (15.24 × 20.32 cm)
The Metropolitan Museum of Art, New York, Walker Evans Archive, 1994, 1994.256.197

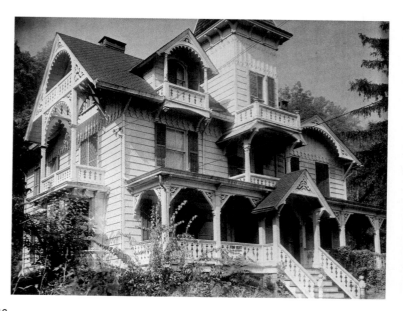

neutrality's appropriateness to the subject itself, when he hailed its "purity, or even its puritanism."[19]

2. Photographer and Modernist

The Museum of Modern Art that Evans knew in the early 1930s was not yet identified with the artistic vision that would make it the epitome of the international modern art museum. Kirstein was the agent of that reconciliation. Through his intercession, in 1930, Evans became the first photographer appointed by the New York institution. He photographed the works for the museum's *Weber, Klee, Lehmbruck, Maillol* exhibition catalogue. Again, in 1933, he was called upon to photograph the Mayan and Aztec objects that MoMA showed in its *American Sources of Modern Art* exhibition. If his photographs were displayed in the museum's Department of Architecture gallery that same year, it was thanks to Kirstein's commission for the book on New England architecture. In the spring of 1935, Evans was again commissioned by MoMA, this time to photograph all of the works in the *African Negro Art* exhibition (pp. 272–81).

In 1938, Evans finally escaped the status of documentary technician and was recognized by MoMA as a full-fledged artist. He was the first photographer to have a retrospective. The preface to the catalogue, written by Kirstein (who initiated the exhibition), placed his work in line with Atget and Brady. Despite his support from the museum team—Kirstein (the most influential) and Jay Leyda (his former collaborator in photographing the Diego Rivera mural for Rockefeller Center who became a curator at MoMA)—Evans sensed an ambivalence in his relationship with the New York institution, embodied by the personality and aesthetic choices of its director, Alfred Barr: "Except that Alfred Barr was interested in some photography, I don't think he was particularly interested in me. He didn't even like me very much."[20] What could have caused Barr's qualms? Could they have been due to the changes the museum underwent during its first decade?

The renewed interest in the 1920s in American cultural identity—on the part of universities, which were dedicating teaching positions to it, and museums, which inaugurated American collections—and in contemporary art—from regionalistic conservatism to the passion shared by artists of the 1930s for *the great American thing*—could not be ignored by MoMA, the first American institution to take as its mission the goal of documenting contemporary discourse. During its early years, MoMA devoted a part of its exhibition program to the study of the origins of American modernism. It all began, appropriately, with a tribute to the "founding fathers": Winslow Homer, Albert Ryder, and Thomas Eakins formed the triad of artists whose works were exhibited in May–June 1930 (one year after the founding of MoMA). From the first lines of the catalogue preface, Barr gave an account of a recent historicism that contributed to the rehabilitation of American art: "Homer, Ryder and Eakins seem of considerably more importance than they did in 1920." Barr declared that "a new generation of ideas and of painters has arisen in opposition to what was only recently heretical. 'Form' is no longer an end but is again subordinate to other values."[21] To accommodate these "ideas" and "painters," and to contend with their (now eminent) position in the American debate, MoMA devised a line-up that resulted in exhibitions of Charles Burchfield (April 11–27, 1930) and then Edward Hopper (October 30–December 8, 1933).

The opening of the Whitney Museum of American Art in 1931 (the museum was founded in 1930), which was explicitly dedicated to American artists, handily redealt the cards of contemporary art in America. Freed from a mission that it had assumed for tactical reasons only, MoMA was able to devote itself unreservedly to the promotion of international modernism—a choice made "politically" possible by the evolution of ideas, following the discrediting of the identity focus defended with virulence and sectarianism by the advocates of regionalism.

In February 1936, MoMA organized its *Cubism and Abstract Art* exhibition. The cover of the catalogue featured a complex diagram created by Barr himself in which he established a genealogy of modern art flowing from links among its avant-garde factions. There was no place in this family tree for the American realism whose historical importance had, some years earlier, justified the exhibition of its putative creators. Was not Barr's lack of enthusiasm for Evans's work, to which the photographer himself alluded, the expression of a disjunction between what his images historically and sociologically represented and the New York museum's resolutely formalistic orientation?

The very title of Evans's MoMA retrospective, *Walker Evans: American Photographs* (Kirstein had suggested "A Vision of America" or "A View of America"), referred to a national problem on which MoMA intended to turn the page. A significant number of the photographs exhibited were the direct product of the assignment the photographer had carried out for the Farm Security Administration (FSA) (pp. 144–63). The American government had initiated these documentary projects on indigent Southern sharecroppers to justify its action in relocating them. However much Evans may have distanced himself from the pathos such an assignment could entail and resisted any form of indoctrination or political manipulation, his images were nonetheless laden with a political significance that precluded a formalist interpretation—a significance not lost on reviewers of the MoMA exhibition. In the leftist daily paper *The New Masses*, critic David Wolff described images reflecting "a certain hideous miscellaneousness of American life."[22] For First Lady Eleanor Roosevelt, Evans work was open to a patriotic reading, inasmuch as it "shows us contemporary America and I think all of us who care about our country will be deeply interested in this record."[23]

Aware of the potential problems of interpretation inherent in the iconography of Evans's work, Kirstein stated in the catalogue that these images were endowed with artistic qualities in keeping with the formalism whose champion MoMA was preparing to become: "It is 'straight' photography not only in technique but in the rigorous directness of its way of looking."[24] This straightness is in line with the critical history of American photography. In 1904, Sadakichi Hartmann had published "A Plea for Straight Photography" in which he attacked "pictorial extremists who lay more stress on 'individual expression'" and "pictorial photography," and criticized the Photo-Secession painters (Steichen, Stieglitz, etc.), who "mix up photography with the technical devices of painting and the graphic arts." To oppose this, he called for "the natural qualities of photographic technique."[25] This straightness was the foundation on which MoMA's aesthetic *doxa* would be built. It was the magic formula capable of transmuting Evans's "puritanism" into a purely formal quality.[26] This transmutation would allow both Greenberg and MoMA to recognize Evans as "our greatest living photographer."[27]

3. The "Modernism" of Walker Evans

Glorified by Greenberg and blessed by MoMA through several exhibitions from 1938 to 1971,[28] Evans's work necessarily embodied the values underlying Greenberg's theoretical reflections constituting the "critical epistemology" on which the museum's policy was based.

We imagine that showing his photographs at MoMA in 1938 accelerated Evans's "modernist" conversion. He then would have been determined to definitively eradicate any arty dimensions that may have

remained in his images. He would have conceived a procedure capable of annihilating any form of intentionality, any contrivance from his images, their framing, their composition, etc. His quest for "photographicity," for the epiphany on photosensitive paper of a realness not mediated by the photographer, would have led him to realize the ambition of absolute transparency, conceived at the dawn of modernism. In 1913, questioning the specificity of photography, Marius de Zayas had cherished that dream: ". . . photographs can be made to be art. When man uses the camera without any preconceived idea of final results . . ." By applying the "method" described by de Zayas, encouraging the photographer to "[put] himself in front of nature, and without preconceptions, with the free mind of an investigator, with the method of an experimentalist," to "[try] to get out of her a true state of conditions,"[29] Evans could have gone down into the New York subway and, without trying to control his images, activated his camera, giving his subjects the opportunity—the grace—to record their image on the film. He would have entitled these images *Many Are Called*, thus implying the role of risk, chance, or choice that entered into the making of these images. Paraphrasing de Zayas, Evans described that process: "I would like to be able to state flatly that sixty-two people came unconsciously into range before an impersonal fixed recording machine during a certain time period, and that *all* these individuals who came into the film frame were photographed, and photographed without any human selection for the moment of lens exposure."[30] In the name of the same principles, while walking down a Chicago street, he would have activated his camera to "snatch" the images of the passersby. This method would have produced a series of photographs that he would have dubbed *Labor Anonymous*, leaving it to viewers to judge whether the "anonymity" in question was that of the passersby or that to which the photographer aspired (fig. 3).

Would these stratagems, aimed at reducing his control over the image to nearly nothing, have sufficed to purify the photograph of the last dregs of his aestheticizing, his subjectivity, his narrativity? On this point, Greenberg was less "Greenbergian" than his disciples: "Because of the transparency of the medium, the difference between the extra-

artistic, real-life meaning of things and their artistic meaning is even narrower in photography than it is in prose." Commenting on Atget's work, the critic continued: "The photograph has to tell a story if it is to work as art."[31]

Asked to clarify why Evans was the photographer he admired the most, Greenberg responded: "because in a manner of speaking he told a story."[32] The "story" Evans's photographs tell is largely written by their historical context. The two major cycles he produced in the early 1930s—the mansions of New England and the FSA commission that took him to the South—shaped the way he looked and would continue to look at America, at "History" and the stories it inspired in him.

From pre–Civil War architecture to the photographs of Brady, Kirstein had sensitized Evans to a time in the nation's history that was not yet dominated by commercialism, by a consumerism that continued to grow with post–Civil War industrialization. Kirstein expressed this sentiment—not without pathos—in his preface to the *American Photographs* catalogue that accompanied Evans's exhibition at MoMA: "Here are the records of the age before an imminent collapse. His pictures exist to testify to the symptoms of waste and selfishness that caused the ruin and to salvage whatever was splendid for the future reference of the survivors."[33] It cannot be ruled out that this nostalgia, explicitly expressed here by Kirstein, was one of the reasons Greenberg was so attracted to Evans's work. As Jean-Pierre Criqui confirms, that nostalgia is one of the fundamental attributes of American critical thought: "In keeping with Marx, to whom he explicitly refers, by examining the changes made to daily life by the advent of industrial society, Greenberg notes that the most radical and most dire of those was undoubtedly the practically absolute separation of work and leisure."[34] During the Great Depression of the 1930s, Evans had ample time to gauge the effects of this economic and social change. If Kirstein was the exegete of Victorian architecture and Brady's work for Evans, Ben Shahn played that role for Southern poverty. Shahn's activism (which led to his *Passion of Sacco and Vanzetti* in 1931–32 and to his stint as Diego Rivera's assistant for the Rockefeller Center mural in 1933) aroused the political consciousness of Evans, who considered producing a film with Shahn "about people, people and unemployment, people and slums . . ."[35] In the mid-1930s, the photographer defined the themes to which he would thenceforth always adhere: "Architecture, American urban taste, commerce, small scale, large scale, the city street atmosphere, the street smell, the hateful stuff, women's clubs, fake culture, bad education, religion in decay."[36] These subjects are evident in a number of photographs, from the explicit *Graveyard, Houses and Steel Mill, Bethlehem, Pennsylvania* (1935) to the interior of the Burroughs home, to which he imparts a quasi-religious asceticism, making it look like a Quaker interior (p. 151).[37]

Like Sherwood Anderson and Edward Hopper, Evans meditated on the changing of modern American society as it forged ahead on the path of materialism, of consumerism. Interviewed in 1971, he expressed the feelings that moved him in the 1920s: "I was really anti-American at the time. America was big business and I wanted to escape. It nauseated me. My photography was a semi-conscious reaction against right-thinking and optimism; it was an attack on the establishment."[38] Jean-François Chevrier points out that during the 1930s, Evans regularly used the term *decay* in his writings and interviews, and that "waste" constituted a significant source of his iconography.[39] And, like

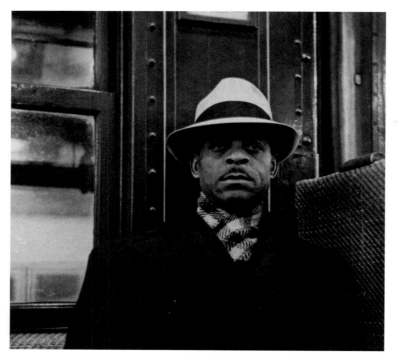

Fig. 3. Walker Evans
Subway Portrait, 1938–41
Gelatin silver print, 7³⁄₈ × 7⁷⁄₈ in. (18.6 × 20 cm)
The Museum of Modern Art, New York.
Purchase, 469.1966

Anderson, Evans was steeped in the world of advertising (in which his father worked). The writer reported on his disillusionment in a series of novels (including *Poor White*), as did Evans in a series of photographs showing the discrepancy between cheerful slogans and a blighted reality.[40]

From his reportage in the crisis-hit South to his work for the immaculate exhibition walls of MoMA, Evans was who Greenberg recognized as "our greatest living photographer"—"our" implying both moderns and Americans.

1. Clement Greenberg, cited in James R. Mellow, *Walker Evans* (New York: Basic Books, 1999), p. 495.

2. William Macbeth, April 1892, cited in Didier Ottinger, ed., *Hopper* (Paris: Galeries Nationales du Grand Palais/Réunion des Musées Nationaux, 2012), p. 25.

3. Edith Halpert, cited in Wanda M. Corn, *The Great American Thing: Modern Art and National Identity, 1915–1935* (Berkeley: University of California Press, 1999), p. 324.

4. Ralph Waldo Emerson, "The American Scholar" (1837), in *Essays and Lectures* (New York: Library of America, 1983), pp. 68–69.

5. Walker Evans, cited in Mellow, *Walker Evans*, p. 213.

6. "Undoubtedly the most insistently 'artistic' practitioner of all time; with the adverse effect that it was he who forced 'art' into quotation marks and into unwonted earnestness." Ibid., p. 87.

7. Corn, *The Great American Thing: Modern Art and National Identity, 1915–1935*.

8. Lincoln Kirstein, in *Walker Evans: American Photographs* (New York: The Museum of Modern Art, 1938), p. 193.

9. John Szarkowski, cited in Mellow, *Walker Evans*, p. 14.

10. Walt Whitman, cited in Belinda Rathbone, *Walker Evans: A Biography* (New York: Houghton Mifflin, 1995), p. 61.

11. Walker Evans, "The Reappearance of Photography," *Hound & Horn* 5, no. 1 (1931), pp. 125–28, reprinted in Alan Trachtenberg, ed., *Classic Essays on Photography* (New Haven: Leete's Island Books, 1980), p. 185.

12. M. F. Agha, cited in Mellow, *Walker Evans*, p. 139.

13. Cited in ibid., p. 164.

14. Rathbone, *Walker Evans*, p. 61.

15. Walker Evans, cited in Mellow, *Walker Evans*, p. 352.

16. Beaumont Newhall, cited in ibid, p. 351.

17. Kirstein planned the book in collaboration with architect John Brooks Wheelwright, but it was never published. See Barnaby Haran, "Homeless Houses: Classifying Walker Evans's Photographs of Victorian Architecture," *Oxford Art Journal* 33, no. 2 (2010), p. 192.

18. It was with this series of watercolors that Hopper finally won the favor of institutions (the Brooklyn Museum acquired a work from this series), of the critics, one of whom wrote that, like Homer, Hopper "believes in the authority of big simple forms over the effect attained by brilliant brushwork," and finally of the collectors. The success of this exhibition would allow Hopper to permanently give up illustration, his "bread and butter."

19. Kirstein, in *Walker Evans: American Photographs*, p. 193. It should be noted that the "puritanism" of Evans's vision was also nurtured by extra-vernacular contributions. In 1928, he met German photographer John (Hanns) Skolle, a disciple of the new German objectivity, the formal teachings of the Bauhaus movement.

20. Walker Evans, cited in Mellow, *Walker Evans*, p. 370.

21. *Homer, Ryder, Eakins* (New York: The Museum of Modern Art/Arno Press, 1930), p. 6.

22. David Wolff, cited in Mellow, *Walker Evans*, p. 379.

23. Eleanor Roosevelt, cited in ibid., p. 380.

24. Lincoln Kirstein, cited in ibid., p. 374.

25. Sadakichi Hartmann, "A Plea for Straight Photography," *American Amateur Photographer*, no. 16 (March 1904), pp. 101–9. "The latter half of the nineteenth century offers that fantastic figure, the art photographer, really an unsuccessful painter with a bag of mysterious tricks." Evans, "The Reappearance of Photography," reprinted in Trachtenberg, ed., *Classic Essays on Photography*, p. 185.

26. In the catalogue, Kirstein revisited Evans's "purely protestant attitude" (see Mellow, *Walker Evans*, p. 375).

27. The critic reconfirmed this in 1991: "The photographer I admired most in my own time was Walker Evans . . ." Clement Greenberg, interview with Russell Bingham, Graham Peacock, and Michel Smith, *Edmonton Contemporary Artists' Society Newsletter* 3, no. 2 and 4, no. 1 (1991).

28. John Szarkowski, chief curator of the Department of Photography at MoMA, was behind the 1966 Evans exhibition and transposed the ideas and values of Greenberg's abstract formalism to the field of photographic studies. According to Rosalind Krauss: "Based on a modernist theory comparable to the one formulated by Clement Greenberg for pictorial art . . . Szarkowski has succeeded in devising an all-purpose theoretical framework. . . . This framework relies on what Roland Barthes himself might have called *photographicity* or, in other words, on the idea that the artistic value of a photograph essentially resides in its self-reflective nature— in its capacity to reveal not only the formal properties (the 'norms') intrinsic to the medium, but also its own history and tradition . . ." Krauss, "Existe-t-il une histoire de la photographie?" (1990), reprinted in *Les Silences d'Atget*, edited by Luce Lebart (Paris: Textuel, 2016), p. 265.

29. Marius de Zayas, "Photography and Artistic-Photography," *Camera Work*, nos. 42–43 (April–July 1913), p. 13.

30. Walker Evans, "Unposed Photographic Records of People," undated note written in preparation for the publication of subway portraits, reproduced in John T. Hill and Jerry L. Thompson, *Walker Evans at Work* (New York: Harper & Row, 1982), p. 160.

31. Clement Greenberg, "Four Photographers," *The New York Review of Books*, January 23, 1964, pp. 8–9.

32. Greenberg, interview with Bingham et al.

33. Kirstein, in *Walker Evans: American Photographs*, p. 196.

34. Jean-Pierre Criqui, "Le modernisme et la voie lactée (note sur Clement Greenberg)," *Cahiers du Musée National d'Art Moderne*, no. 22 (December 1987), p. 16.

35. Walker Evans, letter to Jay Leyda, n.d., cited in Mellow, *Walker Evans*, p. 340.

36. Walker Evans, cited in Rathbone, *Walker Evans*, p. 90.

37. Ibid., p. 131. A "religious" connotation that James Agee again pointed out in Evans's photographs of objects assembled by the woman of the house, which he described as an "altar," evoking that "decline of religion."

38. Walker Evans, in Leslie G. Katz, "Interview with Walker Evans," *Art in America* 59, no. 2 (1971), pp. 84–85.

39. Jean-François Chevrier, "Dialogue?," in *Henri-Cartier Bresson, Walker Evans: Photographier l'Amérique, 1929–1947* (Göttingen: Steidl, 2008), p. 39.

40. "People in such bastard trades as advertising, publicity, etc., have sometimes heard of me because I have two exhibitions of photos" (cited in Mellow, *Walker Evans*, p. 168). Seven images from Evans's reportage for the FSA were reproduced in Anderson's book *Home Town* (1940).

—SVETLANA ALPERS

EVANS' EYE

It is striking that, again and again, Walker Evans remarks forcefully, even aggressively, that what makes him different from other photographers is that he has an eye. The eye was a major thing for him in photography.

I have made a brief list (in the manner of Evans, who was himself a maker of lists) of some of his remarks, annotated to give the context.

1. References to the Eye
Quoted in *Time* magazine on the occasion of his Chicago exhibition (1947):

> After 20-odd years of work I still have great difficulty maintaining enough calm to operate well, at moments when some sort of perfection is in sight.[1]

In a *New Yorker* article ending with his comment on what he teaches students at Yale University (1966):

> . . . what it is really is a non-stop bull-session on the art of seeing. Photography isn't a matter of taking pictures. It's a matter of having an eye.[2]

A proposed title for his essay on photography for Louis Kronenberger (1969):

> *The Seeing-Eye Man.*[3]

Comment on making the photograph *Corrugated Tin Façade* (1971):

> The photograph is an instinctive reaction to a visual object.[4]

Speaking of teaching at Yale (1971):

> . . . I just used it to go off freely and do exactly what came before my eye. . . . Yes, it's the seeing that I am talking about. Oh, yes.[5]

Interviewed about his photographs as compared to other photographers who worked at the time (1930s) for the FSA (1977):

> I knew at the time who I was, in terms of the eye, and that I had a real eye and other people were occasionally phony about it, or they really didn't see.[6]

A Yale interview (1974):

> A garbage can, occasionally, to me at least, can be beautiful. That's because you're seeing. Some people are able to see that—see it and feel it. I lean toward the enchantment, the visual power, of the esthetically rejected subject.[7]

Harvard University lecture two days before his death (1975):

> I have a theory that seems to work with me that some of the best things you ever do sort of come through you. You don't know where you get the impetus and the response to what is before your eyes, but you are using your eyes all the time and teaching yourself unconsciously really from morning to night.[8]

A quote from Joseph Conrad's preface to *Nigger of the "Narcissus"* that repeatedly reappears in Evans's handwriting on pieces of paper in his archive at The Metropolitan Museum of Art:

> My task . . . is, before all, to make you *see*.

People who knew Evans particularly admired him for his eye. James Agee wrote (1937):

> . . . he has the best eye I know . . . the strictest and clearest theory, meaning knowledge of what an eye and a camera is.[9]

2. *Corrugated Tin Façade*
That is the evidence. But what is it evidence of? How does having an eye work in the process of making a photograph? Do Evans's photographs look a certain way because of it?

Let's turn to a case in which we have part of an answer in Evans's own words. He is describing photographing *Corrugated Tin Façade* in Moundville, Alabama (1936; p. 171). But let us look first. The image is formidably flat. A complex, almost shadowless surface of variegated grays, simple vertical strips of worked tin shimmering in the cross-light and marked with lettered signs, constitutes the false front of a contractor's building, centered and viewed straight on, closed in at left and right by sheds and shrubbery, broken by the irregular outline of a mound of sand, underlined by a road.

Now look at that photograph while reading Evans's words. Remember that as a youth he was a disappointed author, his ambitions so high he felt unable to write. He turned to photography, he said later on, for want of subjects to write about.[10] So, first, finding a subject:

> When I came upon it I was principally taken in by the cross-light on silvery corrugated tin. This was just so beautiful I set my camera up, knocked over by that surface, moved by the barren look of the false front, and how the pile of dirt added to it.[11]

Keep in mind his taste for tin—it was a humble American material and attracted Evans's eye. But its beauty here, as elsewhere (see *Stamped Tin Relic* [1929; p. 169] and *Tin Relic* (1930; p. 168 right]), is a sign of loss—a tin false front to the building with its castaway pile of dirt.

He goes on about the impulse to take up his camera:

> The photograph is an instinctive reaction to a visual object. I knew in a flash that I wanted that, and found out a lot more afterward, editing it. You are trying for something, and if it's wrong you know later on. But first you get it on the film, you garner it in.

A photographer makes a picture. But for Evans, the initial interest is the thing seen. His eye is on an object—be it a facade, a shack, a house, a sign, a person, a main street, a discarded tin can top—not on the beauty of the frame. That is distinctive. In looking at an Evans photograph, the first question is: "What is it that caught his eye?" Seeing the object and taking the photograph is only the first step. It was Evans's practice to edit his negatives—using a marking pen or scissors to zero in on, to literally cut down to what he wanted. It is the subject that he wants to take home ("garner in"). The eye is a collector, he said. In his later years, he literally picked up his subjects—signs along a Connecticut road or bottle caps—and took them home. Similarly, throughout his life he saved every piece of paper he wrote something on. They are now all in his archive at the Metropolitan Museum.

He concludes with:

> It's transcendent, you feel it. Its there, the vanished transcendence and insistence of chance, action and fortuity. It's there and you can't unfeel it.

How did Evans get from the visual object to the transcendent (to use his word) image?

Part of the answer lies in his chosen equipment. He photographed the corrugated tin facade with an 8 x 10 view camera—a cumbersome instrument to use, but one that gave him the details and allowed for the straight-on view of the subject he preferred. It also allowed him to view his subject while photographing (upside down and reversed) on a large ground-glass screen. Though he owned many different cameras and used them in inventive ways, he remarked that because of the viewing screen—"It's quite an exciting thing to see"[12]— his favorites were an 8 x 10 and a 4 x 5. We know he also loved his Rolleiflex, which also has a viewing glass. Evans has been described (by, of all people, Roy Stryker, whom he worked both for and against at the FSA) as having "an 8 x 10 camera perception . . . of the world about him."[13] That is a simplification. But it calls attention to the consistent look that goes right through his work. An 8 x 10 camera assumes that the photographer finds the position from which he wants to shoot his object, stands, and stays.

Other photographers, like Robert Frank and Garry Winogrand for example, famously could shoot on the move. But finding the right place to stand, the right view, is the heart of the matter for Evans. Curiously, this held true even when his chosen set-up, as in the *Subway* series, made it impossible for him to see with his camera.

Another part of the answer lies in his stance. It is not only a matter of standing and staying, but of being fixed at a particular place at a chosen distance from the subject. In the world today, when performances, bodily interventions, and light shows are everywhere, and selfies are a means of communication, it is necessary to be reminded that the eye is inescapably at a distance from what it sees. A photograph taken of Evans by his friend and fellow photographer Peter Sekaer shows his head hidden beneath the focusing cloth of the 8 x 10. The friend who made the photograph could see him, but Walker Evans must have felt safely hidden. Although the photographer must emerge to make the photograph, photographing with an 8 x 10 might be described as a disappearing act. Discreetness and withdrawal were basic to Evans's nature. There is much evidence that he was a remote and secretive man in life. But our interest here is that this is essential to his behavior as a photographer and to the look of his photographs.

Evans had a way with words. In an essay remembering Evans (at Glyndebourne, England, about to roam about and photograph the opera crowd), he is quoted as saying, "Watch me, I'm going to disappear."[14] Look again at *Corrugated Tin Façade*: Evans is nowhere, yet what his eye saw is absolutely present.

3. *Georgette Maury near Grasse* and *Girl in Fulton Street*

I want to loop back now to Evans in France, specifically to April 1927 and a tiny photograph he made of his friend Georgette Maury near Grasse (fig. 1). In 1926–27, he was studying French composition, keeping his distance from the great writers in Paris and, as he put it later, learning to look.

> In America people do not look at each other publicly much . . . I remember my first experience as a café sitter in Europe. *There* is staring that startles the American . . . I stare and stare at people, shamelessly. I got my license at the Deux Magots . . .[15]

Made before Evans had any idea of being a photographer, this snapshot is telling in a modest way. It is characteristic of what is to come. He looks and sees a turbaned woman friend leaning against a fence post topped with a stone ball. What caught his eye one supposes was the woman's profile and the echoing shapes of turban and ball. He plays that off against the articulation of farmhouse and hill that appear not at a distance, but on the surface of the print, which is itself a display of surfaces—concrete, stone, cloth, plowed earth, house, hills. We do not look *in* to person or place but rather *on* to it all. In an Evans photograph, the world is a surface.

Back in New York two years later, Evans hit his stride. The Maury woman seen in Grasse is a distant relative of the marvelous 1929 photo of a woman in a cloche hat on Fulton Street. Once more, a woman with a prominent hat and a world of things around her. Echoes here are made not by shapes but rather by reflections in the glass of a store window. As a maker of pictures, the doubling of the world within the seen world was of interest

to Evans. It is a continuation and confirmation of his own photographic makings. In that, he follows the French photographer Eugène Atget, another master of mirrors, whose work he came to know in 1930. A year after *Girl in Fulton Street*, the discarded chest of drawers in *Street Scene, Brooklyn* is a magnificent experiment in the Atget pleasures of mirroring. (Atget, who died in the summer of 1927, was still alive when Evans was in France.)

But it was the woman on Fulton Street who caught Evans's eye—a more firmly stationed version of the one in France, face three-quarter viewed, head defined by a fitted black cloche, coat marked by a large fur collar and muff. A strip of three negatives (unfortunately not numbered) leaves a trail of Evans's pursuit (fig. 2). Both she and he hold still (he here with a small camera) while men wearing fedora hats move by and in between. Evans was attracted to reflections in the window glass she leans on behind her, the rising diagonal of the crane near her head, the sign with the letter R, more bits of signs over the street, and the lettering "Spaghetti" over her head. The reflecting band widens and wanes, faces and hats come in between, and finally he gets his shot. In the mid-sized reflection there is a building, the figure of a hatted man, and things not quite possible to read. To capture it all, he sacrificed the sign with letters spelling out "Spaghetti," but he retained its lower frame above her head.

It is hard to put one's finger on what is so remarkable here—but it is worth trying because the elements occur again and again in Evans's photographs. First, there is the distant take on a woman seen. Her power is in her presence—the set look of the features and her costume. Given the formality of his address, she seems not simply dressed, but in costume. He does not probe further. He likes what he sees and lets her be. There is a resistance to judge or to intervene in any way. That holding back, that keeping of his distance, is a great skill. I could say (and indeed I do believe) that it is basic to the nature of photography. But indeed, it is Evans with the camera. Around her swirls the world—Fulton Street, the city. The swirl is provisional, thrown together from pieces of steel, iron, glass, cloth, stone. And her presence holds out, as it were, against the world. Surely when he saw the woman, the periphery also caught his eye.

We have been looking at the *Girl in Fulton Street* as Evans's chosen image. But several versions of it exist. Evans was at ease exhibiting and publishing different versions at different times. The *Girl in Fulton Street*

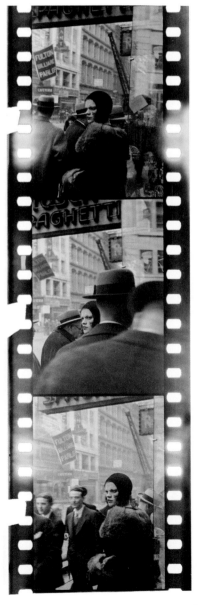

Fig. 2. Walker Evans
Pedestrians, Fulton Street, New York City, 1929
35mm film negative strip, digital inversion
The Metropolitan Museum of Art, New York
Walker Evans Archive, 1994, 1994.253.1

published in *American Photographs* is a slightly different image from the one he put up on a wall for the original MoMA exhibition. (The Getty, which lists all the versions of every Evans photo in the collection, refers to them as variants.) I want to stress the oddity of this. We think of certain photographic images as iconic—Stieglitz's *Steerage*, for example, or *The Blind Woman* by Strand much admired by Evans. But Evans did not work that way. He was accepting of multiple versions of his images without, and this is important, entertaining the subversive notion of multiplicity (think of Sherri Levine).

There are two points. First, I think Evans accepted the fact that photography is repetitive by nature. If you make a number of negatives and edit them, why not accept them? There is no need to pick out only one. The acceptance of multiplicity is akin to his acceptance of the distance of the observer, the straight-on camera view, and the flat surface of the print. Photographers have challenged them all, but not Evans. For him, the constraints of (shall we call it) straight photography matter. It is not only the look of his photographs that is classic, but also their making.

But secondly, this returns us to the question of seeing. Evans's focus on the object seen meant that the particular framing of it (looking at the different images of the *Girl in Fulton Street*) was not so important. His editing of a subject could zero in on and produce several different acceptable images of her. It was the pleasure in the original object seen (refined through his own editing) that interested him.

Evans was a reluctant portraitist at best. The rich and famous held no attraction for him. He engaged with friends and was particularly good with the men. But, as here, his most remarkable images were of people he did not know—anonymous people he caught sight of usually on the street (pp. 230–43). He reached out across differences of race, and of class. Evans makes no distinctions at all. You must remind yourself that this person is black, another dark-skinned, another light. Is the woman of *Girl in Fulton Street* white? The 8 x 10 distance he kept from the person viewed functioned as an equalizer, and it is in place no matter what camera he chooses to use. It is a radical position. Perhaps that is part of the reason why Agee described Evans's *American Photographs* as a dangerous book.[16]

To my eyes, the remarkable women in his *Subway Portraits* series (pp. 244–57), who were famously shot on the sly with a hidden camera, look very much like the girl on Fulton Street. The images have a piercing clarity that nevertheless lets people be. It is interesting that Evans wrote his comment on getting his license for staring at the Deux Magots for an unpublished introduction to his *Subway Portraits* even though in that instance he did not use his camera to stare.

4. Lettering, a Room, and Main Street

A word now about the letters of the "Spaghetti" sign that were sacrificed. Evans's photographs are filled with letters and words of various sorts: handwritten names and prices of goods on shop windows (pp. 104–5, 108–9); words and images making up signs of every kind; letters scribbled or scrawled on walls (p. 131); letters on printed posters (pp. 118–23); words made of light bulbs shining in the night (p. 79).

His letters can be the subject of a photograph, or a part of an array, as "Spaghetti" was here. Finding them clearly gave him huge joy. He reveled in their look and the inherent wit of letters and phrases detached and out on their own.

As a photographer who remained a writer at

heart, Evans liked to refer to photography as the most literary of the graphic arts. But it was the look more than the sense of words and letters that caught his eye. That is what, for example, informs his clever remark about Brassaï's *Picasso's Studio* (1944): "Brassaï habitually overlights, which is comparable to writing italics."[17]

"You dwell on them as on a piece of writing." That was said in astonishment by Jim Dow, a young photographer employed to assist in preparing prints for Evans's 1971 exhibition at MoMA, on first seeing his *American Photographs*.[18] Two things strike one about Dow's reaction. First, there is the choice of the word *writing* rather than *text*. While a text is there for the reading, writing is something you can see. Dow was of course not commenting on the letters and words in the photographs, but they can be described as an embodiment of his observation. It is as if in formal terms (which is only part of the story) Evans's fascination with words for photographs has to do with his interest in seeing.

Secondly, looking takes time. The unexpected use of the word *dwell* gets at the pace Evans's photographs assume. It is true that he slowed looking down by designing sequences of photos in books and in magazine articles. But we linger on his individual photographs as well. The letters that one stops to make out in his photographs are essential to that slow experience.

The people who did the lettering that attracted Evans are nowhere to be seen. Let us say that the words were left behind by people who are absent. Absence was a phenomenon he knew and liked. ("Watch me, I'm going to disappear.") He was also devoted to photographing empty rooms whose spaces and furnishings suggested absent inhabitants. In his own words, "I do feel that I like to suggest people sometimes by their absence. I like to make you feel that an interior is almost inhabited by somebody."[19] For examples of this, look at *Negro Barbershop Interior, Atlanta* (1936; p. 166 bottom) and *Room in Louisiana Plantation House* (1935; p. 167).

An empty room is like a box—most particularly if it is an image of a space closed in on itself, marked off by columns carved from wood, filling the image top to bottom and side to side, as in the photograph of the so-called breakfast room at Belle Grove plantation. It is tempting to consider the relationship between Evans's 8 x 10 camera, itself a piece of architecture, or more precisely a room (*camera*), and the interior architecture Evans found and chose to photograph.[20] Did he see a resonance between the two: camera and room? The Belle Grove photograph commemorates that.

Evans's impulse to seek out a matching enclosure extended also to exterior spaces such as his favored subject—the empty main streets of towns. On assignment for *Fortune* in 1947, he took several pictures of the street in Paducah, Kentucky (fig. 3). In the image that made it into print, a tight web of crisscrossing wires forms a roof across the top of the vertical photograph, while a wide swath of shadowed buildings, articulated by a signature reflecting window, forms a wall to the right. A game is in play between the particular features of the site— variegated low buildings across the street to the left, signs, awnings, a fancy street light, the row of telephone poles—and the roomlike order Evans sees in it all. It makes for a strange image. An essential quality of a great photograph is that it makes the world strange.

5. An Eye for the Period
By way of conclusion, I want to jump from Evans's eye to the period eye. I am playing with Michael Baxandall's term to make the slightly

Fig. 3. Walker Evans
Commercial Quarter, South 3rd St., Paducah, Kentucky, 1947
Gelatin silver print, 7⅝ × 6¹³⁄₁₆ in. (19.3 × 17.3 cm)
The Paul J. Getty Museum, Los Angeles,
84.XM.956.953

different point that Evans had an eye for his period. True enough. It has often been said that his photographs show us his time in America. The notion is that, one by one, thing by thing, theme by theme, he picked out things in the present that would come to be seen as the past (his way of putting it): signs, houses, cars, people, statues, and more. Those are among the subject categories of this exhibition. But there is a different point to be made. Evans's photographic style matched the aesthetic style of his world. It is not individual vernacular objects, but the look they shared—in other words, it is the vernacular aesthetic of America that he attended to. We are not dealing with an inventory of things, but with an aesthetic kinship between the America he sees and the way he photographs. Let me address that with some examples.

The flatness and right-angled structure of buildings built from overlapping strips of wood painted white or left bare are the American country churches and houses of Evans's photographs (pp. 210–11, 218–19). Not thick halls of marble, but thin walls of wood. Evans's level, centered, straight-on photographic view is at one with that aesthetic. "In America the idea of structure envisages a broad assembly of slender parts, standing squarely, but with a quality of light attentiveness, independent but aware."[21] That description of American buildings, inflected by a moral tone, confirms our sense of what Evans saw and captured. They are the words of Lawrence Gowing, an exceptional English art critic whose overlooked 1958 review of American painting is a model for considering the relationship between the look of the vernacular in America and its art. His assumption is that the look of a built culture is itself an aesthetic construction. Unwittingly, his words—*standing squarely; light attentiveness; independent but aware*—speak to the match between an Evans photograph and the American vernacular style.

Gowing goes on to point to the style of lettering and signs much as we see them in Evans's work. "The natural graphic consistency of America, the unity of free, disparate shapes—the consistency of the

clustering proliferation of signs over any sidewalk—belongs to a country on which the natural consistency and unity is simply the new, unknown consistency of human behaviour let loose in an immense and empty space."[22] And from that he moves directly to Evans's other interests in the aesthetic look of the culture in which he lived—attention to tin, but also to the metal of automobiles. Here and there, Gowing's writing about the style seems almost to put Evans's photographs into words: "This style is cut, not as marble is but in the manner that sheet metal is cut, in the same sharp manner as the cluster of signs—the metal arrows pointing with internal fluorescent light to this or that, metal seafood, dry goods and the curling metal signature of soft drinks are cut out against the continental sky."[23]

It is difficult to know, remarked John Szarkowski, whether Evans recorded or invented the America of his youth. Writing a few years later, he said almost the same thing about Evans's great predecessor Eugène Atget—that it was perhaps irrelevant to ask how much of Atget's Paris is Paris and how much Atget. The photographs of Atget and Evans are resonant with the native culture. But perhaps the question is wrongly put. Couldn't one say, rather, that there was a fortuitous match between the photographer and his chosen world? Perhaps Evans was speaking for himself in 1931 when he wrote that "America is really the natural home of photography."[24]

1. Walker Evans, "Art: Puritan Explorer," *Time*, December 13, 1947.
2. Walker Evans, in "The Art of Seeing," *The New Yorker*, December 24, 1966.
3. The Metropolitan Museum of Art, Walker Evans Archive (MMA/WEA). The formula evokes the seeing-eye dog.
4. Walker Evans, in Leslie G. Katz, "Interview with Walker Evans," *Art in America* 59, no. 2 (1971), reprinted in Leslie G. Katz, *Walker Evans: Incognito* (New York: Eakins Press Foundation, 1995).
5. Paul Cummings, "Oral History Interview with Walker Evans, October 13–December 23, 1971," Smithsonian Institution, Archives of American Art, at www.aaa.si.edu/collections/interviews/oral -history-interviewwalker-evans-11721.
6. Bill Ferris, "A Visit with Walker Evans," *Southern Folklore Reports*, no. 1 (1977), p. 33.
7. Walker Evans, in "'The Thing Itself Is Such a Secret and So Unapproachable,'" *Yale Alumni Magazine* 37, no. 5 (1974).
8. Posthumously published in *The New Republic*, November 13, 1976.
9. James Agee, letter to Dwight Macdonald, November 18, 1937, Belinda Rathbone Documents, MMA/WEA.
10. Cummings, "Oral History Interview with Walker Evans," p. 4.
11. Evans, in Katz, "Interview with Walker Evans."
12. "Walker Evans, Visiting Artist: A Transcript of His Discussion with the Students of the University of Michigan, 1971," in *Photography: Essays & Images*, edited by Beaumont Newhall (New York: The Museum of Modern Art, 1980), p. 320.

13. Richard Doud, "Oral History Interview with Roy Emerson Stryker, 1963–1965," Smithsonian Institution, Archives of American Art, at https:// www.aaa.si.edu/collections/interviews/oral-history -interview-roy-emerson-stryker-12480.
14. Nora Sayre, *Previous Convictions: A Journey through the 1950s* (New Brunswick, N.J.: Rutgers University Press, 1995), p. 74.
15. John T. Hill and Jerry L. Thompson, *Walker Evans at Work* (New York: Harper & Row, 1982), p. 161.
16. Cited in Belinda Rathbone, *Walker Evans: A Biography* (New York: Houghton Mifflin, 1995), p. 164.
17. Walker Evans, "Photography," in *Quality: Its Image in the Arts*, edited by Louis Kronenberger (New York: Atheneum, 1969), p. 202.
18. Conversation with Jim Dow, January 18, 1991, Rathbone Documents, MMA/WEA.
19. Cummings, "Oral History Interview with Walker Evans."
20. See Ulf Erdmann Ziegler, "Fotografie an der Schelle: Über eine Erfahrung mit der Architektur," in his *Magische Allianzen: Fotografie und Kunst* (Regensburg: Lindinger & Schmid, 1996), pp. 44–274.
21. Lawrence Gowing, "Paint in America," *The New Statesman*, May 24, 1958, reprinted in Gowing, *Selected Writings on Art*, edited by Sarah Whitfield (London: Ridinghouse, 2015), p. 380.
22. Ibid., p. 382.
23. Ibid.
24. Walker Evans, "The Reappearance of Photography," *Hound & Horn* 5, no. 1

"A good art exhibition is a lesson in seeing . . ."

A good art exhibition is a lesson in seeing to those who need or want one, and a session of visual pleasure and excitement to those who don't need anything—I mean the rich in spirit. Grunts, sighs, shouts, laughter and imprecations ought to be heard in a museum room. Precisely the place where these are usually suppressed. So, some of the values of pictures may be suppressed too, or plain lost, in formal exhibition.

I'd like to address the eyes of people who know how to take their values straight through and beyond the inhibitions accompanying public decorum. I suggest that true religious feeling is sometimes to be had even at church, and perhaps art can be seen and felt on a museum wall; with luck.

Those of us who are living by our eyes—painters, designers, photographers, girl watchers—are both amused and appalled by the following half-truth: "What we see, we are." And by its corollary: our collected work is, in part, shameless, joyous autobiography-cum-confession wrapped in the embarrassment of the unspeakable. For those who can read the language, that is. And we never know just who is in the audience. When the seeing-eye man does turn up to survey our work, and does perceive our metaphors, we are just caught in the act that's all. Should we apologize?

Walker Evans
The Boston Sunday Globe, August 1, 1971

AT THE

(INTROD

FORE
FRONT
OF STYLE
UCTION)

Before he became the photographer acknowledged by history as one of the greatest of the twentieth century, Walker Evans was initially tempted by writing. A stay in Paris, in 1926–27, where he discovered French culture and literature, proved crucial to his artistic education. His true photographic beginnings in the late 1920s were strongly affected by European modernism. A few decisive encounters and a growing passion for American popular culture would make him the photographer we know today, the author of unforgettable American icons in crisis, of photographic essays for *Fortune* magazine, and of that famous "documentary style" that has influenced whole generations of artists and photographers.

The Journey to Paris

In April 1926, Walker Evans arrived in Paris, where he stayed a little over a year, traveling occasionally in the provinces and in Italy. He learned the language, took courses in "French Civilization" at the Sorbonne and the Collège de France, and translated Cendrars, Gide, and Baudelaire. The twenty-three-year-old was not yet a photographer, but did take self-portraits and a few amateur snapshots of his travels and the courtyard of his Parisian pension at 5 rue de la Santé. This journey through what he considered the "incandescent center" of the arts would be of great importance to his intellectual education. In an interview late in his life, he readily declared that Baudelaire's "spirit" and Flaubert's "method" had "influenced him in every respect."

Courtyard at 5, rue de la Santé, Paris, 1926

60

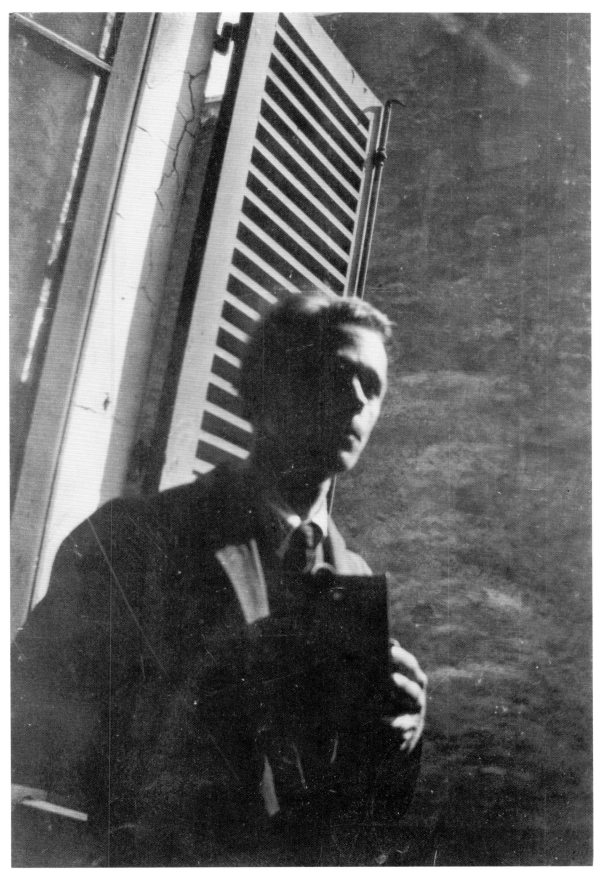

Self-Portrait, *Paris*, September 1926

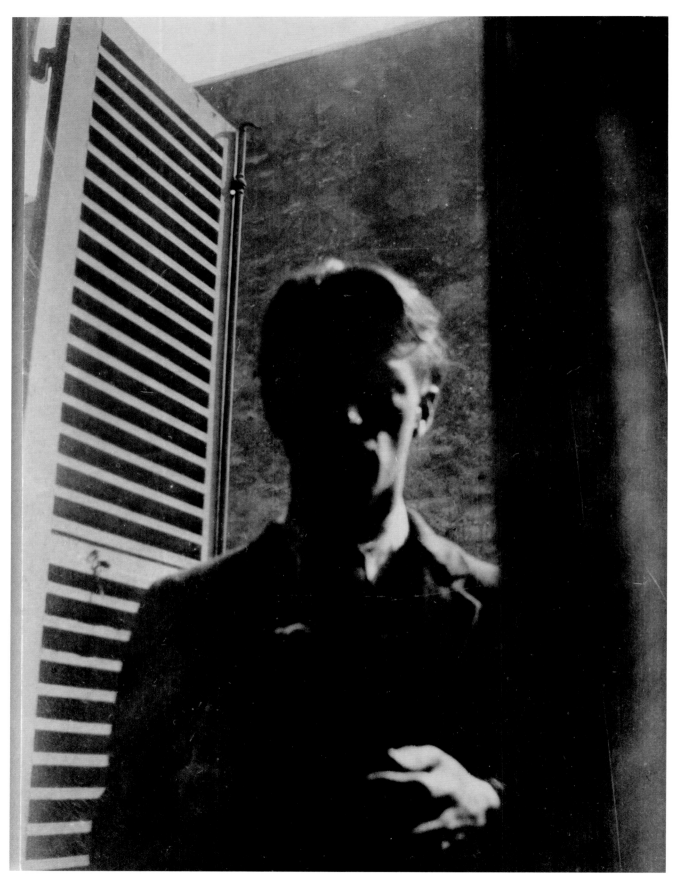

Self-Portrait, 5, rue de la Santé, Paris, September 1926

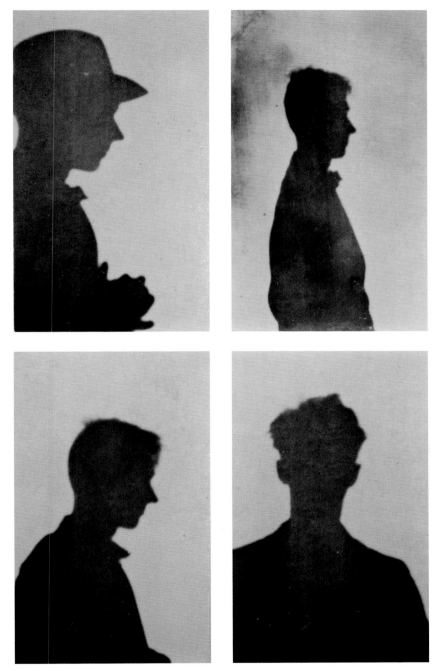

Four Self-Portraits, Juan-les-Pins, France, 1927

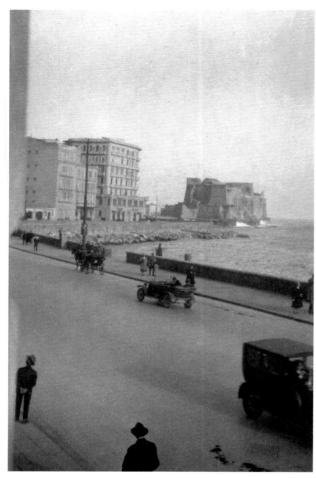

Untitled, Bay of Naples, Italy, 1927

Palazzo Reale, Naples, April–May 1927

THE DOUBLE ROOM

A room which resembles a day-dream, a room veritably <u>intelligent</u>, in which the stagnant atmosphere is lightly tinted with rose and blue.

Here the soul bathes in laziness flavored with regret and desire - there is something of the fall of days, blueish, roselike; a dream of voluptuousness during an eclipse.

The furnishings are lengthened forms, dejected, weakened. They seem to dream; one would say they were gifted with a somnambulistic life, as is vegetable or mineral matter. The materials speak a mute language, as do flowers and skies and sunsets.

On the walls, no artistic abomination. In comparison to pure dream, to unanalysed impression, definite art, positive art, is blasphemy. Here, everything has the adequate clarity of harmony's delicious obscurity.

An infinitesimal fragrance of the most exquisite sort, with which is mixed a very slight humidity, swims in this atmosphere where the slumbering spirit is lulled by hot-house sensations.

Muslin weeps copiously before the windows and over the bed; it falls in snowy cascades. On the bed lies the Idol, the sovereign princess of dreams. But how is she come here? Who has brought her? what magic power has installed her on this throne of reverie and voluptuousness? What does it matter? There she is! I recognize her.

Charles Baudelaire, "The Double Room," translation by Walker Evans, August 1926 (and following spread)

There indeed are those eyes whose flame penetrates
the dusk; those subtile and terrible little mirrors
which I know by their frightful maliciousness. They
attract, they subjugate, they devour the glance of the
imprudent one who contemplates them. I have often
studied them, those black stars which command cur-
iosity and admiration.

To what benevolent demon do I owe this being sur-
rounded with mystery, silence, peace, and perfumes?
Oh bliss! What we know as life, even in its happiest
expansion, has nothing in common with this supreme
existence which I now know, and which I savor minute
by minute, second by second!

No! there are no more minutes, there are no more
seconds! Time has disappeared; Eternity reigns, an
eternity of delights!

But a terrible knocking resounded upon the door,
and, as in infernal dreams, it seemed to me that I
was receiving an axe-blow in the stomach.

And then a Spectre entered. An officer come to
torture me in the name of the law; an infamous con-
cubine come to cry misery, to add the trivialities
of her life to the anguish of my own; or some editor's
errand-boy come after the continuation of a manuscript.

The heavenly room, the idol, the princess of dreams,
the Sylph, as the great Réné used to say, all that
magic disappeared at the brutal knock sounded by the
Spectre.

Horror! I remember! I remember! Yes! this filthy
hole, this abode of eternal ennui, is really my own
room. I see the sottish furniture, dusty and broken-
down; the fireplace without fire or coals, tarnished
with spittle; the sad windows, on which the rain has
traced streaks in the dust; manuscripts, scratched
over or unfinished; the calendar on which my pencil
has marked sinister dates!

which

And this perfume of another world with I intoxicated myself with such perfected sensitiveness,
alas! it is replaced by a fetid odor of tobacco
mixed with I don't know what nauseous mustiness.
Now one breathes here delolation's spoil.

In this narrow world, narrow but so full of disgust, a single object smiles at me: the phial of
laudanum; an old and terrible friend; like all
friends, alas! full of caresses and of treachery.

Ah! Yes! Time has reappeared; Time rules all
now; and with the hideous dotard has returned all
its devilish retinue of remembrances, regrets,
spasms, fears, anguish, nightmares, rages, neurosis.

I assure you that now the seconds are strongly
and solemnly accentuated, and each one, as it leaps
from the clock, says: "I am Life, insupportable,
implacable Life!"

There is but one second in human life which has
the power to announce good tidings, the good tidings
which cause an inexplicable fear to all.

Yes! Time reigns; it has recommenced its brutal
rule. It pushes me with its two-pronged goad as if
I were an ox. "Get along, there! Ass! Sweat now,
slave! Live, damned one!"

BAUDELAIRE

Paris
August, 1926

A Classical Modernism

In May 1927, Walker Evans was back in New York. At the same time as the Surrealists in Paris, he was taking exuberant self-portraits in a photo booth. It was also at this time that he decided to become a photographer. Through his contacts and his reading of the most recent avant-garde publications, he was fully aware of the latest developments in European modernist photography. Very much affected by the use of high-angle, low-angle, and close-up shots, decentering, double exposure, and graphic effects, his style in those first two or three years of practice entirely reflected the New Vision movement. This is what, despite the apparent contradiction, must be described as a *classical* photographic *modernism*.

Self-Portraits in Automated Photobooth, 1929

Self-Portrait, 1927

Wash Day, New York City, before October 1930

Brooklyn Bridge, 1929

Cobblestone Street from Above, Brooklyn, 1928–29

Untitled, ca. 1929

Aboard the Cressida, South Pacific, 1932

Sam Leveman, ca. 1929

New York City Street Corner, 1929

Traffic, New York City, 1928–29

Sixth Avenue El, New York City, 1929

Manhattan, October 1928

Tree, ca. 1929

Untitled (Timber), ca. 1929

Wall Street Windows, 1929

Coney Island Beach, ca. 1929

Broadway, 1930

Two Encounters

How could the young Walker Evans, so modernist in his style, have become the photographer we know today? Through two key encounters: with Lincoln Kirstein and Berenice Abbott. A brilliant student at Harvard, editor of *Hound & Horn*, soon to be adviser to The Museum of Modern Art, New York, and later founder of the New York City Ballet, Kirstein suggested Evans accompany him to photograph the Victorian architecture of the northeastern United States in 1931. Abbott, herself a photographer of great talent, introduced Evans to Eugène Atget's pictures of Old Paris. Thanks to these encounters, Evans discovered a subject that he would never stop exploring: popular culture that was domestic and utilitarian, in other words, *vernacular*.

Lincoln Kirstein, 1930–31

Lincoln Kirstein, 1930–31

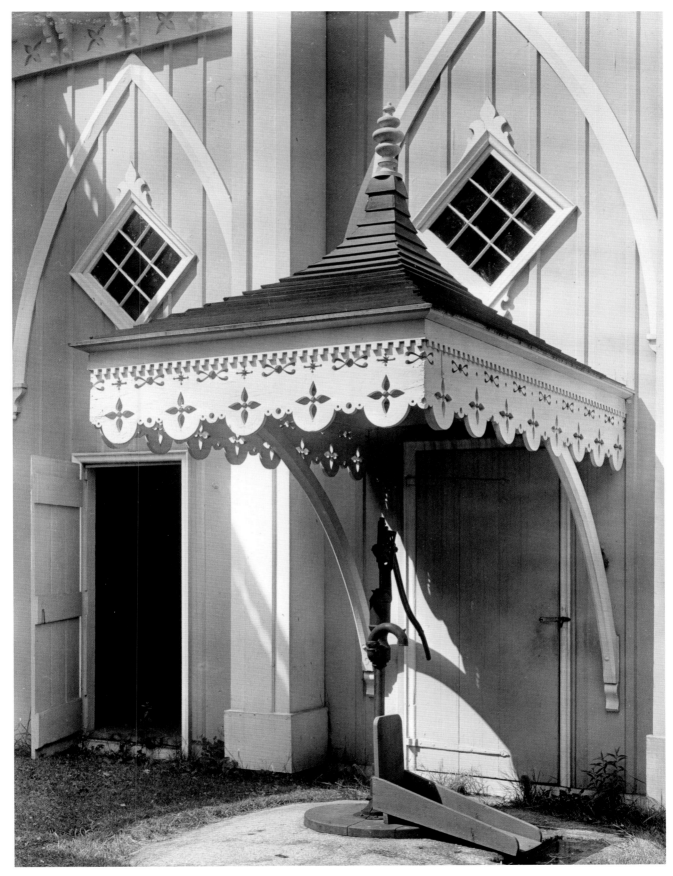

Maine Pump, 1933

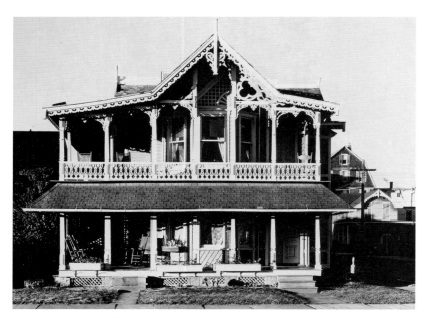

Jigsaw House at Ocean City, New Jersey, 1931

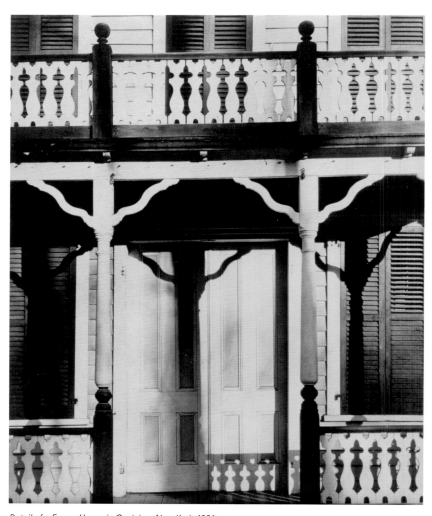

Detail of a Frame House in Ossining, New York, 1931

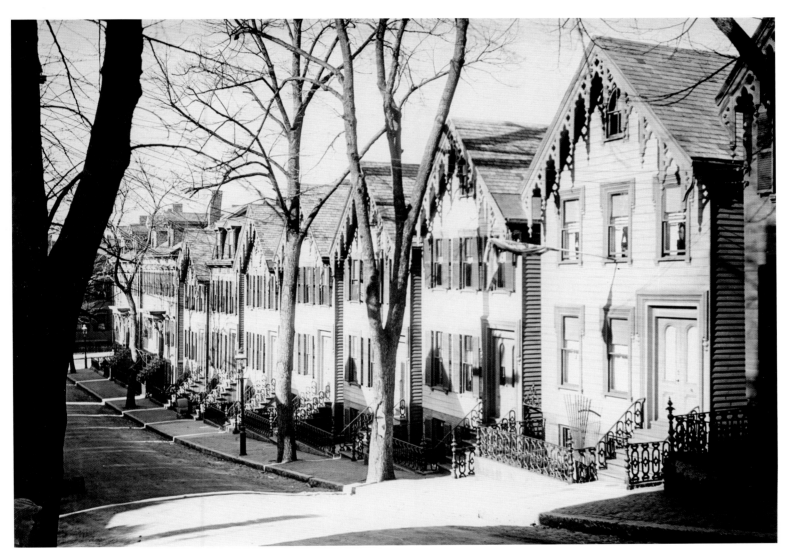

Wooden Houses, Boston, 1930

Berenice Abbott, New York, 1929–30

Photomontage Portrait of Berenice Abbott, 1929–30

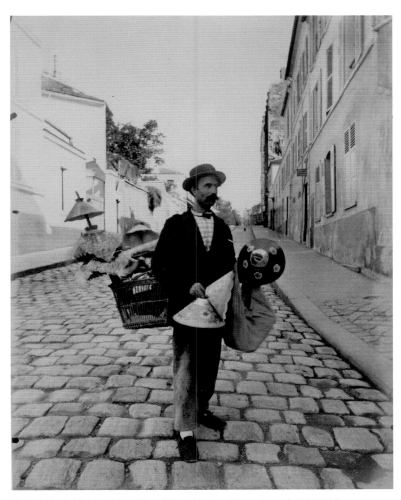

Eugène Atget, *Marchand d'abat-jours* (Street Vendor of Lampshades), 1899–1900

Eugène Atget, *Boutique, Marché aux Halles, Paris*, 1925

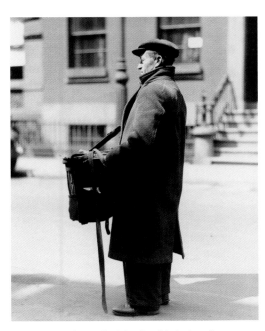

Organ Grinder Street Musician, Possibly Bethune Street, New York, ca. 1929

Dress, April 1963

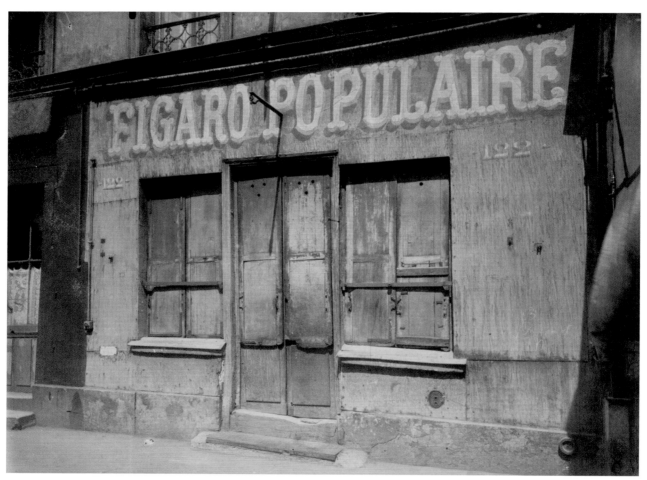

Eugène Atget, *122, boulevard de la Villette*, 1924–25

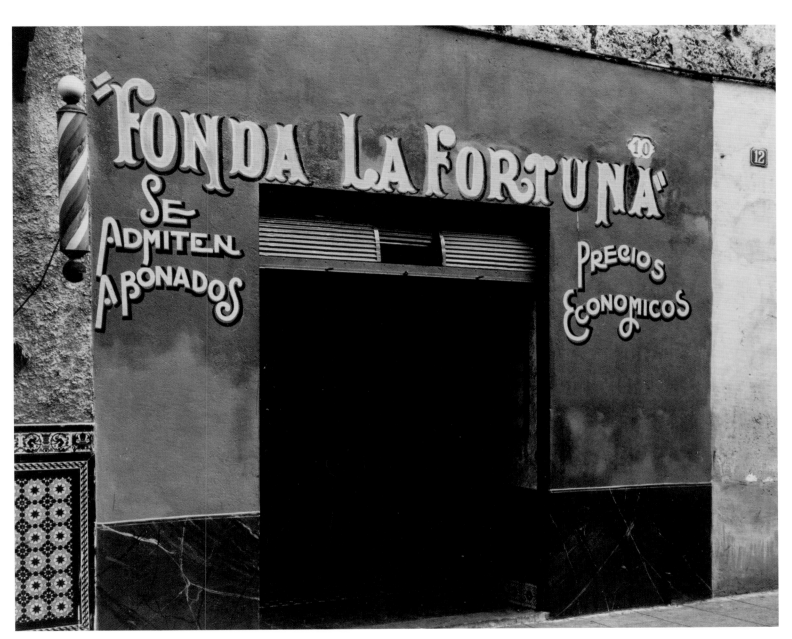

Small Restaurant, Havana, 1933

THE

AS

VERNA CULAR SUBJECT

From the early 1930s on, most of Walker Evans's photographs had the vernacular as their subject. The places he roamed were traffic spaces with no particular attributes: the American highways, the main streets of small towns, city sidewalks with their characteristic signs and shop windows. The subjects of his photographs were anonymous, nameless, and devoid of status. What fascinated him were the most ordinary utilitarian objects, mass produced and intended for everyday use. Evans was passionate about the minute details of everyday life, the invisible and unrecognized culture that he felt revealed a sort of *American-ness*.

Collecting/Photographing

What is the vernacular? The objects that fascinated Walker Evans enable us to understand him better than a long explanation would. As his father worked in advertising, Evans developed a special relationship with that culture very early on. From his childhood through the end of his life, he collected postcards and printed ephemera. When photographing, he never missed an opportunity to include an advertisement, a sign, or a movie poster in the frame. Several of his friends reported that, after photographing a display ad *in situ*, it was not uncommon for Evans to abscond with it. The walls of his last home were covered with them. It was as if photography were a way of extending his collection, or vice versa.

John T. Hill, *[Walker Evans's] House Interior, Fireplace with Painting of Car*, April 1975

Unidentified Sign Painter, "Nectar Tea" sign, collection of Walker Evans

Unidentified Sign Painter, "Coca-Cola" sign, collection of Walker Evans

Unidentified Sign Painter, "No Guning" sign, collection of Walker Evans

Unidentified Sign Painter, "No Dumping" sign, collection of Walker Evans

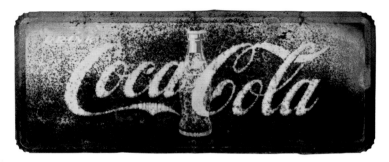

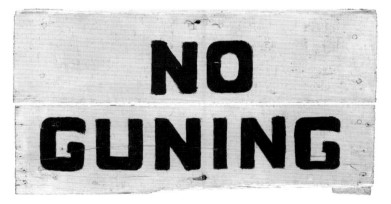

O'Pry Signs, Vintage car sign, collection
of Walker Evans

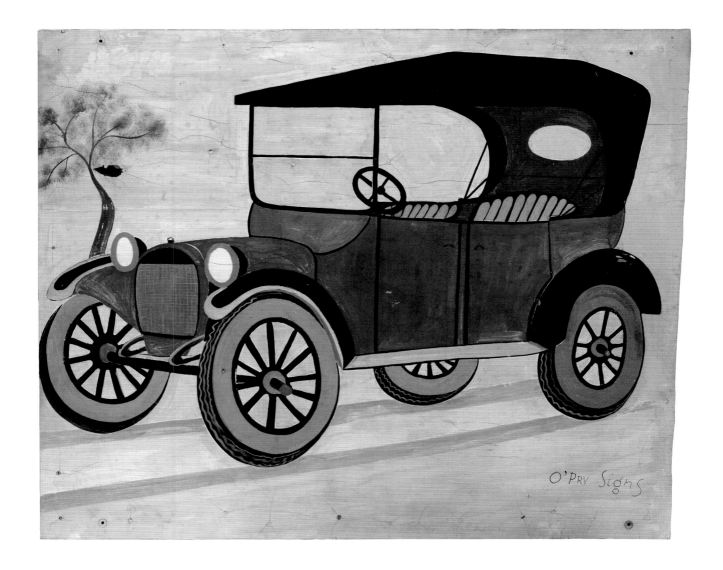

John T. Hill, *[Walker Evans's] House Interior, Sink with Beer Can Tabs*, April 1975

Collage, ca. 1973

Collage with Thirty-Six Ticket Stubs, 1975

1. Édition Grizard, *Les petits métiers de Paris: Les Chiffonniers | Small Trades of Paris: The Rag Pickers*, ca. 1925 (mailed in 1946), postcard collection of Walker Evans

2. Frank E. Cooper (copyright by Irving Underhill), *A Typical Crowd on a Hot Day at Coney Island, New York*, ca. 1940, postcard collection of Walker Evans

3. Curt Teich & Co., *A Portion of "The Floor of Fame," Grauman's Chinese Theatre, Hollywood, California*, ca. 1940, postcard collection of Walker Evans

4. H. H. Tammen Co., *Glass Bottom Boat, Santa Catalina Island, California*, ca. 1930 (mailed in 1956), postcard collection of Walker Evans

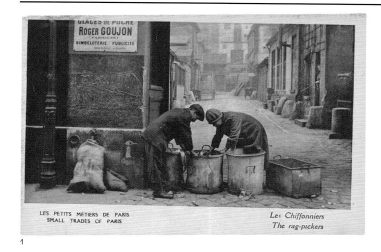

1

2

3

4

5. Unidentified Publisher, *Reading the Latest News Bulletins. Chinatown, San Francisco, California*, ca. 1935, postcard collection of Walker Evans

6. Unidentified Publisher, *Electric Chair, Sing Sing Prison, New York*, ca. 1920, postcard collection of Walker Evans

7. Milton D. Bromsley [?], *Illuminated American Falls, Niagara Falls*, ca. 1920 (mailed in 1974 by Lee Friedlander), postcard collection of Walker Evans

5

6

7

Roadside Shacks

America was built around its roadways. Those who decided to stop and set up shop at the edge of the road displayed a wealth of ingenuity to attract the attention of motorists passing by, looking straight ahead. For example, the Georgia garage owner who wanted to let potential customers know that he sold spare parts hung them on his storefront in a motley but harmonious arrangement. Luncheonettes, gas stations, fruit and vegetable stands—for Walker Evans, the roadside offered an inexhaustible supply of visual finds, a sort of curiosity cabinet, a veritable open-air museum. There is something about it that explains why America is American.

Roadside Fruit. Ponchatoula, Louisiana, March 1936

Garage in Southern City Outskirts, Atlanta, Georgia, 1936

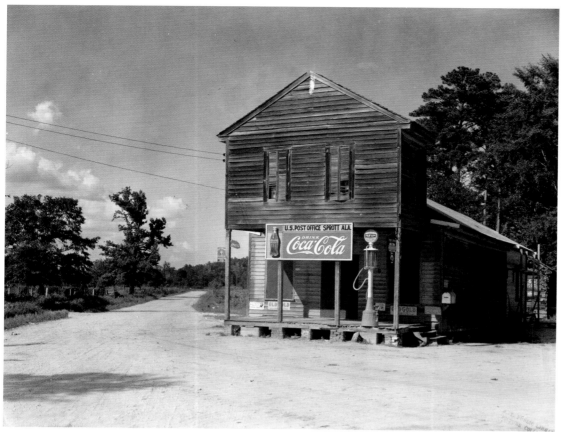

Crossroads Store, Post Office, Sprott, Alabama, 1935–36

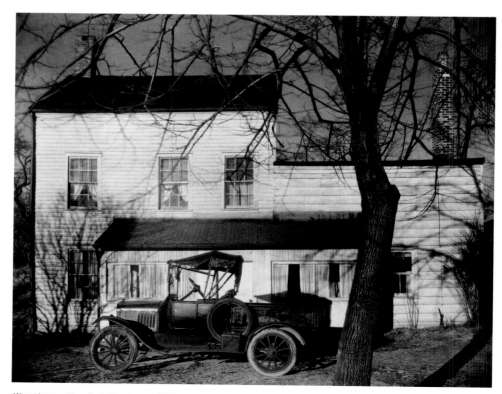

Westchester, New York, Farmhouse, 1931

Highway Corner, Reedsville, West Virginia, March 1936

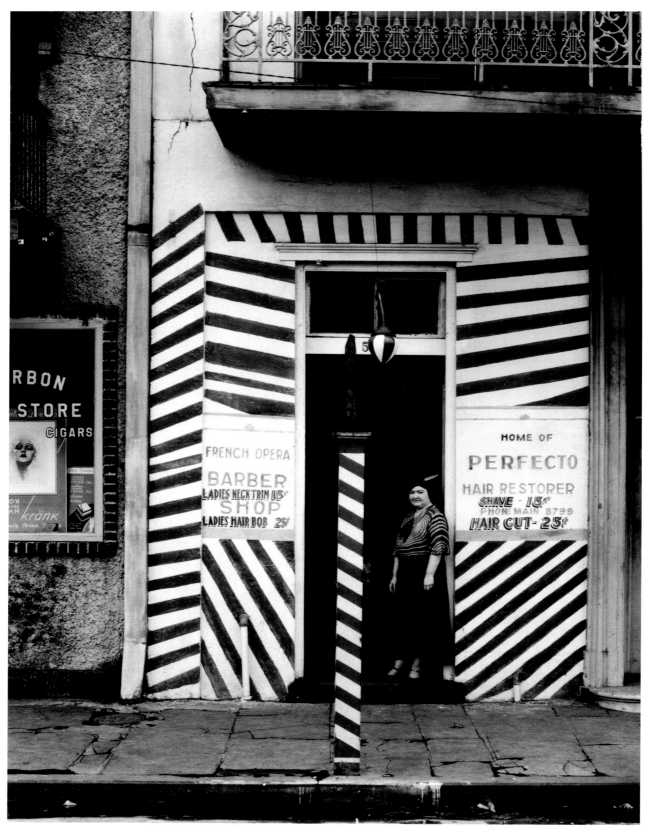

Sidewalk and Shopfront, New Orleans, 1935

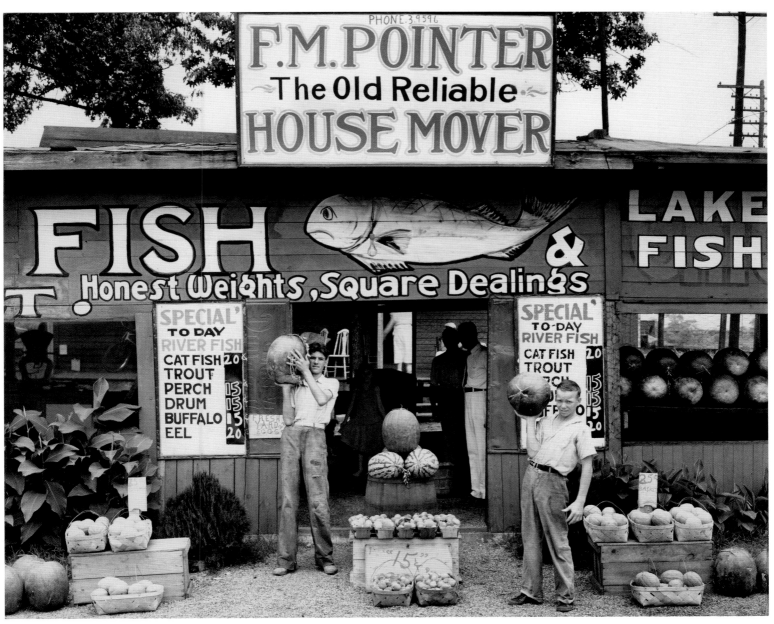

Roadside Stand near Birmingham/Roadside Store between Tuscaloosa and Greensboro, Alabama, 1936

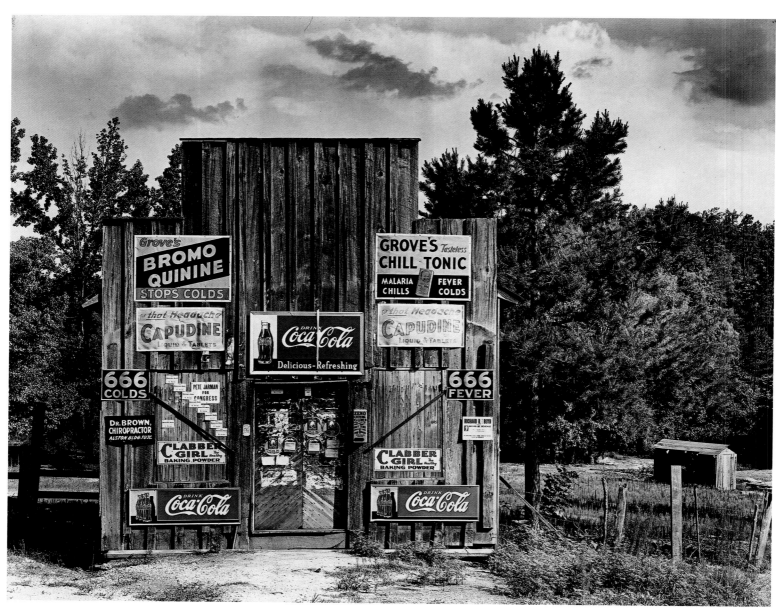

Roadside Store between Tuscaloosa and Greensboro, Alabama, 1936

Anna Maria, Florida, October 1958, oil on fiberboard

Fisherman's Shack, 1945, tempera on wood

Storefronts and Shop Windows

Like Eugène Atget, the great documentarian of the Parisian vernacular, Walker Evans photographed the windows of American shops. Of his entire corpus, it is unquestionably the subject matter most often depicted. He was charmed by the typography of a sign, the look of a mannequin, or the way the vendor displayed his prices. He liked the way a storekeeper painted his storefront to make it more attractive, the care he took in organizing his merchandise according to shape or color. He particularly liked the poetry of a hodgepodge of disparate objects overflowing onto the sidewalk. He felt these rudimentary ways of doing things, which varied by the state or the neighborhood, expressed all the ingenuity of the United States.

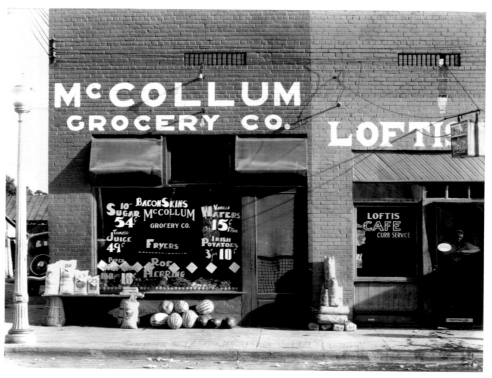

Storefront, Greensboro, Alabama, July–August 1936

Bowery Lunchroom, New York, ca. 1933

Hardware Store, ca. 1932

Fruit in Baskets outside Souvenir Shop, Florida, 1941

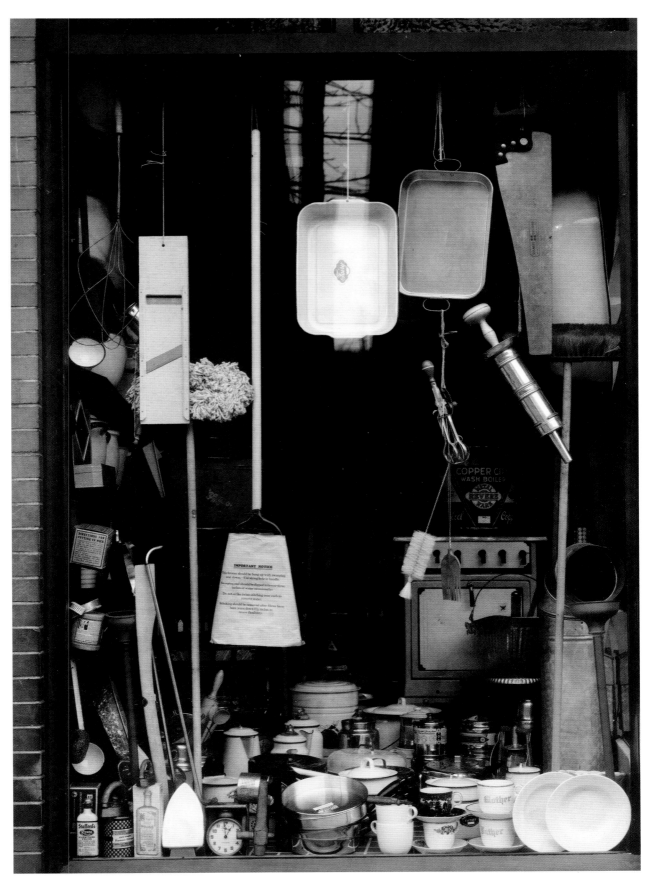

Window Display, Bethlehem, Pennsylvania, November 10, 1933

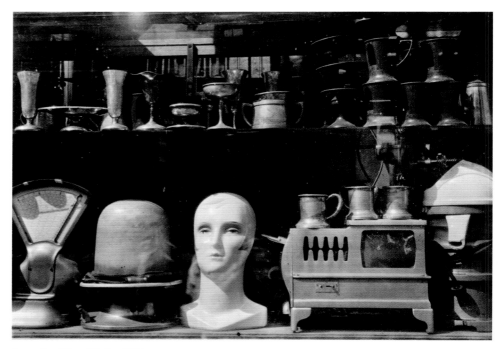

Secondhand Shop Window, 1930

Dress, 1963

Stockings and Bras, 1959

Third Avenue, New York City, 1959

The march of the mops

THE PITCH DIRECT

The sidewalk is the last stand of unsophisticated display

A man needn't travel to the Andes, strapped to his color camera, to relish the sights of outdoor markets. There are American sidewalks, like these in New York, that spill with them. They can look and smell much like market places anywhere, from Naples to Tehuantepec to Nairobi. The stay-at-home tourist, if his eye is properly and purely to be served, should approach the street fair without any reasonable intention, such as that of actually buying something. The cut-rate whistling kettle must sit where it is, along with the mops, the sneakers, the crockery, and the petticoats.

Does this nation overproduce? If so, one can get a lot of pleasure and rich sensual enjoyment out of contemplating great bins of slightly defective tap wrenches, coils upon coils of glinty wire, and parabolas of hemp line honest and fragrant. A man of perfectly good sense may decide after due meditation that a well-placed eggplant (2 for 27 cents) is pigmented with the most voluptuous and assuredly wicked color in the world. There are other delights. Why is it that there is always something comic about a sash weight? What is as dependably entertaining as a really enthusiastic arrangement of plumbers' tools?

—W. E.

Photographs by Walker Evans

FORTUNE October 1958 139

"The Pitch Direct. The sidewalk is the last stand of unsophisticated display," *Fortune* 58, no. 4 (October 1958), pp. 139–43

The light infantry

The kitchen classics

"Positively everything must go"

Moving on One Hundred and Sixteenth Street

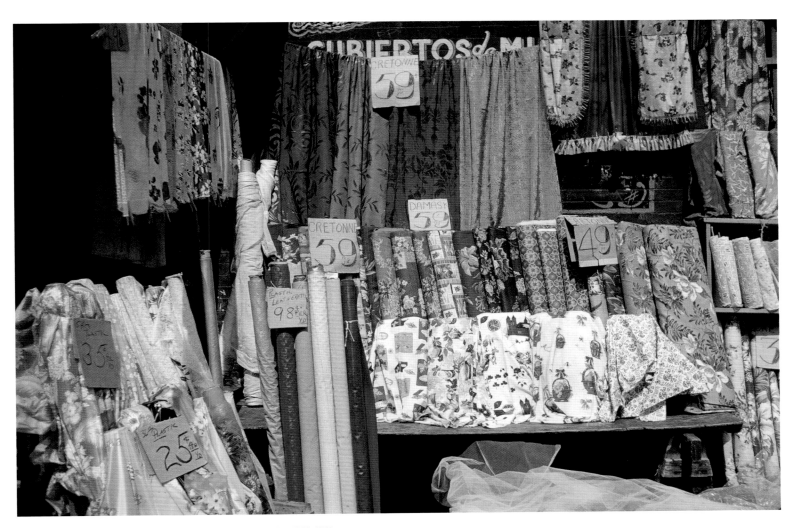

Sidewalk Display, for the Series "The Pitch Direct," Fortune, October 1958, 1957

Landscape of Posters

Unlike many other photographers of his generation who strove to photograph landscapes devoid of posters, Walker Evans systematically searched them out. The worthy son of an ad executive father, he liked enormous pictures on city walls, gaudy colors, and popular slogans. Whether freshly posted, rain-damaged, or torn, he photographed them in context, sometimes straight on and close-up, as if he were simply preserving a reproduction. In *Moravagine*, Blaise Cendrars praised the beauty of "multicolored posters" and "typographic display ads." Evans, who had translated a few excerpts from that book, fully shared his fondness. He too thought of advertising as a modern form of poetry.

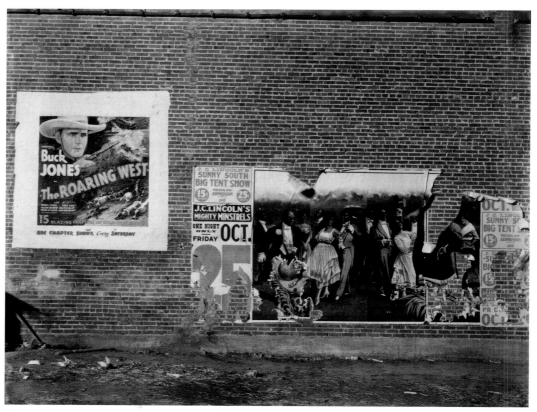

Show Bill, Demopolis, Alabama, 1936

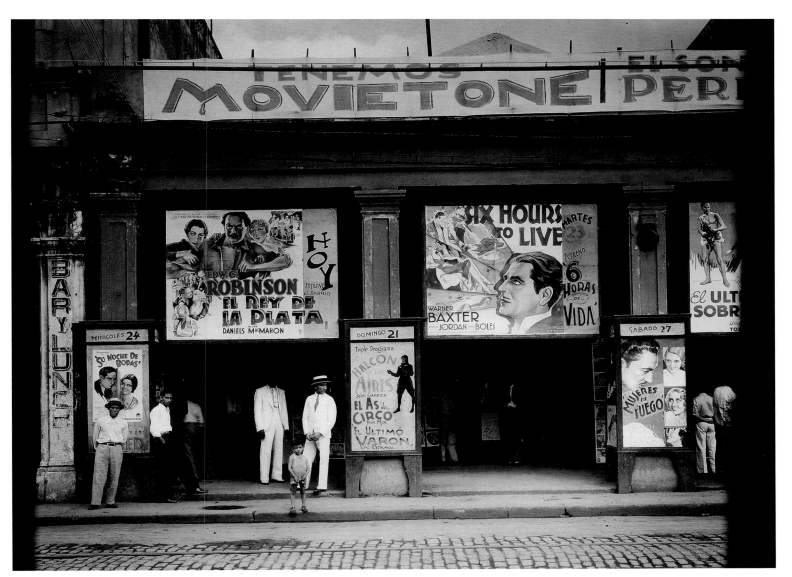

Cinema, Havana, 1933

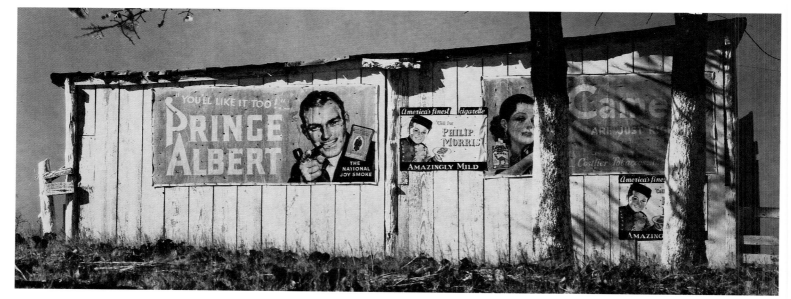

Mississippi Roadside Barn, 1935

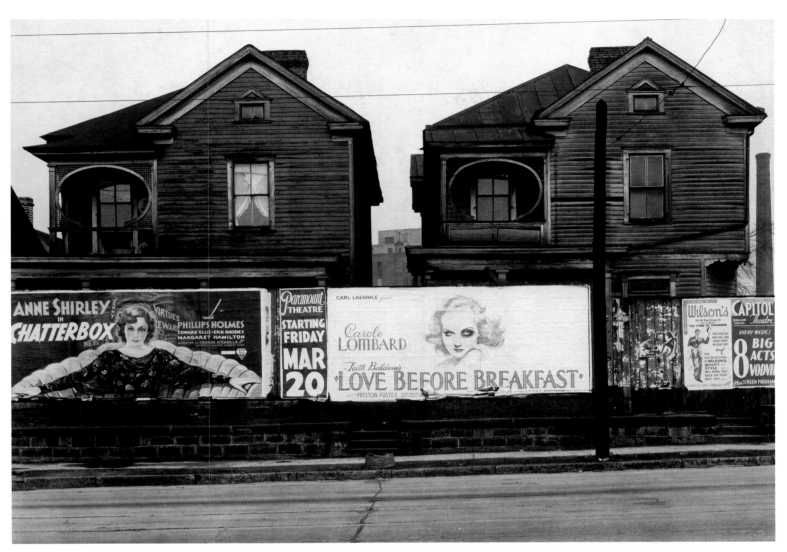

Houses and Billboards in Atlanta, 1936

Outdoor Advertising, Florida, 1934

Sideshow Signs, Santa Monica, California, August–September 1947

Billboard, Birmingham, Alabama, 1936

Circus Poster, Alabama, 1935–36

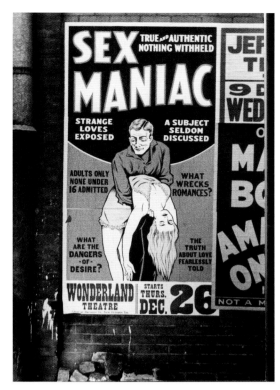

Untitled, 1948

Minstrel Showbill, 1936

Political Poster, Massachusetts Village, 1936

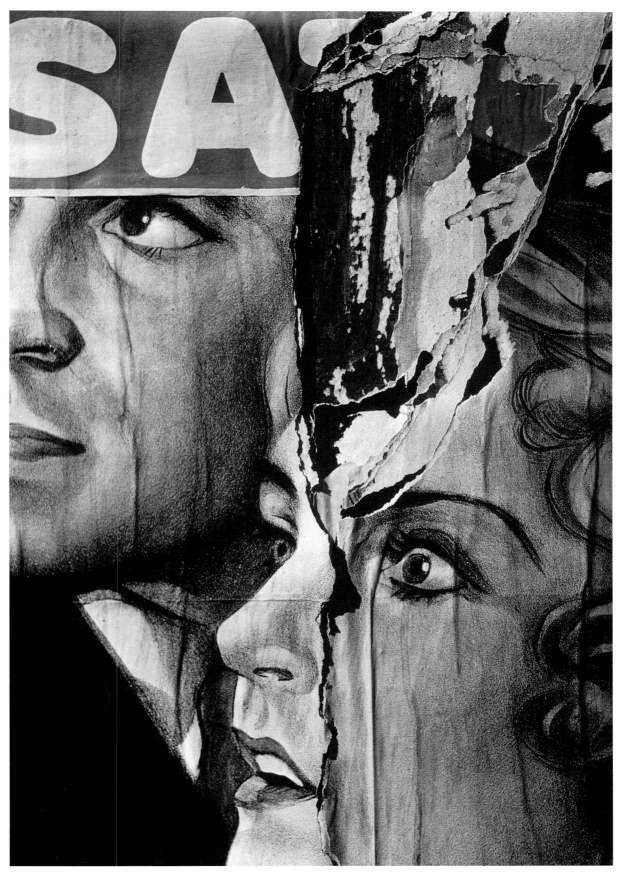

Torn Movie Poster, 1930

Signs

In the typically American urban landscape that Walker Evans undertook to inventory, there were still hanging shop signs. As he did with posters, he documented these in context, but sometimes also in tight shots. Laundry, fortune teller, shoeshine—the hanging signs that interested him most were those of tradespeople, hand-painted in rudimentary fashion. In the 1960s and 1970s, he even specifically looked for misspellings on roadside signs. Evans was fascinated by typography, icons, and logos. He was interested in how letters became images and drawings became signs. According to his last assistant, Jerry Thompson, it was a true "artistic obsession" for him.

Sign, Baton Rouge, Louisiana, 1935

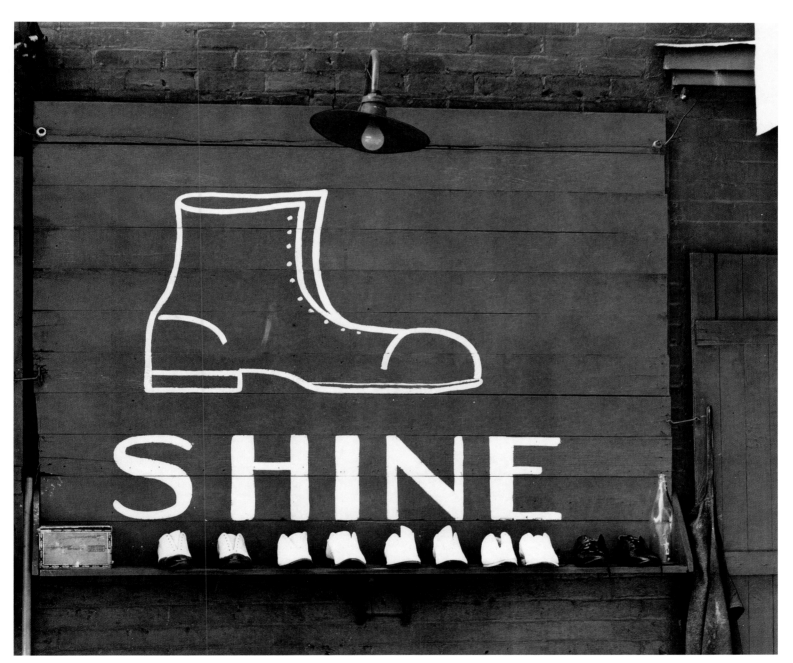

Shoeshine Stand Detail in Southern Town, 1936

The Grand Man. Wall Mural, ca. 1935

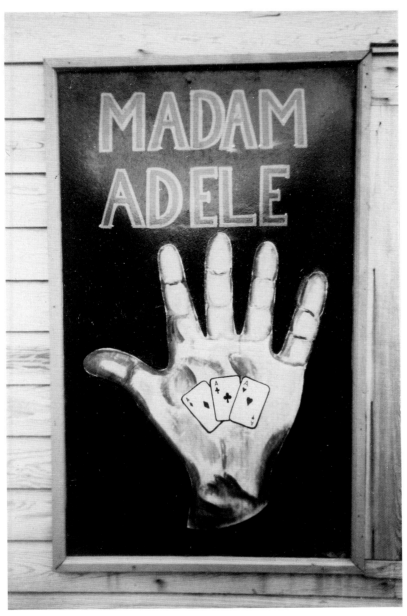

"Madam Adele" Palmistry Sign, 1934–35

"Mr. Walker Evans Records a City's Scene," *Creative Art* 7, no. 6
(December 1930), p. 453

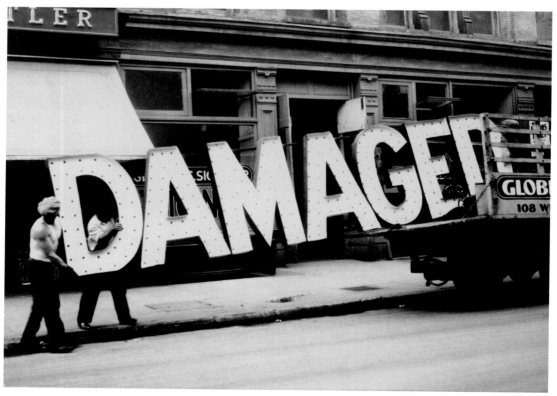

Truck and Sign, 1928–30

Roadside Gas Sign, 1929

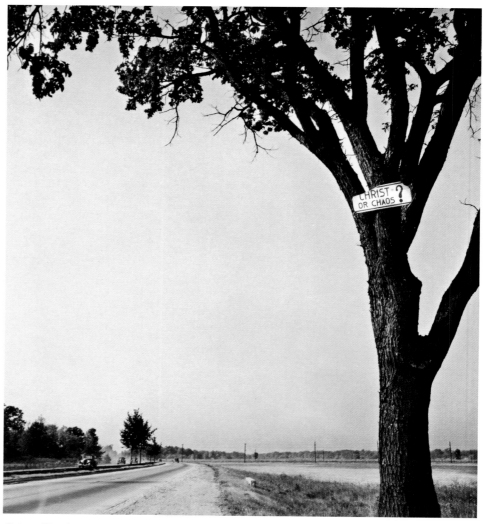

Christ or Chaos?, 1943

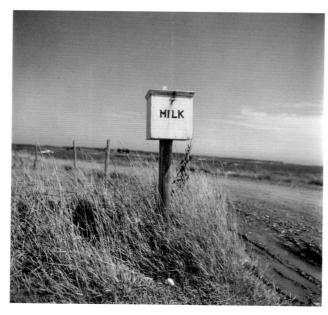

Nova Scotia, 1971

Untitled (No Guning), October 17, 1973

Untitled [Sign in Door: "Office for Rant"], May 30, 1974

Untitled [Hand-Painted Sign of Model T Ford, Old Lyme, Connecticut],
August 13–31, 1974

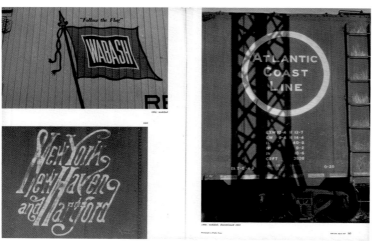

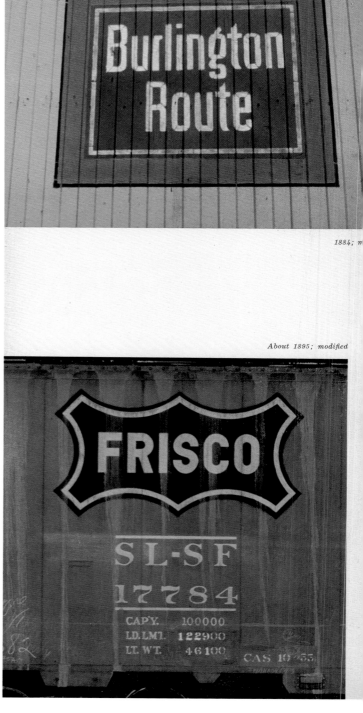

1884; m

About 1895; modified

"Before They Disappear," *Fortune* 55, no. 3 (March 1957), pp. 141–45

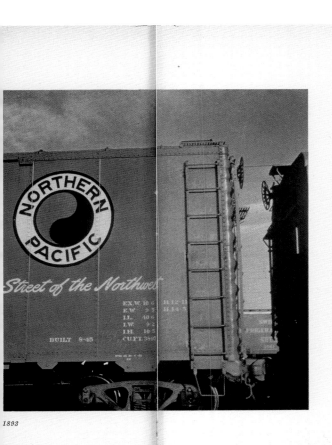

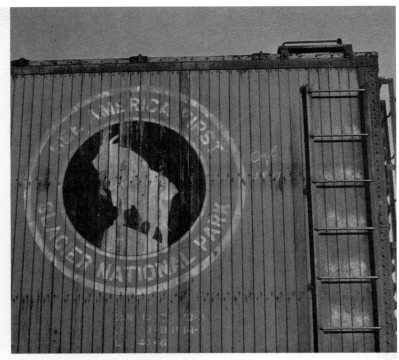

Great Northern, 1921; considerably modified

1893

Chicago & North Western, 1954

Ordinary Folk

Laborers, sharecroppers, dockworkers, hobos, panhandlers— Walker Evans liked to photograph ordinary people. Never bleak or bombastic in his images, he definitely did not seek to make art, but rather to document human resilience and dignity in the face of adversity. With a few rare exceptions, which reveal Evans's boundaries with regard to suffering, his photographs were not surreptitious. The people he photographed were well aware of his presence. They even fully participated in the construction of their image by gazing at the photographer and his lens, seemingly looking through those who would soon be staring at them. As Evans himself wrote in 1961 in an article entitled "People and Places in Trouble," these people "speak with their eyes."

Havana Stevedore, 1933

136

Coal Dock Worker, 1932

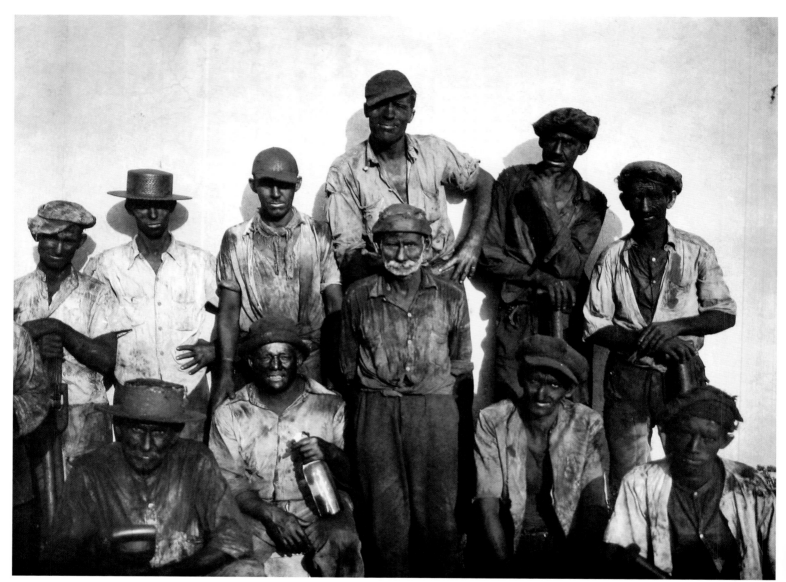

Dock Workers, Havana, 1933

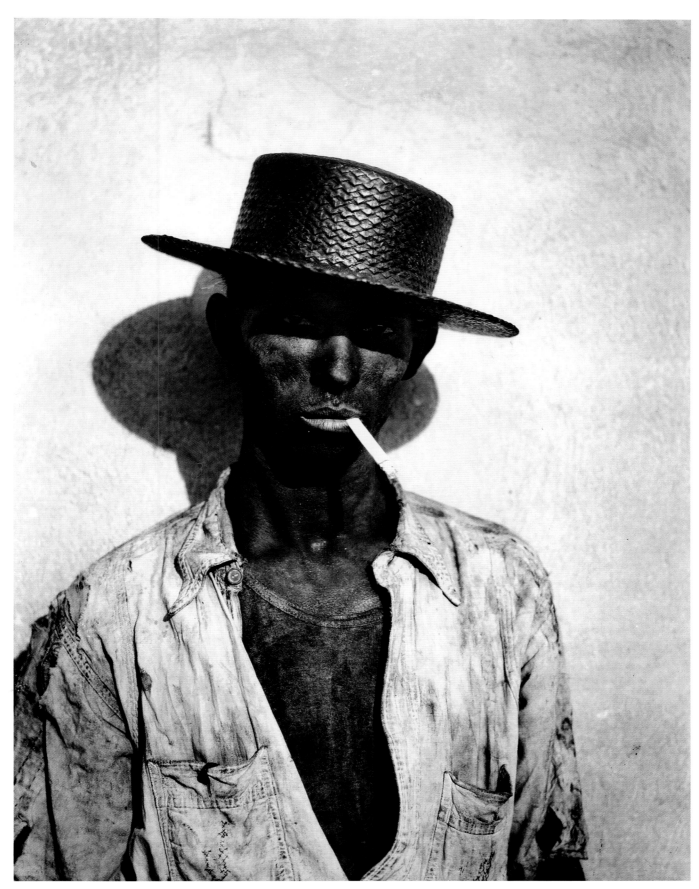

Coal Stevedore, Havana, 1933

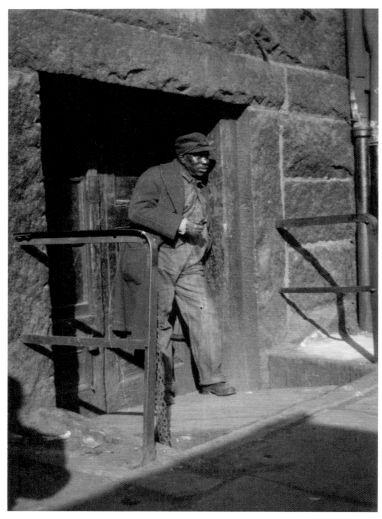

Longshoreman, South Street, New York City, 1928

Chicago [Two Blind Street Musicians, Halsted Street], 1941

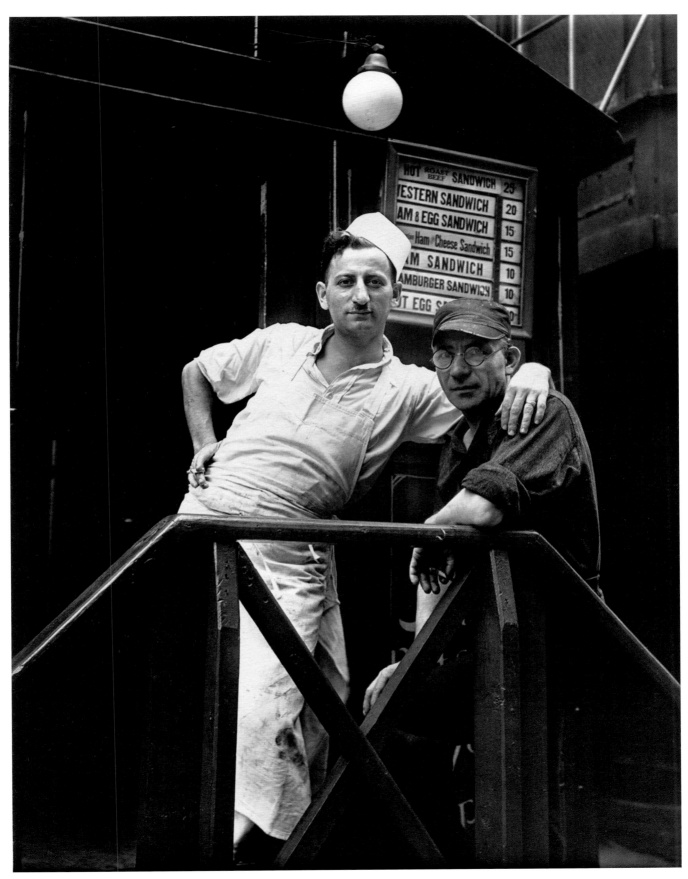

Posed Portraits, New York, 1931

Man on Crutches, Havana, 1933

Man on Crutches, Havana, 1933

Havana Beggar, 1933

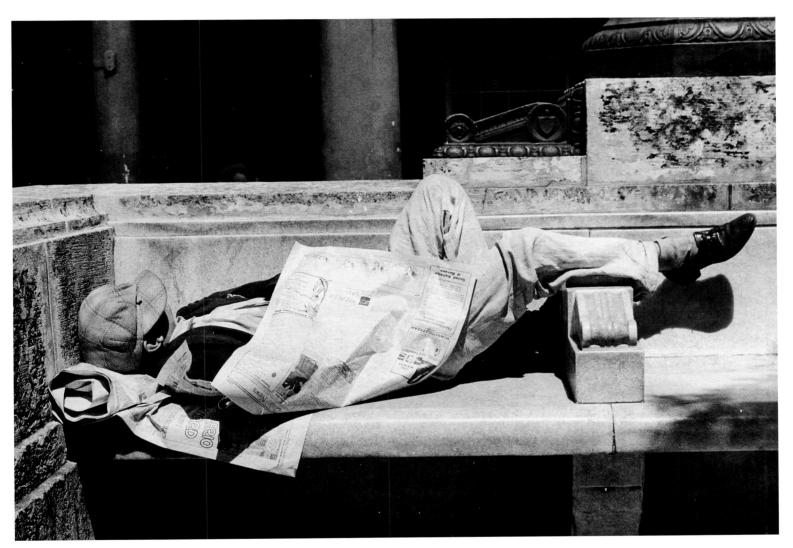

Vagrant in the Prado of Havana, 1933

Three Alabama Families

From 1935 to 1937, Walker Evans worked for the Farm Security Administration (FSA), a New Deal government program established to help the farmers most affected by the economic crisis following the 1929 stock market crash. During the summer of 1936, in the company of writer James Agee, he photographed three sharecropper families in Alabama. For several weeks, the writer and photographer lived with the families, sharing their meals and their worries. There, Evans took some of his most poignant shots. His portraits of the Burroughs, Tengles, and Fields will forever embody the faces of the Great Depression, and *Let Us Now Praise Famous Men*, the product of Evans and Agee's labors in the South published in 1941, has become a classic of American literature.

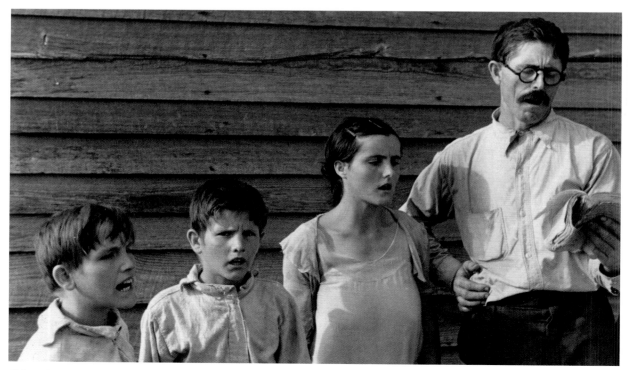

Alabama Tenant Farmer Family Singing Hymns, 1936

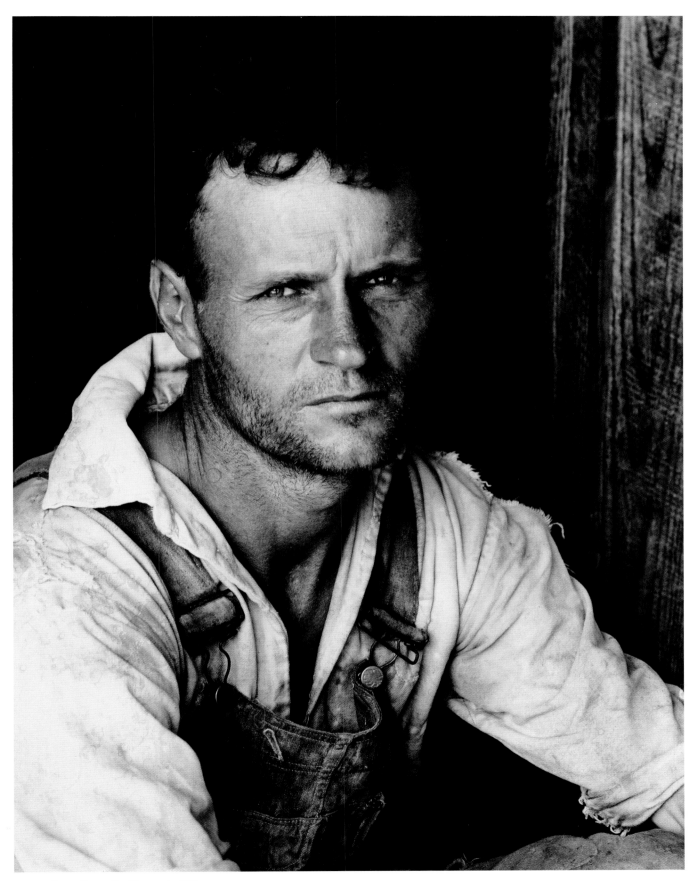

Alabama Tenant Farmer Floyd Burroughs, 1936

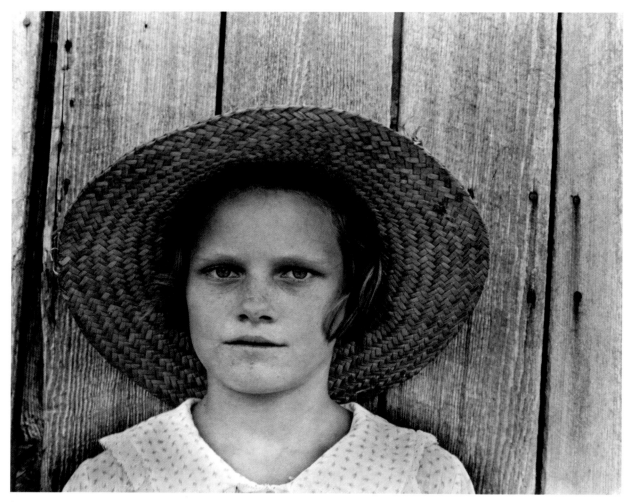

Lucille Burroughs, Daughter of a Cotton Sharecropper, Hale County, Alabama, 1936

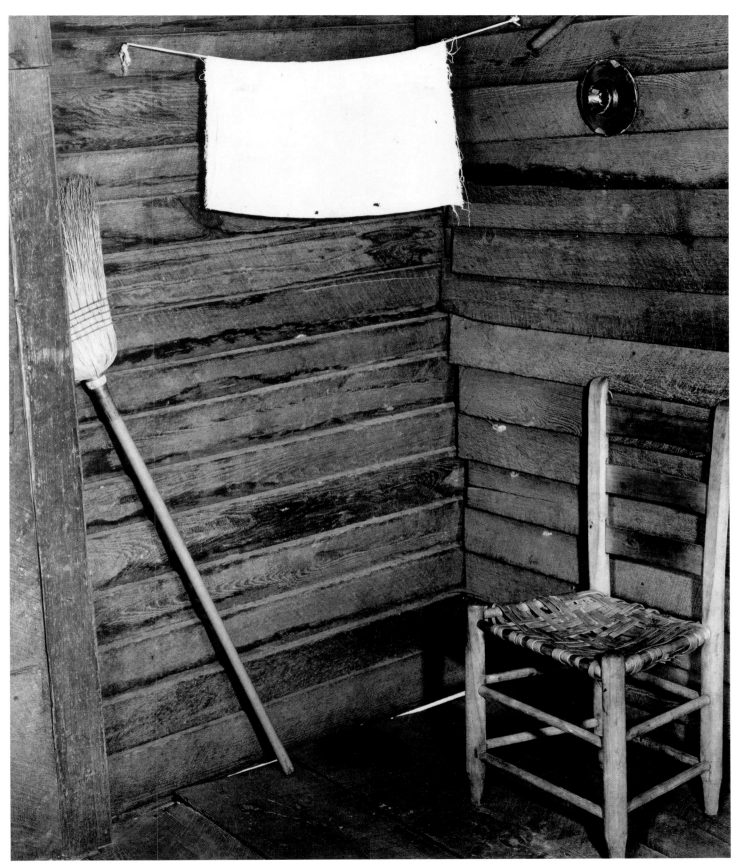

Kitchen Corner, Tenant Farmhouse, Hale County, Alabama, 1936

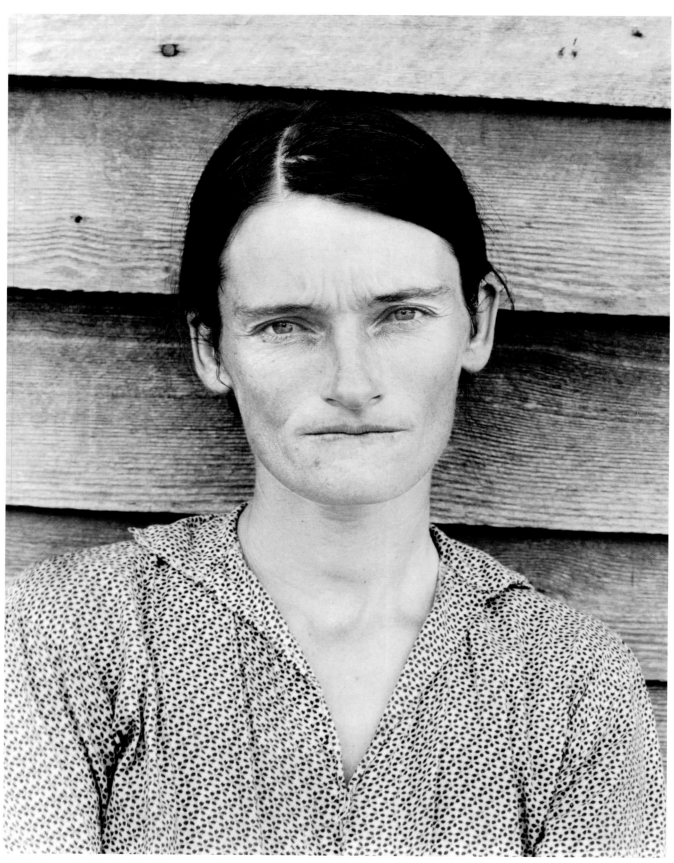

Allie Mae Burroughs, Wife of a Cotton Sharecropper, Hale County, Alabama, 1936

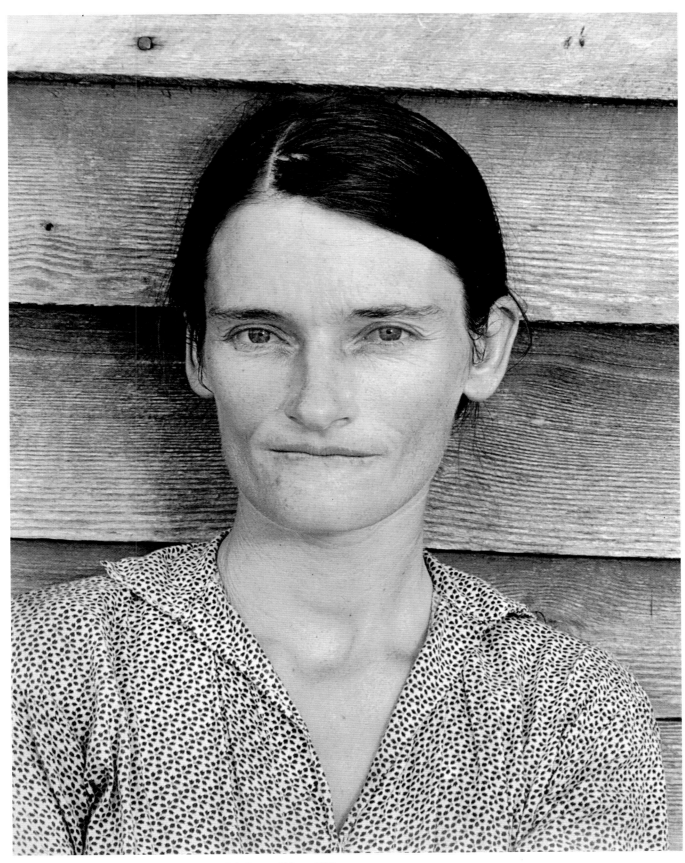

Allie Mae Burroughs, Wife of a Cotton Sharecropper, Hale County, Alabama, 1936

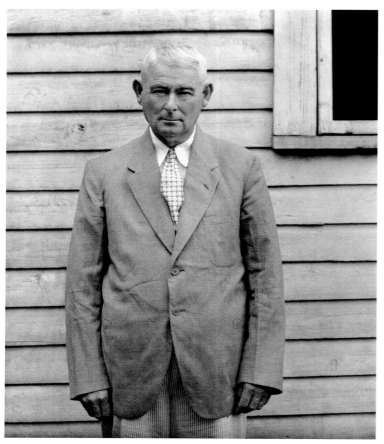

Land Lord, Hale County, Alabama, 1936

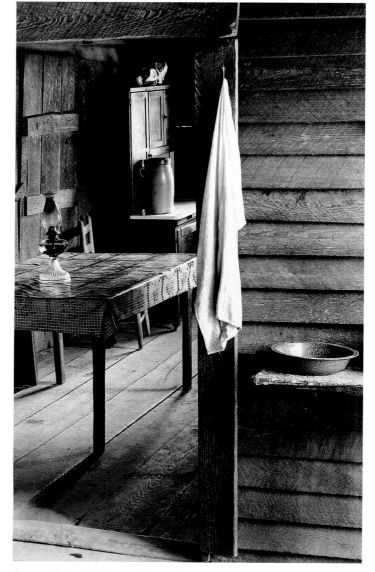

Farmer's Kitchen, Hale County, Alabama, 1936

Part of the Bedroom of Floyd Burroughs's Cabin, Hale County, Alabama, 1936

Lilian Fields, Hale County, Alabama, July–August 1936

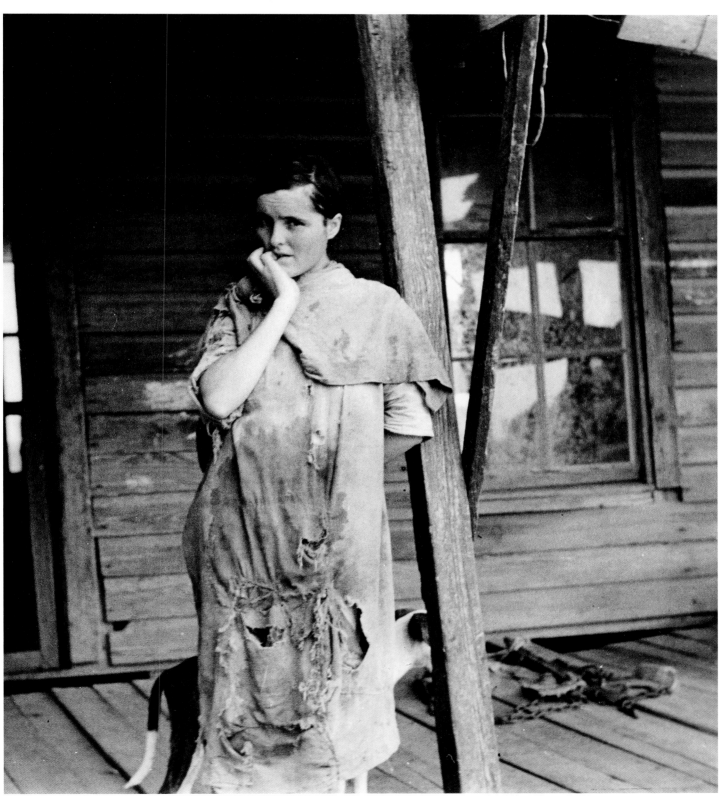

Elizabeth Tengle, Hale County, Alabama, July–August 1936

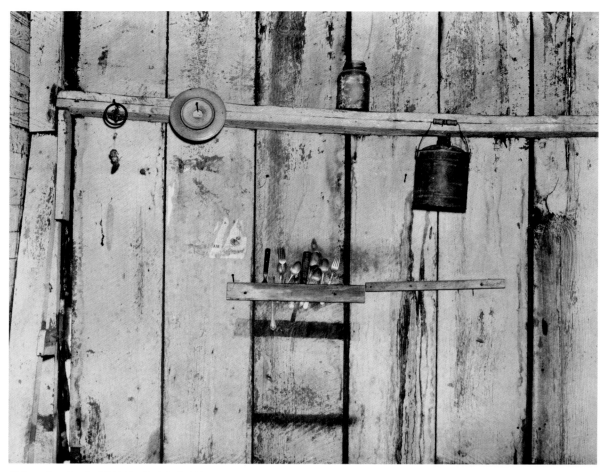

Alabama Farm Interior [Fields Family Cabin], 1936

Squeakie Burroughs Asleep, 1936

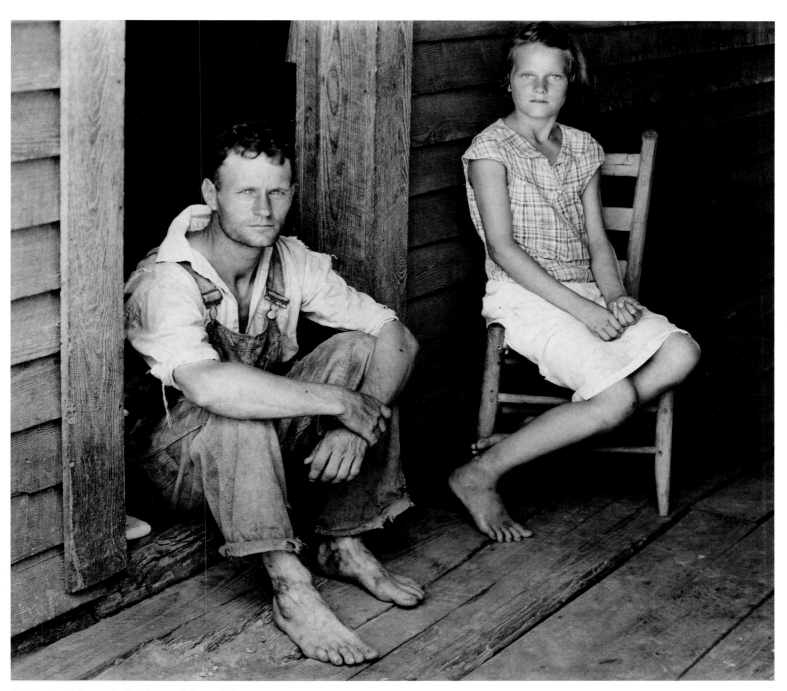

Floyd and Lucille Burroughs, Hale County, Alabama, 1936

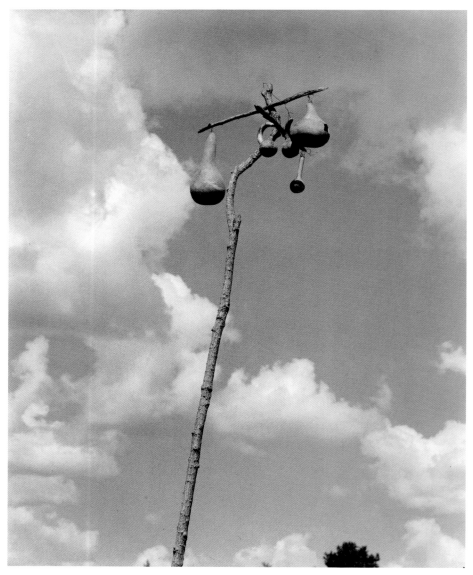

A Gourd Tree for Martins, Hale County, Alabama, 1936

A Child's Grave, Hale County, Alabama, 1936

Child's Grave, Hale County, Alabama, 1936

The Great Flood of 1937

In early 1937, the Farm Security Administration (FSA) sent Walker Evans to Forrest City, Arkansas, to photograph some of the worst flooding of the Mississippi River in the twentieth century. Miles and miles of inundated land, hundreds of deaths, thousands of displaced people temporarily relocated to makeshift camps—this was one more disaster for a region already hard hit by economic crisis and dust storms. Evans arrived there on February 2. For five days, he relentlessly photographed the racially segregated camps, the food lines, and the despair of those who had lost everything. He was emotionally overwhelmed by what he saw. That was to be his last series for the FSA.

Belongings of a Flood Refugee, Forrest City, Arkansas, February 1937

Arkansas Flood Refugee, February 1937

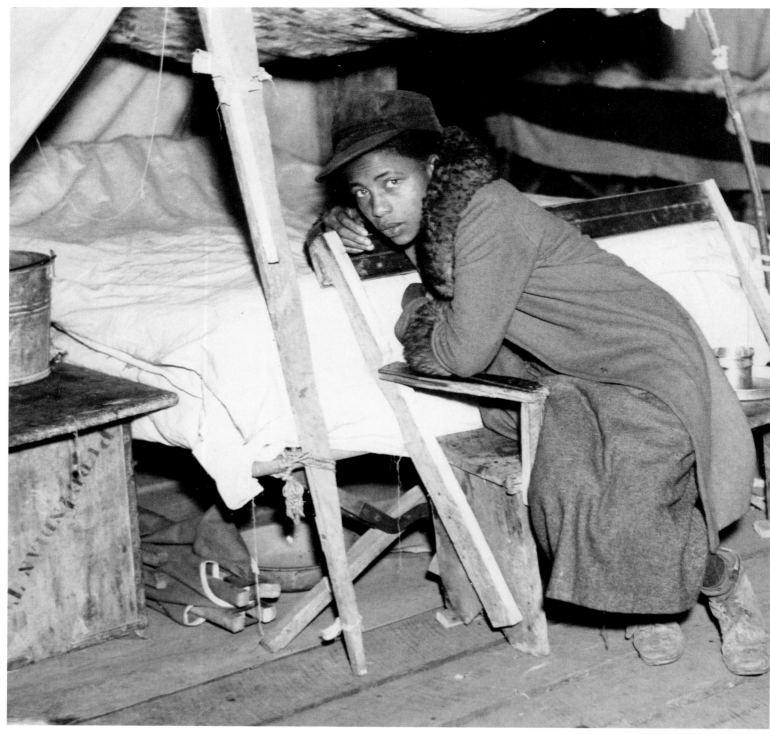

Flood Refugee, Forrest City, Arkansas, February 1937

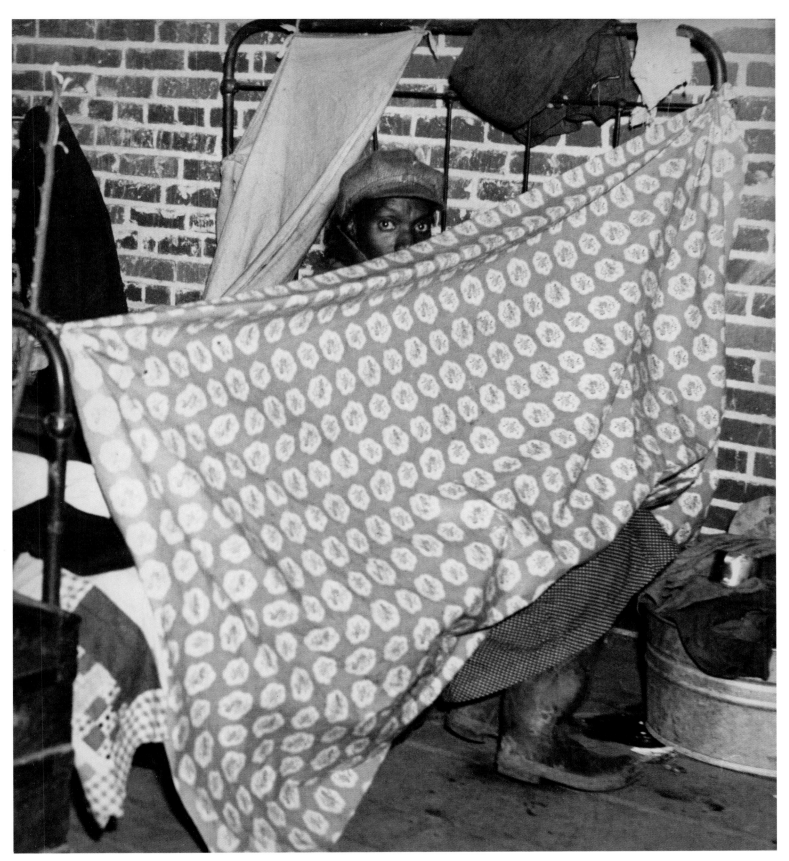

Flood Refugee, Forrest City, Arkansas, February 1937

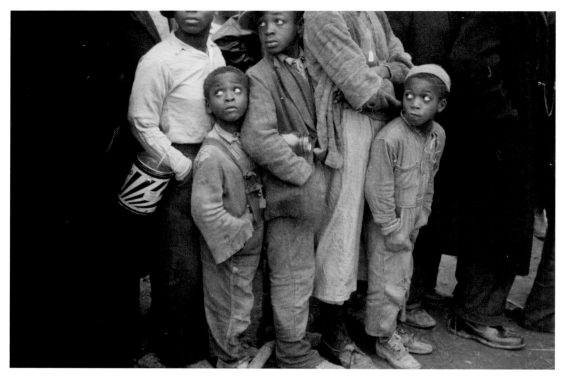

Flood Refugees at Mealtime, Forrest City, Arkansas, February 1937

Negroes in the Lineup for Food at Mealtime in the Camp for Flood Refugees, Forrest City, Arkansas, February 1937

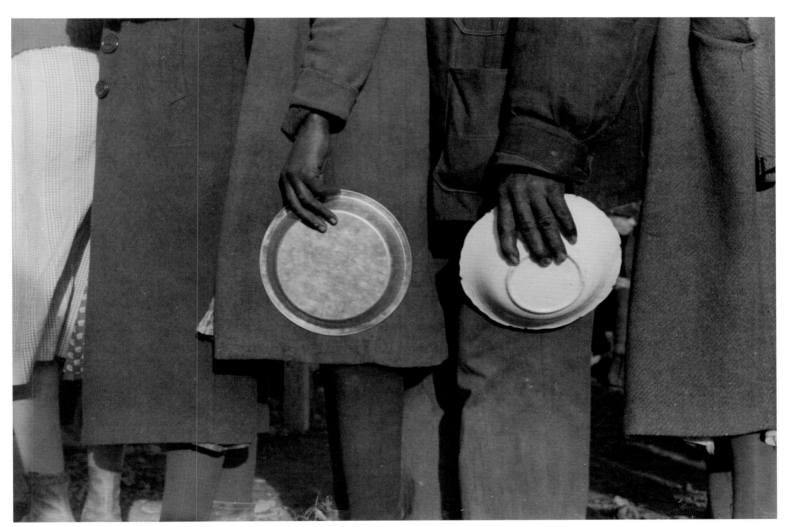

Negroes in the Lineup for Food at Mealtime in the Camp for Flood Refugees, Forrest City, Arkansas, February 1937

The Other Side of Progress

In the United States, modernism is most often associated with a flamboyant era of speed, skyscrapers, assembly lines, ball bearings, and shiny chrome. Walker Evans understood that modernism had a flip side: the perpetual search for novelty accelerated the feeling of aging; excessive consumption led to an inevitable increase in waste; there could be no *pro*gress without a form of *re*gress. For nearly forty years, the photographer tirelessly stalked the signs of this other face of modernism. Faded glory, rundown houses, decrepit interiors, crumpled sheet metal, dilapidated surfaces—he was fascinated by the obsolescence and decline of things.

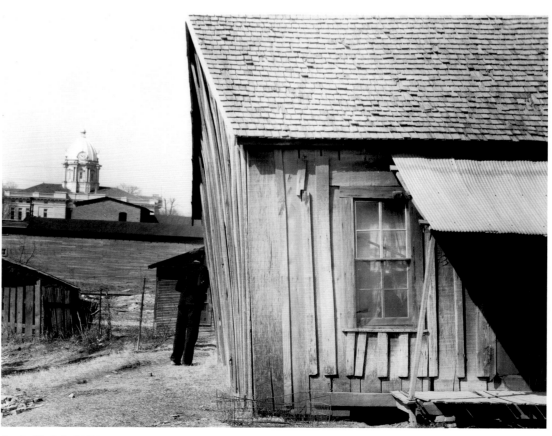

Tupelo, Mississippi, 1936

House on Fire in a Southern State, ca. 1935

Louisiana Plantation House, 1935

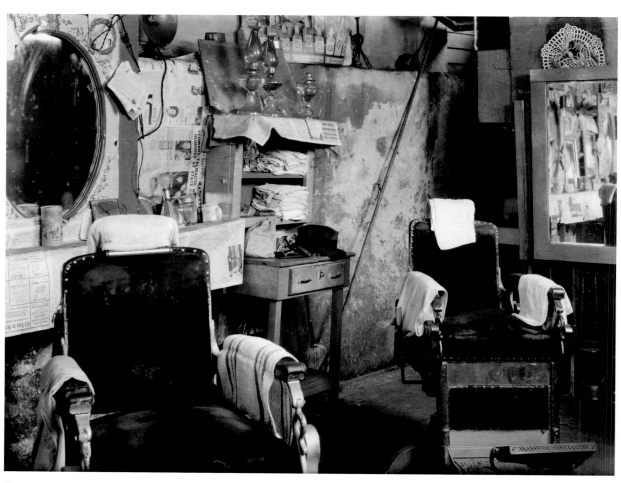

Negro Barbershop Interior, Atlanta, 1936

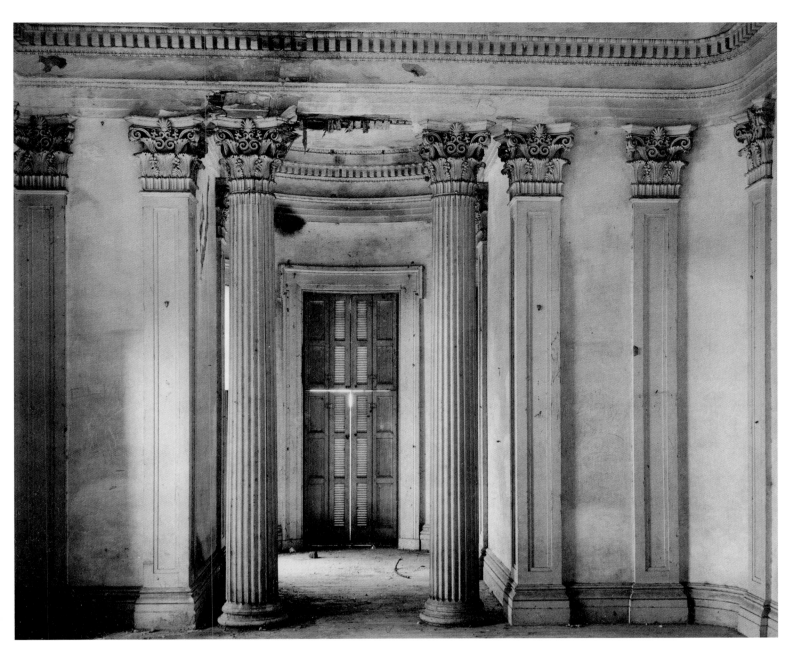

Room in Louisiana Plantation House, 1935

Wood Shingles, ca. 1930

Tin Relic, 1930

Stamped Tin Relic, 1929

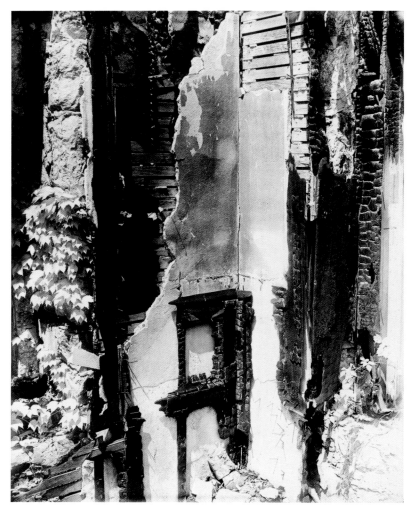

Fire Ruin in Ossining, New York, 1930–31

Mabou Mines, Nova Scotia, 1971

Corrugated Tin Façade, 1936

"The Criticism of Edwin Denby. Photographs by Walker Evans," *Dance Index*, no. 5 (February 1946), cover

Graffiti Backstage, New York City Ballet, 1945

Building Corner with Torn Rock Concert Posters, London, England, 1973

Gallery

Color accidents

American cities other than Boston, Charleston, and New Orleans are notably lacking in small harmonies for the eye. But there is a stimulating counterpleasure to be found in certain metropolitan by-streets. This is the restless cacaphonic design created by time, the weather, neglect, and the fine hand of delinquent youth. The bitter cold and ironic forms splashed and molded on many an old door or torn wall have their own way of arresting attention. In Manhattan, these wry compositions abound; but they must be collected with care. A certain authority about, and taste for, these "finds" comes to the practiced specialist once he starts the hunt. All except one of the examples on these pages were found on East 85th St., New York.

—WALKER EVANS

"Color Accidents," *Architectural Forum* 108, no. 1 (January 1958), pp. 110–11

A dappled patchwork of lavender, old blue, and pale ochre is assuredly beyond the imagination of the most intrepid colorists alive. In terms of painting, this composition should fall somewhere between the work of Klee and that of Congo the Chimpanzee of the London Zoo.

t will be the privilege of this cornerstone
o stand in insulted majesty as long as possible.
ome was not destroyed in a day.
"ere, wall writing is as it should be, illegible,
s form in no way obscured by meaning.

The Beauty of Garbage

The pride of the American automotive industry, the Ford Model T, is generally depicted as shiny and going full speed ahead. Walker Evans chose to photograph it immobile, in derelict condition, in a vehicle graveyard. Thus he offered an image of modernity at a standstill. In the 1930s, he photographed the dark face of progress. In the 1960s and 1970s, he would push this to its logical conclusion, going so far as to photograph trash in gutters and wastebins. Fascinated by what industrial society rejects after consuming it, Evans identified with the figure of the ragpicker, the poet's alter ego that Baudelaire had so glorified. "A garbage can," the photographer said, "occasionally, at least to me, can be beautiful."

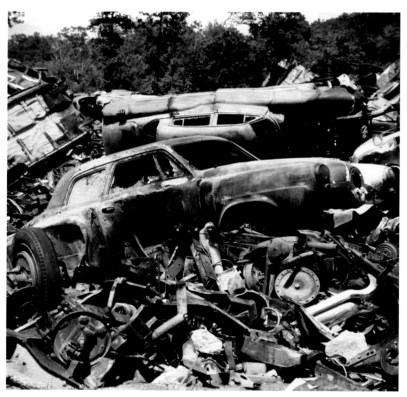

Auto Junkyard, 1961–62

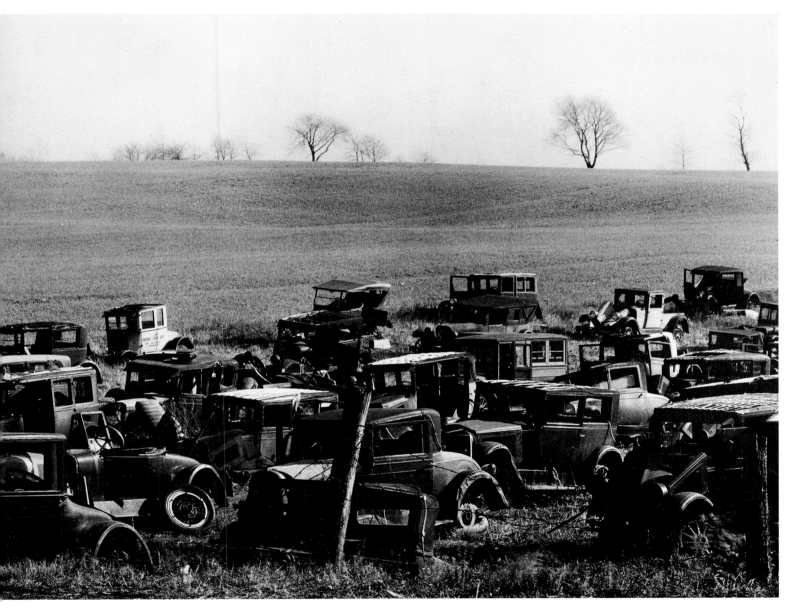

Joe's Auto Graveyard, 1936

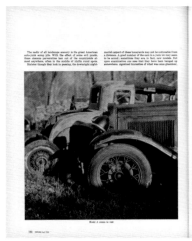
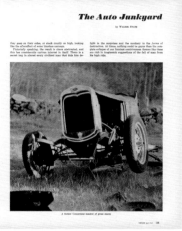
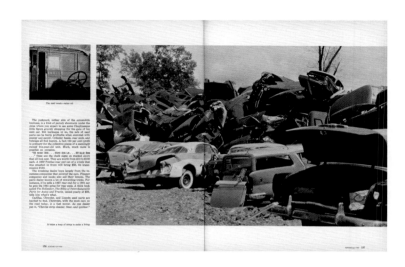
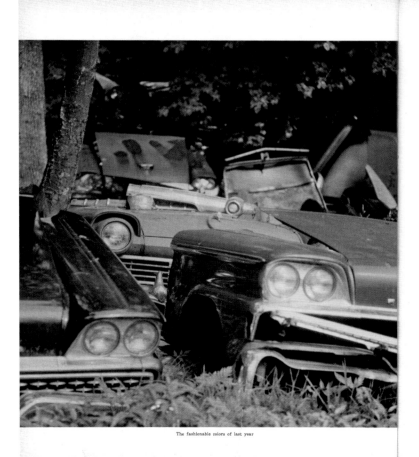

"The Auto Junkyard," *Fortune* 65, no. 4 (April 1962), pp. 132–37

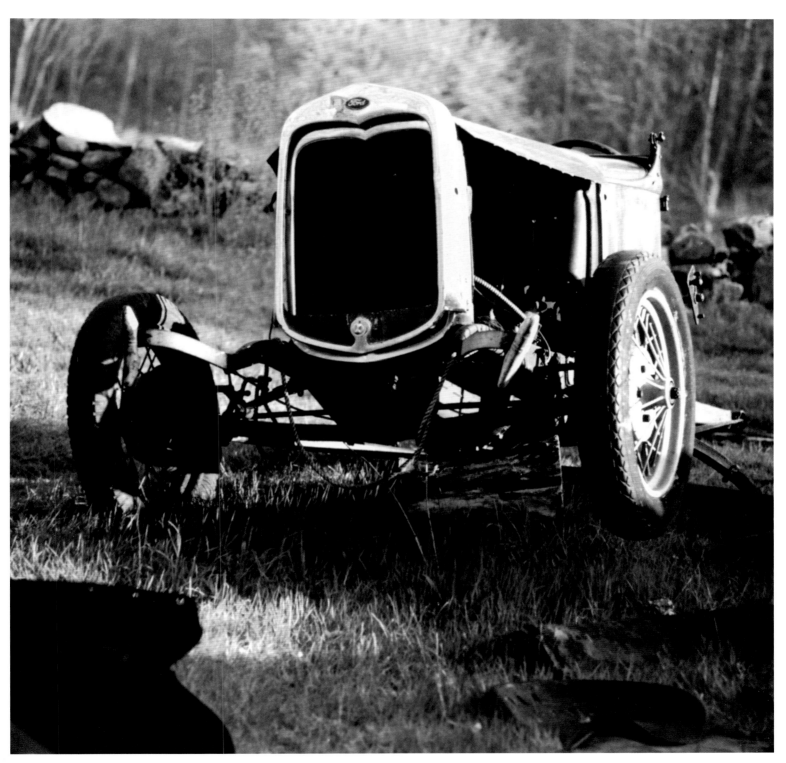

Auto Junkyard, 1961–62

Moving Truck and Bureau Mirror, 1929

Street Litter, Chicago, Illinois, August 1946

Trash Cans, December 1962

Trash Can, New York, ca. 1968

Street Debris, New York City, 1968

Trash #4, January 1, 1962

Trash #3, January 1, 1962

Debris, ca. 1965

Work Glove, 1973–74

Crushed Schmidt's Beer Can, 1973–74

Crushed Red Can, 1973–74

Untitled (Rope), 1973–74

THE
AS

VERNA CULAR METHOD

For Walker Evans, the vernacular was not only a subject but also a method. He looked at vernacular photography a great deal and drew inspiration from it for his own projects. To take his photographs of wooden churches, he became an architectural photographer for the duration of the project. To capture passersby, he worked like a street photographer, suddenly popping up in front of them and taking their picture. And to devise series such as his tools, metal chairs, or African masks, he became a catalogue photographer, specializing in packshots of objects. The paradox of Evans is that he espoused the forms and procedures of nonartistic photography while asserting a resolutely creative approach.

1. I. Steinfeldt, *Ten Hour House, Lancaster, Pennsylvania. Built on Wager in 10 Hours*, ca. 1925, postcard collection of Walker Evans

2. J. C. Mickleboro, *A. J. Marshall & Co.'s Store, Marion, Alabama*, ca. 1920, postcard collection of Walker Evans

3. J. N. Chamberlain, *Romeo Fruit Store, Oak Bluffs, Massachusetts*, ca. 1920, postcard collection of Walker Evans

4. Unidentified Publisher, *Front Street, Looking North, Morgan City, Louisiana*, 1900–1930, postcard collection of Walker Evans

Photographing/Collecting

In his archives, Walker Evans kept some examples of press and police photographs, pages from tool catalogues, and anonymous studio portraits. The categories of his personal postcard collection often reflect subjects he himself profusely photographed— shop windows, monuments, doorways, wooden churches, main streets of small-town America, etc. However, it is not possible to determine whether he collected the cards before photographing those subjects or vice versa. There are also other examples of vernacular photographs that were not specifically part of Evans's collection, but which were manifestly models or sources of inspiration for his projects.

1

2

3

4

5. C. W. Hugues & Co., *Rip Van Dam Hotel, Saratoga Springs, New York*, ca. 1920, postcard collection of Walker Evans

6. Unidentified Publisher, *Hotel Poultney, Poultney, Vermont*, ca. 1930 (mailed in 1964), postcard collection of Walker Evans

7. Unidentified Photographer, *A Pickle Vender in the Ghetto, New York City*, ca. 1920, postcard collection of Walker Evans

8. P. Hammacher, *East Main Street, Mystic, Connecticut*, ca. 1925, postcard collection of Walker Evans

9. Lenoir Book Co., *Main Street, Showing Confederate Monument, Lenoir, North Carolina*, ca. 1925 (mailed in 1937), postcard collection of Walker Evans

5

6

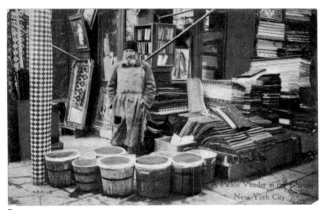

7

8

9

1. Souvenir Post Card Co., *Soldiers' and Sailors' Monument, East Rock Park, New Haven, Connecticut*, ca. 1905 (mailed in 1907), postcard collection of Walker Evans

2. Louis Kaufmann & Sons, *Confederate Monument and Mt. Vernon Boulevard, Alexandria, Virginia*, ca. 1925, postcard collection of Walker Evans

3. E. C. Kroff Co., *Presbyterian Church, St. Marys, Georgia*, ca. 1925, postcard collection of Walker Evans

4. Curt Teich & Co., *Gateway of Simonton House, Built 1776, Charleston, South Carolina*, ca. 1925, postcard collection of Walker Evans

5. S. H. Kress & Co., *Old Charleston Gate, Charleston, South Carolina*, ca. 1920, postcard collection of Walker Evans

1

2

3

4

5

6. Unidentified Publisher, *Soldiers' Monument, Dayton, Ohio*, ca. 1910, postcard collection of Walker Evans

7. Fred James, *Congregational Church, Boscawen, New Hampshire*, ca. 1925, postcard collection of Walker Evans

8. Coastal News Co., *Old Midway Church, Midway, Georgia, Near Savannah, Georgia*, ca. 1925 (mailed in 1938), postcard collection of Walker Evans

9. W. A. Ricker, *Doorway to Cate House, Castine, Maine*, ca. 1910 (mailed in 1916), postcard collection of Walker Evans

6

7

8

9

Unidentified Photographer, *Head of Corpse, Probably in Havana*, ca. 1933, press photograph reproduced by Walker Evans

Unidentified Photographer, *Corpse with Sutured Chest, Probably in Havana*, ca. 1933, press photograph reproduced by Walker Evans

Unidentified Photographer, *Bombed Wall, Probably in Havana*, ca. 1933, press photograph reproduced by Walker Evans

194

Unidentified Photographer, *Press Photograph of a Longshoreman*, 1930–40

Unidentified Photographer, *Nine Guns Propped on Bench Next to Valise, Probably in Havana*, ca. 1933, press photograph reproduced by Walker Evans

Unidentified Photographer, *Corpse of Gonzalez Rubiera with Blood-Stained Face, Havana*, ca. 1933, press photograph reproduced by Walker Evans

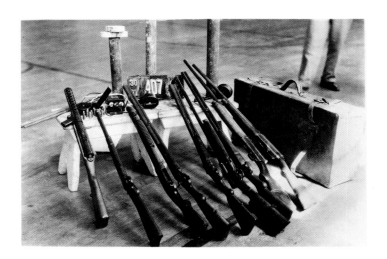

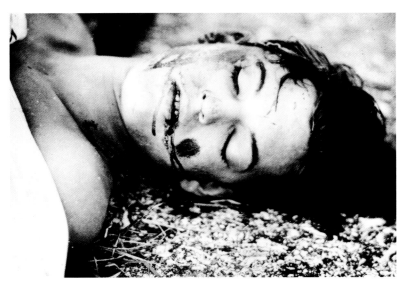

Pages of an album of picture press clippings titled "Pictures of the Time: 1925–1935," scrapbook of Walker Evans, end of the 1930s (and following spread)

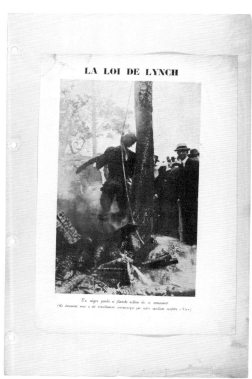

LA LOI DE LYNCH

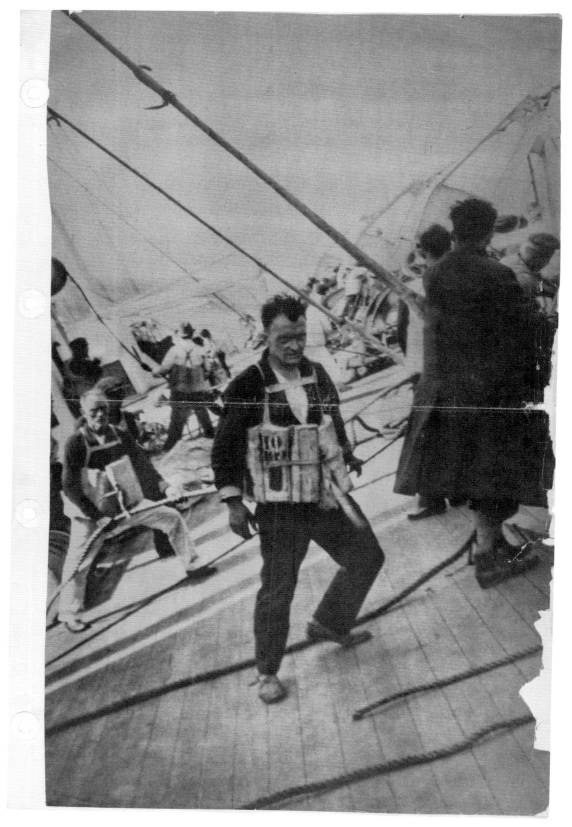

Average net paid circulation of THE NEWS, Dec., 1927:
Sunday, 1,357,556
Daily, 1,193,297

DAILY NEWS

NEW YORK'S PICTURE NEWSPAPER

PINK EDITION

Copyright, 1928, by News Syndicate Co., Inc. Reg. U. S. Pat. Off.

Entered as 2nd class matter Post Office, New York, N. Y.

Vol. 9. No. 174 28 Pages

New York, Saturday, January 14, 1928

2 Cents IN CITY LIMITS | 3 CENTS Elsewhere

CROWDS Follow Ruth and Judd to GRAVE

—Story on Page 3

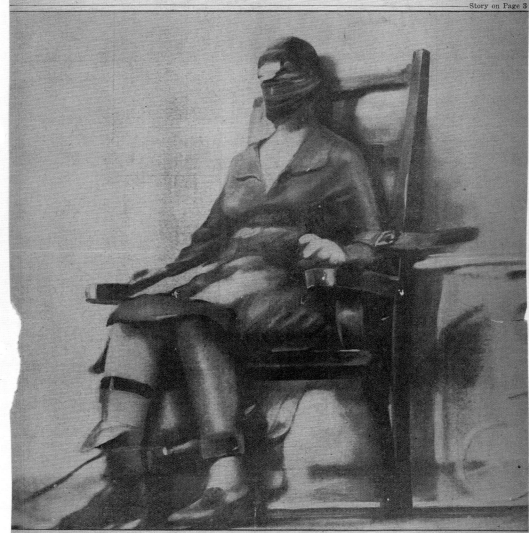

(Photos © 1928 by Pacific & Atlantic)

WHEN RUTH PAID HER DEBT TO THE STATE!—The only unofficial photo ever taken within the death chamber, this most remarkable, exclusive picture shows closeup of Ruth Snyder in death chair at Sing Sing as lethal current surged through her body at 11:06 Thursday night. Its first publication in yesterday's EXTRA edition of THE NEWS was the most talked-of feat in history of journalism. Ruth's body is seen straightened within its confining gyves, her helmeted head, face masked, hands clutching, and electrode strapped to her right leg with stocking down. Autopsy table on which body was removed is beside chair.

—Story on

Fliers Up 33 Hours at 8 o'Clock Despite Accidents to Plane—Page 2

Unidentified Street Photographer,
Portraits, ca. 1940–46

Unidentified Resort Photographer, *Portrait, Saint Petersburg, Florida*, ca. 1942

Unidentified Resort Photographer, *Portrait, Saint Petersburg, Florida*, ca. 1942

Unidentified Resort Photographer, *Portrait, Saint Petersburg, Florida*, 1943

Unidentified Resort Photographer,
Portraits, Saint Petersburg, Florida, 1940

Jeanne at 15 yrs.

Jeanne

Ruth + Jeanne – 1940

"Ruthie"

City Series

There is a form of serial systematism in Walker Evans's work that comes from applied photography. When he shot buildings, streets, doors, churches, or monuments, he did so in the style of a professional. The repetitiveness, impersonality, and lack of emphasis of his images are absolutely characteristic of commissioned photographs. By working like an architectural or postcard photographer, Evans positioned himself in diametric opposition to the artist-photographer exemplified at the time by Alfred Stieglitz. A few decades ahead of the conceptual artists of the 1960s, he made the codes of vernacular photography his own, thus creating everything while seeming not to.

Untitled (Greek Revival Doorway), ca. 1934

Doorway, Greenwich Village, New York, 1934

Ionic Doorway, New York State, 1931

Doorway, 204 West 13th Street, New York City, 1931

Untitled, 1936

Negro Church, South Carolina, March 1936

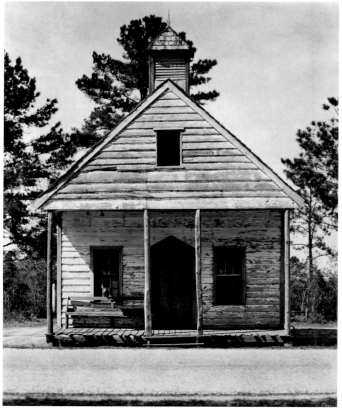

Wooden Church, South Carolina, 1936

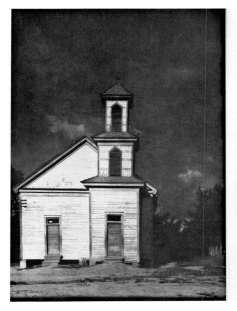

Primitive churches

Out-of-the-way churches like the ones on these pages comprise the most unnoticeable ecclesiastical architecture in the U.S. But they are unnoticeable with a vengeance: even the unbeliever must feel their force.

These buildings are primitive, if the term may be used without its shade of condescension. The wildest, most arresting examples are the converted stores in obscure neighborhoods of towns and cities. To the passing, uninitiated observer these can seem downright forbidding, and they are almost invariably the houses of religion in extremis. Gayer are the country churches of fading, weatherworn wood, with touches of old color on the trim. In these, the rewarding features are belfry and tower, sporting all variety of shingle play and dancing line.

Amplified by understatement, consecration here speaks tenfold over such labored glorifications as Saint Patrick's Fifth Avenue or the Cathedral of St. John the Divine. The harsh, yet happily shingled church on the facing page is in south-central Alabama, in a predominately Negro county. Below is a Church of the Nazarene in Tennessee. It may well be the most unstyled house of worship in the U.S.

TEXT AND PHOTOGRAPHS BY WALKER EVANS

"Gallery: Primitive Churches. Out-of-the-way vignettes of US religious life," *Architectural Forum* 115, no. 6 (December 1961), pp. 102–3

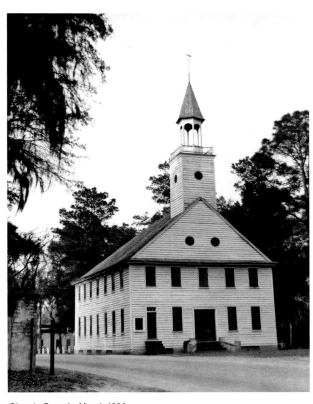

Church, Georgia, March 1936

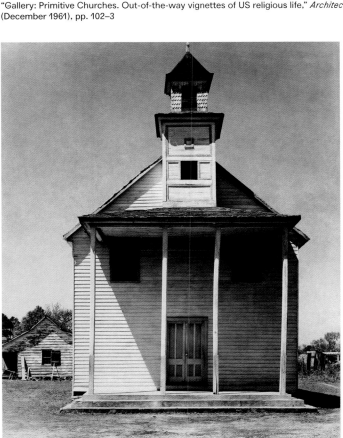

Negroes' Church, South Carolina, March 1936

Battlefield Monument, Vicksburg, Mississippi, 1936

Civil War Monument, Oxford, Mississippi, March 1936

Gravestone (Crystal Springs), Mississippi, 1935

Main Street of Pennsylvania Town, 1935

The Charm of Main Street

Unlike European cities organized around the seats of power, North American cities were built out from a central thoroughfare, Main Street. Walker Evans was fascinated by this distinctive feature of American town planning. Much of his postcard collection consists of views of the main streets of small-town America produced early in the twentieth century by the Detroit Publishing Company. Evans published several articles on these main streets in *Fortune* magazine and photographed them profusely. He liked the rhythm of the storefronts, the telegraph poles, and the diagonally parked cars. He felt these places had a real poetry.

Main Street of County Seat, Alabama, 1931

Main Street, Saratoga Springs, New York, 1931

Roadside View, Alabama Coal Area Company Town, 1935

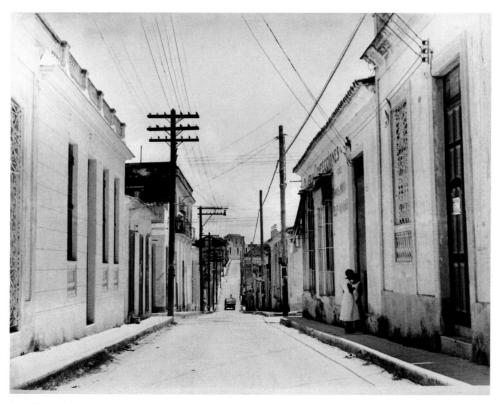

Small Town, Cuba, 1933

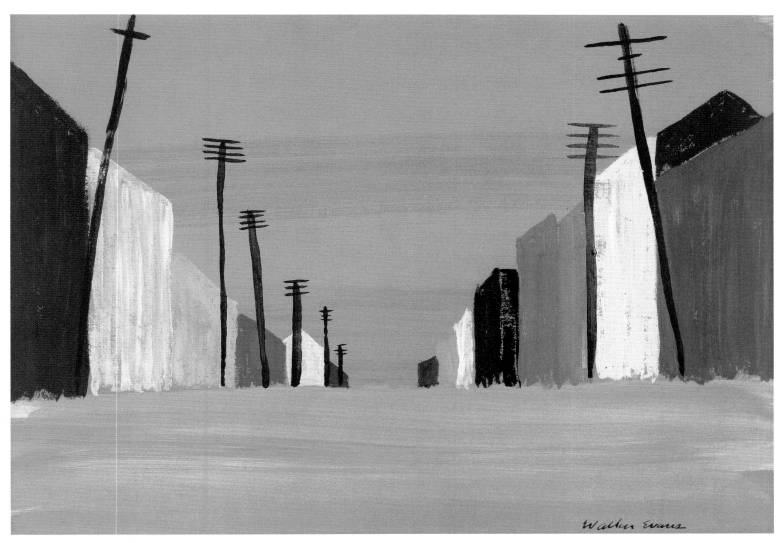

Untitled [Street Scene], ca. 1955, gouache on paper

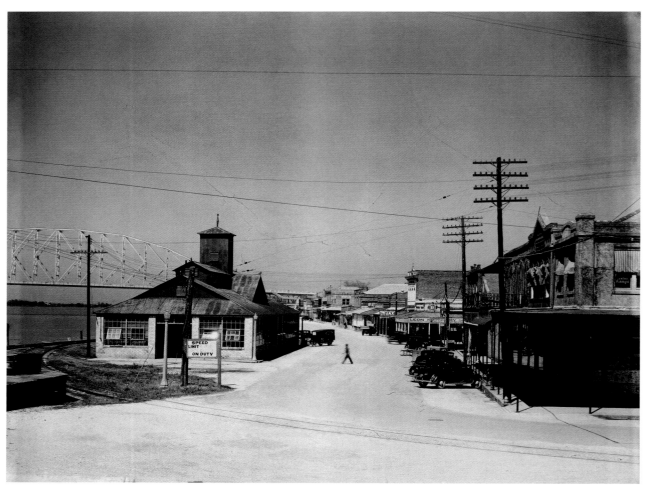

Main Street, from Across Railroad Tracks, Morgan City, Louisiana, 1935

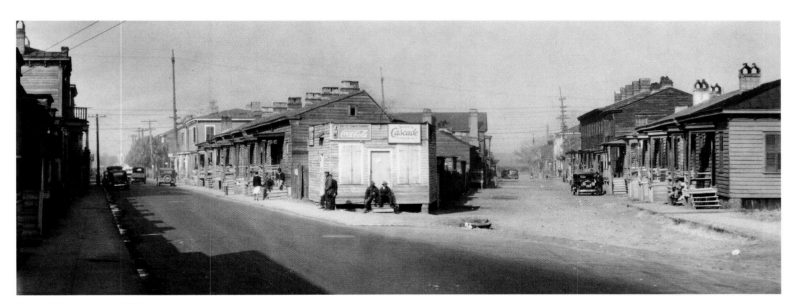

Savannah Negro Quarter, 1935

"MAIN STREET LOOKING NORTH FROM COURTHOUSE SQUARE"

A portfolio of American picture postcards from the trolley-car period.

THE mood is quiet, innocent, and honest beyond words. This, faithfully, is the way East Main Street looked on a midweek summer afternoon. This is how the county courthouse rose from the pavement in sharp, endearing ugliness. These, precisely, are the downtown telegraph poles fretting the sky, looped and threaded from High Street to the depot and back again, humming of deaths and transactions. Not everyone could love these avenues just emerged from the mud-rut period, or those trolley cars under the high elms. But those who did loved well, and were somehow nourished thereby.

What has become of the frank, five-a-nickel postcards that fixed the images of all these things? They arrived from the next town up the line, or from across the continent, inscribed for all to see: "Your Ma and I stopped at this hotel before you were ever heard of," or, shamelessly: "Well if she doesn't care any more than that I don't either. See you Tues." On their tinted surfaces were some of the truest visual records ever made of any period.

They are still around. Tens of thousands of them lie in the dust of attics and junk shops; here and there, files of good ones are carefully ranged in libraries, museums, and in the homes of serious private collectors. Postcard collectors today are a knowing and organized lot, well aware of what to look for, where to look, and how much to pay. As hobbies go, collecting early cards (circa 1890-1910) is financially reasonable: prices range from a penny to a dollar an item.

In the 1900's, sending and saving picture postcards was a prevalent and often a deadly boring fad in a million middle-class family homes. Yet the plethora of cards printed in that period now forms a solid bank from which to draw some of the most charming and, on occasion, the most horrid mementos ever bequeathed one generation by another. At their best, the purity of the humble vintage American cards shines exceeding bright in 1948. For postcards are now in an aesthetic slump from which they may never recover. Quintessence of gimcrack, most recent postcards serve largely as gaudy boasts that such and such a person visited such and such a place, and for some reason had a fine time. Gone is all feeling for actual appearance of street, of lived architecture, or of human mien. In the early-century days color photography was of course in its infancy. Cards were usually made from black-and-white photographs subsequently tinted by hand lithography. Withal, the best ones achieved a fidelity and a restraint that most current color-photography printers have yet to match—notably in flesh tints and in the rendering of patina and the soft tones of town buildings and streets.

But here in the mild morning of forty years ago is "Bank Square, 'Five Corners,' Fishkill-on-Hudson, N. Y.," epitome of Yankee utilitarianism in subject, in execution, and in mood. Made as a routine chore by heaven knows what anonymous photographer, the picture survives as a passable composition, a competent handling of color, and a well-nigh perfect record of place. Indeed, transcending place, it rings a classic note on the theme of small-town main streets. On these pages are a dozen and a half samples from the rich postcard field of realism, sentiment, comedy, fantasy, and minor historical document. They invite you to consider them as fondly, as patriotically, or as historically as you like. If you don't think there is such a thing as period physiognomy, look at the faces in the dice-game scene entitled "Where All Men Are Equal" on page 104. Reflect on the sensuous possibilities of "Listening to the Band, Hazle Park, Hazleton, Pa.," under those sun-mottled leaves, watching the movement of those white dresses. And alas, what were the ghastly events leading to that fateful walk in the woods recorded on page 105? What black anguish under that derby hat? How, with his masculine logic, did that pitiable male come up against the maddening cross-purposes met beneath that intractable sailor straw? **WALKER EVANS**

Bank Square, "Five Corners", Fishkill-on-Hudson, N. Y.

11854 FRIENDS MEETING HOUSE, PHILADELPHIA, PA.

Salisbury Beach, Mass.

"Main Street Looking North from Courthouse Square," *Fortune* 37, no. 5 (May 1948), pp. 102–6

UGH. COURT HOUSE

Chapel Street,
looking east.
New Haven,
Conn.

Picture Collection • N.Y. Public Library

Window Gazing

Means of transportation—the railroad in the nineteenth century and the automobile in the twentieth—played a crucial role in the growth of the United States. Walker Evans understood this very well, but he saw the issues less in terms of economics than of vision. By car or train, he liked nothing better than to "abandon himself to the rich pastime of window gazing." He did a lot of shooting from the window of a moving vehicle. It was not, however, the filtering out of speed that interested him, but rather his ability to satisfy his insatiable eye by affording it more of his favorite subjects more quickly: shop windows, factories, signs, architecture, and the whole American vernacular.

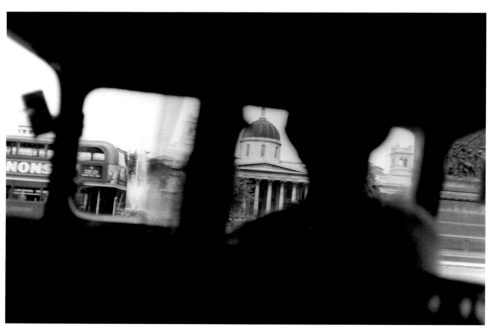

National Gallery/Trafalgar Square from Inside a Car, London, 1973

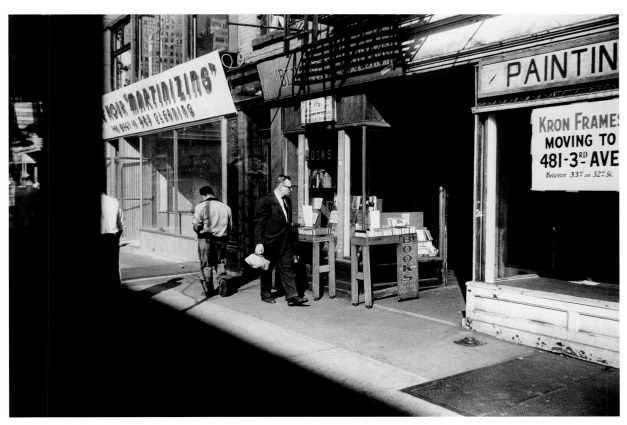

Blue Faun Bookshop, 3rd Avenue, New York, ca. 1950

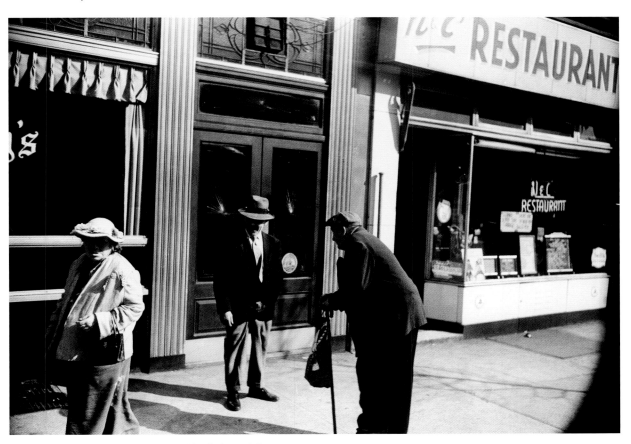

Two Elderly Men and a Woman, 3rd Avenue, New York, ca. 1950

Views from the Train, for the Series "Along the Right-of-Way," Fortune, September 1950, 1950

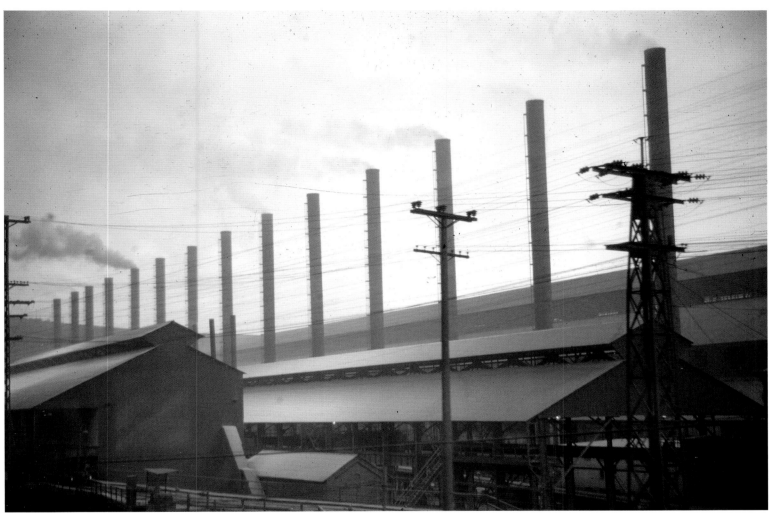

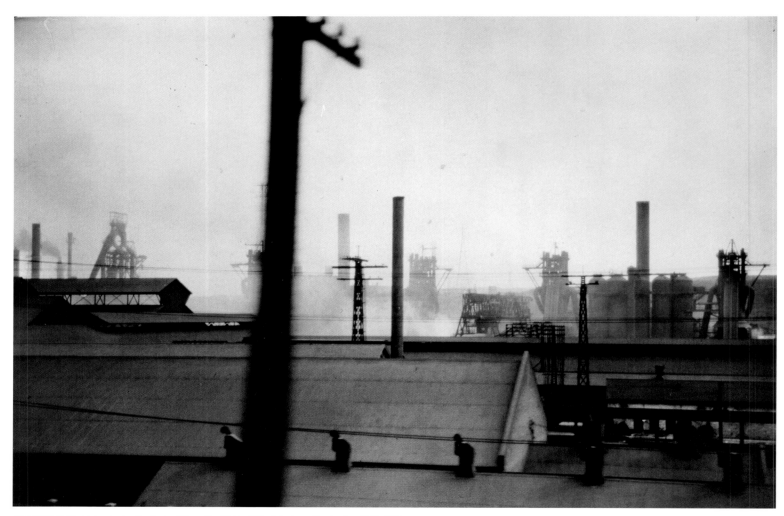

Steel Mills in Pennsylvania, for the Series "Along the Right-of-Way," Fortune, September 1950, 1950

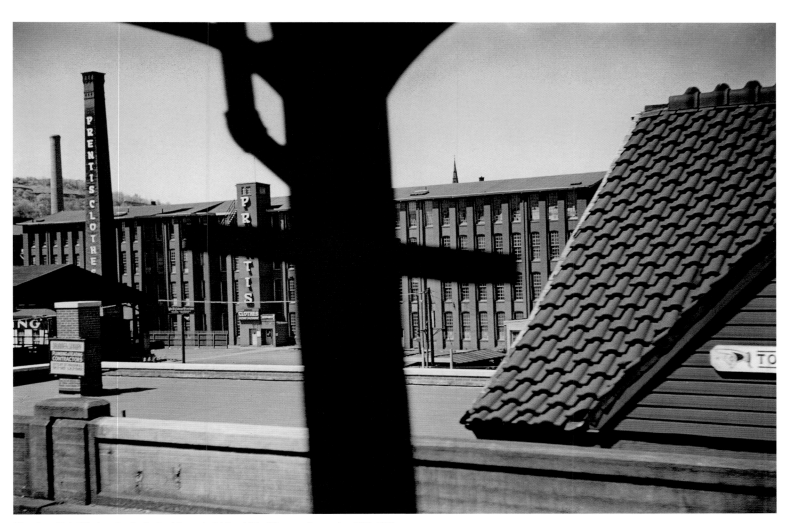

View from Train Window, for the Series "Along the Right-of-Way," Fortune, September 1950, 1950

Along
the
Right-of-Way

In Roomette 6, Car 287, the light has not yet been switched on. For an hour the train has swayed and rattled across the land. This rented steel cubicle, with its solemn and absorbing printed directions of how to work those basic gadgets, is the harassed man's haven of detachment. The captains and the kings depart. Now if ever, in this place and in this mood, the traveler can abandon himself to the rich pastime of window-gazing.

Along the paths of railroads, the country is in semi-undress. You can see some of the anatomy of its living: a back yard with its citizen poking into a rumble seat for a trusted toolbox; an intent group of boys locked in a sandlot ball game; a fading factory wall; a lone child with a cart. Out on the plains, the classic barns and the battalions of cabbages . . .

To some, these sights gain meaning because men like Mark Twain and Sherwood Anderson and Thomas Wolfe have, in a sense, laid hands on them. For others, one fleeting landscape can flush the mind with images of the enchantment a child feels with train trips: waking at dawn to see a cool cornfield cut by a rutted road; a farmer in his wagon drawn up at the crossing; the *TING TING* TING TING TING TING TING of the warning bell–that heart-rending tinny decrescendo which is an early lesson in relativity of the senses. *W.E.*

Seven photographs by Walker Evans of middle-western and eastern landscapes seen through train windows

From the Sunday A.M. local,

106

"Along the Right-of-Way," *Fortune* 42, no. 3 (September 1950), pp. 106–13

the New Jersey factory towns

107

Rolling into Chicago: loading docks along the Central's tracks

108

Gathering speed on a flat straightaway through the midwest farmlands

109

Approaching Pittsburgh: Saturday afternoon beside the Pennsy's roadbed

110

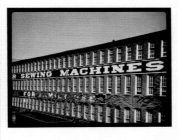

Past a Connecticut landmark: curving through Bridgeport, Shore Line

111

Through the citadels of steel production: Pennsylvania landscape

112

No. 24, fifteen minutes late, pulling out of Greensburg

113

229

Anonymous Passersby

In Bridgeport in 1941, in Detroit in 1946, and again somewhat later in Chicago, Walker Evans photographed pedestrians: men and women, middle class and working class, out for a stroll or on their way home from work. The only thing they had in common was that they were American and anonymous. Evans would position himself at an intersection or in front of a fence. He would prepare a rough frame and wait for passersby to stride into it of their own accord. He would work in the style of those street photographers who worked on the sidewalks of major cities, popping up in front of pedestrians and taking their picture. The challenge for him was to separate his subjects from the crowd while preserving their urban anonymity through a sort of automatic photography.

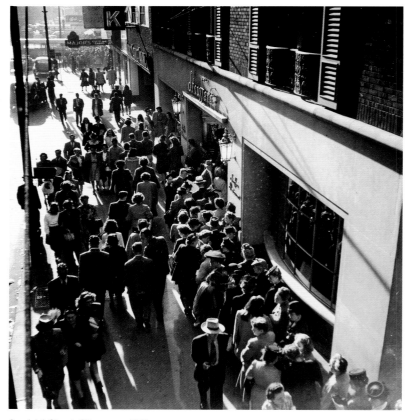

Randolph Street, Chicago, ca. 1946

230

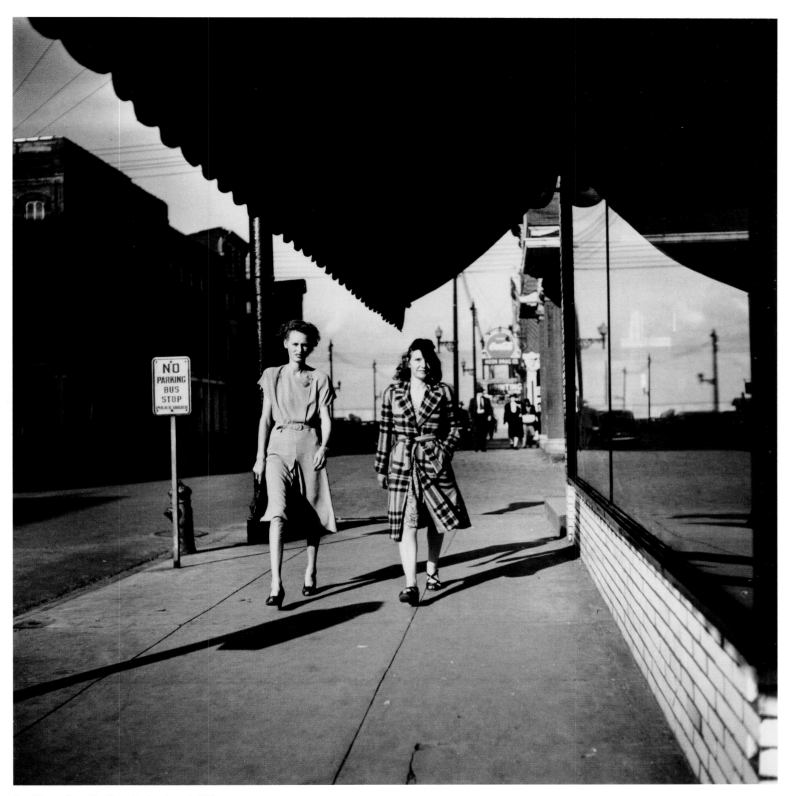

Two Women Beneath a Store Awning, August 1947

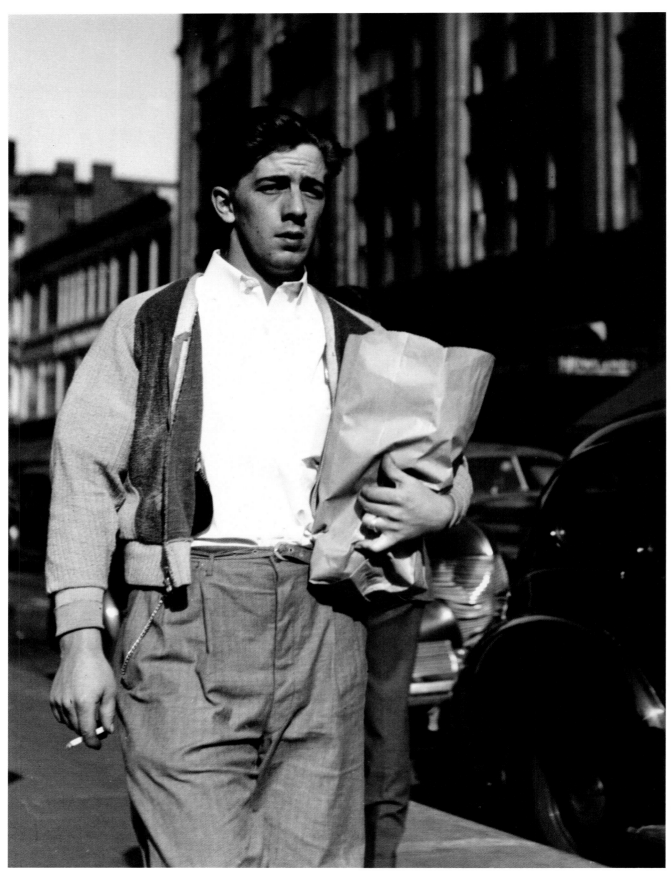

Bridgeport, Connecticut, 1941

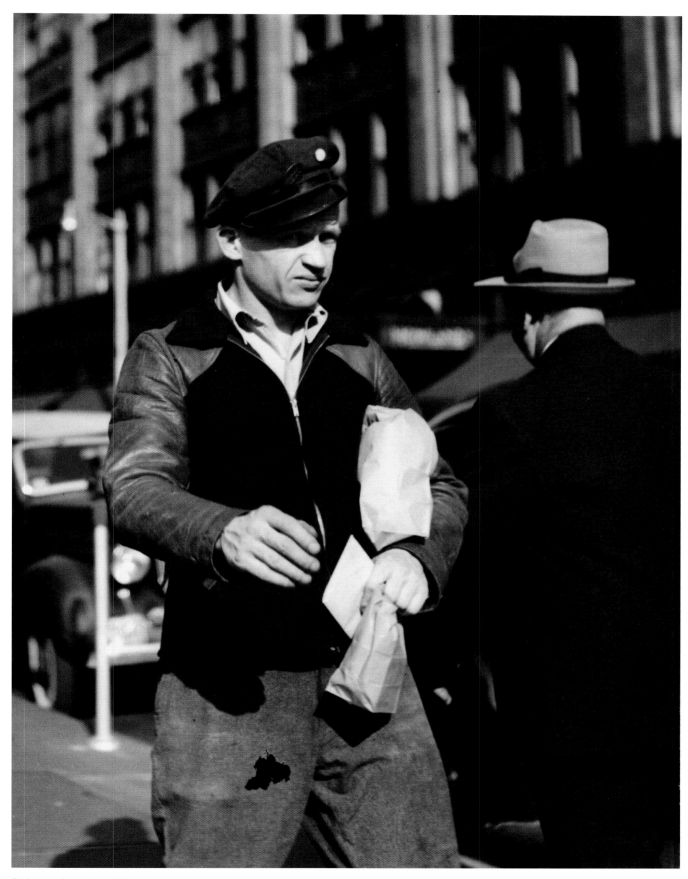

Bridgeport, Connecticut, 1941

Bridgeport, Connecticut, 1941

Bridgeport, Connecticut, 1941

Corner of State and Randolph Streets, Chicago, before February 1947

Edward Steichen, "In and Out of Focus," photographs by Walker Evans: *Corner of State and Randolph Streets, Chicago*, *U.S. Camera Annual 1949*, pp. 12–13

Corner of State and Randolph Streets, Chicago, 1946

Corner of State and Randolph Streets, Chicago, August 1946

Corner of State and Randolph Streets, Chicago, August 29, 1946–
February 1947

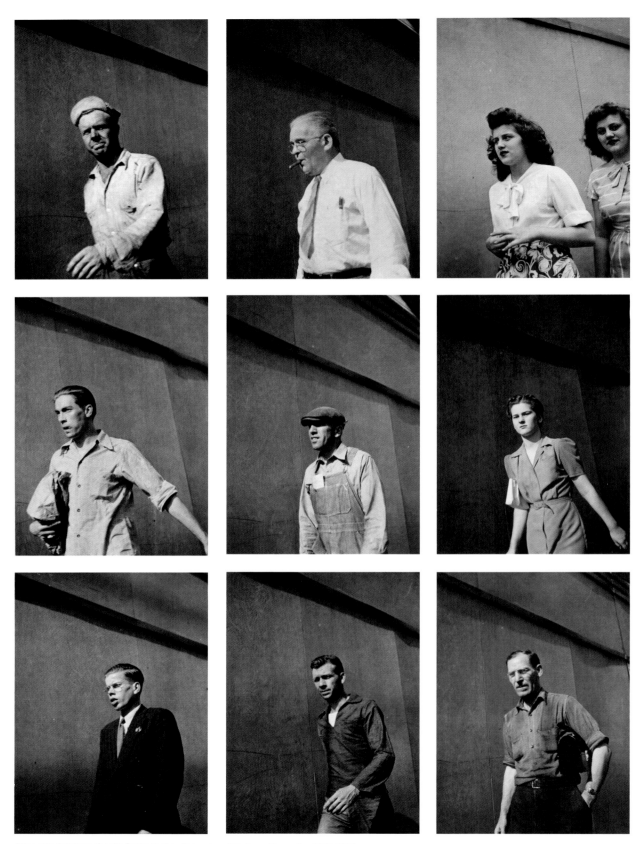

Detroit Pedestrians, for the Series "Labor Anonymous," Fortune, November 1946, 1946

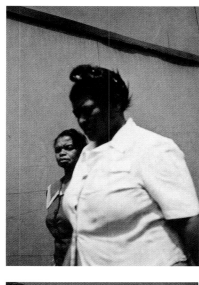 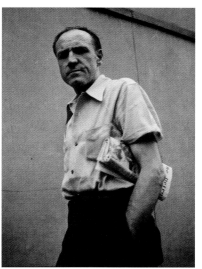 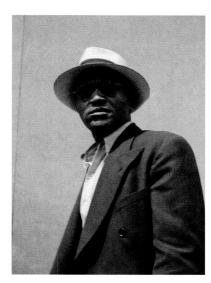

Detroit Pedestrian, for the Series "Labor Anonymous," Fortune, November 1946, 1946

Detroit Pedestrian, for the Series "Labor Anonymous," Fortune, November 1946, 1946

Labor Anonymous

"Labor Anonymous," *Fortune* 34, no. 5 (November 1946), pp. 152–53

ON A SATURDAY AFTERNOON IN DOWNTOWN DETROIT

The American worker, as he passes here, generally unaware of Walker Evans' camera, is a decidedly various fellow. His blood flows from many sources. His features tend now toward the peasant and now toward the patrician. His hat is sometimes a hat, and sometimes he has molded it into a sort of defiant signature. It is this variety, perhaps, that makes him, in the mass, the most resourceful and versatile body of labor in the world. If the war proved anything, it demonstrated that American labor can learn new operations with extraordinary rapidity and speedily carry them to the highest pitch of productive efficiency. There may often be a lack of the craftsmanly traditions of the Older Worlds, but the wide spectrum of temperaments rises to meet almost any challenge; in labor, as in investment portfolios, diversification pays off.

Another thing may be noticed about these street portraits. Most of the men on these pages would seem to have a solid degree of self-possession. By the grace of providence and the efforts of millions, including themselves, they are citizens of a victorious and powerful nation, and they appear to have preserved a sense of themselves as individuals. When editorialists lump them as "labor," these laborers can no doubt laugh that one off.

In Transit

During the winter of 1938, and then occasionally until 1941, Walker Evans photographed passengers on the New York subway. He worked with a small camera concealed under his overcoat. Part of the series would be published in magazines in 1956 and 1962, exhibited at The Museum of Modern Art, New York, in 1966, and published in book form that same year. Unlike a classic portrait photographer, Evans did not choose his subjects based on a particular characteristic, but rather captured passersby who "came unconsciously into range before an impersonal fixed recording-machine." Using his camera setup and then cropping tight shots of the face, he transformed the subway car into a photo booth, the most neutral and automatic of photographic processes.

Subway Portrait, 1941

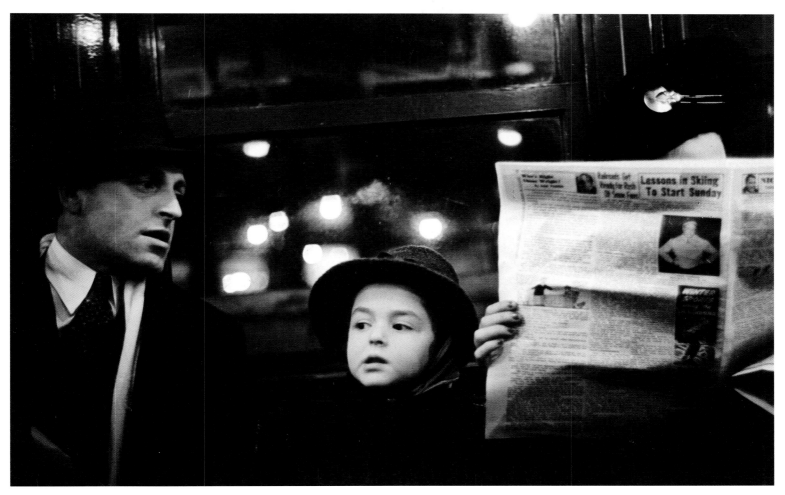

Subway Portrait, 1938

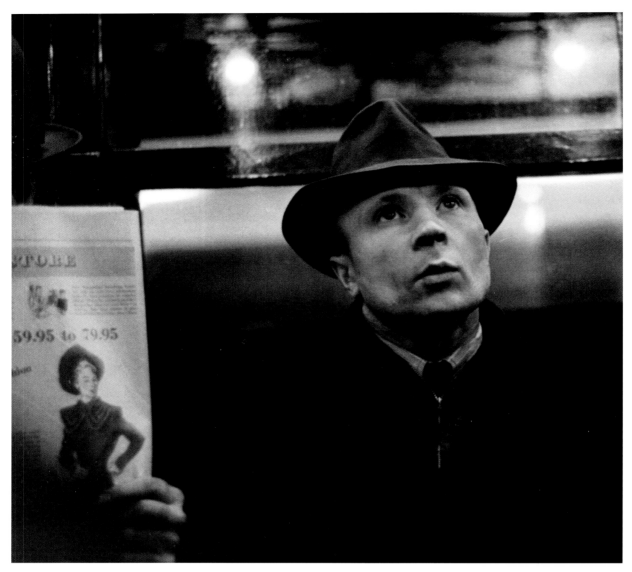

Subway Portrait, 1938–41

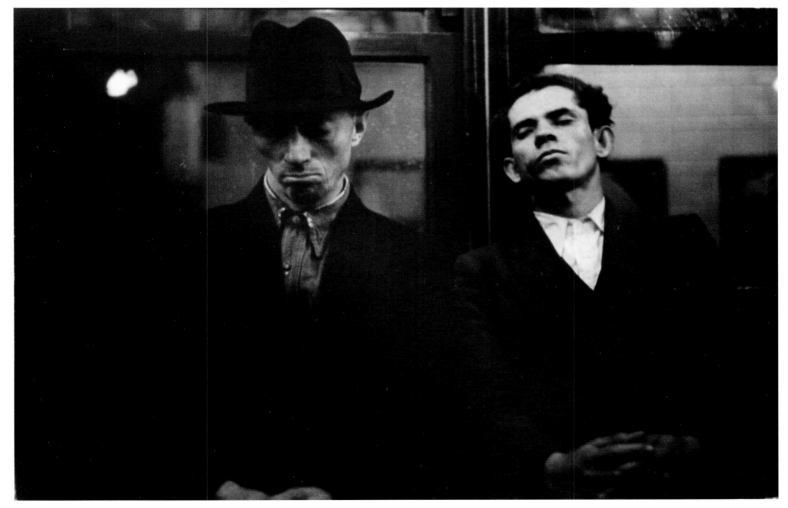

Subway Portrait, 1941

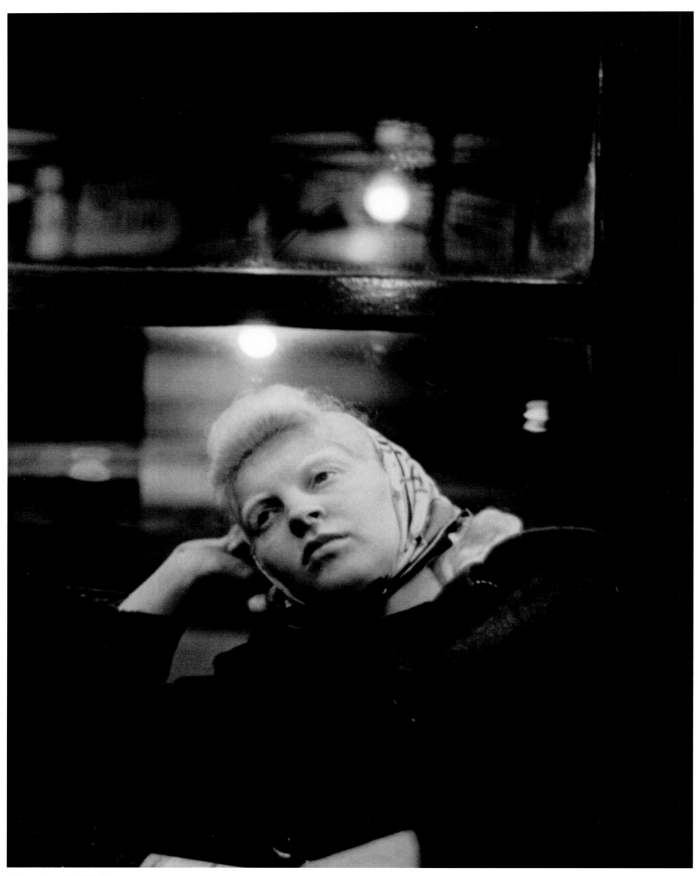

Subway Portrait, 1938–41

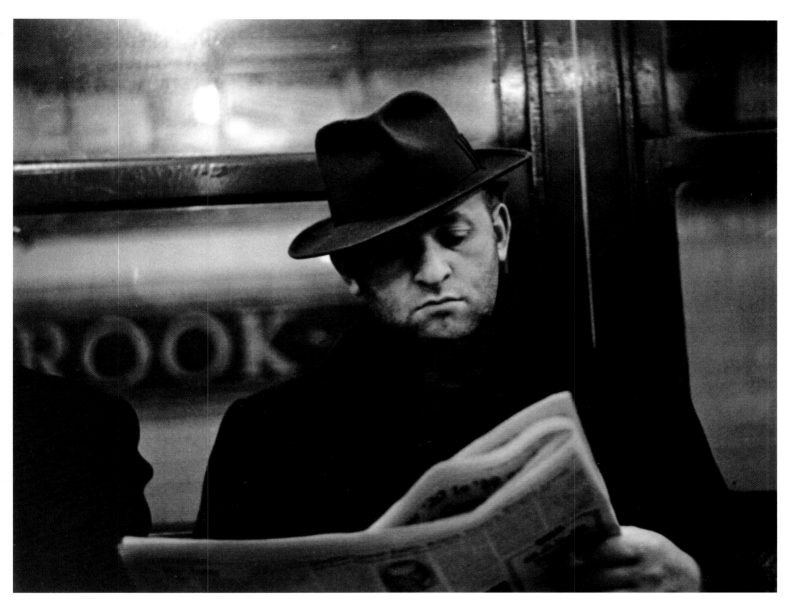

Subway Portrait, 1938–41

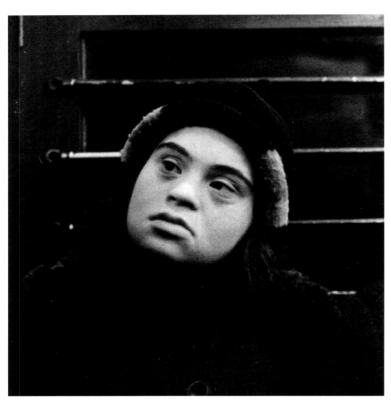

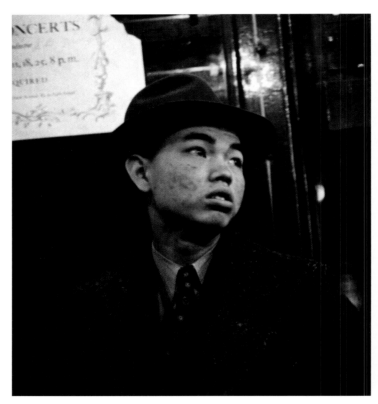

Subway Portrait, 1938–41

Subway Portrait, 1941

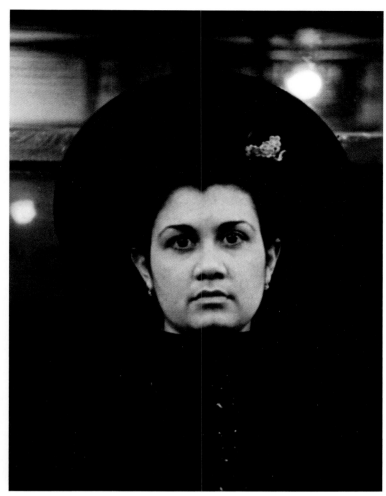

Subway Portrait, 1938–41

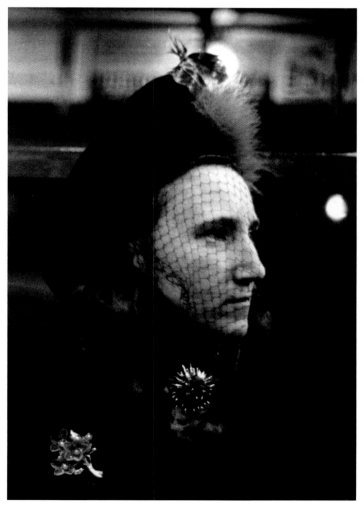

Subway Portrait, 1938–41

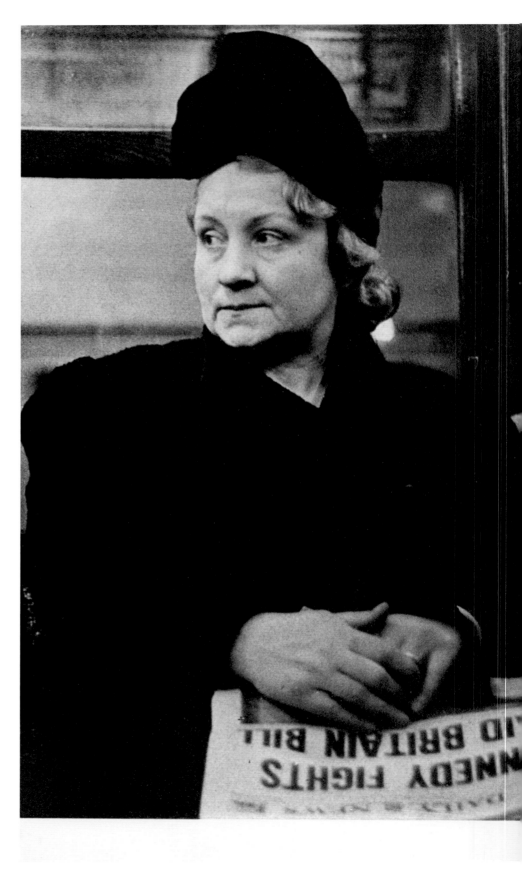

James Agee, "Rapid Transit: Eight Photographs," *The Cambridge Review*, no. 5
(Spring 1956), pp. 24–25

ese photographs were made in the subways of New York City, during late thirties and early forties of the twentieth century. The effort, ays, has been to keep those who were being photographed as unaware the camera as possible. To anyone who understands what a photo- ph can contain, not even that information is necessary, and any ther words can only vitiate the record itself. Because so few people understand what a photograph can contain, and because, of these, ny might learn, a little more will reluctantly be risked.

Those who use the New York subways are several millions. The facts ut them are so commonplace that they have become almost as mean- less, as impossible to realize, as deaths in war. These facts: who they , and the particular thing that happens to them in a subway: need f reviewing, and careful meditation.

They are members of every race and nation of the earth. They are all ages, of all temperaments, of all classes, of almost every imaginable upation. Each is incorporate in such an intense and various con- tration of human beings as the world has never known before. Each, , is an individual existence, as matchless as a thumbprint or a snow- e. Each wears garments which of themselves are exquisitely subtle forms and badges of their being. Each carries in the postures of his ly, in his hands, in his face, in the eyes, the signatures of a time 1 a place in the world upon a creature for whom the name immortal l is one mild and vulgar metaphor.

The simplest or the strongest of these beings has been so designed on by his experience that he has a wound and a nakedness to conceal, 1 guards and disguises by which he conceals it. Scarcely ever, in the ole of his living, are these guards down. Before every other human ng, in no matter what intimate trust, in no matter what apathy, some- ng of the mask is there; before every mirror, it is hard at work, saving creature who cringes behind it from the sight which might destroy Only in sleep (and not fully there); or only in certain waking moments suspension, of quiet, of solitude, are these guards down: and these ments are only rarely to be seen by the person himself, or by any er human being. At the ending of *City Lights*, that was precisely at Chaplin was using, and doing. In that long moment in which, tly gnashing apart the petals of his flower, his soul, his offering, he rceives in the scarcely pitying horror of the blind girl to whom he has en sight, himself as he is, he has made full and terrific use of this fact. t it has almost never been used in art; and it is almost never seen in life.

James Agee
October, 1940

The crashing non-euphoria of New York subway life may someday be recorded by a modern Dickens or Daumier. The setting is a sociological gold mine awaiting a major artist. Meanwhile, it can be the dream 'location' for any portrait photographer weary of the studio and of the horrors of vanity. Down in this swaying sweatbox he finds a parade of unselfconscious captive sitters, the selection of which is automatically destined by raw chance.

The portraits on these pages were caught by a hidden camera, in the hands of a penitent spy and an apologetic voyeur. But the rude and impudent invasion involved has been carefully softened and partially mitigated by a planned passage of time. These pictures were made twenty years ago, and deliberately preserved from publication.

As it happens, you don't see among them the face of a judge or a senator or a bank president. What you do see is at once sobering, startling and obvious: these are the ladies and gentlemen of the jury.

——*Walker Evans*

HARPER'S BAZAAR, M

"Walker Evans: The Unposed Portrait," *Harper's Bazaar* (March 1962), pp. 120–21

AZAAR, MARCH 1962

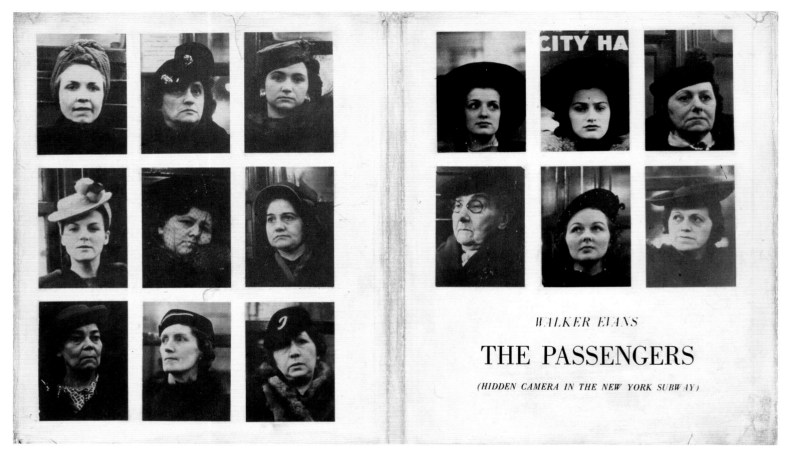

WALKER EVANS

THE PASSENGERS

(HIDDEN CAMERA IN THE NEW YORK SUBWAY)

Maquette for dust jacket of *The Passengers*, 1958–66, unpublished book project

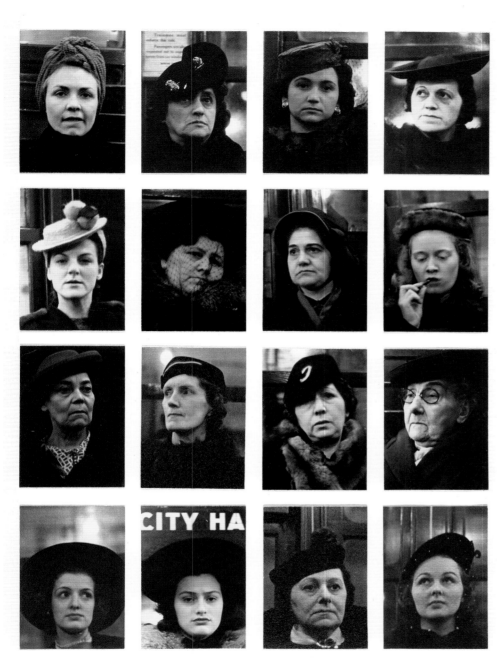

Subway Portraits, 1938–41, assembled ca. 1959

Self-Portrait in Automated Photobooth, ca. 1933

Souvenir Portraits

Walker Evans's inventory of the vernacular would be incomplete if he had not also taken an interest in family photography. From his early days, he took portraits of his friends and of his future wife, Jane Ninas. In amateur style, he took snapshots, without preparation, centering his subject. In Alabama, in 1936, he created a veritable monument to this way of working by simply photographing two small snapshots tacked to a wall. Forty years later, the Polaroid company gave him an SX-70 camera and an unlimited supply of film. During the last three years of his life, his main photographic activity consisted of indulging in this form of popular photography, taking thousands of portraits of friends and family.

Jane Ninas in Front of Parked Cars, in the French Quarter, New Orleans, 1935

Family Snap Shots in Frank Tengle's Home, Hale County, Alabama, July–August 1936

Untitled [Gay Burke, Tuscaloosa, Alabama], October 26, 1973

Untitled [Gay Burke Brushing Her Hair, Old Lyme, Connecticut], May 1974

Untitled [Walker Evans], May 4, 1974

Untitled [Boy Eating Cracker], 1973–74

Untitled [Jerry Thompson], October 1973

Untitled [Nancy Shaver], November 12, 1973

Utilitarian Elegance

Walker Evans also spent a good deal of time looking at tool and manufacturing catalogues and illustrations in encyclopedias and scientific books. He admired the visual effectiveness of these pages covered with utensils set against a neutral background, perfectly underscoring the elegance of their shapes. It was exactly this form of immediacy that he sought to re-create in his own images. In the mid-1930s, he took a series of photographs of wrought metal chairs, like a professional would for a promotional catalogue. In 1955, he produced a portfolio for *Fortune* magazine on the beauty of ordinary tools in which he praised the hardware store as a kind of offbeat museum show. There, he discovered wonders of elegance.

Iron Chair, 1934

Iron Chair, 1934

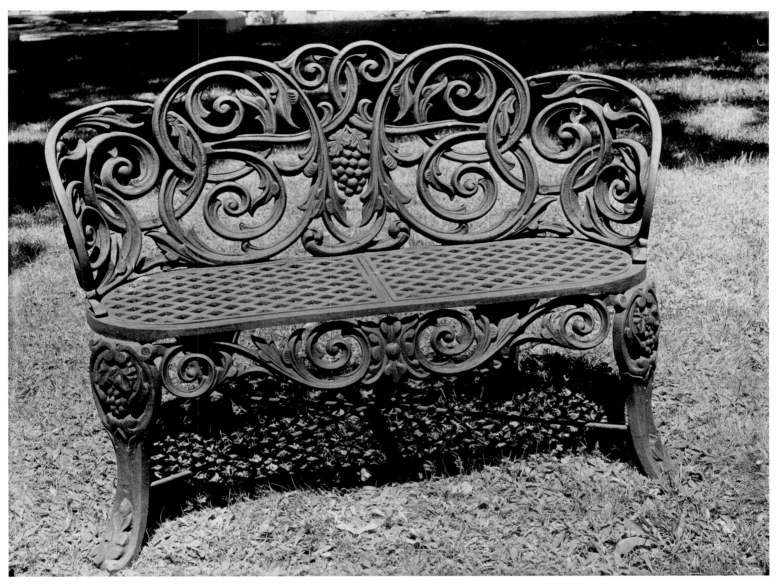

Iron Chair, 1934

Stahls chain-nose pliers (over actual size), from Eskilstuna, Sweden, $2.49

Beauties of the Common Tool

A portfolio by Walker Evans

Among low-priced, factory-produced goods, none is so appealing to the senses as the ordinary hand tool. Hence, a hardware store is a kind of offbeat museum show for the man who responds to good, clear "undesigned" forms. The Swedish steel pliers pictured above, with their somehow swanlike flow, and the objects on the following pages, in all their tough simplicity, illustrate this. Aside from their functions—though they are exclusively wedded to function—each of these tools lures the eye to follow its curves and angles, and invites the hand to test its balance.

Who would sully the lines of the tin-cutting shears on page 105 with a single added bend or whorl? Or clothe in any way the fine naked impression of heft and bite in the crescent wrench on page 107? To be sure, some design-happy manufacturers have tampered with certain tool classics; the beautiful plumb bob, which used to come naively and solemnly shaped like a child's top, now looks suspiciously like a toy space ship, and is no longer brassy. But not much can be done to spoil a crate opener, that nobly ferocious statement in black steel, as may be seen on page 104. In fact, almost all the basic small tools stand, aesthetically speaking, for elegance, candor, and purity. —W.E.

"Beauties of the Common Tool," *Fortune* 52, no. 1 (July 1955), pp. 103–7

Baby Terrier crate opener, by Bridgeport Hardware Mfg. Corp., 69 cents

Tin snips, by J. Wiss & Sons Co., $1.85

Bricklayer's pointing trowel, by Marshalltown Trowel Co., $1.85

Open-end crescent wrench, German manufacture, 56 cents

Bricklayer's Pointing Trowel, by Marshaltown Trowel Co., $1.35, 1955

Open End Crescent Wrench, 1955

Chain-Nose Pliers, 1955

Tin Snips by J. Wiss and Sons Co., $1.85, 1955

["T" Bevel], 1955

Crate Opener, 1955

African Objects

In 1935, at the request of The Museum of Modern Art, New York, Walker Evans photographed two-thirds of the 600 sculptures in its *African Negro Art* exhibition. Seventy-five of these images toured the United States, and seventeen portfolios of 477 prints each were published. Unlike most of the other photographers of the era, including Man Ray and Charles Sheeler, who photographed African sculpture making use of shadow to reinforce its expressionistic character, Evans aimed for neutrality. He used tight framing on a neutral background, rotating the light around the object during long exposure times to make the shadows disappear. Once again, he went for immediacy and effectiveness, in the style of catalogue photographers.

Plate no. 249 in *African Negro Art* portfolio, 1935

Enlargement of plate no. 417 in *African Negro Art* portfolio, 1935

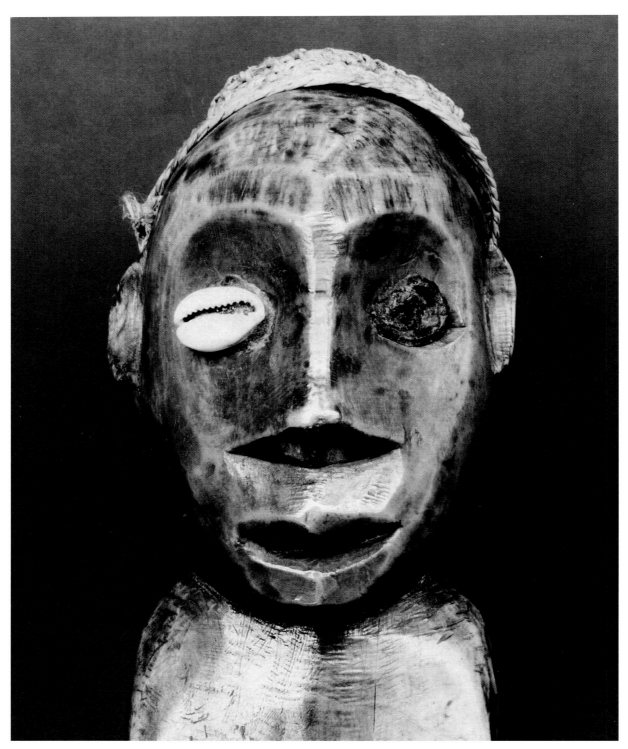

Plate no. 402 in *African Negro Art* portfolio, 1935

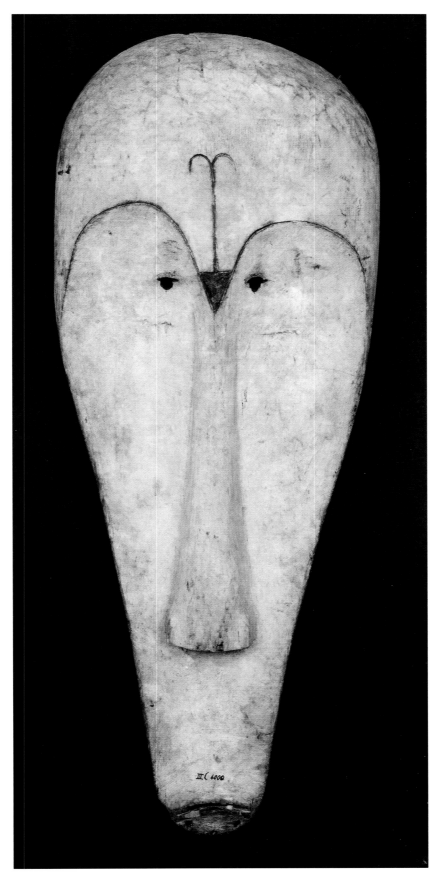

Plate no. 351 in *African Negro Art* portfolio, 1935

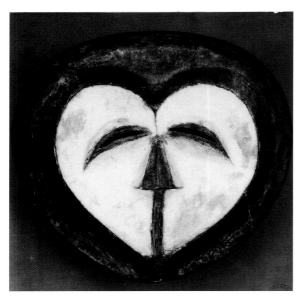

Plate no. 358 in *African Negro Art* portfolio, 1935

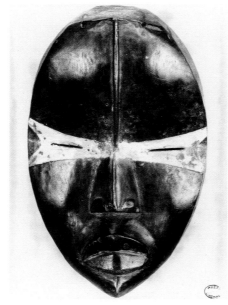

Plate no. 102 in *African Negro Art* portfolio, 1935

Plate no. 107 in *African Negro Art* portfolio, 1935

Plate no. 283 in *African Negro Art* portfolio, 1935

Plate no. 271 in *African Negro Art* portfolio, 1935

Plate no. 476 in *African Negro Art* portfolio, 1935

Plate no. 330 in *African Negro Art* portfolio, 1935

Plate no. 407 in *African Negro Art* portfolio, 1935

Plate no. 436 in *African Negro Art* portfolio, 1935

Plate no. 450 in *African Negro Art* portfolio, 1935

Plate no. 144 in *African Negro Art* portfolio, 1935

Plate no. 139 in *African Negro Art* portfolio, 1935

The Circus Wagon

Walker Evans was captivated by everything related to transportation: cars, the road itself, the roadside and its specific architecture, trains and their passengers, what could be seen from their windows, and so on. In 1941, in Sarasota, Florida, he discovered the place where one of the most famous American circuses, Ringling Brothers, stored its old wagons. Like a forensic scientist responsible for taking a detailed survey of a crime scene, he photographed them from every angle: front, side, and three-quarter view, in detail or in context. The popular, utilitarian, and antiquated aspects of these vehicles fascinated him. They condensed two of his favorite themes into a single object: the vernacular and the vehicular.

Circus Wagon (Calliope Car), Winter Quarters, Sarasota, 1941

Circus Wagons, 1972

Ringling Bandwagon, Circus Winter Quarters, Sarasota, 1941

Ringling Bandwagon, 1941

Ringling Bandwagon, Circus Winter Quarters, Sarasota, 1941

64

Alice S. Morris, "The Circus at Home. Photographed in Sarasota by Walker Evans," *Harper's Bazaar* 73 (April 1942), pp. 64–65

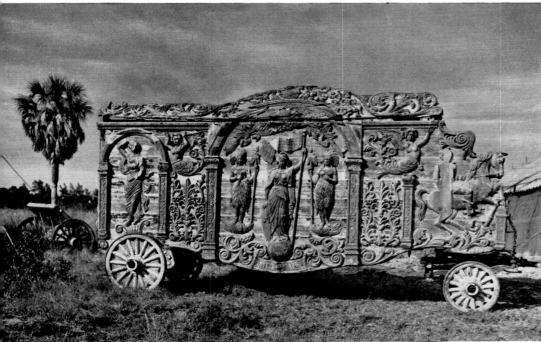

Photographed in Sarasota by Walker Evans

THE CIRCUS AT HOME

• For the four winter months the circus is at home in Sarasota. It rests, lets down its hair, gets in its annual groundwork for the great spring exodus to Madison Square Garden and points north, south, and sideways. Near the end of November, the ninety cars of circus train pull into the old Sarasota Fair Grounds outside the city, are shunted off in long lines to laze in the flat Florida sun. The animals' wagons roll off their flat-cars, rejoin the spaced-out rows of left be-hinds: the magnificent circus wagons of the past—heavily carved, adorned with caryatids and weathered paint—too old now, or too cumbersome, for the new, crack, streamlined, air-conditioned Greatest Show on Earth. Some of the animals remain in their wagons, scattered at random about the grounds, or go into the menagerie under the tent house; others have corrals, kraals, special shelters. Roustabouts set to putting up the 1941 Big Top; the Bel Geddes vision in black and red canvas lifts skyward, empty, a tunnel of huge darkness—not to be used now, but just to be safeguarded against mildew, creasing, and cracking. In the tent house, 21,800 yards of new canvas are put in work for the 1942 Big Top; last year's already takes on the status of a spare. High above the tentmakers' heads extends a wooden gallery hung with the circus finery of years—a splotched kaleidoscope of masks, headdresses, elephant trappings, trapeze and bareback spangles, clown motley.

Stretch of wagons and canvas tops . . . gleam of silver paint, red trim . . . smell of upturned turf and animals in the sun . . . screams, roars, barks, chatterings of beasts . . . stutter of tractors hauling cars and cages over the shabby grass . . . soft Indian cries of Amer-ican trainers exhorting the elephants in the (Continued on page 116)

65

(CONCL

PHOTO-GRAPHY, ITSELF
USION)

American vernacular culture was at the heart of Walker Evans's work. He documented it, drawing inspiration from the forms and procedures of vernacular photography. For him, the vernacular was thus both a *subject* and a *method*. Yet he sometimes chose subjects that did not simply come under the heading of vernacular culture in general, but more specifically, of vernacular photography itself: the front of a neighborhood studio, a postcard display, family portraits hanging on a wall, and a few itinerant or seasonal street photographers. He thus folded the method into the subject and produced photographs that constitute professions of faith expressing his concept of photography—in short, photographic manifestos.

Postcard Display, 1941

Penny Picture Display, Savannah, 1936

Photographic Enlargers, ca. 1946, crayon on paper

Self-Portrait with Enlarger, ca. 1930

Untitled [Walker Evans's Darkroom at 92 Fifth Avenue], ca. 1930

Walker Evans's Darkroom, ca. 1930

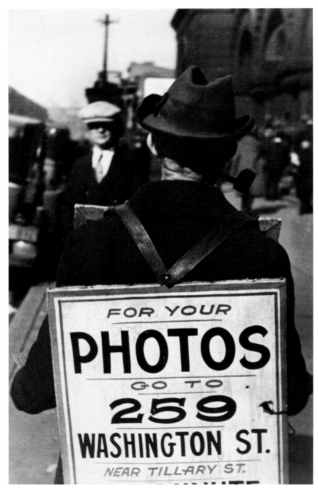

Sandwich-Man Advertising Washington Street Studio, ca. 1930

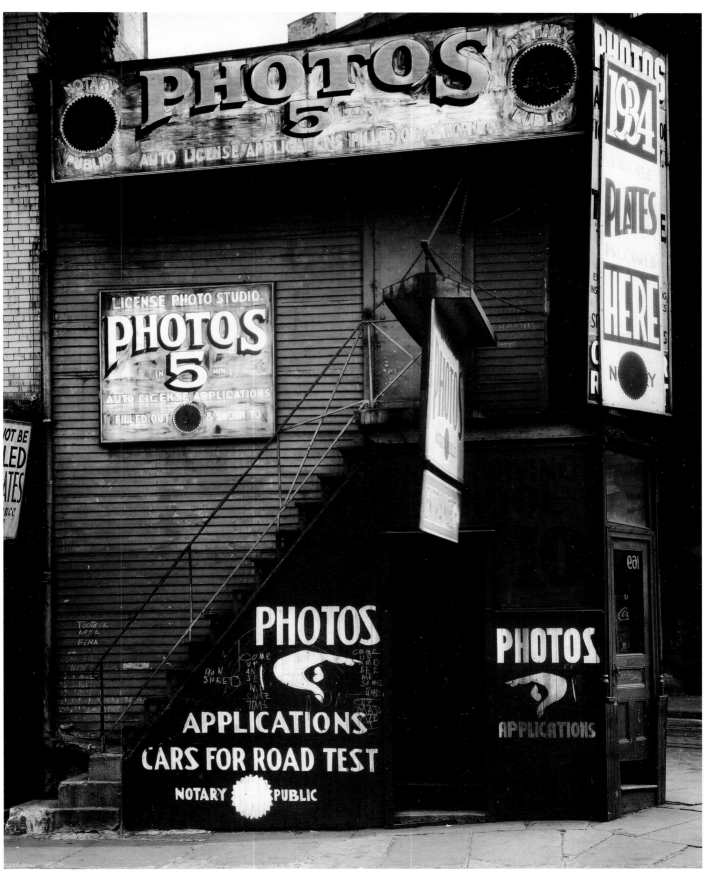

License Photo Studio, New York, 1934

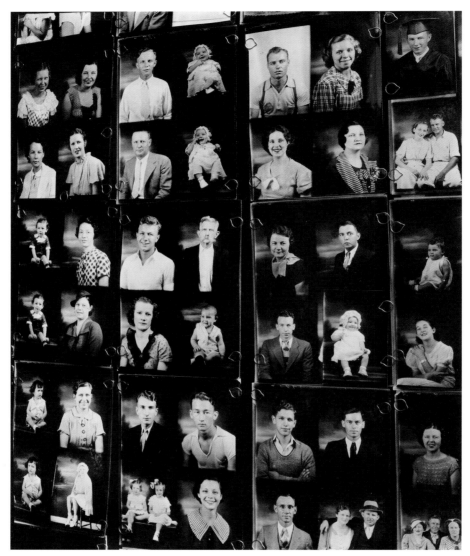

Untitled, Photographer's Window, 1936

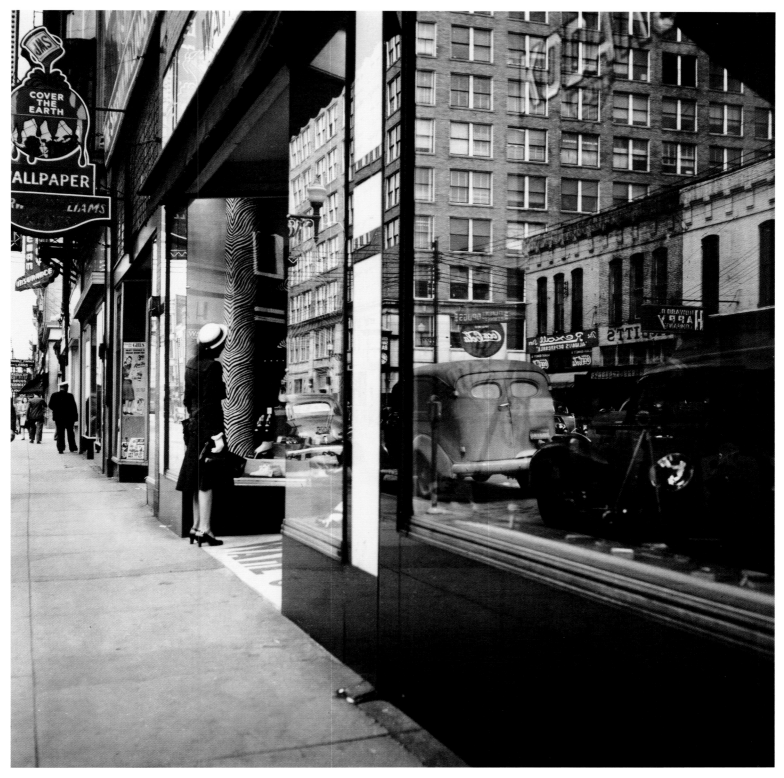

Store Window Reflections, August 1947

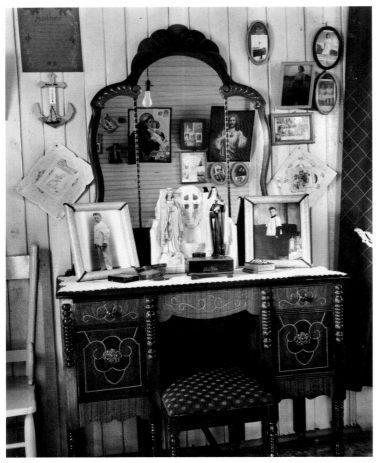

Bedroom Dresser, Shrimp Fisherman's House, Biloxi, Mississippi, 1945

Bed and Stove, Truro, Massachusetts, 1931

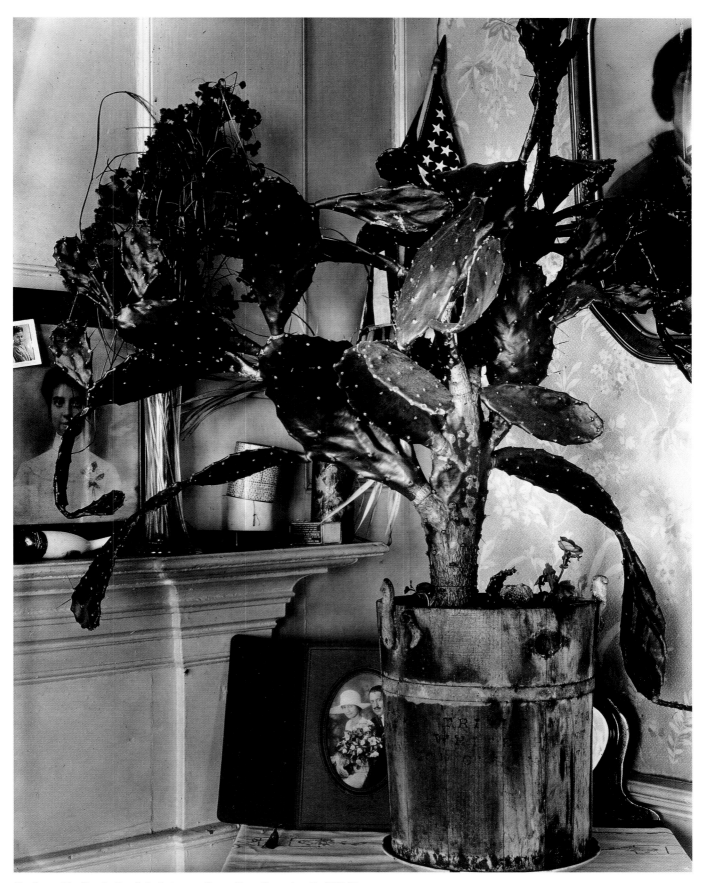

The Cactus Plant/Interior Detail of a Portuguese House, Truro, Massachusetts, 1930–31

Untitled, ca. 1930

Yale Graduate Photography Students on Street, near Accomac, Virginia, 1973

Resort Photographer at Work, 1941

Untitled [Marcia Due and Leila Hill], 1973–74

Untitled [Walker Evans Dinner Party, Old Lyme, Connecticut: Jerry Thompson, Barbara Gizzi, and Mary Knollenberg], October 12, 1973

Untitled [Polaroid Film Packs and Boxes in Grass], May 19, 1974

CHRONOLOGY

1903-15: Walker Evans is born on November 3, 1903, in Saint Louis, Missouri, to Jessie (Crane) Evans and Walker Evans Jr., who works in advertising. In 1907, the family moves to Kenilworth, Illinois, and then in 1915, to Toledo, Ohio.

1919: Evans enters high school at Loomis Chaffee, in Windsor, Connecticut. He remains there until 1920, and then joins his mother and sister in New York.

1921-22: In the fall of 1921, he enters Phillips Academy in Andover, Massachusetts. The following year, he enrolls at Williams College, in Williamstown, Massachusetts.

1923-25: Evans returns to New York in 1923. From March 1924 to the fall of 1925, he works in the Map Division of the New York Public Library.

1926-27: On April 6, 1926, Evans sails for Paris, where he spends 13 months, taking classes at the Sorbonne and studying French at the Collège de la Guilde. He takes a few snapshots with a small-format camera. He travels to the South of France that summer and in January 1927, and visits Italy in April, returning to New York the following month.

1928: Evans shares an apartment in Columbia Heights, a neighborhood of Brooklyn, with painter Hanns Skolle and becomes friends with a neighbor, poet Hart Crane. He works as a clerk on Wall Street until 1929.

1929: Late in the year, he becomes friends with Berenice Abbott.
In August, Evans publishes a translation of an excerpt from *Moravagine* (1926) by Blaise Cendrars, as well as a first photograph in the short-lived avant-garde magazine *Alhambra*.
He begins using a view camera.

1930: Early in the year, Evans declares himself a "photographer." He befriends Lincoln Kirstein, who is a Harvard student at the time, and discovers the work of Eugène Atget in Abbott's studio.
In January, Evans publishes a review of the book *Dancing Catalans* by John Langdon-Davies. Three of his photographs illustrate *The Bridge*, a poem by Hart Crane. Other publications follow in *Architectural Record*, *Hound & Horn*, and *Creative Art*.
In May, Evans begins using Ralph Steiner's glass plate camera (6½ x 8½ inches).
In November, Kirstein includes Evans in the exhibition *Photography* at the Harvard Society of Contemporary Art.

1931: In the spring, Evans publishes two photographs in *Hound & Horn*. The magazine also publishes his article "The Reappearance of Photography," a review of modern European photography, that winter.
Evans exhibits with Margaret Bourke-White and Ralph Steiner at the John Becker Gallery in New York, and then participates in the Third Annual Exhibition of Contemporary Photography at Ayer Galleries in Philadelphia.
In the spring and summer, Evans accompanies Kirstein and architectural historian John Brooks Wheelwright to the Boston area, where he photographs Victorian vernacular architecture. Some 40 of these photographs are exhibited at New York's Museum of Modern Art (MoMA) in 1933.
Evans spends the summer with painter Ben Shahn and his family at their home on Cape Cod.
Receiving a commission from architect Charles Fuller, Evans continues his documentation of American vernacular architecture.

1932: From January to April, Evans is engaged as a photographer aboard a private yacht, the *Cressida*, for a cruise in the Pacific.
In February, the exhibition *Modern Photographs by Walker Evans and George Platt Lynes* is held at the Julien Levy Gallery in New York.

1933: In May, Evans travels to Havana to photograph a portfolio for Carleton Beals's book *The Crime of Cuba* (1933).
At year end, MoMA presents the exhibition *Walker Evans: Photographs of Nineteenth-Century Houses*, organized by Kirstein, in the Department of Architecture gallery.

1934: In September, Evans works for the first time with *Fortune* magazine, producing six photographs

to illustrate Dwight Macdonald's article on the Communist Party USA.
In November, Gifford Cochran, a friend of Kirstein, asks Evans to photograph his home in Croton Falls, New York, along with other Neoclassical buildings in the region.

1935: Cochran commissions Evans to expand his documentation to the South. In February, the photographer travels to Savannah and then to New Orleans, where he meets Jane Smith Ninas, a young artist who assists him on the project. He then goes to Morgan City and Natchez.
On returning to New York in early April, he photographs the African art sculptures for MoMA's *African Negro Art* exhibition. He compiles 17 portfolios consisting of 477 photographs each.
In the spring, he takes part in the exhibition *Documentary and Anti-Graphic: Photographs by Manuel Alvarez Bravo, Henri Cartier-Bresson, and Walker Evans* at the Julien Levy Gallery.
On September 16, he begins working for the U.S. government's Resettlement Administration (later the Farm Security Administration, or FSA), an agency of the Department of Agriculture that provides financial assistance to farmers hard hit by the Depression. Evans leaves on October 31 to photograph Bethlehem, Pennsylvania, and then travels to New Orleans, Alabama, Mississippi, and Georgia.

1936: In the spring, Evans heads to Washington, D.C., by way of South Carolina and West Virginia.
In May, writer James Agee, whom *Fortune* has just commissioned to write an article on Southern sharecroppers, suggests Evans accompany him. They spend the summer in Hale County, Alabama, where they live with three families: the Fields, the Tengles, and the Burroughs. *Fortune* declines to publish the resulting essay. Agee works the manuscript into a book, *Let Us Now Praise Famous Men* (Boston: Houghton Mifflin, 1941), which includes a portfolio of 31 of Evans's photographs.
Alfred Barr includes Evans in the exhibition *Fantastic Art, Dada, Surrealism* at MoMA in the winter of 1936–37.

1937: On January 30, Roy Stryker, director of the FSA, sends Evans to Arkansas and Tennessee, areas severely damaged by flooding. This commission is Evans's last project for the FSA; on March 23, he is dismissed.
Beaumont Newhall includes six of Evans's photographs in MoMA's exhibition *Photography 1839–1937*.
In the fall, Evans exhibits a few photographs at the Julien Levy Gallery, alongside works by Abbott, Atget, Cartier-Bresson, Lynes, Nadar, and Man Ray.

1938: From September 28 to November 18, MoMA presents *Walker Evans: American Photographs*, the first major solo exhibition that the museum devotes to a photographer (the catalogue includes an essay by Kirstein).
During the winter, Evans takes photographs in the New York subway with a Contax 35mm camera. He pursues this project throughout the winter of 1940–41. In 1950 and 1960, he reworks these negatives and makes different prints by varying the cropping.

1940: Evans receives a fellowship from the Guggenheim Foundation.

1941: *Let Us Now Praise Famous Men* is published by Houghton Mifflin (Boston).

1943: Evans begins work at *Time* magazine, where he reviews films, books, and exhibitions.

1945: Evans becomes the first full-time staff photographer at *Fortune*.

1947: *Walker Evans Retrospective* is held at the Art Institute of Chicago.

1948: In May, Evans publishes "Main Street Looking North from Courthouse Square" in *Fortune*. This portfolio is composed of color reproductions of postcards from his collection along with text—the first under his byline in that magazine. The 9,000 postcards collected by Evans throughout his life are now preserved at The Metropolitan Museum of Art in New York.

1952: In October, Evans reviews Cartier-Bresson's *The Decisive Moment* (the U.S. edition of *Images à la sauvette*), in *The New York Times Book Review*.

1955: Evans helps Robert Frank obtain a Guggenheim Foundation fellowship for a book project that will become *Les Américains / The Americans* (1958/59).

1956: In March, *The Cambridge Review* publishes Evans's hitherto unpublished New York subway photographs with a text by Agee (dated October 1940).

1958-66: Evans works on the draft for a book of his New York subway photographs. Entitled *The Passengers*, it remains unpublished.

1959: Evans receives a second Guggenheim Foundation fellowship.

1960: *Let Us Now Praise Famous Men* is reissued in an expanded edition with 62 photographs.

1962: A second edition of *American Photographs* is published to coincide with a reprised exhibition at MoMA.

1964: On March 11, Evans delivers a lecture entitled "Lyric Documntary" at Yale University, showcasing his postcard collection.

1965: Evans leaves *Fortune* and begins teaching photography at Yale University's School of Art and Architecture.

1966: The first exhibition of Evans's New York subway photographs is held at MoMA. Houghton Mifflin publishes 89 of the subway photos under the title *Many Are Called*.
Message from the Interior is published by Eakins Press with an essay by John Szarkowski.

1968: Evans contributes some 60 photographs to John A. Kouwenhoven's *Partners in Banking*. The book commemorates the 150th anniversary of the founding of a major American private bank, Brown Brothers Harriman & Co.

1971: *Walker Evans*, a retrospective organized by John Szarkowski, opens at MoMA.
In December, Yale University Art Gallery presents *Walker Evans: Forty Years*. The exhibition, which runs to January 16, 1972, is designed by the photographer and includes objects from his collection of ephemera.

1972: In the fall, Evans is artist-in-residence at Dartmouth College in Hanover, New Hampshire.

1973: Evans begins using the small-format Polaroid SX-70.

1975: Evans dies on April 10 in New Haven, Connecticut.

SELECTED BIBLIOGRAPHY

PRIMARY SOURCES

Hart Crane. *The Bridge: A Poem*. Paris: Black Sun Press, 1930. Photographs by Walker Evans.

Carleton Beals. *The Crime of Cuba*. Philadelphia: J. B. Lippincott, 1933. Photographs by Walker Evans.

Walker Evans: American Photographs. Exh. cat. New York: The Museum of Modern Art, 1938. Essay by Lincoln Kirstein.

James Agee and Walker Evans. *Let Us Now Praise Famous Men*. Boston: Houghton Mifflin, 1941; 2d ed., expanded, 1960.

Walker Evans. *Wheaton College Photographs*. Norton, Mass.: Wheaton College, 1941.

Karl A. Bickel. *The Mangrove Coast: The Story of the West Coast of Florida*. New York: Coward-McCann, 1942. Photographs by Walker Evans.

Walker Evans. *Many Are Called*. Boston: Houghton Mifflin, 1966. Introduction by James Agee.

Walker Evans. *Message from the Interior*. New York: Eakins Press, 1966. Essay by John Szarkowski.

John A. Kouwenhoven. *Partners in Banking: An Historical Portrait of a Great Private Bank, Brown Brothers Harriman & Co., 1818–1968*. Garden City, N.Y.: Doubleday, 1968. Photographs by Walker Evans.

Walker Evans. "Photography." In *Quality: Its Image in the Arts*, edited by Louis Kronenberger, pp. 169–211. New York: Atheneum, 1969.

INTERVIEWS

Davis Pratt. Interview with Walker Evans, September 24, 1969. Transcript preserved in The Metropolitan Museum of Art, New York, Walker Evans Archive.

"Walker Evans, Visiting Artist: A Transcript of His Discussion with the Students of the University of Michigan, 1971." In *Photography: Essays & Images*, edited by Beaumont Newhall, pp. 310–20. New York: The Museum of Modern Art, 1980.

Leslie G. Katz. Interview with Walker Evans. Transcript preserved in The Metropolitan Museum of Art, New York, Walker Evans Archive. Edited version published as "An Interview with Walker Evans," *Art in America* 59, no. 2 (1971), pp. 82–89. Reedited for Leslie G. Katz, *Walker Evans: Incognito* (New York: Eakins Press Foundation, 1995).

Jonathan Goell. Interview with Walker Evans, August 4, 1971. Transcript preserved in The Metropolitan Museum of Art, New York, Walker Evans Archive.

Paul Cummings. "Oral History Interview with Walker Evans, October 13–December 23, 1971." Smithsonian Institution, Archives of American Art, at www.aaa.si.edu/collections/interviews/oral-history-interviewwalker-evans-11721. Edited version published in Paul Cummings, *Artists in Their Own Words* (New York: St. Martin's Press, 1979), pp. 82–100.

"A Dialogue between Walker Evans, Robert Frank, and Various Students and Faculty." *Still* (Yale University School of Art and Architecture), no. 3 (1973), pp. 2–6.

"'The Thing Itself Is Such a Secret and So Unapproachable.'" *Yale Alumni Magazine* 37, no. 5 (1974), pp. 12–16. Reprinted in *Image Magazine* 17, no. 4 (1974).

James R. Mellow. "Walker Evans Captures the Unvarnished Truth." *The New York Times*, December 1, 1974, sec. D, pp. 37–38. Reprinted in *America Observed: Etchings by Edward Hopper, Photographs by Walker Evans* (San Francisco: Fine Arts Museums of San Francisco, 1976).

Bill Ferris. "A Visit with Walker Evans." *Southern Folklore Reports*, no. 1 (1977).

"Walker Evans on Himself." *The New Republic* 175 (November 13, 1976), pp. 23–27. Reprinted in *Exposure* 15, no. 1 (1977), pp. 15–17.

MONOGRAPHS AND EXHIBITION CATALOGUES

John Szarkowski. *Walker Evans*. Exh. cat. New York: The Museum of Modern Art, 1971.

Walker Evans: Photographs for the Farm Security Administration, 1935–1938: A Catalog of Photographic Prints Available from the Farm Security Administration Collection in the Library of Congress. Introduction by Jerald C. Maddox. New York: Da Capo Press, 1973.

Lesley K. Baier. *Walker Evans at Fortune, 1945–1965*. Exh. cat. Wellesley, Mass.: Wellesley College Museum, 1977.

Walker Evans, First and Last. New York: Harper & Row, 1978.

Walker Evans. Introduction de Lloyd Fonvielle. Millerton, N.Y.: Aperture, 1979.

Tod Papageorge. *Walker Evans and Robert Frank: An Essay on Influence*. Exh. cat. New Haven: Yale University Art Gallery, 1981.

John T. Hill and Jerry L. Thompson. *Walker Evans at Work*. New York: Harper & Row, 1982.

Walker Evans 1903–1974. Essays by Jeff Rosenheim, Vicent Todolí, and Alan Trachtenberg. Exh. cat. Valencia: Conselleria de Cultura, Educación i Ciencia de la Generalitat Valenciana, 1983.

Joseph A. Ward. *American Silences: The Realism of James Agee, Walker Evans, and Edward Hopper*. Baton Rouge: Louisiana State University Press, 1985.

Gilles Mora and John T. Hill. *Walker Evans: Havana 1933*. New York: Pantheon Books, 1989.

Michael Brix and Birgit Mayer, eds. *Walker Evans, Amerika: Bilder aus den Jahren der Depression*. Exh. cat. Munich: Schirmer/Mosel, 1990.

Sarah Greenough. *Walker Evans: Subways and Streets*. Exh. cat. Washington, D.C.: National Gallery of Art, 1991.

Jean-François Chevrier, Allan Sekula, and Benjamin H. D. Buchloh. *Walker Evans & Dan Graham*. Exh. cat. Rotterdam and New York: Witte de With and Whitney Museum of American Art, 1992.

Gilles Mora and John T. Hill. *Walker Evans: The Hungry Eye*. New York: Abrams, 1993.

Astrid Böger. *Documenting Lives: James Agee's and Walker Evans's Let Us Now Praise Famous Men*. Frankfurt: P. Lang, 1994.

Judith Keller. *Walker Evans: The Getty Museum Collection*. Malibu: J. Paul Getty Museum, 1995.

Rodger Kingston. *Walker Evans in Print: An Illustrated Bibliography*. Belmont, Mass.: R. P. Kingston Photographs, 1995.

Belinda Rathbone. *Walker Evans: A Biography*. New York: Houghton Mifflin, 1995.

Walker Evans, Simple Secrets: Photographs from the Collection of Marian and Benjamin A. Hill. Exh. cat. Atlanta: High Museum of Art, 1997.

Jerry L. Thompson. *The Last Years of Walker Evans: A First-Hand Account*. New York: Thames & Hudson, 1997.

Walker Evans: Signs. Essay by Andrei Codrescu. Los Angeles: J. Paul Getty Museum, 1998.

James R. Mellow. *Walker Evans*. New York: Basic Books, 1999.

Maria Morris Hambourg et al. *Walker Evans*. Exh. cat. New York: The Metropolitan Museum of Art, 2000.

Walker Evans: Florida. Essay by Robert Plunket. Los Angeles: J. Paul Getty Museu, 2000.

Walker Evans: The Lost Work. Essays by Belinda Rathbone and Clark Worswick. Santa Fe: Arena Editions, 2000.

Peter Galassi. *Walker Evans & Company*. Exh. cat. New York: The Museum of Modern Art, 2000.

Jeff L. Rosenheim, ed. *Unclassified: A Walker Evans Anthology: Selections from the Walker Evans Archive, Department of Photographs, The Metropolitan Museum of Art*. Zurich: Scalo, 2000.

Virginia-Lee Webb. *Perfect Documents: Walker Evans and African Art, 1935*. Exh. cat. New York: The Metropolitan Museum of Art, 2000.

Walker Evans: Cuba. Essays by Judith Keller and Andrei Codrescu. Los Angeles: J. Paul Getty Museum, 2001.

Jeff L. Rosenheim. *Walker Evans: Polaroids*. New York and Zurich: The Metropolitan Museum of Art and Scalo, 2002.

John T. Hill. *Walker Evans: Lyric Documentary: Selections from Evans' Work for the U.S. Resettlement Administration and the Farm Security Administration, 1935–1937*. Essay by Alan Trachtenberg. Göttingen: Steidl, 2006.

Yves Le Fur and Virginia-Lee Webb. *Walker Evans: Photographies*. Exh. cat. Paris: Musée du Quai Branly and Éditions Nicolas Chaudun, 2007.

Henri-Cartier Bresson, Walker Evans: Photographier l'Amérique, 1929–1947. Exh. cat. Göttingen: Steidl, 2008. English ed.: *Henri Cartier-Bresson, Walker Evans: Photographing America, 1929–1947*. London: Thames & Hudson, 2009. Essays by Jean-François Chevrier and Agnès Sire.

Jeff L. Rosenheim. *Walker Evans and the Picture Postcard*. Exh. cat. Göttingen and New York: Steidl and The Metropolitan Museum of Art, 2009.

Jean-François Chevrier *Walker Evans dans le temps et dans l'histoire*. Paris: L'Arachnéen, 2010.

James Crump. *Walker Evans, Decade by Decade*. Exh. cat. Ostfildern and Cincinnati: Hatje Cantz and Cincinnati Art Museum, 2010.

David Campany. *Walker Evans: The Magazine Work*. Göttingen: Steidl, 2014.

Walker Evans. Essay by David Campany. 2d ed. New York: Aperture, 2015.

John T. Hill and Heinz Liesbrock, eds. *Walker Evans: Depth of Field*. Essays by John T. Hill, Heinz Liesbrock, Jerry L. Thompson, Alan Trachtenberg, and Thomas Weski. Exh. cat. New York: Prestel, 2015.

Thomas Zander, ed. *Walker Evans: Labor Anonymous*. Essays by David Campany, Heinz Liesbrock, and Jerry L. Thompson. Cologne: Koenig, 2016.

WORKS IN THE EXHIBITION

AT THE FOREFRONT OF STYLE (INTRODUCTION)
The Journey to Paris

Courtyard at 5, rue de la Santé, Paris, 1926
Gelatin silver print, 1⅛ x 2¼ in. (3.1 x 5.8 cm)
The Metropolitan Museum of Art, New York.
Anonymous Gift, 1999, 1999.246.6
p. 60

Self-Portrait, Paris, September 1926
Gelatin silver print, 4⅛ x 2¾ in.
(10.5 x 6.9 cm)
The J. Paul Getty Museum, Los Angeles,
89.XM.48
p. 61

Self-Portrait, 5, rue de la Santé, Paris,
September 1926
Gelatin silver print, 4⅛ x 3 in. (10.5 x 7.6 cm)
Private collection, San Francisco
p. 62

Four Self-Portraits, Juan-les-Pins, France, 1927
Four gelatin silver prints, each 2⅜ x 1½ in.
(6.1 x 3.7 cm)
Collection of Thomas H. Lee and
Ann Tenenbaum
p. 63

Untitled, Bay of Naples, Italy, 1927
Gelatin silver print, 2⅜ x 1½ in. (6 x 3.8 cm)
Private collection
p. 64 left

Palazzo Reale, Naples, April–May 1927
Gelatin silver print, 4½ x 6⅞ in.
(11.4 x 17.5 cm)
National Gallery of Canada, Ottawa. Gift of
Phyllis Lambert, Montreal, 1982, 19230
p. 64 right

Charles Baudelaire, "The Double Room,"
translation by Walker Evans, August 1926
Typed manuscript, 9 x 7 in. (22.8 x 17.8 cm)
The Metropolitan Museum of Art, New York.
Walker Evans Archive, 1994, 1994.250.1.4
pp. 65–67

Four-page essay in French: "Enquête," 1926
Ink on paper, 10⅜ x 8⅛ in. (26.5 x 20.5 cm)
The Metropolitan Museum of Art, New York.
Walker Evans Archive, 1994, 1994.250.2.13

Self-Portrait, Paris, 1926
Gelatin silver print, 4⅛ x 3 in. (10.5 x 7.7 cm)
Private collection

Two-page essay in French: "Chère avis,
avis chère," June 1926
Ink on paper, 11 x 8½ in. (27.9 x 21.6 cm)
The Metropolitan Museum of Art, New York.
Walker Evans Archive, 1994, 1994.250.2.2

Antibes, 1927
Gelatin silver print, 5⅜ x 3⅜ in.
(13.6 x 8.6 cm)
The Bluff Collection

A Classical Modernism
Self-Portrait in Automated Photobooth, 1929
Gelatin silver print, 1¾ x 1¼ in. (4.4 x 3.2 cm)
The Metropolitan Museum of Art, New York.
Anonymous Gift, 1999, 1999.246.17
p. 68 top

Self-Portrait in Automated Photobooth, 1929
Gelatin silver print, 1¾ x 1¼ in. (4.5 x 3.1 cm)
The Metropolitan Museum of Art, New
York. Purchase, The Horace W. Goldsmith
Foundation Gift, through Joyce and Robert
Menschel, 1996, 1996.166.38
p. 68 center

Self-Portrait in Automated Photobooth, 1929
Gelatin silver print, 1¾ x 1¼ in. (4.5 x 3.2 cm)
The Metropolitan Museum of Art, New
York. Purchase, The Horace W. Goldsmith
Foundation Gift, through Joyce and Robert
Menschel, 1996, 1996.166.37
p. 68 bottom

Self-Portrait, 1927
Gelatin silver print, 5⅞ x 4 in. (15 x 10.1 cm)
The Metropolitan Museum of Art, New York.
Ford Motor Company Collection, Gift of Ford
Motor Company and John Waddell, 1987,
1987.1100.67
p. 69

Wash Day, New York City, before
October 1930
Gelatin silver print, 11½ x 8⅛ in.
(29.1 x 20.6 cm)
National Gallery of Canada, Ottawa.
Purchased in 1980, 21771
p. 70

Brooklyn Bridge, 1929
Gelatin silver print, 4⅜ x 2⅝ in. (11.1 x 6.7 cm)
The Bluff Collection
p. 71 left

Cobblestone Street from Above, Brooklyn,
1928–29
Gelatin silver print, 9¾ x 7½ in.
(24.76 x 19.05 cm)
Private collection, San Francisco
p. 71 right

Untitled, ca. 1929
Gelatin silver print, 7 x 10⅝ in.
(17.8 x 26.9 cm)
The Museum of Modern Art, New York.
Purchase, 341.1989
p. 72 top

Aboard the Cressida, South Pacific, 1932
Gelatin silver print, 6⅜ x 8⅞ in.
(16.1 x 22.7 cm)
The Art Institute of Chicago. Gift of
David C. and Sarajean Ruttenberg, 1991.1198
p. 72 bottom

Sam Leveman, ca. 1929
Gelatin silver print, 6⅛ x 4½ in.
(15.4 x 11.3 cm)
The J. Paul Getty Museum, Los Angeles,
84.XM.956.74
p. 73

New York City Street Corner, 1929
Gelatin silver print, 7¼ x 5 in. (18.4 x 12.7 cm)
The J. Paul Getty Museum, Los Angeles,
84.XM.956.47
p. 74

Traffic, New York City, 1928–29
Gelatin silver print, 8 x 12 in. (20.2 x 30.6 cm)
The Bluff Collection
p. 75 top

Sixth Avenue El, New York City, 1929
Gelatin silver print, 9⅛ x 5⅞ in.
(23.18 x 15.08 cm)
National Gallery of Art, Washington, D.C.
Corcoran Collection. Gift of Murray H. Bring,
2015.19.4233
p. 75 bottom

Manhattan, October 1928
Gelatin silver print, 1⅝ x 2½ in. (4.1 x 6.4 cm)
Private collection
p. 76 top

Tree, ca. 1929
Gelatin silver print, 2¼ x 1⅝ in. (5.7 x 4.1 cm)
Private collection
p. 76 center

Untitled (Timber), ca. 1929
Gelatin silver print, 3⅜ x 5⅜ in. (8.6 x 13.6 cm)
The Bluff Collection
p. 76 bottom

Wall Street Windows, 1929
Gelatin silver print, 3⅜ x 2⅞ in. (8.6 x 7.2 cm)
Private collection
p. 77

Coney Island Beach, ca. 1929
Gelatin silver print, 8⅞ x 12¼ in.
(22.5 x 31 cm)
The J. Paul Getty Museum, Los Angeles,
84.XM.956.121
p. 78

Broadway, 1930
Gelatin silver print, 10⅝ x 9⅛ in.
(27 x 23.17 cm)
Private collection, San Francisco
p. 79

New York, 1928–29
Gelatin silver print, 2⅜ x 1½ in. (6.1 x 3.8 cm)
Private collection

"Mad, by Blaise Cendrars. Translated by
Walker Evans," *Alhambra* 1, no. 3
(August 1929), pp. 34–35
11⅜ x 16⅞ in. (29 x 43 cm)
Centre Pompidou, Musée National d'Art
Moderne, Paris. Bibliothèque Kandinsky,
David Campany Collection

Abstraction with Shadow and Grating Patterns,
1930
Gelatin silver print, 2½ x 1⅝ in. (6.3 x 4.1 cm)
Private collection

Cover of *Advertising & Selling: Broadway
Composition*, June 24, 1931
11½ x 8⅛ in. (29.1 x 21.5 cm)
Centre Pompidou, Musée National d'Art
Moderne, Paris. Bibliothèque Kandinsky,
David Campany Collection

Two Encounters
Lincoln Kirstein, 1930–31
Gelatin silver print, 5⅛ x 3⅞ in.
(12.9 x 9.8 cm)
The Metropolitan Museum of Art, New York.
Twentieth-Century Photography Fund, 2010,
2010.11
p. 80 top

Lincoln Kirstein, 1930–31
Gelatin silver print, 6½ x 4¾ in. (16.5 x 12 cm)
Collection of Marcia L. Due and Jerry L.
Thompson
p. 80 bottom

Maine Pump, 1933
Gelatin silver print, printed between 1955
and 1967, 8 x 6 in. (20.3 x 15.2 cm)
Bank of America Art Collection
p. 81

Jigsaw House at Ocean City, New Jersey, 1931
Gelatin silver print, 5⅜ x 7 in. (13.65 x
17.8 cm)
Private collection, San Francisco
p. 82 left

*Detail of a Frame House in Ossining,
New York*, 1931
Gelatin silver print, printed 1931, 7 x 5¾ in.
(17.8 x 14.6 cm)
Collection of Gary S. Davis
p. 82 right

Wooden Houses, Boston, 1930
Gelatin silver print, 9½ x 13¼ in.
(24.13 x 33.65 cm)
Private collection, San Francisco
p. 83

Berenice Abbott, New York, 1929–30
Gelatin silver print, 6½ x 4⅝ in. (16.6 x 11.8 cm)
National Gallery of Canada, Ottawa. Gift of
Benjamin Greenberg, Ottawa, 1981, 20397
p. 84 left

Photomontage Portrait of Berenice Abbott,
1929–30
Gelatin silver print, 4⅜ x 4⅝ in. (11.1 x 11.9 cm)
The J. Paul Getty Museum, Los Angeles,
86.XM.519
p. 84 right

Eugène Atget
Marchand d'abat-jours (Street Vendor of
Lampshades), 1899–1900
Gelatin silver print, 8¾ x 6¾ in.
(22.2 x 17.3 cm)
The Museum of Modern Art, New York.
Abbott-Levy Collection. Partial gift of
Shirley C. Burden, 1.1969.892
p. 85 top left

Eugène Atget
Boutique, Marché aux Halles, Paris, 1925
Collection of Walker Evans
Gelatin silver print, printed by Berenice
Abbott in 1929, 9⅛ x 6¾ in. (23.1 x 17 cm)
The Metropolitan Museum of Art,
New York. Purchase, The Horace W.
Goldsmith Foundation Gift, through Joyce
and Robert Menschel, 1999, 1999.188.1
p. 85 top right

*Organ Grinder Street Musician, Possibly
Bethune Street, New York*, ca. 1929
Gelatin silver print, 10 x 8 in. (25.4 x 20.3 cm)
The Museum of Modern Art, New York.
Gift of the artist, SC 1971.1.559
p. 85 bottom left

Dress, April 1963
Gelatin silver print, 6⅛ x 9¼ in. (15.5 x 23.5 cm)
Collection of Thomas H. Lee and Ann
Tenenbaum
p. 85 bottom right

Eugène Atget
122, boulevard de la Villette, 1924–25
Gelatin silver print, 7 x 8⅞ in. (17.8 x 22.5 cm)
The Museum of Modern Art, New York.
Abbott-Levy Collection. Partial gift of
Shirley C. Burden, 1.1969.2159
p. 86

Small Restaurant, Havana, 1933
Gelatin silver print, 6 x 7⅜ in. (15.3 x 18.7 cm)
The J. Paul Getty Museum, Los Angeles,
84.XM.956.261
p. 87

THE VERNACULAR AS SUBJECT
Collecting/Photographing
John T. Hill
*[Walker Evans's] House Interior, Fireplace with
Painting of Car*, April 1975
Pigment inkjet print, 7½ x 14 in. (19.06 x
35.56 cm)
Private collection
p. 90

306

Unidentified Sign Painter
"Nectar Tea" sign, collection of Walker Evans
Paint on metal, 12½ x 21 in. (31.7 x 53.3 cm)
The Metropolitan Museum of Art, New York.
Walker Evans Archive, 1994, 1994.264.110.12
p. 91 top left

Unidentified Sign Painter
"Coca-Cola" sign, collection of
Walker Evans
Paint on metal, 23½ x 57¾ in.
(59.7 x 146.7 cm)
The Metropolitan Museum of Art, New York.
Walker Evans Archive, 1994, 1994.264.110.46
p. 91 top right (not in exhibition)

Unidentified Sign Painter
"No Guning" sign, collection of Walker Evans
Paint on metal, 10½ x 20½ in. (26.7 x 52 cm)
The Metropolitan Museum of Art, New York.
Walker Evans Archive, 1994, 1994.264.110.40
p. 91 bottom left

Unidentified Sign Painter
"No Dumping" sign, collection of
Walker Evans
Painted aluminum, mounted on weathered
wood boards and frame, 9⅞ x 6⅞ in.
(25 x 17.5 cm)
The Metropolitan Museum of Art, New York.
Walker Evans Archive, 1994, 1994.264.110.38
p. 91 bottom right

Unidentified Sign Painter
"Attention Peinture, Wet Paint" sign,
collection of Walker Evans
Ink(?) on fiberboard, mounted on painted
wood board and frame, 10 x 13¾ in.
(25.4 x 34.9 cm)
The Metropolitan Museum of Art, New York.
Walker Evans Archive, 1994, 1994.264.110.25
p. 92

O'Pry Signs, Vintage car sign, collection of
Walker Evans
Paint on metal, 47¾ x 49 in. (121.3 x 124.5 cm)
The Metropolitan Museum of Art, New York.
Walker Evans Archive, 1994, 1994.264.110.75
p. 93 (not in exhibition)

John T. Hill
[Walker Evans's] House Interior, Sink with Beer
Can Tabs, April 1975
Pigment inkjet print, 10⅞ x 14 in.
(27.49 x 35.56 cm)
Private collection
p. 94 left

Collage, ca. 1973
Printed papers, ink, 10 x 7 in.
(25.4 x 17.8 cm)
Private collection
p. 94 right

Collage with Thirty-Six Ticket Stubs, 1975
Photomechanical prints, 10 x 8 in.
(25.4 x 20.3 cm)
The Metropolitan Museum of Art, New York.
Walker Evans Archive, 1994, 1994.261.171
p. 95

Édition Grizard, Les petits métiers de Paris:
Les Chiffonniers / Small Trades of Paris:
The Rag Pickers, ca. 1925 (mailed in 1946),
postcard collection of Walker Evans
Photomechanical print, 3½ x 5½ in.
(9 x 14 cm)
The Metropolitan Museum of Art, New York.
Walker Evans Archive, 1994, 1994.264.56.1
p. 96 top left

Frank E. Cooper (copyright by Irving
Underhill), A Typical Crowd on a Hot Day at
Coney Island, New York, ca. 1940, postcard
collection of Walker Evans
Photomechanical print, 3½ x 5½ in. (9 x 14 cm)
The Metropolitan Museum of Art, New York.
Walker Evans Archive, 1994, 1994.264.37.1
p. 96 top right

H. H. Tammen Co., Glass Bottom Boat, Santa
Catalina Island, California, ca. 1930 (mailed in
1956), postcard collection of Walker Evans
Photomechanical print, 3½ x 5½ in.
(9 x 14 cm)
The Metropolitan Museum of Art, New York.
Walker Evans Archive, 1994, 1994.264.111.39
p. 96 bottom left

Curt Teich & Co., A Portion of "The Floor of
Fame," Grauman's Chinese Theatre, Hollywood,
California, ca. 1940, postcard collection of
Walker Evans
Photomechanical print, 3½ x 5½ in.
(9 x 14 cm)
The Metropolitan Museum of Art, New York.
Walker Evans Archive, 1994, 1994.264.60.1
p. 96 bottom right

Unidentified Publisher, Reading the Latest
News Bulletins. Chinatown, San Francisco,
California, ca. 1935, postcard collection of
Walker Evans
Photomechanical print, 3½ x 5½ in.
(9 x 14 cm)
The Metropolitan Museum of Art, New York.
Walker Evans Archive, 1994, 1994.264.98.5
p. 97 top left

Unidentified Publisher, Electric Chair, Sing
Sing Prison, New York, ca. 1920, postcard
collection of Walker Evans
Photomechanical print, 3½ x 5½ in.
(9 x 14 cm)
The Metropolitan Museum of Art, New York.
Walker Evans Archive, 1994, 1994.264.109.28
p. 97 top right

Milton D. Bromsley [?], Illuminated American
Falls, Niagara Falls, ca. 1920 (mailed in 1974
by Lee Friedlander), postcard collection of
Walker Evans
Photomechanical print, 3½ x 5½ in.
(9 x 14 cm)
The Metropolitan Museum of Art, New York.
Walker Evans Archive, 1994, 1994.264.111.45
p. 97 bottom

Unidentified Artist
Poster for the film The Roaring West
(directed by Ray Taylor), 1935
Photomechanical print, 28¾ x 21¼ in.
(73 x 54 cm)
Private collection, Paris
p. 98 left

Unidentified Artist
Poster for the film Sex Maniac (directed by
Dwain Esper), 1934
Photomechanical print, 41 x 27 in.
(104.1 x 68.6 cm)
Courtesy of Jack Feldman, Special Thanks
to Posteritati
p. 98 right

Morgan Litho. Corp., Poster for the film
Love Before Breakfast (directed by Walter
Lang), 1936
Photomechanical print, 39½ x 26¾ in.
(100.3 x 67.95 cm)
The Mike Kaplan Collection
p. 99

Six Ticket Stubs, 1975
Photomechanical prints, 10 x 8 in.
(25.4 x 20.3 cm)
The Metropolitan Museum of Art, New York.
Walker Evans Archive, 1994, 1994.261.172

Berger Bros., Old Man's Face, Point Judith,
Narragansett Pier, Rhode Island, ca. 1930,
postcard collection of Walker Evans
Photomechanical print, 3½ x 5½ in.
(9 x 14 cm)
The Metropolitan Museum of Art, New York.
Walker Evans Archive, 1994, 1994.264.40.32

C. T. American Art Colored, Detroit-Windsor
Tunnel, ca. 1920, postcard collection of
Walker Evans
Photomechanical print, 3½ x 5½ in.
(9 x 14 cm)
The Metropolitan Museum of Art, New York.
Walker Evans Archive, 1994, 1994.264.108.360

Eastern Photo Litho Co., Potato—The Kind We
Raise in Maine, ca. 1920, postcard collection
of Walker Evans
Photomechanical print, 3½ x 5½ in.
(9 x 14 cm)
The Metropolitan Museum of Art, New York.
Walker Evans Archive, 1994, 1994.264.29.7

Gut & Steers, Art Glass Studios. 374 East
141st Street, New York, 1920–40, postcard
collection of Walker Evans
Photomechanical print, 3½ x 5½ in.
(9 x 14 cm)
The Metropolitan Museum of Art, New York.
Walker Evans Archive, 1994, 1994.264.111.60

John T. Hill
[Walker Evans's] House Interior, Living Room
with Lobster Sign, April 1975
Pigment inkjet print, 11⅞ x 14 in.
(30.02 x 35.56 cm)
Private collection

Moses King, Future New York, "The City of
Skyscrapers," ca. 1905, postcard collection
of Walker Evans
Photomechanical print, 3½ x 5½ in.
(9 x 14 cm)
The Metropolitan Museum of Art, New York.
Walker Evans Archive, 1994, 1994.264.20.2

Unidentified Sign Painter
Coca-Cola thermometer sign, collection of
Walker Evans
Enamel on ferrous metal, mounted on painted
wood and frame, 17 x 15¼ in. (43.2 x 38.7 cm)
The Metropolitan Museum of Art, New York.
Walker Evans Archive, 1994, 1994.264.110.3

Roadside Shacks
Roadside Fruit. Ponchatoula, Louisiana,
March 1936
Gelatin silver print, 7½ x 9½ in.
(19.1 x 24.1 cm)
The New York Public Library. The Miriam and
Ira D. Wallach Division of Art, 008093-A
p. 100

Garage in Southern City Outskirts, Atlanta,
Georgia, 1936
Gelatin silver print, printed 1972, 7½ x 9 in.
(19 x 23 cm)
The Metropolitan Museum of Art, New
York. Administrative Purchase Fund, 1972,
1972.741.50
p. 101

Crossroads Store, Post Office, Sprott,
Alabama, 1935–36
Gelatin silver print, 8⅜ x 10¼ in.
(21.3 x 26 cm)
The New York Public Library. The Miriam and
Ira D. Wallach Division of Art, 008224-A
p. 102 top

Westchester, New York, Farmhouse, 1931
Gelatin silver print, 7⅛ x 8¾ in. (18 x 22.1 cm)
Centre Pompidou, Musée National d'Art
Moderne, Paris. Purchased in 1984,
AM 1984-715
p. 102 bottom

Highway Corner, Reedsville, West Virginia,
March 1936
Gelatin silver print, 9½ x 7½ in. (24 x 19 cm)
The New York Public Library. The Miriam and
Ira D. Wallach Division of Art, 00847-A
p. 103

Sidewalk and Shopfront, New Orleans, 1935
Gelatin silver print, 8⅜ x 6¼ in. (21.4 x 16 cm)
The Museum of Modern Art, New York.
Gift of Williard Van Dyke, 1461.1968
p. 104

Roadside Stand near Birmingham/Roadside
Store between Tuscaloosa and Greensboro,
Alabama, 1936
Gelatin silver print, 7¼ x 8⅞ in.
(18.4 x 22.4 cm)
The J. Paul Getty Museum, Los Angeles,
84.XM.956.519
p. 105

Roadside Store between Tuscaloosa and
Greensboro, Alabama, 1936
Gelatin silver print, printed 1970, 7⅝ x 9¼ in.
(19.3 x 23.5 cm)
National Gallery of Canada, Ottawa.
Purchased in 1977, 21758
p. 106

Anna Maria, Florida, October 1958
Oil on fiberboard, 15¾ x 19¾ in.
(40 x 50.2 cm)
The Metropolitan Museum of Art, New York.
Walker Evans Archive, 1994, 1994.261.178
p. 107 top

Fisherman's Shack, 1945
Tempera on wood, 11½ x 15½ in.
(29.2 x 39.4 cm)
The Metropolitan Museum of Art, New York.
Walker Evans Archive, 1994, 1994.261.165
p. 107 bottom (not in exhibition)

The Shell House, 1950–60
Oil on fiberboard, 15¾ x 19¾ in.
(40 x 50.2 cm)
The Metropolitan Museum of Art, New York.
Walker Evans Archive, 1994, 1994.261.176

Storefronts and Shop Windows
Storefront, Greensboro, Alabama,
July–August 1936
Gelatin silver print, 8¼ x 9½ in.
(18.5 x 24.2 cm)
Pier 24 Photography, San Francisco
p. 108

Bowery Lunchroom, New York, ca. 1933
Gelatin silver print, printed ca. 1970 by James
Dow, 6⅛ x 8¼ in. (15.5 x 20.7 cm)
The Museum of Modern Art, New York.
Purchase, 355.2015
p. 109

Hardware Store, ca. 1932
Gelatin silver print, 4⅝ x 3⅜ in.
(11.8 x 8.6 cm)
The Metropolitan Museum of Art, New York.
Gift of Joyce F. Menschel, 2011, 2011.553.2
p. 110 left

*Fruit in Baskets outside Souvenir Shop,
Florida*, 1941
Gelatin silver print, 6⅞ x 8 in. (17.5 x 20.3 cm)
The Art Institute of Chicago. Gift of
Mr. Arnold Crane, 1970.315
p. 110 right

Window Display, Bethlehem, Pennsylvania,
November 10, 1933
Gelatin silver print, 8⅝ x 6⅛ in. (22 x 15.6 cm)
The Museum of Modern Art, New York.
Gift of the artist, 383.2015
p. 111

Secondhand Shop Window, 1930
Gelatin silver print, 4½ x 6½ in.
(11.4 x 16.4 cm)
The J. Paul Getty Museum, Los Angeles,
84.XM.956.63
p. 112 top

Dress, 1963
Gelatin silver print, 9¼ x 6⅛ in.
(23.6 x 15.6 cm)
Estate of Harry H. Lunn Jr.
p. 112 bottom left

Stockings and Bras, 1959
Gelatin silver print, 11⅞ x 8⅞ in.
(30.2 x 22.4 cm)
Centre Pompidou, Musée National d'Art
Moderne, Paris. Purchase, 1996, AM 1996-331
p. 112 bottom right

Third Avenue, New York City, 1959
Gelatin silver print, 13⅝ x 9½ in.
(34.6 x 24.1 cm)
The Art Institute of Chicago. Gift of David C.
and Sarajean Ruttenberg, 1991.1488
p. 113

"The Pitch Direct. The sidewalk is the last
stand of unsophisticated display," *Fortune* 58,
no. 4 (October 1958), pp. 139–43
13 x 20½ in. (33.1 x 52 cm)
Centre Pompidou, Musée National d'Art
Moderne, Paris. Bibliothèque Kandinsky,
David Campany Collection
pp. 114–15

*Sidewalk Display, for the Series "The Pitch
Direct," Fortune, October 1958*, 1957
Color film transparency, 35mm
The Metropolitan Museum of Art, New York.
Walker Evans Archive, 1994, 1994.259.13.1–.80
p. 115 top

Landscape of Posters
Show Bill, Demopolis, Alabama, 1936
Gelatin silver print, 7½ x 9⅞ in. (19 x 25 cm)
Bibliothèque Nationale de France, Paris
p. 116 (print reproduced: *Minstrel Posters,
Alabama*, 1936, Yale University Art Gallery,
New Haven. Katharine Ordway Fund
2002.52.12)

Cinema, Havana, 1933
Gelatin silver print, 4⅜ x 6⅛ in.
(11.2 x 15.7 cm)
National Gallery of Canada, Ottawa.
Purchased through the Phyllis Lambert Fund,
1984, 28620
p. 117

Mississippi Roadside Barn, 1935
Gelatin silver print, 3½ x 9¼ in.
(8.8 x 23.4 cm)
National Gallery of Canada, Ottawa. Gift of
Phyllis Lambert, Montreal, 1982, 19268
p. 118

Houses and Billboards in Atlanta, 1936
Gelatin silver print, 6½ x 9⅛ in.
(16.5 x 23.2 cm)
The Museum of Modern Art, New York.
Purchase, 303.1963
p. 119

Outdoor Advertising, Florida, 1934
Gelatin silver print, 7 x 8⅛ in.
(17.78 x 20.63 cm)
Private collection, San Francisco
p. 120 top

Sideshow Signs, Santa Monica, California,
August–September 1947
Dye transfer print, 15¼ x 19½ in.
(38.6 x 49.6 cm)
The Metropolitan Museum of Art, New York.
Walker Evans Archive, 1994, 1994.261.232.2
p. 120 bottom

Billboard, Birmingham, Alabama, 1936
Gelatin silver print, 7½ x 9⅜ in.
(19.1 x 23.9 cm)
The Metropolitan Museum of Art,
New York. Purchase, The Horace W.
Goldsmith Foundation Gift, through Joyce
and Robert Menschel, 1990, 1990.1169
p. 121

Circus Poster, Alabama, 1935–36
Gelatin silver print, 8¼ x 10¼ in. (21 x 26 cm)
The New York Public Library. Farm Security
Administration Collection, 001153-A
p. 122

Minstrel Showbill, 1936
Gelatin silver print, 19⅞ x 15⅞ in.
(50.4 x 40.4 cm)
Centre Pompidou, Musée National d'Art
Moderne, Paris. Purchase, 1984, AM 1984-711
p. 123 left

Untitled, 1948
Gelatin silver print, 7¾ x 5¼ in. (19.8 x 13.2 cm)
The Museum of Modern Art, New York.
Gift of the artist, 318.1963
p. 123 right

Political Poster, Massachusetts Village, 1936
Gelatin silver print, 6⅛ x 4⅛ in.
(15.6 x 10.6 cm)
The J. Paul Getty Museum, Los Angeles,
84.XM.956.495
p. 124

Torn Movie Poster, 1930
Gelatin silver print, 6⅜ x 4½ in.
(16.2 x 11.2 cm)
The Museum of Modern Art, New York.
Purchase, 459.1966
p. 125

Stables, Natchez, Mississippi, March 1935
Gelatin silver print, 8⅛ x 7¼ in.
(20.6 x 18.4 cm)
The Museum of Modern Art, New York. Gift
of Mr. and Mrs. Alfred H. Barr, Jr., 548.1967

Malcolm Bradbury, "Collectors' Items," four
black-and-white photographs and legends by
Walker Evans, *Mademoiselle*, 1963, pp. 182–83
11¼ x 16⅞ in. (28.5 x 43 cm)
Centre Pompidou, Musée National d'Art
Moderne, Paris. Bibliothèque Kandinsky,
David Campany Collection

Signs
Sign, Baton Rouge, Louisiana, 1935
Gelatin silver print, 7 x 8⅜ in. (17.8 x 21.3 cm)
Jeffrey Fraenkel & Alan Mark, San Francisco
p. 126

Shoeshine Stand Detail in Southern Town, 1936
Gelatin silver print, 5¾ x 6¾ in. (14.5 x 17 cm)
The Metropolitan Museum of Art, New York.
Anonymous Gift, 2007, 2007.458.5
p. 127

The Grand Man. Wall Mural, ca. 1935
Gelatin silver print, 7 x 4⅝ in. (17.7 x 11.8 cm)
Estate of Harry H. Lunn Jr.
p. 128

"Madam Adele" Palmistry Sign, 1934–35
Gelatin silver print, 10 x 5¼ in.
(25.4 x 13.33 cm)
Collection of Thomas H. Lee and
Ann Tenenbaum
p. 129

"Mr. Walker Evans Records a City's Scene,"
Creative Art 7, no. 6 (December 1930), p. 453
11½ x 8⅛ in. (29.3 x 20.6 cm)
Centre Pompidou, Musée National d'Art
Moderne, Paris. Bibliothèque Kandinsky,
David Campany Collection
p. 130 top

Truck and Sign, 1928–30
Gelatin silver print, 6½ x 8¾ in.
(16.5 x 22.2 cm)
Private collection, San Francisco
p. 130 bottom

Roadside Gas Sign, 1929
Gelatin silver print, 4⅜ x 6⅛ in.
(11.2 x 15.5 cm)
Centre Pompidou, Musée National d'Art
Moderne, Paris. Purchase, 1984, AM 1984-712
p. 131

Christ or Chaos?, 1943
Gelatin silver print, 8⅝ x 7⅞ in.
(21.9 x 19.9 cm)
The Art Institute of Chicago. Gift of David C.
and Sarajean Ruttenberg, 1991.1476
p. 132 top

Nova Scotia, 1971
Gelatin silver print, printed ca. 1970 by Charlie
Rodemeyer, 7¼ x 7⅜ in. (18.4 x 18.8 cm)
The Museum of Modern Art, New York.
Gift of the artist, SC 1971.1.363.1.XI
p. 132 bottom

Untitled (No Guning), October 17, 1973
Polaroid print, 4⅛ x 3 in. (10.63 x 7.77 cm)
Collection of Marcia L. Due and Jerry L.
Thompson
p. 133 top left

Untitled [Sign in Door: "Office for Rant"],
May 30, 1974
SX-70 Polaroid print, 3⅛ x 3⅛ in.
(7.9 x 7.8 cm)
Yale University Art Gallery, New Haven.
Katharine Ordway Fund, 2008.101.15
p. 133 top right

*Untitled [Hand-Painted Sign of Model T Ford,
Old Lyme, Connecticut]*, August 13–31, 1974
SX-70 Polaroid print, 3⅛ x 3⅛ in.
(7.9 x 7.8 cm)
Yale University Art Gallery, New Haven.
Katharine Ordway Fund, 2008.101.12
p. 133 bottom

"Before They Disappear," *Fortune* 55, no. 3
(March 1957), pp. 141–45
13 x 20½ in. (33 x 52 cm)
Centre Pompidou, Musée National d'Art
Moderne, Paris. Bibliothèque Kandinsky,
David Campany Collection
pp. 134–35

Anna Maria, Florida, 1968
Gelatin silver print, 10⅜ x 9⅞ in.
(26.2 x 25.1 cm)
National Gallery of Canada, Ottawa. Gift of
Phyllis Lambert, Montreal, 1982, 19274

Untitled [Mailbox: "27"], 1973–74
SX-70 Polaroid print, 3⅛ x 3⅛ in.
(7.9 x 7.8 cm)
Yale University Art Gallery, New Haven.
Katharine Ordway Fund, 2009.5.17

*Untitled [Roadside Signs: Fruit and Vegetable
Stand]*, January 9, 1974
SX-70 Polaroid print, 3⅛ x 3⅛ in.
(7.9 x 7.8 cm)
Yale University Art Gallery, New Haven.
Katharine Ordway Fund, 2008.101.10

Ordinary Folk
Havana Stevedore, 1933
Gelatin silver print, 9⅜ x 6⅛ in.
(23.8 x 15.4 cm)
The J. Paul Getty Museum, Los Angeles,
84.XM.956.263
p. 136

Coal Dock Worker, 1932
Gelatin silver print, 7⅛ x 5⅞ in. (18 x 15 cm)
The Museum of Modern Art, New York.
The Parkinson Fund, 216.1970
p. 137

Dock Workers, Havana, 1933
Gelatin silver print, printed ca. 1970 by
James Dow, 6⅛ x 8⅛ in. (15.7 x 20.5 cm)
The Museum of Modern Art, New York.
Purchase, 357.2015
p. 138

Coal Stevedore, Havana, 1933
Gelatin silver print, printed ca. 1970,
8⅛ x 6¼ in. (20.5 x 15.8 cm)
The Art Institute of Chicago. Gift of David C.
and Sarajean Ruttenberg, 1991.1208
p. 139

*Longshoreman, South Street,
New York City*, 1928
Gelatin silver print, 7⅞ x 5½ in. (20 x 14 cm)
The J. Paul Getty Museum, Los Angeles,
84.XM.956.52
p. 140 left

*Chicago [Two Blind Street Musicians,
Halsted Street]*, 1941
Gelatin silver print, 9⅝ x 7½ in.
(24.5 x 19.2 cm)
The J. Paul Getty Museum, Los Angeles,
84.XM.956.969
p. 140 right

Posed Portraits, New York, 1931
Gelatin silver print, 8 x 6 in. (20.3 x 15.2 cm)
Collection of Gary S. Davis
p. 141

Man on Crutches, Havana, 1933
Gelatin silver print, 8⅛ x 5 in. (20.5 x 12.7 cm)
The J. Paul Getty Museum, Los Angeles,
84.XM.956.143
p. 142 top left

Man on Crutches, Havana, 1933
Gelatin silver print, 9⅝ x 7¼ in.
(24.5 x 18.4 cm)
The Metropolitan Museum of Art, New York.
Anonymous Gift, 1999, 1999.246.45
p. 142 top right

Havana Beggar, 1933
Gelatin silver print, 5⅞ x 8⅞ in.
(14.8 x 22.7 cm)
The J. Paul Getty Museum, Los Angeles,
84.XM.956.177
p. 142 bottom

Vagrant in the Prado of Havana, 1933
Gelatin silver print, 6⅝ x 9⅜ in.
(16.9 x 23.8 cm)
The Art Institute of Chicago. Julien Levy
Collection, Gift of Jean Levy and the Estate of
Julien Levy, 1988.157.29
p. 143

Dock Worker, Havana, 1932
Gelatin silver print, printed ca. 1970 by
James Dow, 8 x 6⅛ in. (20.4 x 15.7 cm)
The Museum of Modern Art, New York.
David H. McAlpin Fund, 55.1971

Dock Workers, Havana, 1932
Gelatin silver print, 8⅜ x 6⅜ in.
(21.2 x 16.3 cm)
The Museum of Modern Art, New York.
Lily Auchincloss Fund, 54.1971

"People and Places in Trouble," Fortune 63,
no. 8 (March 1961), pp. 110–17
13 x 20½ in. (33.1 x 52 cm)
Centre Pompidou, Musée National d'Art
Moderne, Paris. Bibliothèque Kandinsky,
David Campany Collection

Three Alabama Families
Alabama Tenant Farmer Family Singing Hymns,
1936
Gelatin silver print, 4⅞ x 7¾ in.
(12.3 x 19.8 cm)
The Museum of Modern Art, New York.
Gift of the artist, 385.2015
p. 144

Alabama Tenant Farmer Floyd Burroughs, 1936
Vintage gelatin silver print, 9 x 7¼ in.
(22.86 x 18.41 cm)
Private collection, San Francisco
p. 145

Lucille Burroughs, Daughter of a Cotton
Sharecropper, Hale County, Alabama, 1936
Gelatin silver print, 8 x 10 in. (20.3 x 25.4 cm)
The New York Public Library. The Miriam and
Ira D. Wallach Division of Art, 008140-A
p. 146

Kitchen Corner, Tenant Farmhouse,
Hale County, Alabama, 1936
Gelatin silver print, 7⅝ x 6⅜ in.
(19.5 x 16.1 cm)
The Metropolitan Museum of Art,
New York. Purchase, The Horace W.
Goldsmith Foundation Gift, through Joyce
and Robert Menschel, 1988, 1988.1030
p. 147

Allie Mae Burroughs, Wife of a Cotton
Sharecropper, Hale County, Alabama, 1936
Gelatin silver print, printed 1971, 9 x 6⅞ in.
(23 x 17.5 cm)
Pier 24 Photography, San Francisco
p. 148

Allie Mae Burroughs, Wife of a Cotton
Sharecropper, Hale County, Alabama, 1936
Gelatin silver print, 8¾ x 6¾ in.
(22.3 x 17.3 cm)
Private collection
cover, p. 149

Land Lord, Hale County, Alabama, 1936
Gelatin silver print, 10 x 8 in.
(25.4 x 20.32 cm)
Collection of Marcia L. Due and Jerry L.
Thompson
p. 150 left

Farmer's Kitchen, Hale County, Alabama, 1936
Gelatin silver print, 9 x 5¾ in. (23 x 14.7 cm)
Pier 24 Photography, San Francisco
p. 150 right

Part of the Bedroom of Floyd Burroughs's
Cabin, Hale County, Alabama, 1936
Gelatin silver print, 7⅛ x 8⅝ in.
(18.1 x 21.9 cm)
The Metropolitan Museum of Art,
New York. Purchase, The Horace W.
Goldsmith Foundation Gift, through Joyce
and Robert Menschel, 1999, 1999.35
p. 151

Lilian Fields, Hale County, Alabama,
July–August 1936
Gelatin silver print, 5⅛ x 3⅝ in. (13 x 9.1 cm)
National Gallery of Canada, Ottawa. Gift of
Phyllis Lambert, Montreal, 1982, 19376
p. 152

Elizabeth Tengle, Hale County, Alabama,
July–August 1936
Gelatin silver print, 7¾ x 7 in. (19.8 x 17.7 cm)
National Gallery of Canada, Ottawa. Gift of
Benjamin Greenberg, Ottawa, 1981, 20381
p. 153

Alabama Farm Interior [Fields Family Cabin],
1936
Gelatin silver print, 7¼ x 9⅛ in.
(18.57 x 23.17 cm)
Collection of Marcia L. Due and Jerry L.
Thompson
p. 154 top

Squeakie Burroughs Asleep, 1936
Gelatin silver print, printed by the Library of
Congress, 7⅞ x 7½ in. (20.1 x 19 cm)
The Museum of Modern Art, New York.
Purchase, SC2015.1.190
p. 154 bottom

Floyd and Lucille Burroughs, Hale County,
Alabama, 1936
Gelatin silver print, 7½ x 8⅜ in.
(19.1 x 21.4 cm)
The J. Paul Getty Museum, Los Angeles,
84.XM.956.336
p. 155

A Gourd Tree for Martins, Hale County,
Alabama, 1936
Gelatin silver print, 9½ x 7½ in.
(24.1 x 19.2 cm)
The J. Paul Getty Museum, Los Angeles,
84.XM.956.298
p. 156 top

A Child's Grave, Hale County, Alabama, 1936
Gelatin silver print, 7½ x 9½ in. (19 x 24 cm)
Bibliothèque Nationale de France, Paris
p. 156 bottom (print reproduced: The Art
Institute of Chicago. Restricted gift of Lucia
Woods Lindley and Daniel A. Lindley, Jr.,
1987.235)

Child's Grave, Hale County, Alabama, 1936
Gelatin silver print, printed by the Library of
Congress, 7⅜ x 9⅜ in. (18.7 x 23.9 cm)
The Museum of Modern Art, New York.
Purchase, 390.2015
p. 157

Alabama Tenant Farmer Bud Fields, 1936
Gelatin silver print, 7⅛ x 8⅛ in.
(18.09 x 20.63 cm)
Private collection, San Francisco

Tengle Children, Hale County, Alabama,
July–August 1936
Gelatin silver print, 5⅝ x 8⅜ in.
(14.3 x 21.4 cm)
National Gallery of Canada, Ottawa. Gift of
Phyllis Lambert, Montreal, 1982, 19373

Ross Spears and Jude Cassidy
Interview with Allie Mae Burroughs, 1975
Audio recording, 34 minutes
James Agee Film Project

The Great Flood of 1937
Belongings of a Flood Refugee, Forrest City,
Arkansas, February 1937
Gelatin silver print, 7 x 9⅛ in.
(17.94 x 23.18 cm)
San Francisco Museum of Modern Art.
Gift of Susan Ehrens
p. 158

Arkansas Flood Refugee, February 1937
Gelatin silver print, 8⅞ x 7½ in. (22.5 x 19 cm)
The Museum of Modern Art, New York.
Purchase, 420.2015
p. 159

Flood Refugee, Forrest City, Arkansas,
February 1937
Gelatin silver print, 6¾ x 7 in. (17.2 x 17.7 cm)
The J. Paul Getty Museum, Los Angeles,
84.XM.956.362
p. 160

Flood Refugee, Forrest City, Arkansas,
February 1937
Gelatin silver print, 7¾ x 6⅞ in.
(19.8 x 17.5 cm)
The J. Paul Getty Museum, Los Angeles,
84.XM.956.292
p. 161

Flood Refugees at Mealtime, Forrest City,
Arkansas, February 1937
Gelatin silver print, 8¼ x 10¼ in. (21 x 26 cm)
The New York Public Library. Farm Security
Administration Collection, 009231-M1
p. 162 top

Negroes in the Lineup for Food at Mealtime
in the Camp for Flood Refugees, Forrest City,
Arkansas, February 1937
Gelatin silver print, 8 x 10¼ in. (20.3 x 26 cm)
The New York Public Library. Farm Security
Administration Collection, 009230-M4
p. 162 bottom

Negroes in the Lineup for Food at Mealtime
in the Camp for Flood Refugees, Forrest City,
Arkansas, February 1937
Gelatin silver print, 8 x 10 in. (20.3 x 25.4 cm)
The New York Public Library. The Miriam and
Ira D. Wallach Division of Art, 009217-M3
p. 163

The Other Side of Progress
Tupelo, Mississippi, 1936
Gelatin silver print, 7⅝ x 9⅝ in.
(19.3 x 24.3 cm)
National Gallery of Art, Washington, D.C.
Horace W. Goldsmith Foundation Gift,
through Robert and Joyce Menschel,
1989.69.10
p. 164

House on Fire in a Southern State, ca. 1935
Gelatin silver print, 4⅞ x 3⅞ in.
(12.5 x 9.9 cm)
The J. Paul Getty Museum, Los Angeles,
84.XM.956.697
p. 165

Louisiana Plantation House, 1935
Gelatin silver print, 8 x 10 in.
(20.32 x 25.4 cm)
Collection of Marcia L. Due and Jerry L.
Thompson
p. 166 top

Negro Barbershop Interior, Atlanta, 1936
Gelatin silver print, 7½ x 9½ in. (19 x 24.1 cm)
Collection of Gary S. Davis
p. 166 bottom

Room in Louisiana Plantation House, 1935
Gelatin silver print, 26 x 7⅞ in. (66 x 20.16 cm)
Private collection, San Francisco
p. 167

Wood Shingles, ca. 1930
Gelatin silver print, 6⅜ x 4½ in.
(16.2 x 11.5 cm)
The J. Paul Getty Museum, Los Angeles,
84.XM.956.100
p. 168 left

Tin Relic, 1930
Gelatin silver print, 6⅛ x 7¼ in.
(15.4 x 18.3 cm)
The J. Paul Getty Museum, Los Angeles,
84.XM.956.478
p. 168 right

Stamped Tin Relic, 1929
Gelatin silver print, 4⅜ x 6½ in.
(11.1 x 16.4 cm)
Centre Pompidou, Musée National d'Art
Moderne, Paris. Purchase, 1996,
AM 1996-330
p. 169

Fire Ruin in Ossining, New York, 1930–31
Gelatin silver print, 8¼ x 6⅜ in. (21 x 16.2 cm)
Estate of Harry H. Lunn Jr.
p. 170 left

Mabou Mines, Nova Scotia, 1971
Gelatin silver print, 9⅝ x 7⅛ in.
(24.4 x 18.2 cm)
Yale University Art Gallery, New Haven.
Director's Purchase Fund, 1971.112.25
p. 170 right

Corrugated Tin Façade, 1936
Gelatin silver print, printed ca. 1970,
6½ x 9⅛ in. (16.6 x 23.1 cm)
The Museum of Modern Art, New York.
David H. McAlpin Fund, 58.1971
p. 171

"The Criticism of Edwin Denby. Photographs
by Walker Evans," Dance Index, no. 5
(February 1946), cover
9¼ x 7¼ in. (23.5 x 18.5 cm)
Centre Pompidou, Musée National d'Art
Moderne, Paris. Bibliothèque Kandinsky,
David Campany Collection
p. 172 top

Graffiti Backstage, New York City Ballet, 1945
Gelatin silver print, 7 x 9 in. (17.9 x 23 cm)
National Gallery of Canada, Ottawa. Gift of
Phyllis Lambert, Montreal, 1982, 19273
p. 172 bottom

*Building Corner with Torn Rock Concert
Posters, London, England*, 1973
Gelatin silver print, 7⅝ x 7⅝ in.
(19.3 x 19.3 cm)
Estate of Harry H. Lunn Jr.
p. 173

"Color Accidents," *Architectural Forum* 108,
no. 1 (January 1958), pp. 110–11
12¼ x 18⅝ in. (31 x 47.4 cm)
Centre Pompidou, Musée National d'Art
Moderne, Paris. Bibliothèque Kandinsky,
David Campany Collection
pp. 174–75

"Color Accidents," *Architectural Forum* 108,
no. 1 (January 1958), pp. 114–15
12¼ x 18⅝ in. (31 x 47.4 cm)
Collection Alain Ménard

*Interior Detail, West Virginia, Coal Miner's
Home*, 1935
Gelatin silver print, 10 x 8 in. (25.4 x 20.32 cm)
Collection of Marcia L. Due and Jerry L.
Thompson

Negro Houses, Tupelo, Mississippi, March 1936
Gelatin silver print, 7⅝ x 9½ in. (19.4 x 24 cm)
The New York Public Library, 008020-A

"The Wreckers," *Fortune* 43, no. 5 (May 1951),
pp. 102–5
13 x 20½ in. (33 x 52 cm)
Centre Pompidou, Musée National d'Art
Moderne, Paris. Bibliothèque Kandinsky,
David Campany Collection

The Beauty of Garbage
Auto Junkyard, 1961–62
Chromogenic print, 7⅝ x 7⅝ in.
(19.4 x 19.3 cm)
The Metropolitan Museum of Art, New York.
Walker Evans Archive, 1994, 1994.261.217
p. 176

Joe's Auto Graveyard, 1936
Gelatin silver print, 4½ x 7⅜ in.
(11.43 x 18.73 cm)
Private collection, San Francisco
p. 177

"The Auto Junkyard," *Fortune* 65, no. 4
(April 1962), pp. 132–37
13 x 20½ in. (33 x 52 cm)
Centre Pompidou, Musée National d'Art
Moderne, Paris. Bibliothèque Kandinsky,
David Campany Collection
p. 178

Auto Junkyard, 1961–62
Chromogenic print, 7⅝ x 7⅝ in.
(19.4 x 19.3 cm)
The Metropolitan Museum of Art, New York.
Walker Evans Archive, 1994, 1994.261.218
p. 179

Moving Truck and Bureau Mirror, 1929
Gelatin silver print, 4⅝ x 6⅝ in.
(11.7 x 16.7 cm)
Yale University Art Gallery, New Haven.
Director's Purchase Fund, 1971.112.2
p. 180

Street Litter, Chicago, Illinois, August 1946
Gelatin silver print, 6⅞ x 6¼ in. (17.4 x 16 cm)
Estate of Harry H. Lunn Jr.
p. 181

Trash Cans, December 1962
Gelatin silver print, 9¼ x 13¾ in. (24 x 35 cm)
Courtesy Baudoin Lebon
p. 182

Trash Can, New York, ca. 1968
Gelatin silver print, printed ca. 1970 by Charlie
Rodemeyer, 8 x 10 in. (20.3 x 25.4 cm)
The Museum of Modern Art, New York.
Gift of the artist, 442.2015
p. 183

Street Debris, New York City, 1968
Gelatin silver print, 9¼ x 13¼ in.
(23.49 x 33.65 cm)
Private collection, San Francisco
p. 184

Trash #4, January 1, 1962
Gelatin silver print, 7½ x 12⅛ in.
(19.2 x 30.7 cm)
Centre National des Arts Plastiques / Fonds
National d'Art Contemporain, Paris
p. 185 top

Trash #3, January 1, 1962
Gelatin silver print, 4¾ x 7¼ in.
(12.2 x 18.4 cm)
Centre National des Arts Plastiques / Fonds
National d'Art Contemporain, Paris
p. 185 center

Debris, ca. 1965
Gelatin silver print, 4⅞ x 7¼ in.
(12.4 x 18.5 cm)
National Gallery of Art, Washington, D.C.
Horace W. Goldsmith Foundation Gift,
through Robert and Joyce Menschel,
1989.72.8
p. 185 bottom

*Studies of Found Objects, Debris and Street
Furniture. Work Glove*, 1973–74
Chromogenic print, 7½ x 7½ in. (19 x 19 cm)
The Metropolitan Museum of Art, New York.
Walker Evans Archive, 1994, 1994.262.2806
p. 186 top

*Studies of Found Objects, Debris and Street
Furniture. Crushed Schmidt's Beer Can*,
1973–74
Chromogenic print, 7½ x 7½ in. (19 x 19 cm)
The Metropolitan Museum of Art, New York.
Walker Evans Archive, 1994, 1994.262.2830
p. 186 bottom left

*Studies of Found Objects, Debris and Street
Furniture. Crushed Red Can*, 1973–74
Chromogenic print, 7½ x 7½ in. (19 x 19 cm)
The Metropolitan Museum of Art, New York.
Walker Evans Archive, 1994, 1994.262.2856
p. 186 bottom right

Untitled (Rope), 1973–74
Polaroid print, 4¼ x 3½ in. (10.79 x 8.89 cm)
The Heithoff Family Collection, Minneapolis
p. 187

*The Auto Junkyard [Frame and Steering
Wheel]*, 1962
Gelatin silver print, 10 x 8 in. (25.3 x 20.4 cm)
Courtesy Baudoin Lebon

Debris with Broken Glass, 1973–74
Chromogenic print, 7⅝ x 7⅝ in.
(19.3 x 19.3 cm)
The Metropolitan Museum of Art, New York.
Walker Evans Archive, 1994, 1994.262.2809

VERNACULAR AS METHOD
Photographing/Collecting
I. Steinfeldt, *Ten Hour House, Lancaster,
Pennsylvania. Built on Wager in 10 Hours*,
ca. 1925, postcard collection of Walker Evans
Photomechanical print, 3½ x 5½ in.
(9 x 14 cm)
The Metropolitan Museum of Art, New York.
Walker Evans Archive, 1994, 1994.264.74.146
p. 190 top

J. C. Mickleboro, *A. J. Marshall & Co.'s
Store, Marion, Alabama*, ca. 1920, postcard
collection of Walker Evans
Photomechanical print, 3½ x 5½ in.
(9 x 14 cm)
The Metropolitan Museum of Art, New York.
Walker Evans Archive, 1994, 1994.264.108.3
p. 190 center left

J. N. Chamberlain, *Romeo Fruit Store, Oak
Bluffs, Massachusetts*, ca. 1920, postcard
collection of Walker Evans
Photomechanical print, 3½ x 5½ in.
(9 x 14 cm)
The Metropolitan Museum of Art, New York.
Walker Evans Archive, 1994, 1994.264.76.6
p. 190 center right

Unidentified Publisher, *Front Street, Looking
North, Morgan City, Louisiana*, 1900–1930,
postcard collection of Walker Evans
Photomechanical print, 3½ x 5½ in.
(9 x 14 cm)
The Metropolitan Museum of Art, New York.
Walker Evans Archive, 1994, 1994.264.107.188
p. 190 bottom

C. W. Hugues & Co., *Rip Van Dam Hotel,
Saratoga Springs, New York*, ca. 1920,
postcard collection of Walker Evans
Photomechanical print, 3½ x 5½ in.
(9 x 14 cm)
The Metropolitan Museum of Art, New York.
Walker Evans Archive, 1994, 1994.264.27.439
p. 191 top left

Unidentified Publisher, *Hotel Poultney,
Poultney, Vermont*, ca. 1930 (mailed in 1964),
postcard collection of Walker Evans
Photomechanical print, 3½ x 5½ in.
(9 x 14 cm)
The Metropolitan Museum of Art, New York.
Walker Evans Archive, 1994, 1994.264.111.205
p. 191 top right

Unidentified Photographer, *A Pickle Vender in
the Ghetto, New York City*, ca. 1920, postcard
collection of Walker Evans
Photomechanical print, 3½ x 5½ in.
(9 x 14 cm)
The Metropolitan Museum of Art, New York.
Walker Evans Archive, 1994, 1994.264.94.2
p. 191 center

P. Hammacher, *East Main Street, Mystic,
Connecticut*, ca. 1925, postcard collection of
Walker Evans
Photomechanical print, 3½ x 5½ in.
(9 x 14 cm)
The Metropolitan Museum of Art, New York.
Walker Evans Archive, 1994, 1994.264.107.48
p. 191 bottom left

Lenoir Book Co., *Main Street, Showing
Confederate Monument, Lenoir, North
Carolina*, ca. 1925 (mailed in 1937),
postcard collection of Walker Evans
Photomechanical print, 3½ x 5½ in.
(9 x 14 cm)
The Metropolitan Museum of Art, New York.
Walker Evans Archive, 1994, 1994.264.107.468
p. 191 bottom right

Souvenir Post Card Co., *Soldiers' and Sailors'
Monument, East Rock Park, New Haven,
Connecticut*, ca. 1905 (mailed in 1907),
postcard collection of Walker Evans
Photomechanical print, 3½ x 5½ in.
(9 x 14 cm)
The Metropolitan Museum of Art, New York.
Walker Evans Archive, 1994, 1994.264.65.4
p. 192 top left

Louis Kaufmann & Sons, *Confederate
Monument and Mt. Vernon Boulevard,
Alexandria, Virginia*, ca. 1925, postcard
collection of Walker Evans
Photomechanical print, 3½ x 5½ in.
(9 x 14 cm)
The Metropolitan Museum of Art, New York.
Walker Evans Archive, 1994, 1994.264.103.46
p. 192 top right

E. C. Kroff Co., *Presbyterian Church,
St. Marys, Georgia*, ca. 1925, postcard
collection of Walker Evans
Photomechanical print, 3½ x 5½ in.
(9 x 14 cm)
The Metropolitan Museum of Art, New York.
Walker Evans Archive, 1994, 1994.264.41.44
p. 192 center

Curt Teich & Co., *Gateway of Simonton
House, Built 1776, Charleston, South Carolina*,
ca. 1925, postcard collection of Walker Evans
Photomechanical print, 3½ x 5½ in.
(9 x 14 cm)
The Metropolitan Museum of Art, New York.
Walker Evans Archive, 1994, 1994.264.74.168
p. 192 bottom left

S. H. Kress & Co., *Old Charleston Gate,
Charleston, South Carolina*, ca. 1920, postcard
collection of Walker Evans
Photomechanical print, 3½ x 5½ in.
(9 x 14 cm)
The Metropolitan Museum of Art, New York.
Walker Evans Archive, 1994, 1994.264.74.167
p. 192 bottom right

Unidentified Publisher, *Soldiers' Monument,
Dayton, Ohio*, ca. 1910, postcard collection of
Walker Evans
Photomechanical print, 3½ x 5½ in.
(9 x 14 cm)
The Metropolitan Museum of Art, New York.
Walker Evans Archive, 1994, 1994.264.65.81
p. 193 top

Fred James, *Congregational Church,
Boscawen, New Hampshire*, ca. 1925, postcard
collection of Walker Evans
Photomechanical print, 3½ x 5½ in.
(9 x 14 cm)
The Metropolitan Museum of Art, New York.
Walker Evans Archive, 1994, 1994.264.41.88
p. 193 center left

Coastal News Co., *Old Midway Church,
Midway, Georgia, Near Savannah, Georgia*,
ca. 1925 (mailed in 1938), postcard collection
of Walker Evans
Photomechanical print, 3½ x 5½ in.
(9 x 14 cm)
The Metropolitan Museum of Art, New York.
Walker Evans Archive, 1994, 1994.264.103.10
p. 193 center right

W. A. Ricker, *Doorway to Cate House, Castine,
Maine*, ca. 1910 (mailed in 1916), postcard
collection of Walker Evans
Photomechanical print, 3½ x 5½ in.
(9 x 14 cm)
The Metropolitan Museum of Art, New York.
Walker Evans Archive, 1994, 1994.264.74.41
p. 193 bottom

Unidentified Photographer
Head of Corpse, Probably in Havana, ca. 1933,
press photograph reproduced by
Walker Evans
Gelatin silver negative, 10 x 8 in.
(25.4 x 20.32 cm)
The Metropolitan Museum of Art, New York.
Walker Evans Archive, 1994, 1994.258.761
p. 194 left

Unidentified Photographer
*Corpse with Sutured Chest, Probably
in Havana*, ca. 1933, press photograph
reproduced by Walker Evans
Gelatin silver negative, 8½ x 6½ in.
(21.59 x 16.51 cm)
The Metropolitan Museum of Art, New York.
Walker Evans Archive, 1994, 1994.256.106
p. 194 top

Unidentified Photographer
Bombed Wall, Probably in Havana, ca. 1933,
press photograph reproduced by
Walker Evans
Gelatin silver negative, 8 x 10 in.
(20.32 x 25.4 cm)
The Metropolitan Museum of Art, New York.
Walker Evans Archive, 1994, 1994.258.758
p. 194 bottom

Unidentified Photographer
Press Photograph of a Longshoreman, 1930–40
Gelatin silver print, 7⅝ x 9½ in. (19.4 x 24.1 cm)
The Metropolitan Museum of Art, New York.
Walker Evans Archive, 1994, 1994.263.187
p. 195 top

Unidentified Photographer
*Nine Guns Propped on Bench Next to
Valise, Probably in Havana*, ca. 1933, press
photograph reproduced by Walker Evans
Gelatin silver negative, 8 x 10 in.
(20.32 x 25.4 cm)
The Metropolitan Museum of Art, New York.
Walker Evans Archive, 1994, 1994.258.759
p. 195 center

Unidentified Photographer
*Corpse of Gonzalez Rubiera with Blood-Stained
Face, Havana*, ca. 1933, press photograph
reproduced by Walker Evans
Gelatin silver negative, 6¼ x 9 in. (15.9 x 22.86)
The Metropolitan Museum of Art, New York.
Walker Evans Archive, 1994, 1994.257.97
p. 195 bottom

Pages of an album of picture press clippings
titled "Pictures of the Time: 1925–1935,"
scrapbook of Walker Evans, end of the 1930s
Photomechanical prints, each 16 x 10½ in.
(40.8 x 26.8 cm)
The Metropolitan Museum of Art, New York.
Walker Evans Archive, 1994, 1994.250.88.3,
.10, .19, .22, .24, .27
pp. 196–99

Unidentified Itinerant Photographer
Portrait in front of a house, ca. 1925
Gelatin silver print, 5⅜ x 3⅜ in. (13.7 x 8.7 cm)
Private collection, Paris
p. 200 top

Unidentified Itinerant Photographer
Portrait in front of a house, ca. 1925
Gelatin silver print, 5⅜ x 3⅜ in. (13.7 x 8.7 cm)
Private collection, Paris
p. 200 center

Unidentified Itinerant Photographer
Portrait in front of a house, ca. 1925
Gelatin silver print, 5⅜ x 3⅜ in. (13.7 x 8.7 cm)
Private collection, Paris
p. 200 bottom

Unidentified Street Photographer
Portrait, ca. 1940–46
Gelatin silver print, 3¼ x 2⅜ in. (8.2 x 6 cm)
Private collection, Paris
p. 201 far left

Unidentified Street Photographer
Portrait, ca. 1940–46
Gelatin silver print, 3¼ x 2⅜ in. (8.2 x 6 cm)
Private collection, Paris
p. 201 center left

Unidentified Street Photographer
Portrait, ca. 1940–46
Gelatin silver print, 3⅜ x 2⅜ in. (8.4 x 6.1 cm)
Private collection, Paris
p. 201 center right

Unidentified Street Photographer
Portrait, ca. 1940–46
Gelatin silver print, 2¾ x 2⅛ in. (7.1 x 5.5 cm)
Private collection, Paris
p. 201 far right

Unidentified Resort Photographer
Portrait, Saint Petersburg, Florida, ca. 1942
Gelatin silver print, 4 x 3¼ in. (10.2 x 8.2 cm)
Private collection, Paris
p. 202 top left

Unidentified Resort Photographer
Portrait, Saint Petersburg, Florida, ca. 1942
Gelatin silver print, 4⅛ x 3¼ in.
(10.4 x 8.2 cm)
Private collection, Paris
p. 202 top right

Unidentified Resort Photographer
Portrait, Saint Petersburg, Florida, 1943
Gelatin silver print, 4 x 3¼ in. (10.3 x 8.2 cm)
Private collection, Paris
p. 202 bottom

Unidentified Resort Photographer
Portraits, Saint Petersburg, Florida, 1940
Gelatin silver prints, 9⅛ x 7⅛ in.
(23.3 x 18 cm)
Private collection, Paris
p. 203

The Sheldon-Claire Company, "This is
America . . .," U.S. government poster, 1942
Photograph by Walker Evans, colorized
Photomechanical print, 36 x 23⅞ in.
(91.5 x 60.7 cm)
Collection David Campany
p. 204

Stanley Hoyt
Pacific Coast Credit Co. Billboard, 1907–10
Gelatin silver print, 4⅝ x 6⅝ in.
(11.7 x 16.8 cm)
San Francisco Museum of Modern Art.
Gift of Bruce Berman and Nancy Goliger
p. 205 top

Stanley Hoyt
Bismarck Café Billboard, 1908–10
Gelatin silver print, 6⅝ x 4⅝ in.
(16.8 x 11.7 cm)
San Francisco Museum of Modern Art.
Gift of Bruce Berman and Nancy Goliger
p. 205 center

Stanley Hoyt
Pacific Coast Credit Clothing Co. Billboard,
1907–10
Gelatin silver print, 4⅝ x 6⅝ in.
(11.7 x 16.8 cm)
San Francisco Museum of Modern Art.
Gift of Bruce Berman and Nancy Goliger
p. 205 bottom

Page from the Russell Harrington Cutlery Co./
Dexter catalogue used to prepare Walker
Evans's "Beauties of the Common Tool"
portfolio published in *Fortune* 65, no. 4
(July 1955)
Ink on paper, photomechanical print,
6⅛ x 3⅛ in. (15.7 x 8.1 cm)
The Metropolitan Museum of Art, New York.
Walker Evans Archive, 1994, 1994.250.33.29.1
p. 206 left

Envelope containing Stahls flat pliers,
photographed for Walker Evans's "Beauties
of the Common Tool" portfolio published in
Fortune 65, no. 4 (July 1955)
Ink on paper, photomechanical print,
17 x 11 in. (43.2 x 28 cm)
The Metropolitan Museum of Art, New York.
Walker Evans Archive, 1994, 1994.250.33.29.2
p. 206 right

Irving Underhill
Wrenches, ca. 1915
Digital print from gelatin silver negative,
7 x 5 in. (17.8 x 12.7 cm)
George Eastman Museum, Rochester,
New York, 1979.1994.0313
p. 207 (not in exhibition)

Pages of an album of picture press clippings
titled "Pictures of the Time: 1925–1935,"
scrapbook of Walker Evans, end of the 1930s
Photomechanical prints, 16⅛ x 10½ in.
(40.8 x 26.8 cm)
The Metropolitan Museum of Art, New York.
Walker Evans Archive, 1994, 1994.250.88.2

Six Tintypes, 1970–75
Tintypes and graphite on paper, 10¾ x 9¼ in.
(27.3 x 23.5 cm)
The Metropolitan Museum of Art, New York.
Walker Evans Archive, 1994, 1994.261.173

Braun Post Card Co., *General Moses
Cleaveland, Founder of Cleveland, Ohio*,
ca. 1915, postcard collection of Walker Evans
Photomechanical print, 3½ x 5½ in. (9 x 14 cm)
The Metropolitan Museum of Art, New York.
Walker Evans Archive, 1994, 1994.264.65.78

Commercialchrome, *Main Street, Looking
West, Elkin, North Carolina*, ca. 1915,
postcard collection of Walker Evans
Photomechanical print, 3½ x 5½ in. (9 x 14 cm)
The Metropolitan Museum of Art, New York.
Walker Evans Archive, 1994, 1994.264.107.643

E. Cuff, *Main Street, Danbury, Connecticut*,
ca. 1910, postcard collection of Walker Evans
Photomechanical print, 3½ x 5½ in. (9 x 14 cm)
The Metropolitan Museum of Art, New York.
Walker Evans Archive, 1994, 1994.264.107.35

Detroit Publishing Co., *Betsy Ross House,
Philadelphia, Pennsylvania*, ca. 1909 (mailed in
1922), postcard collection of Walker Evans
Photomechanical print, 3½ x 5½ in. (9 x 14 cm)
The Metropolitan Museum of Art, New York.
Walker Evans Archive, 1994, 1994.264.34.77

Mike Disfarmer
Eila and Barb Poole, 1920–30
Gelatin silver print, 5 x 3 in. (12.7 x 7.6 cm)
Courtesy Steven Kasher Gallery, New York

Mike Disfarmer
*Ina and Jerry Wayne Kendall (Kendall Family
set of 8)*, 1939–46
Gelatin silver print, 5 x 3 in. (12.7 x 7.6 cm)
Courtesy Steven Kasher Gallery, New York

Mike Disfarmer
Untitled, 1940
Gelatin silver print, 4½ x 3 in. (11.4 x 7.6 cm)
Courtesy Steven Kasher Gallery, New York

Mike Disfarmer
Untitled, ca. 1940
Gelatin silver print, 5 x 3 in. (12.7 x 7.6 cm)
Courtesy Steven Kasher Gallery, New York

Mike Disfarmer
Mr. Hipp, ca. 1940
Gelatin silver print, 4½ x 3 in. (11.4 x 7.6 cm)
Courtesy Steven Kasher Gallery, New York

Mike Disfarmer
Estee and Neeta Sue, 1940–45
Gelatin silver print, 5½ x 3½ in. (14 x 9 cm)
Courtesy Steven Kasher Gallery, New York

Mike Disfarmer
Untitled, 1940–45
Gelatin silver print, 5 x 3 in. (12.7 x 7.6 cm)
Courtesy Steven Kasher Gallery, New York

Mike Disfarmer
Untitled, 1940–45
Gelatin silver print, 5 x 3 in. (12.7 x 7.6 cm)
Courtesy Steven Kasher Gallery, New York

Mike Disfarmer
Untitled, 1940–45
Gelatin silver print, 4½ x 3 in. (11.4 x 7.6 cm)
Courtesy Steven Kasher Gallery, New York

Mike Disfarmer
Untitled, 1940–45
Gelatin silver print, 5 x 3 in. (12.7 x 7.6 cm)
Courtesy Steven Kasher Gallery, New York

Mike Disfarmer
Untitled, 1940–45
Gelatin silver print, 5 x 3 in. (12.7 x 7.6 cm)
Courtesy Steven Kasher Gallery, New York

Mike Disfarmer
*Ina Kendall and Her Son Jerry Wayne (Kendall
Family set of 8)*, ca. 1942
Gelatin silver print, 5 x 3 in. (12.7 x 7.6 cm)
Courtesy Steven Kasher Gallery, New York

Mike Disfarmer
Lloyd Stokes, ca. 1945
Gelatin silver print, 5 x 3 in. (12.7 x 7.6 cm)
Courtesy Steven Kasher Gallery, New York

Mike Disfarmer
Pete, Age 24, 1947
Gelatin silver print, 5 x 3½ in. (12.7 x 8.9 cm)
Courtesy Steven Kasher Gallery, New York

Mike Disfarmer
Irene Verser Beasley, ca. 1950
Gelatin silver print, 5 x 3 in. (12.7 x 7.6 cm)
Courtesy Steven Kasher Gallery, New York

Stanley Holt
Calegaris Pharmacy Billboard, 1907–10
Gelatin silver print, 6½ x 4½ in.
(16.5 x 11.4 cm)
San Francisco Museum of Modern Art.
Gift of Bruce Berman and Nancy Goliger

Stanley Holt
Hopsburger Billboard, 1907–10
Gelatin silver print, 4½ x 6½ in.
(11.4 x 16.5 x cm)
San Francisco Museum of Modern Art.
Gift of Bruce Berman and Nancy Goliger

C. W. Hugues & Co., *Main Street, Cobleskill, New York*, ca. 1920, postcard collection of Walker Evans
Photomechanical print, 3½ x 5½ in.
(9 x 14 cm)
The Metropolitan Museum of Art, New York.
Walker Evans Archive, 1994, 1994.264.107.496

E. C. Kropp Co., *Looking East on Main Street, West Frankfort, Illinois*, ca. 1920, postcard collection of Walker Evans
Photomechanical print, 3½ x 5½ in.
(9 x 14 cm)
The Metropolitan Museum of Art, New York.
Walker Evans Archive, 1994, 1994.264.107.162

J. C. Mickleboro, *Episcopal Church, Marion, Alabama*, ca. 1920, postcard collection of Walker Evans
Photomechanical print, 3½ x 5½ in.
(9 x 14 cm)
The Metropolitan Museum of Art, New York.
Walker Evans Archive, 1994, 1994.264.41.1

Photo and Art Postal Card Co., *Grant Monument, Bedford Ave., Brooklyn, New York*, ca. 1906 (mailed in 1907), postcard collection of Walker Evans
Photomechanical print, 3½ x 5½ in.
(9 x 14 cm)
The Metropolitan Museum of Art, New York.
Walker Evans Archive, 1994, 1994.264.65.53

Unidentified Photographer
Portrait, 1940–46
Gelatin silver print, 3⅛ x 2⅜ in. (8.1 x 6.1 cm)
Private collection, Paris

Unidentified Photographer
Portrait, 1940–46
Gelatin silver print, 3¼ x 2½ in. (8.2 x 6.3 cm)
Private collection, Paris

Unidentified Photographer
Portrait, 1940–46
Gelatin silver print, 3⅛ x 2½ in. (8 x 6.2 cm)
Private collection, Paris

Stengel & Co., *Old Curiosity Shop (Lincolns Inn), London*, ca. 1900 (mailed in 1904), postcard collection of Walker Evans
Photomechanical print, 3½ x 5½ in.
(9 x 14 cm)
The Metropolitan Museum of Art, New York.
Walker Evans Archive, 1994, 1994.264.11.113

City Series
Untitled (Greek Revival Doorway), ca. 1934
Gelatin silver print, 9½ x 7¼ in.
(24.13 x 18.57 cm)
San Francisco Museum of Modern Art.
Gift of Russ Anderson
p. 208 top

Doorway, Greenwich Village, New York, 1934
Gelatin silver print, 8⅜ x 6⅜ in.
(21.2 x 16.3 cm)
Estate of Harry H. Lunn Jr.
p. 208 center

Ionic Doorway, New York State, 1931
Gelatin silver print, 8 x 6⅜ in. (20.2 x 16.1 cm)
The Art Institute of Chicago. Gift of David and Sarajean Ruttenberg, 1991.1192
p. 208 bottom

Doorway, 204 West 13th Street, New York City, 1931
Gelatin silver print, 7¾ x 5 in. (19.7 x 12.6 cm)
National Gallery of Canada, Ottawa. Gift of Phyllis Lambert, Montreal, 1982, 19276
p. 209

Untitled, 1936
Gelatin silver print, printed in 1970 by James Dow, 7½ x 9½ in. (19.2 x 24.1 cm)
The Museum of Modern Art, New York.
Purchase, SC 2015.1.80
p. 210 top

Negro Church, South Carolina, March 1936
Gelatin silver print, 10 x 8 in. (25.4 x 20.3 cm)
The New York Public Library. The Miriam and Ira D. Wallach Division of Art, 008054-A c.2
p. 210 bottom left

Wooden Church, South Carolina, 1936
Gelatin silver print, 10 x 8 in. (25.2 x 20.4 cm)
Bibliothèque Nationale de France, Paris
p. 210 bottom right (print reproduced: Collection of Marcia L. Due and Jerry L. Thompson. Gift from Norman Ives [portfolio producer] to Jerry L. Thompson, ca. 1975)

"Gallery: Primitive Churches. Out-of-the-way vignettes of US religious life," *Architectural Forum* 115, no. 6 (December 1961), pp. 102–3
12¼ x 18⅝ in. (31 x 47.4 cm)
Centre Pompidou, Musée National d'Art Moderne, Paris. Bibliothèque Kandinsky, David Campany Collection
p. 211 top left

Church, Georgia, March 1936
Gelatin silver print, 10¼ x 8⅜ in.
(25.9 x 21.2 cm)
The New York Public Library. The Miriam and Ira D. Wallach Division of Art, 008125-C
p. 211 top right

Negroes' Church, South Carolina, March 1936
Gelatin silver print, printed in April 1969 by the Library of Congress, 9½ x 7½ in.
(24.1 x 19.1 cm)
National Gallery of Canada, Ottawa.
Purchased in 1969, 21721
p. 211 bottom

Battlefield Monument, Vicksburg, Mississippi, 1936
Gelatin silver print, 8 x 9⅞ in. (20.3 x 25 cm)
National Gallery of Art, Washington, D.C.
Corcoran Collection (Gift of Murray H. Bring), 2015.19.4218
p. 212 top

Civil War Monument, Oxford, Mississippi, March 1936
Gelatin silver print, 9⅝ x 7⅝ in.
(24.4 x 19.3 cm)
National Gallery of Canada, Ottawa. Gift of Phyllis Lambert, Montreal, 1982, 19359
p. 212 center

Gravestone (Crystal Springs), Mississippi, 1935
Gelatin silver print, 5⅝ x 8 in. (14.4 x 20.3 cm)
Fraenkel Gallery, San Francisco
p. 212 bottom

Main Street of Pennsylvania Town, 1935
Gelatin silver print, 8 x 7 in. (20.4 x 17.8 cm)
The J. Paul Getty Museum, Los Angeles, 84.XM.956.491
p. 213

Doorway, 1931
Gelatin silver print, 8¼ x 6⅜ in. (21 x 16.2 cm)
Centre Pompidou, Musée National d'Art Moderne, Paris. Purchase, 1984, AM 1984-713

Church of the Nazarene, Tennessee, 1936
Gelatin silver print, 7¼ x 9½ in.
(18.4 x 24.1 cm)
Bank of America Art Collection

Civil War Monument. Vicksburg, Mississippi, February 1936
Gelatin silver print, 8¼ x 10⅛ in.
(20.8 x 25.8 cm)
The New York Public Library, 001307-A

Negro Church at Vicksburg, Mississippi, March 1936
Gelatin silver print, 6⅜ x 7¾ in.
(16.2 x 19.8 cm)
The New York Public Library, 008070-A

The Charm of Main Street
Main Street of County Seat, Alabama, 1931
Gelatin silver print, 7⅜ x 9¼ in.
(18.6 x 23.6 cm)
Private collection, San Francisco
p. 214

Main Street, Saratoga Springs, New York, 1931
Gelatin silver print, 7⅜ x 6⅜ in.
(18.7 x 16.2 cm)
Private collection, San Francisco
p. 215

Roadside View, Alabama Coal Area Company Town, 1935
Gelatin silver print, 7¼ x 8⅞ in.
(18.3 x 22.4 cm)
The J. Paul Getty Museum, Los Angeles, 84.XM.956.498
p. 216 top

Small Town, Cuba, 1933
Gelatin silver print, 8 x 9⅞ in. (20.3 x 25.2 cm)
The J. Paul Getty Museum, Los Angeles, 84.XM.956.151
p. 216 bottom

Untitled [Street Scene], ca. 1955
Gouache on paper, 6¼ x 8⅞ in.
(15.9 x 22.4 cm)
The J. Paul Getty Museum, Los Angeles, 98.PA.197
p. 217

Main Street, from Across Railroad Tracks, Morgan City, Louisiana, 1935
Gelatin silver print, 7⅝ x 9⅝ in.
(19.4 x 24.5 cm)
Estate of Harry H. Lunn Jr.
p. 218

Savannah Negro Quarter, 1935
Gelatin silver print, 3½ x 9⅛ in.
(8.9 x 23.1 cm)
Yale University Art Gallery, New Haven.
Director's Purchase Fund, 1971.112.12
p. 219

"Main Street Looking North from Courthouse Square," *Fortune* 37, no. 5 (May 1948), pp. 102–6
13 x 20⅞ in. (33 x 53 cm)
Centre Pompidou, Musée National d'Art Moderne, Paris. Bibliothèque Kandinsky, David Campany Collection
pp. 220–21

Window Gazing
National Gallery/Trafalgar Square from Inside a Car, London, 1973
Gelatin silver print, 6½ x 9⅝ in.
(16.4 x 24.4 cm)
The J. Paul Getty Museum, Los Angeles, 95.XM.45.88
p. 222

Blue Faun Bookshop, 3rd Avenue, New York, ca. 1950
Gelatin silver print, 9¼ x 13⅝ in.
(23.6 x 34.5 cm)
National Gallery of Canada, Ottawa. Gift of Phyllis Lambert, Montreal, 1982, 19469
p. 223 top

Two Elderly Men and a Woman, 3rd Avenue, New York, ca. 1950
Gelatin silver print, 9¼ x 13⅝ in.
(23.6 x 34.5 cm)
National Gallery of Canada, Ottawa. Gift of Phyllis Lambert, Montreal, 1982, 19470
p. 223 bottom

Views from the Train, for the Series "Along the Right-of-Way," Fortune, September 1950, 1950
Color film transparencies, each ⅞ x 1⅜ in.
(2.4 x 3.6 cm)
The Metropolitan Museum of Art, New York.
Walker Evans Archive, 1994, 1994.259.3.1–.130
pp. 224–25

Steel Mills in Pennsylvania, for the Series "Along the Right-of-Way," Fortune, September 1950, 1950
Gelatin silver print, 6⅜ x 9⅝ in.
(16.2 x 24.4 cm)
The Metropolitan Museum of Art, New York. Purchase, The Horace W. Goldsmith Foundation Gift through Joyce and Robert Menschel and Frish Brandt Gift, 2001, 2001.250
p. 226

View from Train Window, for the Series "Along the Right-of-Way," Fortune, September 1950, 1950
Dye transfer print, 9½ x 14⅛ in.
(24 x 35.8 cm)
The Metropolitan Museum of Art, New York.
Walker Evans Archive, 1994, 1994.261.234
p. 227

"Along the Right-of-Way," *Fortune* 42, no. 3 (September 1950), pp. 106–13
13 x 20½ in. (33 x 52 cm)
Centre Pompidou, Musée National d'Art Moderne, Paris. Bibliothèque Kandinsky, David Campany Collection
pp. 228–29

National Gallery St. Martins-in-the-Field's (Church) from Inside a Car, London, 1973
Gelatin silver print, 6½ x 9⅝ in.
(16.4 x 24.4 cm)
The J. Paul Getty Museum, Los Angeles, 95.XM.45.87

Anonymous Passersby
Randolph Street, Chicago, ca. 1946
Gelatin silver print, 7⅛ x 6¾ in. (18 x 17.2 cm)
The Art Institute of Chicago. Gift of David and Sarajean Ruttenberg, 1998.396.7
p. 230

Two Women Beneath a Store Awning, August 1947
Gelatin silver print, 7⅛ x 6¾ in. (18 x 17 cm)
Yale University Art Gallery, New Haven.
Katharine Ordway Fund, 2002.52.10
p. 231

Bridgeport, Connecticut, 1941
Gelatin silver print, 8⅞ x 6⅞ in.
(22.6 x 17.4 cm)
National Gallery of Art, Washington, D.C. Gift of Kent and Marcia Minichiello, 2012.111.2
p. 232

Bridgeport, Connecticut, 1941
Gelatin silver print, 8⅞ x 6¾ in.
(22.7 x 17.2 cm)
National Gallery of Art, Washington, D.C. Gift
of Kent and Marcia Minichiello, 2012.111.7
p. 233

Bridgeport, Connecticut, 1941
Gelatin silver print, 8⅞ x 7 in. (22.5 x 17.7 cm)
National Gallery of Art, Washington, D.C. Gift
of Kent and Marcia Minichiello, 2012.111.21
p. 234 top

Bridgeport, Connecticut, 1941
Gelatin silver print, 8⅞ x 7⅛ in.
(22.7 x 18.1 cm)
National Gallery of Art, Washington, D.C. Gift
of Kent and Marcia Minichiello, 2012.111.23
p. 234 center

Bridgeport, Connecticut, 1941
Gelatin silver print, 8⅝ x 6½ in. (22 x 16.6 cm)
National Gallery of Art, Washington, D.C. Gift
of Kent and Marcia Minichiello, 2012.111.17
p. 234 bottom

Bridgeport, Connecticut, 1941
Gelatin silver print, 8⅞ x 6⅞ in.
(22.6 x 17.4 cm)
National Gallery of Art, Washington, D.C. Gift
of Kent and Marcia Minichiello, 2012.111.10
p. 235

Corner of State and Randolph Streets, Chicago,
before February 1947
Gelatin silver print, 10⅜ x 14⅞ in.
(26.4 x 37.7 cm)
National Gallery of Canada, Ottawa.
Purchased with the Phyllis Lambert Fund,
1984, 28619
p. 236 top

Edward Steichen, "In and Out of Focus,"
photographs by Walker Evans: *Corner of State
and Randolph Streets, Chicago*, *U.S. Camera
Annual 1949*, pp. 12–13
12¼ x 18½ in. (31 x 47 cm)
Centre Pompidou, Musée National d'Art
Moderne, Paris. Bibliothèque Kandinsky,
David Campany Collection
p. 236 bottom

*Corner of State and Randolph Streets,
Chicago*, 1946
Gelatin silver print, 8⅛ x 8⅛ in.
(20.48 x 20.48 cm)
San Francisco Museum of Modern Art.
Margery Mann Memorial Collection, Gift of
Tom Vasey
p. 237 top left

Corner of State and Randolph Streets, Chicago,
August 1946
Gelatin silver print, 8⅝ x 9½ in. (21.8 x 24 cm)
National Gallery of Canada, Ottawa. Gift of
Phyllis Lambert, 1984, 19459
p. 237 top right

Corner of State and Randolph Streets, Chicago,
August 29, 1946–February 1947
Gelatin silver print, 10¼ x 9⅞ in.
(26.1 x 25 cm)
National Gallery of Canada, Ottawa. Gift of
Benjamin Greenberg, Ottawa, 1981, 20392
p. 237 bottom

*Detroit Pedestrian, for the Series "Labor
Anonymous," Fortune, November 1946*, 1946
Gelatin silver print, 6¼ x 4½ in. (16 x 11.4 cm)
Fondation A Stichting, Astrid Ullens de
Schooten Collection, Brussels
p. 238 top left

*Detroit Pedestrian, for the Series "Labor
Anonymous," Fortune, November 1946*, 1946
Gelatin silver print, 6¼ x 4½ in. (16 x 11.5 cm)
Fondation A Stichting, Astrid Ullens de
Schooten Collection, Brussels
p. 238 top center

*Detroit Pedestrian, for the Series "Labor
Anonymous," Fortune, November 1946*, 1946
Gelatin silver print, 6⅜ x 4½ in.
(16.1 x 11.5 cm)
Fondation A Stichting, Astrid Ullens de
Schooten Collection, Brussels
p. 238 top right

*Detroit Pedestrian, for the Series "Labor
Anonymous," Fortune, November 1946*, 1946
Gelatin silver print, 6⅞ x 4½ in.
(17.5 x 11.5 cm)
Fondation A Stichting, Astrid Ullens de
Schooten Collection, Brussels
p. 238 center left

*Detroit Pedestrian, for the Series "Labor
Anonymous," Fortune, November 1946*, 1946
Gelatin silver print, 6¼ x 4½ in.
(15.9 x 11.5 cm)
Fondation A Stichting, Astrid Ullens de
Schooten Collection, Brussels
p. 238 center

*Detroit Pedestrian, for the Series "Labor
Anonymous," Fortune, November 1946*, 1946
Gelatin silver print, 6¼ x 4½ in. (16 x 11.5 cm)
Fondation A Stichting, Astrid Ullens de
Schooten Collection, Brussels
p. 238 center right

*Detroit Pedestrian, for the Series "Labor
Anonymous," Fortune, November 1946*, 1946
Gelatin silver print, 6¼ x 4½ in. (16 x 11.4 cm)
Fondation A Stichting, Astrid Ullens de
Schooten Collection, Brussels
p. 238 bottom left

*Detroit Pedestrian, for the Series "Labor
Anonymous," Fortune, November 1946*, 1946
Gelatin silver print, 6¼ x 4½ in. (16 x 11.5 cm)
Fondation A Stichting, Astrid Ullens de
Schooten Collection, Brussels
p. 238 bottom center

*Detroit Pedestrian, for the Series "Labor
Anonymous," Fortune, November 1946*, 1946
Gelatin silver print, 6⅜ x 4½ in.
(16.1 x 11.5 cm)
Fondation A Stichting, Astrid Ullens de
Schooten Collection, Brussels
p. 238 bottom right

*Detroit Pedestrian, for the Series "Labor
Anonymous," Fortune, November 1946*, 1946
Gelatin silver print, 6⅜ x 4½ in.
(16.1 x 11.4 cm)
Fondation A Stichting, Astrid Ullens de
Schooten Collection, Brussels
p. 239 top left

*Detroit Pedestrian, for the Series "Labor
Anonymous," Fortune, November 1946*, 1946
Gelatin silver print, 6¼ x 4½ in. (16 x 11.5 cm)
Fondation A Stichting, Astrid Ullens de
Schooten Collection, Brussels
p. 239 top center

*Detroit Pedestrian, for the Series "Labor
Anonymous," Fortune, November 1946*, 1946
Gelatin silver print, 6¼ x 4½ in. (16 x 11.5 cm)
Fondation A Stichting, Astrid Ullens de
Schooten Collection, Brussels
p. 238 top center

*Detroit Pedestrian, for the Series "Labor
Anonymous," Fortune, November 1946*, 1946
Gelatin silver print, 6⅜ x 4½ in.
(16.1 x 11.4 cm)
Fondation A Stichting, Astrid Ullens de
Schooten Collection, Brussels
p. 239 center left

*Detroit Pedestrian, for the Series "Labor
Anonymous," Fortune, November 1946*, 1946
Gelatin silver print, 6⅞ x 4½ in.
(17.5 x 11.5 cm)
Fondation A Stichting, Astrid Ullens de
Schooten Collection, Brussels
p. 239 center

*Detroit Pedestrian, for the Series "Labor
Anonymous," Fortune, November 1946*, 1946
Gelatin silver print, 6⅞ x 4½ in.
(17.5 x 11.5 cm)
Fondation A Stichting, Astrid Ullens de
Schooten Collection, Brussels
p. 239 center right

*Detroit Pedestrian, for the Series "Labor
Anonymous," Fortune, November 1946*, 1946
Gelatin silver print, 6⅜ x 4½ in.
(16.1 x 11.5 cm)
Fondation A Stichting, Astrid Ullens de
Schooten Collection, Brussels
p. 239 bottom left

*Detroit Pedestrian, for the Series "Labor
Anonymous," Fortune, November 1946*, 1946
Gelatin silver print, 6¼ x 4½ in. (16 x 11.5 cm)
Fondation A Stichting, Astrid Ullens de
Schooten Collection, Brussels
p. 239 bottom center

*Detroit Pedestrian, for the Series "Labor
Anonymous," Fortune, November 1946*, 1946
Gelatin silver print, 6¼ x 4½ in.
(15.8 x 11.5 cm)
Fondation A Stichting, Astrid Ullens de
Schooten Collection, Brussels
p. 240

*Detroit Pedestrian, for the Series "Labor
Anonymous," Fortune, November 1946*, 1946
Gelatin silver print, 4½ x 4⅛ in.
(11.5 x 10.4 cm)
Fondation A Stichting, Astrid Ullens de
Schooten Collection, Brussels
p. 241

"Labor Anonymous," *Fortune* 34, no. 5
(November 1946), pp. 152–53
13 x 20⅞ in. (33 x 53 cm)
Centre Pompidou, Musée National d'Art
Moderne, Paris. Bibliothèque Kandinsky,
David Campany Collection
pp. 242–43

Bridgeport, Connecticut, 1941
Gelatin silver print, 8⅞ x 6⅞ in.
(22.7 x 17.4 cm)
National Gallery of Art, Washington, D.C. Gift
of Kent and Marcia Minichiello, 2012.111.3

In Transit
Subway Portrait, 1941
Gelatin silver print, 6⅜ x 7⅛ in.
(16.2 x 18.1 cm)
The J. Paul Getty Museum, Los Angeles,
84.XM.956.580
p. 244

Subway Portrait, 1938
Gelatin silver print, 4⅞ x 7½ in.
(12.3 x 19.2 cm)
National Gallery of Art, Washington, D.C. Gift
of Kent and Marcia Minichiello, in Honor of
the 50th Anniversary of the National Gallery
of Art, 1990.114.13
p. 245

Subway Portrait, 1938–41
Gelatin silver print, 6⅞ x 7½ in.
(17.6 x 19.1 cm)
The Museum of Modern Art, New York.
Purchase, 466.1966
p. 246

Subway Portrait, 1941
Gelatin silver print, 5 x 7⅝ in. (12.7 x 19.4 cm)
The J. Paul Getty Museum, Los Angeles,
84.XM.956.661
p. 247

Subway Portrait, 1938–41
Gelatin silver print, 5 x 3⅞ in. (12.8 x 10 cm)
The Museum of Modern Art, New York.
Purchase, 471.1966
p. 248

Subway Portrait, 1938–41
Gelatin silver print, 6⅞ x 8¾ in.
(17.5 x 22.2 cm)
The J. Paul Getty Museum, Los Angeles,
84.XM.956.685
p. 249

Subway Portrait, 1938–41
Gelatin silver print, 10⅞ x 8½ in.
(27.6 x 21.5 cm)
National Gallery of Art, Washington, D.C. Gift
of Kent and Marcia Minichiello, in Honor of
the 50th Anniversary of the National Gallery
of Art, 1990.114.2
p. 250 left

Subway Portrait, 1941
Gelatin silver print, 6⅞ x 6¼ in.
(17.6 x 15.9 cm)
The J. Paul Getty Museum, Los Angeles,
84.XM.956.778
p. 250 right

Subway Portrait, 1938–41
Gelatin silver print, 6¾ x 5 in. (17 x 12.7 cm)
The Museum of Modern Art, New York.
Purchase, 472.1966
p. 251 left

Subway Portrait, 1938–41
Gelatin silver print, 6¾ x 4⅞ in.
(17.2 x 12.3 cm)
National Gallery of Art, Washington, D.C. Gift
of Kent and Marcia Minichiello, in Honor of
the 50th Anniversary of the National Gallery
of Art, 1990.114.1
p. 251 right

James Agee
"Rapid Transit: Eight Photographs," *The
Cambridge Review*, no. 5 (Spring 1956),
pp. 24–25
9 x 12¼ in. (22.8 x 31 cm)
Centre Pompidou, Musée National d'Art
Moderne, Paris. Bibliothèque Kandinsky,
David Campany Collection
pp. 252–53

"Walker Evans: The Unposed Portrait,"
Harper's Bazaar (March 1962), pp. 120–21
12¾ x 19½ in. (32.5 x 49.4 cm)
Centre Pompidou, Musée National d'Art
Moderne, Paris. Bibliothèque Kandinsky,
David Campany Collection
pp. 254–55

*Detroit Pedestrian, for the Series "Labor
Anonymous," Fortune, November 1946*, 1946
Gelatin silver print, 5⅛ x 4¼ in.
(13.1 x 10.7 cm)
The Metropolitan Museum of Art, New York.
Gift of Ann Tenenbaum and Thomas H. Lee,
2013, 2013.246.10
p. 239 top right (not in exhibition)

Maquette for dust jacket of *The Passengers*,
1958–66
9¼ x 7⅝ in. (23.5 x 19.3 cm)
Unpublished book project
National Gallery of Art, Washington, D.C. Gift
of Mr. and Mrs. Harry H. Lunn, Jr., in Honor of
the 50th Anniversary of the National Gallery
of Art, 1991.113.1
p. 256

Subway Portraits, 1938–41, assembled
ca. 1959
Gelatin silver print, overall 13 x 8½ in.
(33 x 21.7 cm), each 2⅝ x 1⅞ in. (6.7 x 4.8 cm)
The J. Paul Getty Museum, Los Angeles,
84.XM.956.792
p. 257 left

Self-Portrait in Automated Photobooth,
ca. 1933
Gelatin silver print, overall 7¼ x 1½ in.
(18.3 x 3.8 cm), each 1¾ x 1⅜ in.
(4.4 x 3.5 cm)
The Metropolitan Museum of Art, New York.
Walker Evans Archive, 1994, 1994.261.48
p. 257 right

Subway Portrait, 1938–41
Gelatin silver print, 7 x 7⅜ in. (17.8 x 18.7 cm)
The Museum of Modern Art, New York.
Purchase, 462.1966

Subway Portrait, January 1941
Gelatin silver print, 8¼ x 7½ in.
(20.9 x 19.1 cm)
National Gallery of Art, Washington, D.C. Gift
of Kent and Marcia Minichiello, in Honor of
the 50th Anniversary of the National Gallery
of Art, 1990.114.6

Souvenir Portraits
*Jane Ninas in Front of Parked Cars, in the
French Quarter, New Orleans*, 1935
Gelatin silver print, 4½ x 6⅜ in.
(11.5 x 16.2 cm)
Myriam Lunn Collection
p. 258

*Family Snap Shots in Frank Tengle's Home,
Hale County, Alabama*, July–August 1936
Gelatin silver print, printed in April 1969
by the Library of Congress, 7½ x 9½ in.
(19.1 x 24.1 cm)
National Gallery of Canada, Ottawa.
Purchased in 1969, 21720
p. 259

Untitled [Gay Burke, Tuscaloosa, Alabama],
October 26, 1973
SX-70 Polaroid print, 3⅛ x 3⅛ in.
(7.9 x 7.8 cm)
Yale University Art Gallery, New Haven.
Gift of Eliza Mabry and Jonathan Gibson,
2008.195.31
p. 260 top

*Untitled [Gay Burke Brushing Her Hair,
Old Lyme, Connecticut]*, May 1974
SX-70 Polaroid print, 3⅛ x 3⅛ in.
(7.9 x 7.8 cm)
Yale University Art Gallery, New Haven.
Gift of Eliza Mabry and Jonathan Gibson,
2008.195.78
p. 260 center

Untitled [Walker Evans], May 4, 1974
SX-70 Polaroid print, 3⅛ x 3⅛ in.
(7.9 x 7.8 cm)
Yale University Art Gallery, New Haven.
Gift of Eliza Mabry and Jonathan Gibson,
2015.23.265
p. 260 bottom

Untitled [Boy Eating Cracker], 1973–74
SX-70 Polaroid print, 3⅛ x 3⅛ in.
(7.9 x 7.8 cm)
Yale University Art Gallery, New Haven.
Gift of Eliza Mabry and Jonathan Gibson,
2015.23.122
p. 261 top

Untitled [Jerry Thompson], October 1973
SX-70 Polaroid print, 3⅛ x 3⅛ in.
(7.9 x 7.8 cm)
Yale University Art Gallery, New Haven.
Gift of Eliza Mabry and Jonathan Gibson,
2015.23.122
p. 261 center

Untitled [Nancy Shaver], November 12, 1973
SX-70 Polaroid print, 3⅛ x 3⅛ in.
(7.9 x 7.8 cm)
Yale University Art Gallery, New Haven.
Gift of Eliza Mabry and Jonathan Gibson,
2015.23.3
p. 261 bottom

Untitled [Norm Ives], December 30, 1973
SX-70 Polaroid print, 3⅛ x 3⅛ in.
(7.9 x 7.8 cm)
Yale University Art Gallery, New Haven.
Gift of Eliza Mabry and Jonathan Gibson,
2015.23.160

*Untitled [Alan Trachtenberg, American Studies
Dept. Welcome Picnic, Powers Lake, East
Lyme, Connecticut]*, September 15, 1974
SX-70 Polaroid print, 3⅛ x 3⅛ in.
(7.9 x 7.8 cm)
Yale University Art Gallery, New Haven.
Gift of Eliza Mabry and Jonathan Gibson,
2015.23.103

Untitled [Jane Corrigan], 1974
SX-70 Polaroid print, 3⅛ x 3⅛ in.
(7.9 x 7.8 cm)
Yale University Art Gallery, New Haven.
Gift of Eliza Mabry and Jonathan Gibson,
2015.23.51

Utilitarian Elegance
Iron Chair, 1934
Gelatin silver print, printed ca. 1970 by Charlie
Rodemeyer, 8 x 10 in. (20.3 x 25.4 cm)
The Museum of Modern Art, New York.
Gift of the artist, SC 1971.1.349
p. 262 top

Iron Chair, 1934
Gelatin silver print, printed ca. 1970 by Charlie
Rodemeyer, 8 x 10 in. (20.3 x 25.4 cm)
The Museum of Modern Art, New York.
Gift of the artist, SC 1971.1.346
p. 262 bottom

Iron Chair, 1934
Gelatin silver print, printed ca. 1970 by Charlie
Rodemeyer, 8 x 10 in. (20.3 x 25.4 cm)
The Museum of Modern Art, New York.
Gift of the artist, SC 1971.1.350
p. 263

"Beauties of the Common Tool," *Fortune* 52,
no. 1 (July 1955), pp. 103–7
13 x 20½ in. (33 x 52 cm)
Centre Pompidou, Musée National d'Art
Moderne, Paris. Bibliothèque Kandinsky,
David Campany Collection
pp. 264–65

*Bricklayer's Pointing Trowel, by Marshaltown
Trowel Co., $1.35*, 1955
Gelatin silver print, 9½ x 7⅝ in.
(24.3 x 19.4 cm)
The J. Paul Getty Museum, Los Angeles,
84.XP.453.17
p. 266

Open End Crescent Wrench, 1955
Gelatin silver print, 9½ x 7⅝ in.
(24.13 x 19.4 cm)
The Bluff Collection
p. 267

Chain-Nose Pliers, 1955
Gelatin silver print, 8 x 10 in. (20.3 x 25.4 cm)
The Bluff Collection
p. 268

Tin Snips by J. Wiss and Sons Co., $1.85, 1955
Gelatin silver print, 9⅝ x 7⅝ in.
(24.4 x 19.4 cm)
The J. Paul Getty Museum, Los Angeles,
84.XP.453.1
p. 269

["T" Bevel], 1955
Gelatin silver print, 9¾ x 7⅞ in. (24.9 x 20 cm)
The J. Paul Getty Museum, Los Angeles,
84.XM.956.1067
p. 270

Crate Opener, 1955
Gelatin silver print, 8¼ x 6¾ in.
(20.81 x 17.14 cm)
Private collection, San Francisco
p. 271

African Objects
Plate no. 249 in *African Negro Art* portfolio,
1935
Gelatin silver print, 9½ x 7 in. (24.1 x 17.8 cm)
Musée du Quai Branly–Jacques Chirac, Paris
p. 272

Enlargement of plate no. 417 in *African Negro
Art* portfolio, 1935
Gelatin silver print, 18⅝ x 13⅞ in.
(47.2 x 35.3 cm)
The Museum of Modern Art, New York.
Transferred from the Museum Library,
383.1941
p. 273

Plate no. 402 in *African Negro Art* portfolio,
1935
Gelatin silver print, 6⅞ x 5⅜ in.
(17.6 x 13.6 cm)
Musée du Quai Branly–Jacques Chirac, Paris
p. 274

Plate no. 351 in *African Negro Art* portfolio,
1935
Gelatin silver print, 9¼ x 4½ in.
(23.6 x 11.3 cm)
Musée du Quai Branly–Jacques Chirac, Paris
p. 275

Plate no. 358 in *African Negro Art* portfolio,
1935
Gelatin silver print, 7¾ x 7⅜ in.
(19.6 x 18.8 cm)
Musée du Quai Branly–Jacques Chirac, Paris
p. 276 top

Plate no. 102 in *African Negro Art* portfolio,
1935
Gelatin silver print, 9½ x 6¾ in.
(24.1 x 17.2 cm)
Musée du Quai Branly–Jacques Chirac, Paris
p. 276 center

Plate no. 283 in *African Negro Art* portfolio,
1935
Gelatin silver print, 9½ x 6⅞ in. (24 x 17.4 cm)
Musée du Quai Branly–Jacques Chirac, Paris
p. 276 bottom left

Plate no. 107 in *African Negro Art* portfolio,
1935
Gelatin silver print, 9⅜ x 5¾ in.
(23.9 x 14.7 cm)
Musée du Quai Branly–Jacques Chirac, Paris
p. 276 bottom right

Plate no. 271 in *African Negro Art* portfolio,
1935
Gelatin silver print, 8⅞ x 7¼ in.
(22.4 x 18.5 cm)
Musée du Quai Branly–Jacques Chirac, Paris
p. 277 top

Plate no. 476 in *African Negro Art* portfolio,
1935
Gelatin silver print, 9½ x 5⅝ in. (24 x 14.3 cm)
Musée du Quai Branly–Jacques Chirac, Paris
p. 277 center

Plate no. 330 in *African Negro Art* portfolio,
1935
Gelatin silver print, 9⅛ x 5⅞ in.
(23.1 x 14.8 cm)
Musée du Quai Branly–Jacques Chirac, Paris
p. 277 bottom

Plate no. 407 in *African Negro Art* portfolio,
1935
Gelatin silver print, 8⅛ x 5⅛ in. (20.6 x 13 cm)
Musée du Quai Branly–Jacques Chirac, Paris
p. 278

Plate no. 436 in *African Negro Art* portfolio,
1935
Gelatin silver print, 7¾ x 6¼ in. (19.6 x 16 cm)
Musée du Quai Branly–Jacques Chirac, Paris
p. 279

Plate no. 450 in *African Negro Art* portfolio,
1935
Gelatin silver print, 9⅛ x 5⅛ in. (23.3 x 13 cm)
Musée du Quai Branly–Jacques Chirac, Paris
p. 280 left

Plate no. 144 in *African Negro Art* portfolio,
1935
Gelatin silver print, 6 x 7⅝ in. (15.1 x 19.3 cm)
Musée du Quai Branly–Jacques Chirac, Paris
p. 280 right

Plate no. 139 in *African Negro Art* portfolio,
1935
Gelatin silver print, 9¼ x 7 in. (23.5 x 17.8 cm)
Musée du Quai Branly–Jacques Chirac, Paris
p. 281

Plate no. 213 in *African Negro Art* portfolio,
1935
Gelatin silver print, 9⅛ x 7⅛ in.
(23.2 x 18.2 cm)
Musée du Quai Branly–Jacques Chirac, Paris

Plate no. 217 in *African Negro Art* portfolio,
1935
Gelatin silver print, 9⅛ x 6⅞ in.
(23.1 x 17.6 cm)
Musée du Quai Branly–Jacques Chirac, Paris

Plate no. 317 in *African Negro Art* portfolio,
1935
Gelatin silver print, 9¼ x 5⅛ in. (23.6 x 13 cm)
Musée du Quai Branly–Jacques Chirac, Paris

Plate no. 410 in *African Negro Art* portfolio, 1935
Gelatin silver print, 7⅞ x 7⅛ in. (20 x 18.2 cm)
Musée du Quai Branly–Jacques Chirac, Paris

Plate no. 418 in *African Negro Art* portfolio, 1935
Gelatin silver print, 9¼ x 5 in. (23.5 x 12.6 cm)
Musée du Quai Branly–Jacques Chirac, Paris

Plate no. 425 in *African Negro Art* portfolio, 1935
Gelatin silver print, 9⅜ x 6⅛ in.
(23.7 x 15.4 cm)
Musée du Quai Branly–Jacques Chirac, Paris

Plate no. 432 in *African Negro Art* portfolio, 1935
Gelatin silver print, 8⅛ x 5⅞ in. (20.7 x 15 cm)
Musée du Quai Branly–Jacques Chirac, Paris

Plate no. 454 in *African Negro Art* portfolio, 1935
Gelatin silver print, 9⅛ x 6¼ in.
(23.3 x 15.8 cm)
Musée du Quai Branly–Jacques Chirac, Paris

Plate no. 472 in *African Negro Art* portfolio, 1935
Gelatin silver print, 9⅜ x 6¾ in.
(23.7 x 17.3 cm)
Musée du Quai Branly–Jacques Chirac, Paris

The Circus Wagon
Circus Wagon (Calliope Car), Winter Quarters, Sarasota, 1941
Gelatin silver print, 5⅞ x 9⅛ in.
(14.8 x 23.2 cm)
The J. Paul Getty Museum, Los Angeles, 84.XM.956.851
p. 282

Circus Wagons, 1972
Gelatin silver print, 6 x 7⅜ in. (15.2 x 18.7 cm)
Yale University Art Gallery, New Haven. Gift of Mrs. Winthrop Sargeant, 1978.72.2
p. 283

Ringling Bandwagon, Circus Winter Quarters, Sarasota, 1941
Gelatin silver print, 6½ x 9⅛ in.
(16.5 x 23.2 cm)
Private collection, San Francisco
p. 284 top

Ringling Bandwagon, 1941
Gelatin silver print, 6¾ x 5⅝ in.
(17.3 x 14.2 cm)
National Gallery of Art, Washington, D.C.
Horace W. Goldsmith Foundation Gift, through Robert and Joyce Menschel, 1990.38.7
p. 284 bottom

Ringling Bandwagon, Circus Winter Quarters, Sarasota, 1941
Gelatin silver print, 7⅝ x 6⅞ in.
(19.5 x 17.5 cm)
The J. Paul Getty Museum, Los Angeles, 84.XM.956.831
p. 285

Alice S. Morris, "The Circus at Home. Photographed in Sarasota by Walker Evans," *Harper's Bazaar* 73 (April 1942), pp. 64–65
13 x 20½ in. (33 x 52 cm)
Centre Pompidou, Musée National d'Art Moderne, Paris. Bibliothèque Kandinsky, David Campany Collection
pp. 286–87

PHOTOGRAPHY, ITSELF (CONCLUSION)
Postcard Display, 1941
Gelatin silver print, 6½ x 5¼ in.
(16.4 x 13.3 cm)
The J. Paul Getty Museum, Los Angeles, 84.XM.956.874
p. 290

Penny Picture Display, Savannah, 1936
Gelatin silver print, 8⅝ x 6⅞ in.
(21.9 x 17.6 cm)
The Museum of Modern Art, New York. Gift of Willard Van Dyke, 1458.1968
p. 291

Photographic Enlargers, ca. 1946
Pencil on paper, 16¾ x 13⅞ in.
(42.4 x 35.2 cm)
The Metropolitan Museum of Art, New York. Walker Evans Archive, 1994, 1994.261.183
p. 292 left

Self-Portrait with Enlarger, ca. 1930
Gelatin silver print, 6⅞ x 4¾ in.
(17.5 x 12.07 cm)
San Francisco Museum of Modern Art.
Fund of the '80s purchase
p. 292 right

Untitled [Walker Evans's Darkroom at 92 Fifth Avenue], ca. 1930
Gelatin silver print, printed ca. 1970 by Charlie Rodemeyer, 10 x 8 in. (25.4 x 20.3 cm)
The Museum of Modern Art, New York. Gift of the artist, SC1971.1.41
p. 293 left

Walker Evans's Darkroom, ca. 1930
Gelatin silver print, 9½ x 7⅛ in. (24 x 18 cm)
Estate of Harry H. Lunn Jr.
p. 293 right

Sandwich-Man Advertising Washington Street Studio, ca. 1930
Gelatin silver print, 7¾ x 4¾ in.
(19.7 x 12.2 cm)
The J. Paul Getty Museum, Los Angeles, 84.XM.956.66
p. 294

License Photo Studio, New York, 1934
Gelatin silver print, 7¼ x 5⅝ in.
(18.3 x 14.4 cm)
The J. Paul Getty Museum, Los Angeles, 84.XM.956.456
p. 295

Untitled, Photographer's Window, 1936
Gelatin silver print, 10 x 8 in.
(25.4 x 20.32 cm)
Collection of Marcia L. Due and Jerry L. Thompson
p. 296

Store Window Reflections, August 1947
Gelatin silver print, 7⅛ x 6¾ in. (18 x 17 cm)
Yale University Art Gallery, New Haven. Katharine Ordway Fund, 2002.52.11
p. 297

Bedroom Dresser, Shrimp Fisherman's House, Biloxi, Mississippi, 1945
Gelatin silver print, 9⅞ x 7⅞ in.
(25.2 x 20.1 cm)
Courtesy Baudoin Lebon
p. 298 top

Bed and Stove, Truro, Massachusetts, 1931
Gelatin silver print, printed 1971, 6 x 7¾ in.
(15.2 x 19.7 cm)
San Francisco Museum of Modern Art, 71.39.3
p. 298 bottom

The Cactus Plant/Interior Detail of a Portuguese House, Truro, Massachusetts, 1930–31
Gelatin silver print, 8 x 6¼ in. (20.3 x 16 cm)
The J. Paul Getty Museum, Los Angeles, 84.XM.129.1
p. 299

Untitled, ca. 1930
Gelatin silver print, 8 x 10 in.
(20.32 x 25.4 cm)
Collection of Marcia L. Due and Jerry L. Thompson
p. 300 top

Yale Graduate Photography Students on Street, near Accomac, Virginia, 1973
Gelatin silver print, 9½ x 7⅝ in.
(24.2 x 19.3 cm)
The Metropolitan Museum of Art, New York. Walker Evans Archive, 1994, 1994.261.237
p. 300 bottom

Resort Photographer at Work, 1941
Gelatin silver print, 6¼ x 8⅞ in.
(15.9 x 22.4 cm)
The J. Paul Getty Museum, Los Angeles, 84.XM.956.948
p. 301

Untitled [Marcia Due and Leila Hill], 1973–74
SX-70 Polaroid print, 3⅛ x 3⅛ in.
(7.9 x 7.8 cm)
Yale University Art Gallery, New Haven. Gift of Eliza Mabry and Jonathan Gibson, 2015.23.43
p. 302 top

Untitled [Walker Evans Dinner Party, Old Lyme, Connecticut: Jerry Thompson, Barbara Gizzi, and Mary Knollenberg], October 12, 1973
SX-70 Polaroid print, 3⅛ x 3⅛ in.
(7.9 x 7.8 cm)
Yale University Art Gallery, New Haven. Gift of Eliza Mabry and Jonathan Gibson, 2015.23.131
p. 302 bottom

Untitled [Polaroid Film Packs and Boxes in Grass], May 19, 1974
SX-70 Polaroid print, 3⅛ x 3⅛ in.
(7.9 x 7.8 cm)
Yale University Art Gallery, New Haven. Gift of Eliza Mabry and Jonathan Gibson, 2015.23.195
p. 303

What, No Garters? (Chicago), 1946
Gelatin silver print, 7½ x 7½ in.
(19.2 x 18.9 cm)
The Art Institute of Chicago. Gift of David C. and Sarajean Ruttenberg, 1991.1471

Sedat Pakay (director)
Walker Evans, His Time, His Presence, His Silence, 1969
16mm film, 28 minutes
All rights reserved by Hudson Film Works 11
With credit for sedatpakay.com

CATALOGUE

Editor
—Clément Chéroux
assisted by Julie Jones

Scientific Committee
—Anne Bertrand
—Jeff L. Rosenheim

Publications Managers
—Marion Diez
—Audrey Klébaner
—Amarante Szidon

Image Acquisition
—Mai-Lise Benedic
—Marion Diez
—Audrey Klébaner

Document Digitization
—Bruno Descout

Translation
—Jean-François Cornu (French edition)
—Pierre-Emmanuel Dauzat (French edition)
—Sharon Grevet (English edition)

Graphic Design and Layout
—Julie[&]Gilles

Production
—Bernadette Borel Lorie

PUBLICATIONS DEPARTMENT
MUSÉE NATIONAL D'ART MODERNE–CENTRE DE CRÉATION INDUSTRIELLE

Director
—Nicolas Roche

Head of Publishing
—Claire de Cointet

Editorial Manager
—Françoise Marquet

Sales Officer
—Francesca Baldi

Marketing Manager
—Ingrid Bentégeat

Sales Administration Manager
—Thomas Savary

Administrative and Financial Management

Head of Legal Procedures and Budgetary Control
—Marie Savoldelli

Receipts and Contracts Manager
—Matthias Battestini

Administrative Assistants
—Isabelle Charles-Planchet
—Violaine Ho-Kchen-Fong
—Philippe Léonard

Manager of Image Rights
—Claudine Guillon

Image Acquisition
—Mai-Lise Benedic
—Xavier Delamare
—Clarisse Deubel

PARIS VENUE

MUSÉE NATIONAL D'ART MODERNE–CENTRE DE CRÉATION INDUSTRIELLE

Director
—Bernard Blistène

Deputy Directors
—Brigitte Leal (Collections)
—Catherine David (Research and Globalization)
—Frédéric Migayrou (Industrial Design)
—Didier Ottinger (Cultural Programming)

Chief Administrative Officer
—Xavier Bredin

Exhibition Curator
—Clément Chéroux
assisted by Julie Jones

Scientific Committee
—Anne Bertrand
—Jeff L. Rosenheim

PHOTOGRAPHY DEPARTMENT

Chief Curator
—Clément Chéroux

Curator
—Karolina Ziebinska-Lewandowska

Associate Curators
—Emmanuelle Etchecopar-Etchart
—Julie Jones

Collection Associate
—Carole Hubert

Assistant Curator
—Damarice Amao

Storage, Framing Manager
—Jean-Gabriel Massardier

Restorer
—Véronique Landy

Exhibition Manager
—Sara Renaud

Architect-Scenographer
—Pascal Rodriguez

Registrar
—Flavie Jauffret

Management of Exhibition Space
—Alain Chaume

Lighting Specialist
—Eric Brayer

Graphic Design
—Costanza Matteucci with Caroline Pauchant

WORKSHOPS AND TECHNICAL RESOURCES DEPARTMENT

Assembly and Layout of Documents
—James Caritey
—Françoise Perronno

Lighting
—Arnaud Jung, Manager

Installation
—Michel Naït, Manager
—Patrick Gapenne
—Laurent Melloul
—Jean-Marc Mertz

Painting
—Lamri Bouaoune
—Mokhlos Farhat
—Dominique Gentilhomme
—Emmanuel Gentilhomme
—Sofiane Saal

AUDIOVISUAL PRODUCTION

—Kim Levy, Audiovisual Production Manager
—Yann Bellet, Graphic Design
—Ivan Gariel, Sound Engineer
—Axel Misipo, Image and Sound Processing

Handling
—Vahid Hamidi, Manager
—Christophe Bechter
—Eric Hagopian
—Emmanuel Rodoréda

Photographic Laboratory
—Anne Paounov, Manager
—Bruno Descout
—Audrey Laurans
—Valérie Leconte
—Philippe Migeat
—Hervé Véronèse

BIBLIOTHÈQUE KANDINSKY

Curator and Head of the Department
—Didier Schulmann

Loan Coordinator
—Nathalie Cissé-Mongaillard

Periodicals Manager
—Laurence Gueye-Parmentier

DEPARTMENT OF CULTURAL DEVELOPMENT

Director
—Kathryn Weir

Spoken Word Unit
—Jean-Max Colard, Unit Head
—William Chamay, Assistant Unit Head

Live Shows Department
—Serge Laurent, Department Head

PRODUCTION DEPARTMENT

Director
—Stéphane Guerreiro

Deputy Director, Head of Administration and Finance
—Anne Poperen

Head of Exhibitions Management Unit
—Yvon Figueras

Head of Scenography and Museum Productions Unit
—Gaëlle Seltzer

Head of Workshops and Technical Resources Unit
—Gilles Carle

Head of Audiovisual Production
—Sylvain Wolff

Security
—David Martin

PUBLIC PROGRAMS DEPARTMENT

Director
—Catherine Guillou

Deputy Director, Head of Cultural Mediation Unit
—Patrice Chazottes

Head of Public Reception Unit
—Benoît Sallustro

Head of Public Information Unit
—Josée Chapelle

Head of Public Development Unit
—Cécile Venot

Head of Administrative Unit
—Vincent Brico

Project Manager–Cultural Outreach
—Morgane Elbaz

COMMUNICATIONS AND PARTNERSHIPS DEPARTMENT

Director—Benoît Parayre

Deputy Directors
—Marc-Antoine Chaumien
—Stéphanie Hussonnois-Bouhayati

Delegate, International Relations
—Michael Schischke

Image Unit
—Christian Beneyton

Head of Public Relations Unit
—Lydia Poitevin

Public Relations
—Élise Falgayrettes

Multimedia Unit
—Gilles Duffau, Manager

Sponsorship and Corporate Partners
—Raphaëlle Haccart

Press Attachée
—Élodie Vincent

SAN FRANCISCO VENUE

SAN FRANCISCO MUSEUM OF MODERN ART

Helen and Charles Schwab Director
—Neal Benezra

Deputy Museum Director, Curatorial Affairs
—Ruth Berson

Deputy Museum Director, Administration and Finance
—Janet Alberti

Deputy Museum Director, External Affairs
—Nan Keeton

Exhibition Curator
—Clément Chéroux
assisted by Linde B. Lehtinen and Christina Wiles

DEPARTMENT OF PHOTOGRAPHY

Senior Curator
—Clément Chéroux

Curator
—Corey Keller

Baker Street Foundation Associate Curator
—Erin O'Toole

Assistant Curators
—Linde B. Lehtinen
—Adam Ryan

Curatorial Assistants
—Matthew Kluk
—Christina Wiles

Department Administrator
—Margaret Ann O'Connor

Curator Emerita
—Sandra Phillips

The curatorial team wishes to acknowledge the following colleagues:

EXHIBITIONS

Jessica Woznak
Jillian Aubrey
Annie Hagar

EXHIBITION DESIGN

Kent Roberts
Sarah Choi

INSTALLATION

Joshua Pieper
Jess Kreglow
Greg Wilson
Alex Dangles
Travis Kerkela

EXHIBITIONS TECHNICAL

Steve Dye
Joshua Churchill

CONSERVATION

Theresa Andrews
Roberta Piantavigna

REGISTRATION

Olga Charyshyn

PUBLICATIONS

Amanda Glesmann
Jennifer Knox White
Brianna Nelson

DESIGN STUDIO

Jennifer Sonderby
Bosco Hernández
Carrie Taffel

COLLECTIONS INFORMATION AND ACCESS

Sriba Kwadjovie

WEB AND DIGITAL PLATFORMS

Sarah Bailey Hogarty
Ana Fox-Hodess

DEVELOPMENT

Samantha Leo
Caroline Stevens
Denise Marica
Jacqueline Rais
Elizabeth Waller
Beth Harker

MARKETING AND COMMUNICATIONS

Jennifer Northrop
Jill Lynch
Dana Goldberg
Tracy Wada

VISITOR SERVICES

Christopher Lentz
Kelly Bishop

ACKNOWLEDGMENTS

We would like to thank all those who, through their generous loans, made this exhibition possible—the institutions, the collectors whose names appear below, and those who prefer to remain anonymous:

Bank of America LaSalle Collection, Boston: Lillian Lambrechts, Mary Edith Alexander
Bibliothèque Nationale de France, Paris: Laurence Engel, Sylvie Aubenas, Dominique Versavel
The Bluff Collection, San Francisco
David Campany, London
Centre National des Arts Plastiques, Paris: Yves Robert, Pascal Beausse
The Ellen and Gary Davis Foundation, Greenwich, Connecticut: Ellen and Gary Davis, Cat Celebrezze
Marcia L. Due and Jerry L. Thompson, Amenia, New York
Jack Feldman
Fondation A Stichting, Collection Astrid Ullens de Schooten, Brussels: Astrid Ullens de Schooten, Jean-Paul Deridder
Fraenkel Gallery, San Francisco: Jeffrey Fraenkel, Frish Brandt, Amy Whiteside
The Heithoff Family Collection, Minneapolis
Galerie Baudoin Lebon, Paris: Baudoin Lebon
Tom Lee and Ann Tenenbaum
Los Angeles County Museum of Art: Michael Govan, Britt Salvesen, Wallis Annenberg
Estate of Harry H. Lunn Jr.: Myriam Lunn, Christophe Lunn
Alain Menard, Paris
Musée du Quai Branly-Jacques Chirac, Paris: Stéphane Martin, Christine Barthe
National Gallery of Art, Washington, D.C.: Earl A. Powell III, Franklin Kelly, Sarah Greenough, Andrea Nelson
National Gallery of Canada, Ottawa: Marc Meyer, Ann Thomas, Luce Lebart
Pier 24, San Francisco: Andrew Pilara, Christopher McCall, Allie Haeusslein
Sammlung Falckenberg, Hamburg-Harburg: Harald Falckenberg, Dirk Luckow
San Francisco Museum of Modern Art: Neal Benezra, Ruth Berson, Sandra Phillips, Corey Keller, Matthew Kluk, Linde B. Lehtinen, Christina Wiles, Olga Charyshyn, Allison Spangler, Jessica Woznak, Annie Hagar, Jillian Aubrey
Steven Kasher Gallery, New York: Elaina Breen
The Art Institute of Chicago: James Cuno, Eloise W. Martin, Matthew Witkovsky, Heather C. Roach
The J. Paul Getty Museum, Los Angeles: Timothy Potts, Virginia Heckert, Judith Keller, Amanda Maddox, Mazie M. Harris
The Metropolitan Museum of Art, New York: Thomas P. Campbell, Jeff L. Rosenheim, Anna Wall, Meredith Reiss, Beth Saunders, Jeri Wagner, Julie Zeftel
The Museum of Modern Art, New York: Glenn D. Lowry, Quentin Bajac, Tasha Lutek
The New York Public Library: Joshua Chuang, Elizabeth Cronin, Zulay Chang, David Lowe
Yale University Art Gallery, New Haven: Jock Reynolds, Pamela Franks

The curator of the exhibition would also like to express his gratitude to all those who, in one way or another, contributed to this project:

Brett Abbott
Barbara Adams
L. Lynne Addison
Elizabeth Arthur
Geanna Barlaam
Allen Blevins
Katherine Bourguignon
Beverly W. Brannan
Philip Brookman
Jackie Burns
Raphaëlle Cartier
Cyril Chazal
Olivier Cousinou
Verna Curtis
Anne David
Christelle Demoussis
Natasha Derrickson
Goesta Diercks
Marc Donnadieu
Laurence Dubaut
Anaïs Feyeux
Robert Fisher
Lee Friedlander
Peter Galassi
Jennifer Garpner
Arno Gisinger
Andrea Hackman
Karen Hellman
Garry Henderson
Pauline Hervault
John T. Hill
Akiko Issaverdens
Michael Jerch
Mike Kaplan
Miriam Katz
Peter Kayafas
Tammy Kiter
Ross Knapper
Jennifer Lande
Marie Liard-Dexet
Heinz Liesbrock
Brice Matthieussent
Christian Milovanoff
Clarissa Morales
Nina Nazionale
Carol Nesemann
Jonathan Newman
Abner Nolan
Kathy Pakay
Carine Peltier-Caroff
Alessandra Pinzani
Michelle Povilaitis
John Pritzker
Lisa Pritzker
Brigitte Robin-Loiseau
Francesca Rose
Andrew Ruth et Gabriel Catone
Sam Sarowitz
Kendall Siewert
Françoise Simeray
Anna Simonovic
Gary B. Sokol
Ross Spears
Heidi Strassner
Deborah M. Straussman
Gabriella Svenningsen Omonte
Cynthia Tovar
Timmons Advisors LLC
Thomas Yarker

CONTENTS

PHOTO CREDITS